UNREAL CITY

Urban experience in modern
European literature and art

UNREAL CITY

Urban experience in modern European literature and art

edited by EDWARD TIMMS and
DAVID KELLEY

St. Martin's Press New York

Copyright © MANCHESTER UNIVERSITY PRESS 1985
All rights reserved. For information, write:
St. Martin's Press, Inc., 175 Fifth Avenue, New York, NY 10010
Printed in Great Britain
First published in the United States of America in 1985

ISBN 0-312-83348-2

Library of Congress Cataloging in Publication Data
Main entry under title:

Unreal city.

 Includes bibliographies and index.
 1. Cities and towns in art—Addresses, essays,
lectures. 2. Arts, Modern—20th century—Europe—Ad-
dresses, essays, lectures. 3. Avant-garde (Aesthetics)—
Europe—History—20th century—Addresses, essays, lectures.
I. Timms, Edward. II. Kelley, David, 1941–
NX542.U57 1985 700'.94 85–2209
ISBN 0-312-83348-2

CONTENTS

List of illustrations vii

Introduction:
Unreal city—theme and variations EDWARD TIMMS 1

1 The metropolis and the
emergence of Modernism RAYMOND WILLIAMS 13

2 Nineteenth-century
Paris: vision and nightmare PETER COLLIER 25

3 The city in painting FRANK WHITFORD 45

4 Mechanical millenium:
Sant'Elia and the poetry of Futurism JUDY DAVIES 65

5 Defeat and rebirth:
The city poetry of Apollinaire DAVID KELLEY 80

6 Rilke's Paris – 'cité pleine de rêves' NAOMI SEGAL 97

7 Expressionists
and Georgians: demonic
city and enchanted village EDWARD TIMMS 111

8 *Occupied City:*
Ostaijen's Antwerp and
the impact of the First World War ELSA STRIETMAN 128

9 Eliot, Pound, Joyce: Unreal city? MICHAEL LONG 144

10 Petersburg – Moscow – Petropolis JANA HOWLETT 158

11 Asphalt jungle: Brecht
and German poetry of the 1920s DAVID MIDGLEY 178

12 The City in early cinema:
 Metropolis, *Berlin* and *October* MICHAEL MINDEN 193

13 Surrealist
 city narrative: Breton and Aragon PETER COLLIER 214

14 Lorca: Poet in New York ALISON SINCLAIR 230

15 Musil's Vienna and
 Kafka's Prague:
 The quest for a spiritual city EDWARD TIMMS 247

 Index 265
 Acknowledgements 269

ILLUSTRATIONS

1 Braun and Hogenberg, *Nuremberg*—5

2 Meidner, *Berlin*—5

3 Delaunay, *Eiffel Tower*—6

4 Seurat, *Bathers, Asnières*—29

5 Manet, *The Bar at the Folies-Bergere*—29

6 Monet, *Boulevard des Capucines*—46

7 Meidner, *I and the City* — 46

8 Munch, *Spring Evening on Karl Johan* — 50

9 Kirchner, *The Street*—53

10 Boccioni, *The Street Enters the House*—55

11 Delaunay, *The City of Paris*—56

12 Grosz, *The Big City*—61

13 Dix, *Big City Triptych*—62

14–16 Sant'Elia: *The New City*; Study for a building;
Project for an electric generating station—67

17 Braque, *Bottle, Glass and Pipe*—93

18 Picasso, *The Acrobat with a Ball*—94

19 Alciati, *Art Assisting Nature*—94

20 Kley, *Industrial Breakdown*—121

21 Kirchner, *The City* — 121

22–3 Ostaijen: *Zeppelin over London; Threatened City* — 136

24 Mayakovsky and Lissitzky, *For the Voice*—169

25 Grosz, *Cross-Section*—179

26–29 *Metropolis*: Above ground; Machine room;
Laboratory; The slaves—196, 198, 202, 204

30 *Berlin:* Placard-carrying Negroes—206

31–2 *October:* Crowd scene; Kerensky going upstairs—209, 210

33 Lorca, *Urban Perspective with Self-Portrait* — 241

34 *Die Fackel:* Cover design—251

35 Lasker-Schüler, *Thebes with Yussuf*—252

Unreal city – theme and variations

This book analyses the responses of European writers and artists of the early twentieth century to the challenge of the city. From earliest recorded history the city has formed one of the magnetic poles of human existence.[1] But the growth of great metropolises during the nineteenth century gave an unprecedented urgency to this theme.[2] Around 1900 the city became the focal point for an intense debate about the dynamics of technological civilisation and its effect on the quality of human life. The urgency of this debate was signalled by the Futurist Manifesto of 1909, which identified the city as the pre-eminent theme of modern poetry and painting. This challenge was taken up by avant-garde artists and writers in every capital city of Europe, from Paris to St Petersburg.

Their responses are analysed in this sequence of fifteen chapters, origi-nally delivered as lectures in Cambridge during 1983–84. The aim is to explore the richness and diversity of these responses, but also to identify underlying patterns of coherence. Hence the comparative and interdiscipli-nary perspective. The poets and painters of the city were cosmopolitan, and it was the interaction between different cultures which generated the most complex images. The pressures of urbanisation were felt in all parts of Europe, though with significant regional and social variations. The response of writers in Berlin is very different from that in London, just as (within the individual city) Whitechapel is pictured differently from the West End. But from among these varied responses a certain consensus emerges, which is epitomised by the topos of the 'unreal city'.

The vision of the 'unreal city' is most memorably formulated in T. S. Eliot's *Waste Land*. But this book places Eliot's poem in a wider European context, showing that his images of the city are anticipated or echoed by a rich tradition of European writing from Baudelaire to Brecht. The perspec-tive may be political or mystical, Expressionist or Surrealist, but in almost every instance there is a rejection of urban experience as it had conven-tionally been defined. From Laforgue to Lorca there is a pervasive sense of

disorientation. Even the Futurists, whose response was more affirmative, picture the city as unstable and insecure.

This is a historical paradox. For the urban historian the great cities of Edwardian Europe represent one of the highest levels of metropolitan civilisation.[3] In London, Paris, Vienna and Berlin, elegant boulevards and public buildings now replaced the ramparts and alleyways of the old medieval towns. The problems of sanitation, water supply and hygiene which had preoccupied the Victorian social reformers were on the way to being solved. Electric lighting was dispersing the urban gloom, trams and underground trains replacing the chaos of horse-drawn transport. For the privileged inhabitants of the metropolis, the wealth of colonial empires and modern industries created an era of affluence. The working classes still suffered severe deprivation. But even here progress was being made towards better housing, hospitals and schools, improved diet and sanitation. Thus, although the political problem created by the glaringly unequal distribution of wealth remained unsolved, there were grounds for a sense of social progress, cultural achievement and civic pride.

Why do these achievements find such a distorted echo in European literature and art?[4] Why was the response of avant-garde authors so 'antagonistic'?[5] The metropolis offered unprecedented advantages to writers and artists. Cheap paper and enterprising publishers provided outlets into an expanding market for books and magazines. A growing leisured class helped to sustain a wide range of cultural endeavours. Artists and writers were drawn to the capital cities of Europe like moths to a brilliant light. And in their memoirs they often acknowledge the exhilaration of life in the metropolis. In a sense these were indeed the 'banquet years'.[6] Why then are the images of the city which emerge from the literature and art of this period so fraught with tension and unease?

One answer is to see this response as a reflection of historical contradictions, as Trotsky does in his analysis of Russian Futurism:

> Futurism reflected in art the historical development which began in the middle of the 'nineties, and which became merged in the World War. Capitalist society passed through two decades of unparalleled economic prosperity which destroyed the old concepts of wealth and power, and elaborated new standards, new criteria of the possible and of the impossible, and urged people towards new exploits.
>
> At the same time, the social movement lived on officially in the automatism of yesterday. The armed peace, with its patches of diplomacy, the hollow parliamentary systems, the external and internal politics based on the system of safety valves and brakes, all this weighed heavily on poetry at a time when the air, charged with accumulated electricity, gave sign of impending great explosions.[7]

These dynamic contradictions undermined the sense of a stable social order, of a 'here and now' which could be unproblematically affirmed. The technological future was a manifest force, to be greeted with joy or foreboding. The cultural past could also easily be identified, cherished or repudiated. But the society – and the city – of the present were in a state of flux which eluded representation.

A crucial factor was not merely the overwhelming size of the metropolis, but also the dynamic acceleration of urban and technological development. Within a single lifespan a rural community might be transformed into an industrial conurbation. The impact on human sensibility was all the greater because so many city-dwellers were not born in the metropolis, but were migrants from more traditional communities. The poet who sought to come to terms with the city was often a young man from the country, or indeed from another country (Eliot in London, Rilke in Paris, Lorca in New York).

A rural community, even a provincial town, is a structured and comprehensible system. It can be accommodated to a stable and unified artistic viewpoint, as in the print of Nuremberg in 1579 (Fig. 1). The city is depicted as a closed system reflecting a harmonious hierarchy of values. The dominating bulk of the castle is flanked by the spires of the principal churches and girdled by the roofs of patrician houses. Humbler dwellings huddle against the city walls, which enclose the urban ensemble. The massive gate-towers convey a sense of security, while the river in the foreground suggests a balance between town and country. The pride of the Renaissance in the achievements of urban culture is reflected in a harmonious iconography.

The amorphousness of the metropolis precludes this perspective. There is no longer any position *outside* the city from which it can be viewed as a coherent whole.[8] The poet, novelist or painter is trapped within the turmoil of the metropolis, as in Ludwig Meidner's image of Berlin in 1913 (Fig. 2). The rush of modern traffic creates lines of energy which seem to collide at the centre of the picture. The foreground is filled with faceless crowds, while the buildings blot out the skyline, creating an atmosphere of impending collapse. In every sphere – painting, poetry, and the novel – the dynamics of city life generated new forms of expression which accentuated its energy and turmoil. Conventional modes of representation were no longer adequate, as Ezra Pound pointed out in a comment on *The Waste Land*: 'The life of the village is narrative. . . . In a city the visual impressions succeed each other, overlap, overcross, they are cinematographic.'[9]

The acceleration of city life was accompanied by a redefinition of the relationship between perception and environment. Influenced by Bergson,

Freud and William James, the artists and writers of the early twentieth century assigned to subjective perceptions a higher truth than to photographic accuracy. For them the city was no longer the aggregate of its interacting social parts; it was a source of fleeting impressions registered by fluid states of consciousness. The realistic novels of the nineteenth century had depicted social milieux that were relatively fixed and stable, so that they could be encapsulated in self-contained chapters. But after 1900 the accelerated pace of social and technological change precipitated new modes of perception. How were sensibilities shaped by the ox-cart, oil-lamp and school slate to adjust to an environment of aeroplanes, electric lights and telephones? The culture shock of metropolitan civilisation required an unprecedented degree of mental and social readjustment.

The images of the city examined in this book thus reflect a heightened subjectivity of perception, as well as dynamic patterns of historical change. These writers take the pulse of city life and touch the nerve of urban anxiety. There is no stable centre to be found either in the city or in the civilisation which it epitomises. Thus the city ceases to be pictured as a social environment and is transposed on to an existential plane. The metropolis ultimately becomes a metaphor – a dynamic configuration of the conflicting hopes and fears of the twentieth century.

The most impressive achievements are those which strive towards a synthesis, establishing coherence within the turmoil by means of unifying myths or symbols. This process is epitomised by the paintings of Robert Delaunay, in which the Eiffel Tower becomes the vortex of the city's surging energies (Fig. 3). Between 1910 and 1912 Delaunay painted a series of studies of the tower with varying emphasis.[10] They synthesise the chaos depicted by Meidner with a more traditional iconography in which the city rises towards an apex (as in the print of Nuremberg). Some emphasise the tower's strength and functional construction. Its use as a radio transmitter made it a symbol of modern communications, simultaneously in contact with other parts of the world. But in Delaunay's paintings the tower does not stand in potent isolation on the Champs de Mars. It seems to generate energies so powerful that it draws the buildings of the city in upon it. And its structure is so fragmented by Delaunay's Cubist technique that the tower itself seems to be on the point of collapse. Underlying the triumphant image of modern technology is the archetype of the Tower of Babel. These paintings strike a precarious balance between coherence and disintegration.

The writers and artists who achieve this balance are relatively few. We find it perhaps in the poetry of Eliot and Apollinaire, or the novels of Joyce and Bely. But the predominant tendency is to recoil from the city towards divergent extremes. The responses range from the Futurist exaltation of

1. Braun and Hogenberg, *Nuremberg*
2. Meidner, *Berlin*

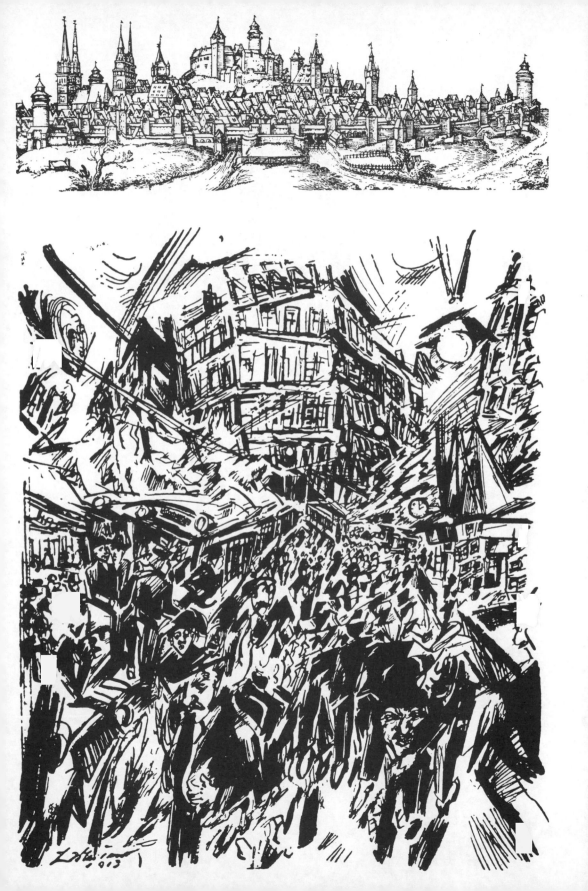

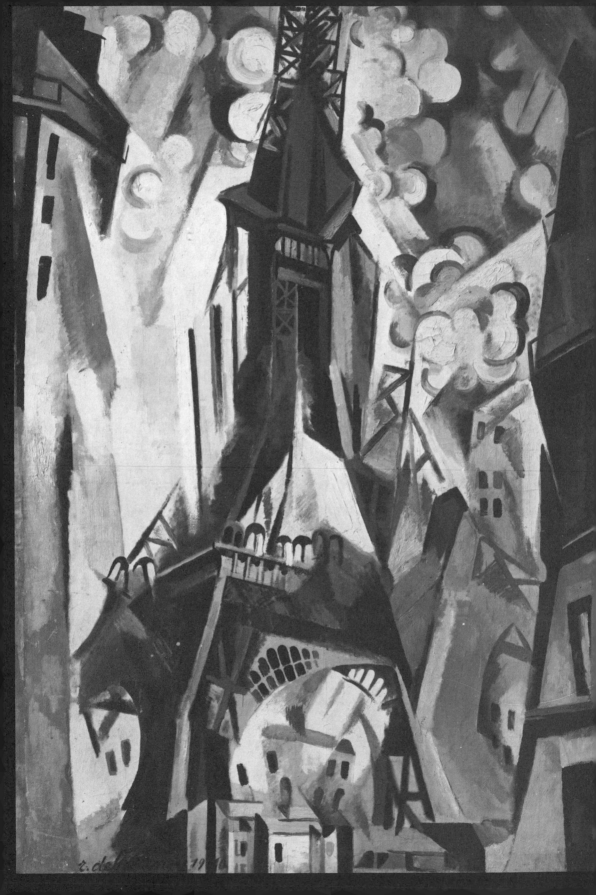

Sant'Elia to the Expressionist dread of Georg Heym. But the architect's dream is related to the poet's despair. Underlying the work of almost all the artists and writers reviewed in this book is a reluctance to accept the city in its mundane routine. They are visionaries rather than realists. They explore an 'unreal city' located between the extremes of hope and dread, between distant Utopia and imminent Apocalypse.[11]

These themes can already be identified in the work of nineteenth-century authors, analysed in the first two chapters of this book. In Chapter 1, 'The metropolis and the emergence of Modernism', Raymond Williams focuses critically on the concept of Modernism itself, identifying the problems which arise when this concept is narrowly applied to the artistic innovations of the early twentieth century. He shows that modernist responses to the city have a 'hidden history', with antecedents in the work of nineteenth-century writers like Wordsworth, Dickens, James Thomson and Friedrich Engels. The transformation which occurred at the beginning of the twentieth century was a matter not so much of thematic innovation as of new modes of artistic expression. The metropolis was a melting-pot in which national cultures were broken down and avant-garde artists found a new community of purpose through an intense preoccupation with their artistic medium.

In Chapter 2, 'Nineteenth-century Paris: vision and nightmare', Peter Collier shows that the city held an even greater fascination for French authors like Flaubert, Vigny, Baudelaire, Rimbaud and Laforgue. These writers found new modes for expressing the disturbing challenge of urban experience, which were to have a decisive influence on avant-garde authors of the early twentieth century. Paris was thus not only (in Walter Benjamin's terms) 'the capital of the nineteenth century'; it also provided the paradigms for the modernist visions of the city of Apollinaire, Rilke, T. S. Eliot and James Joyce. This chapter also focuses on the work of Impressionist painters, who developed new expressive techniques to convey the paradoxes of city life.

The responses of European painters are analysed in greater detail by Frank Whitford in Chapter 3, 'The city in painting'. Contrasting Monet's *Boulevard des Capucines* (1873) with Ludwig Meidner's *I and the City* (1913), he shows how radically artistic perception has been transformed. Where Monet is primarily concerned with external light effects, Meidner portrays the chaotic forces which convulse the metropolis. The argument also identifies the diversity of response in different European countries. The dehumanising effects of city life are accentuated by Kirchner and the German Expressionists (under the influence of Edvard Munch). The response of the Italian Futurists is more exuberant, as is evident from the

3. Delaunay, *Eiffel Tower*

work of Boccioni. Robert Delaunay's Paris paintings celebrate the rhythms of city life, while George Grosz and Otto Dix convey the conflict-laden atmosphere of Berlin in images of chaos and deprivation.

It was the Italian Futurists who made the most decisive contribution to the transformation of attitudes to the city. Their paintings and manifestos proclaim that the dynamics of city life have created a new sensibility. In Chapter 4, 'Mechanical millenium', Judy Davies analyses Marinetti's vision of modern art and Sant'Elia's prophetic designs for the city of the future. She shows how enthusiastically the Futurists espoused the values of urban civilisation: speed, energy and danger, sexuality and aggression, mechanisation and functionalism. But a closer look at Futurist poetry reveals an underlying ambiguity: the machines which enhance man's power are also perceived as a threat to a residual humanism.

The ideas of the Futurists were assimilated in very divergent ways. In Paris, Apollinaire was not untouched by the enthusiasm for a new mechanical age. But Apollinaire's city poetry, analysed by David Kelley in Chapter 5, combines a challenging modernity with a strong sense of the values of tradition. His poetry thus achieves more subtle and sophisticated effects by juxtaposing the fragmentation of urban experience with the cohesion of traditional myth. This paradoxical appeal to tradition, as a source both of disjunction and of integration, is also echoed in the paintings of Picasso, whose apparently modernist images prove to be modelled on earlier modes of representation.

If Paris offered its poets a sense of cultural rapport, it also abounded in images of insecurity. This is even more evident in the writings of Rilke, analysed by Naomi Segal in Chapter 6, 'Rilke's Paris – "cité pleine de rêves" '. When Rilke came to Paris from Germany in 1902, he felt overwhelmed by the destitution and desolation of the city. Although his imagination was fired by Baudelaire, Rilke's vision of the city is most powerfully conveyed not in his poetry, but in his novel *Malte Laurids Brigge*. Naomi Segal shows how the fractured form of the novel corresponds to the bombardment of exciting and horrific impressions in the metropolis. She also shows how Rilke's hero responds by making an imaginative journey into his childhood, alleviating the nightmare experience of the present by means of a kind of Freudian self-analysis. The originality of Rilke's narrative is contrasted with the more simplistic ways in which the Surrealists were later to assimilate the ideas of psychoanalysis.

In this same period Berlin was beginning to rival Paris as a centre of cultural activity. The responses of German Expressionist poets to the challenge of the metropolis are analysed by Edward Timms in Chapter 7, 'Demonic city and enchanted village'. Their city poetry is contrasted with

the pastoralism of the English Georgians in this same period. The visionary poetry of the Expressionists portrays a city haunted by demons and threatened by portents of disaster. This theme finds most powerful expression in the work of Georg Heym. The English Georgians, on the other hand, responded to the pressures of city life by taking refuge in an enchanted village of the imagination. Inspired by the example of Rupert Brooke, they celebrate the timeless rhythms of the English countryside.

The poetry of the early Expressionists foreshadows the orgy of self-destruction which convulsed Europe during the First World War. The war itself forms the subject of Paul van Ostaijen's poem *Occupied City*, analysed by Elsa Strietman in Chapter 8. In theme this poem relates to the German military occupation of Antwerp. But Ostaijen combined strong Flemish regional loyalties with an eager assimilation of the new poetic techniques of the European avant-garde. In form, particularly in its typography, *Occupied City* echoes the experimental techniques of Marinetti. But where Marinetti celebrates the dynamism of modern warfare, Ostaijen's poem portrays its destructiveness and inhumanity.

The trauma of the First World War is more obliquely reflected in T. S. Eliot's *Waste Land*. In Chapter 9, 'Eliot, Pound, Joyce: unreal city?', Michael Long shows how memorably Eliot expresses his fragmented vision of the city as the locus of disillusionment and despair. In Pound's *Cantos* this vision is intensified to the point of nausea. But Michael Long argues that this recoil from the city, often taken to epitomise the modernist response, appears deficient when measured against Joyce's *Ulysses*. For Joyce's novel is a celebration of a city which is irreducibly alive, in a style whose variety and energy mirrors the heterogeneous perambulations of Joyce's characters through the streets of Dublin.

The Waste Land epitomises the disillusionment of the 1920s. But other poets of this same period pictured the city in more dynamic terms. The transformation of the attitude of Russian writers is discussed by Jana Howlett in Chapter 10, which looks at the work of three contemporaries: Bely, Mayakovsky and Mandelshtam. The city is central to their work, both as reality and symbol, and their divergent treatment of this theme reflects the momentous changes which Russian society underwent in this period. All three writers saw violent change as inevitable. For Bely the Revolution of 1917 was the fulfilment of the apocalyptic prophecies which feature in his novel *Petersburg*. For Mayakovsky it marked the transition from Futurist aesthetic revolt to Communist political commitment. For Mandelshtam, however (as for Bely), the links with the past are more important than the energies of the future. Thus Mandelshtam's *Petersburg Strophes* invoke a city and identity under threat.

Disillusionment with the city is one of the leitmotifs of German poetry of the 1920s, analysed by David Midgley in Chapter 11, 'Asphalt jungle'. It is a period of retrenchment in which the visionary mode of the Expressionists is superseded by a new sobriety. This mood is epitomised by the poetry of Brecht, in which pithy prose rhythms express a pervasive scepticism. But Brecht's career is exceptional. His poetry redefines the experience of urban alienation so that it issues in a commitment to political struggle.

The 1920s also saw the first full-scale attempts to express the turmoil of city life through the medium of film. In Chapter 12, 'The city in early cinema', Michael Minden analyses three films in contrasting styles. Fritz Lang's *Metropolis* (1926) conveys powerful visual images of life dominated by machines, but in an over-simplified mode. Walther Ruttmann's documentary *Berlin* (1927) uses more flexible montage techniques to convey the confusion and the perceptual overloading of experience in the city. But it is Eisenstein's *October* (1928) which most effectively demystifies the city by showing St Petersburg in specific historical terms, as the location of a struggle for power. These films suggest that the cinema may be more successful than other art forms in conveying the dynamics of the city.

Where German attitudes of the 1920s tended towards a new sobriety, the most influential movement in France was Surrealism. In Chapter 13, 'Surrealist city narrative', Peter Collier focuses on the attempt by Louis Aragon and André Breton to divest the urban scene of its utilitarian functions. Breton's *Nadja* explores the uncanny power of Paris to generate irrational emotional experience. Aragon's *Paysan de Paris* recreates in a verbal extravaganza the visual fantasies of a receptive pedestrian. Both writers abandon the conventions of the realistic novel in favour of subjective indulgence in quasi-mystical images of the city, exploring self-consciously the problematic text which it yields.

Surrealist images of the city also abound in the work of Spanish poets, reviewed by Alison Sinclair in Chapter 14, 'Lorca: poet in New York'. Setting Lorca's work in the context of contemporary Spanish writing, she traces his extraordinary poetic response to the city, when he visited New York in 1929. Lorca's poem offers a spectacle of urban emptiness more desolate than Eliot's *Waste Land*, alternating with images of crowded chaos more anarchic than Brecht's 'asphalt jungle'.

In a final chapter Edward Timms discusses 'Musil's Vienna and Kafka's Prague'. The approach taken in this book is necessarily selective, since the subject is far too rich for comprehensive treatment.[12] But the map of European responses to the city would clearly be incomplete if it ignored the response of Austrian authors to the crisis of modern civilisation. This

chapter focuses not only on Musil's *Man without Qualities*, but also on others in Vienna who created alternative models of urban experience – whether architectural (Adolf Loos and Otto Wagner), psychological (Freud and Mach), or political (Theodor Herzl and Adolf Hitler). However unrealistic they may have seemed, these visions decisively shaped the events of the early twentieth century. Kafka's work embodies a similar paradox. Despite the subjectivity of his vision, his writings have come to exemplify the existential anxiety underlying urban existence. For Kafka, as for Musil, the quest is ultimately for a spiritual city which is by definition unreal.

This book is open-ended. Chronologically, it is centred on the period 1910–30. It thus does not take account of the poets of the 'Auden generation', who engaged so memorably with urban themes.[13] Nor does it attempt to relate the avant-garde art of the early decades of the twentieth century to the political reaction which so devastatingly occurred during the 1930s. It is clear from individual chapters that attitudes which were artistically avant-garde were by no means necessarily progressive in a political sense. Indeed, the 'dehumanisation of art' which has been identified in this period may obliquely have contributed to the triumph of political inhumanity.[14] The questioning of received conceptions of 'reality' was itself ideological, to a greater extent than these writers and artists recognised.[15] And few of them had a constructive alternative to offer to the 'unreal city' which they decried. To study the divergent political conclusions which may be drawn from their imaginative visions would require a second volume more political in orientation. The city was primarily perceived as the locus of alienation. Gradually they became aware that it was also the centre of political power. But that is another story.

Notes to introduction

1 Lewis Mumford, *The City in History: Its Origins, Its Transformations, Its Prospects*, London, 1961.
2 See Raymond Williams, *The Country and the City*, London, 1973; Carl E. Schorschke, 'The idea of the city in European thought: Voltaire to Spengler', in *The Historian and the City*, ed. Oscar Handlin and John Burchard, Cambridge, Mass., 1963, pp. 95–114.
3 For the Victorian background see *The Victorian City: Images and Realities*, ed. H. J. Dyos and Michael Wolff, 2 vols., London, 1973. Advances in town planning are documented in a series of volumes edited by Anthony Sutcliffe, including *Towards the Planned City: Germany, Britain, the United States and France, 1780–1914*, Oxford, 1980.
4 The equally negative American responses to the city, which fall outside the scope of this book, are analysed in *Literature and the American Urban Experience*, ed. Michael C. Jaye and Ann Chalmers Watts, Manchester, 1981; and Morton and

Lucia White, *The Intellectual versus the City: From Thomas Jefferson to Frank Lloyd Wright*, Cambridge, Mass., 1962.

5 Renato Poggioli, *The Theory of the Avant-Garde*, Cambridge, Mass., 1968, pp. 30–40.

6 Roger Shattuck, *The Banquet Years: The Arts in France 1885–1918*, London, 1959.

7 Leon Trotsky, *Literature and Revolution*, translated by Rose Strunsky, London, 1925, p. 126, reprinted 1960, Ann Arbor, Michigan.

8 On the problem of 'legibility', and the loss of a 'visual hierarchy' in modern conurbations, see Kevin Lynch, *The Image of the City*, Cambridge, Mass., 1974.

9 Quoted in Helen Williams, *T. S. Eliot: The Waste Land*, London, 1973, p. 15.

10 For an analysis of Delaunay's Eiffel Tower paintings see Sherry A. Buckberrough, *Robert Delaunay: The Discovery of Simultaneity*, Ann Arbor, 1982, pp. 47–77.

11 For a more detailed account of the Utopian strain in modern architecture, see Reyner Banham, *Theory and Design in the First Machine Age*, London, 1960; Robert Hughes, *The Shock of the New*, London, 1980, Chapter 4; Robert Fishman, *Urban Utopias of the Twentieth Century*, Cambridge, Mass., 1982.

12 Further guidance about the literature and art of the city can be found in *Modernism 1890–1930*, ed. Malcolm Bradbury and James McFarlane, Harmondsworth, 1976; *Metropolis 1890–1940*, ed. Anthony Sutcliffe, London, 1984; *Visions of the Modern City*, ed. William Sharpe and Leonard Wallock, New York, 1984; Diana Festa-McCormick, *The City as Catalyst: A Study of Ten Novels*, Fairleigh Dickinson, 1983; Monroe K. Spears, *Dionysus and the City: Modernism in Twentieth-Century Poetry*, New York, 1970; William B. Thesing, *The London Muse: Victorian Poetic Responses to the City*, Athens, Georgia, 1982; Burton Pike, *The Image of the City in Modern Literature*, Princeton, 1981.

13 See Samuel Hynes, *The Auden Generation: Literature and Politics in England in the 1930s*, London, 1976.

14 Ortega y Gasset, *The Dehumanization of Art and Other Writings*, New York, 1956.

15 See J. P. Stern, ' "Reality" in early twentieth-century German literature', in *Philosophy and Literature*, ed. A. Phillips Griffiths, Cambridge, 1984, pp. 41–57.

The metropolis and the emergence of Modernism

Modernism as a critical concept

It is now clear that there are decisive links between the practices and ideas of the avant-garde movements of the twentieth century and the specific conditions and relationships of the twentieth-century metropolis. The evidence has been there all along, and is indeed in many cases obvious. Yet until recently it has been difficult to disengage this specific historical and cultural relationship from a less specific but widely celebrated (and execrated) sense of 'the modern'.

In the late twentieth century it has become increasingly necessary to notice how relatively far back the most important period of 'modern art' now appears to be. The conditions and relationships of the early twentieth-century metropolis have in many respects both intensified and been widely extended. In the simplest sense, great metropolitan aggregations, continuing the development of cities into vast conurbations, are still historically increasing (at an even more explosive rate in the Third World). In the old industrial countries, a new kind of division between the crowded and often derelict 'inner city' and the expanding suburbs and commuter developments has been marked. Moreover, within the older kinds of metropolis, and for many of the same reasons, various kinds of avant-garde movement still persist and even flourish. Yet at a deeper level the cultural conditions of the metropolis have decisively changed.

The most influential technologies and institutions of art, though they are still centred in this or that metropolis, extend and indeed are directed beyond it, to whole diverse cultural areas, not by slow influence but by immediate transmission. There could hardly be a greater cultural contrast than that between the technologies and institutions of what is still mainly called 'modern art' – writing, painting, sculpture, drama, in minority

presses and magazines, small galleries and exhibitions, city-centre theatres – and the effective output of the late twentieth-century metropolis, in film, television, radio and recorded music. Conservative analysts still reserve the categories 'art' or 'the arts' to the earlier technologies and institutions, with continued attachment to the metropolis as the centre in which an enclave can be found for them or in which they can, often as a 'national' achievement, be displayed. But this is hardly compatible with a continued intellectual emphasis on their 'modernity', when the actual modern media are of so different a kind. Secondly, the metropolis has taken on a much wider meaning, in the extension of an organised global market in the new cultural technologies. It is not every vast urban aggregation, or even great capital city, which has this cultural metropolitan character. The effective metropolis – as is shown in the borrowing of the word to indicate relations between nations, in the neo-colonial world – is now the modern transmitting metropolis of the technically advanced and dominant economies.

Thus the retention of such categories as 'modern' and 'Modernism' to describe aspects of the art and thought of an undifferentiated twentieth-century world is now at best anachronistic, at worst archaic. What accounts for the persistence is a matter for complex analysis, but three elements can be emphasised. First, there is a factual persistence, in the old technologies and forms but with selected extensions to some of the new, of the specific relations between minority arts and metropolitan privileges and opportunities. Secondly, there is a persistent intellectual hegemony of the metropolis, in its command of the most serious publishing houses, newspapers and magazines, and intellectual institutions, formal and especially informal. Ironically, in a majority of cases, these formations are in some important respects residual: the intellectual and artistic forms in which they have their main roots are for social reasons – especially in their supporting formulations of 'minority' and 'mass', 'quality' and 'popular' – of that older, early twentieth-century period, which for them is the perennially 'modern'. Thirdly and most fundamentally, the central product of that earlier period, for reasons which must be explored, was a new set of 'universals', aesthetic, intellectual and psychological, which can be sharply contrasted with the older 'universals' of specific cultures, periods and faiths, but which in just that quality resist all further specificities, of historical change or of cultural and social diversity: in the conviction of what is beyond question and for all effective time the 'modern absolute', the defined universality of a human condition which is effectively permanent.

There are several possible ways out of this intellectual deadlock, which now has so much power over a whole range of philosophical, aesthetic and political thinking. The most effective involve contemporary analysis in a

still rapidly changing world. But it is also useful, when faced by this curious condition of cultural stasis – curious because it is a stasis which is continually defined in dynamic and experientially precarious terms – to identify some of the processes of its formation: seeing a present beyond 'the modern' by seeing how, in the past, that specifically absolute 'modern' was formed. For this identification, the facts of the development of the city into the metropolis are basic. We can see how certain themes in art and thought developed as specific responses to the new and expanding kinds of nineteenth-century city and then, as the central point of analysis, see how these went through a variety of actual artistic transformations, supported by newly offered (and competitive) aesthetic universals, in certain metropolitan conditions of the early twentieth century: the moment of 'modern art'.

Nineteenth-century antecedents to the theme of urban alienation

It is important to emphasise how relatively old some of these apparently modern themes are. For that is the inherent history of themes at first contained within 'pre-modern' forms of art which then in certain conditions led to actual and radical changes of form. It is the largely hidden history of the conditions of these profound internal changes which we have to explore, often against the clamour of the 'universals' themselves.

For convenience I will take examples of the themes from English literature, which is particularly rich in them. Britain went through the first stages of industrial and metropolitan development very early, and almost at once certain persistent themes were arrived at. Thus the effect of the modern city as a crowd of strangers was identified, in a way that was to last, by Wordsworth:

> O Friend! one feeling was there which belonged
> To this great city, by exclusive right;
> How often, in the overflowing streets,
> Have I gone forward with the crowd and said
> Unto myself, 'The face of every one
> That passes by me is a mystery!'

> Thus have I looked, nor ceased to look, oppressed
> By thoughts of what and whither, when and how,
> Until the shapes before my eyes became
> A second-sight procession, such as glides
> Over still mountains, or appears in dreams.
> And all the ballast of familiar life,

> The present, and the past; hope, fear; all stays,
> All laws of acting, thinking, speaking man
> Went from me, neither knowing me, nor known.[1]

What is evident here is the rapid transition from the mundane fact that the people in the crowded street are unknown to the observer – though we now forget what a novel experience that must in any case have been to people used to customary small settlements – to the now characteristic interpretation of strangeness as 'mystery'. Ordinary modes of perceiving others are seen as overborne by the collapse of normal relationships and their laws: a loss of 'the ballast of familiar life'. Other people are then seen as if in 'second sight' or, crucially, as in dreams: a major point of reference for many subsequent modern artistic techniques.

Closely related to this first theme of the crowd of strangers is a second major theme, of an individual lonely and isolated within the crowd. We can note some continuity in each theme from more general Romantic motifs: the general apprehension of mystery and of extreme and precarious forms of consciousness; the intensity of a paradoxical self-realisation in isolation. But what has happened, in each case, is that an apparently objective milieu, for each of these conditions, has been identified in the newly expanding and overcrowded modern city. There are a hundred cases, from James Thomson to George Gissing and beyond, of the relatively simple transition from earlier forms of isolation and alienation to their specific location in the city. Thomson's poem, 'The Doom of a City' (1857) addresses the theme explicitly, as 'Solitude in the midst of a great City':

> The cords of sympathy which should have bound me
> In sweet communication with earth's brotherhood
> I drew in tight and tighter still around me,
> Strangling my lost existence for a mood.[2]

Again, in the better-known 'City of Dreadful Night' (1870), a direct relationship is proposed between the city and a form of agonised consciousness:

> The City is of Night, but not of Sleep;
> There sweet sleep is not for the weary brain;
> The pitiless hours like years and ages creep,
> A night seems termless hell. This dreadful strain
> Of thought and consciousness which never ceases,
> Or which some moment's stupor but increases,
> This, worse than woe, makes wretches there insane.[3]

There is direct influence from Thomson in Eliot's early city poems. But more generally important is the extension of the association between isolation and the city to alienation in its most subjective sense: a range from

dream or nightmare (the formal vector of 'Doom of a City'), through the distortions of opium or alcohol, to actual insanity. These states are being given a persuasive and ultimately conventional social location.

On the other hand, alienation in the city could be given a social rather than a psychological emphasis. This is evident in Elizabeth Gaskell's interpretation of the streets of Manchester in *Mary Barton*, in much of Dickens, especially in *Dombey and Son*, and (though here with more emphasis on the isolated and crushed observer) in Gissing's *Demos* and *The Nether World*. It is an emphasis drawn out and formally argued by Engels:

> . . . They crowd by one another as though they had nothing in common, nothing to do with one another. . . . The brutal indifference, the unfeeling isolation of each in his private interest becomes the more repellent and offensive, the more these individuals are crowded together, within a limited space. And, however much one may be aware that this isolation of the individual, this narrow self-seeking is the fundamental principle of our society everywhere, it is nowhere so shamelessly barefaced, so self-conscious as just here in the crowding of the great city. The dissolution of mankind into monads . . . is here carried out to its utmost extremes.[4]

These alternative emphases of alienation, primarily subjective or social, are often fused or confused within the general development of the theme. In a way their double location within the modern city has helped to override what is otherwise a sharp difference of emphasis. Yet both the alternatives and their fusion or confusion point ahead to observable tendencies in twentieth-century avant-garde art, with its at times fused, at times dividing, orientations towards extreme subjectivity (including subjectivity as redemption or survival) and social or social/cultural revolution.

There is also a third theme, offering a very different interpretation of the strangeness and crowding and thus the 'impenetrability' of the city. Already in 1751 Fielding had observed:

> Whoever considers the Cities of London and Westminster, with the late vast increases of their suburbs, the great irregularity of their buildings, the immense numbers of lanes, alleys, courts and bye-places, must think that had they been intended for the very purpose of concealment they could not have been better contrived.[5]

This was a direct concern with the facts of urban crime, and the emphasis persisted. The 'dark London' of the late nineteenth-century, and particularly the East End, were often seen as warrens of crime, and one important literary response to this was the new figure of the urban detective. In Conan Doyle's *Sherlock Holmes* stories there is a recurrent image of the penetration by an isolated rational intelligence of a dark area of crime which is to be found in the otherwise (for specific physical reasons, as in the London

fogs, but also for social reasons, in that teeming, mazelike, often alien area) impenetrable city. This figure has persisted in the urban 'private eye' (as it happens, an exact idiom for the basic position in consciousness) in cities without the fogs.

On the other hand, the idea of 'darkest London' could be given a social emphasis. It is already significant that the use of statistics to understand an otherwise too complex and too numerous society had been pioneered in Manchester from the 1830s. Booth in the 1880s applied statistical survey techniques to London's East End. There is some relation between these forms of exploration and the generalising panoramic perspectives of some twentieth-century novels (Dos Passos, Tressell). There were naturalistic accounts from within the urban environment, again with an emphasis on crime, in several novels of the 1890s, for example, Morrison's *Tales of Mean Streets* (1894). But in general it was as late as the 1930s, and then in majority in realist modes, before any of the actual inhabitants of these dark areas wrote their own perspectives, which included the poverty and the squalor but also, in sharp contradiction to the earlier accounts, the neighbourliness and community which were actual working-class responses.

A fourth general theme can, however, be connected with this explicit late response. Wordsworth, interestingly, saw not only the alienated city but new possibilities of unity:

> among the multitudes
> Of that huge city, oftentimes was seen
> Affectingly set forth, more than elsewhere
> Is possible, the unity of men.[6]

What could be seen, as often in Dickens, as a deadening uniformity, could be seen also, as again in Dickens and indeed, crucially, in Engels, as the site of new kinds of human solidarity. The ambiguity had been there from the beginning, in the interpretation of the urban crowd as 'mass' or 'masses', a significant change from the earlier 'mob'. The masses could indeed be seen, as in one of Wordsworth's emphases, as:

> slaves unrespited of low pursuits,
> Living amid the same perpetual flow
> Of trivial objects, melted and reduced
> To one identity . . .[7]

But 'mass' and 'masses' were also to become the heroic, organising words of working-class and revolutionary solidarity. The factual development of new kinds of radical organisation within both capital and industrial cities sustained this positive urban emphasis.

A fifth theme goes beyond this, but in the same positive direction.

Dickens's London can be dark, and his Coketown darker. But although, as also later in H. G. Wells, there is a conventional theme of escape to a more peaceful and innocent rural spot, there is a specific and unmistakable emphasis of the vitality, the variety, the liberating diversity and mobility of the city. As the physical conditions of the cities were improved, this sense came through more and more strongly. The idea of the pre-Industrial and pre-metropolitan city as a place of light and learning, as well as of power and magnificence, was resumed with a special emphasis on physical light: the new illuminations of the city. This is evident in very simple form in Le Gallienne in the 1890s:

> London, London, our delight,
> Great flower that opens but at night,
> Great city of the midnight sun,
> Whose day begins when day is done.
>
> Lamp after lamp against the sky
> Opens a sudden beaming eye,
> Leaping a light on either hand
> The iron lilies of the Strand.[8]

The metropolis as a melting-pot: new attitudes to the medium of art

It is not only the continuity, it is also the diversity of these themes, composing as they do so much of the repertory of modern art, which should now be emphasised. Although Modernism can be clearly identified as a distinctive movement, in its deliberate distance from and challenge to more traditional forms of art and thought, it is also strongly characterised by its internal diversity of methods and emphases: a restless and often directly competitive sequence of innovations and experiments, always more immediately recognised by what they are breaking from than by what, in any simple way, they are breaking towards. Even the range of basic cultural positions, within Modernism, stretches from an eager embrace of modernity, either in its new technical and mechanical forms or in the equally significant attachments to ideas of social and political revolution, to conscious options for past or exotic cultures, as sources or at least as fragments *against* the modern world. This range of responses, from the Futurist affirmation of the city to Eliot's pessimistic recoil, is explored in subsequent chapters of this book.

Many elements of this diversity have to be related to the specific cultures and situations within which different kinds of work and position were to be developed, though within the simpler ideology of modernism this is often

resisted: the innovations being directly related only to themselves (as the related critical procedures of formalism and structuralism came to insist). But the diversity of position and method has another kind of significance. The themes, in their variety, including as we have seen diametrically opposite as well as diverse attitudes to the city and its modernity, had formerly been included within relatively traditional forms of art. What then stands out as new, and is in this defining sense 'modern', is the series (including the competitive sequence) of breaks in form. Yet if we say only this we are carried back inside the ideology, ignoring the continuity of themes from the nineteenth century and isolating the breaks of form, or worse, as often in subsequent pseudo-histories, relating the formal breaks to the themes as if both were comparably innovative. For it is not the general themes of response to the city and its modernity which compose anything that can be properly called Modernism. It is rather the new and specific location of the artists and intellectuals of this movement within the changing cultural milieu of the metropolis.

For a number of social and historical reasons the metropolis of the second half of the nineteenth century and of the first half of the twentieth century moved into a quite new cultural dimension. It was now much more than the very large city, or even the capital city of an important nation. It was the place where new social and economic and cultural relations, beyond both city and nation in their older senses, were beginning to be formed: a distinct historical phase which was in fact to be extended, in the second half of the twentieth century, at least potentially, to the whole world.

In the earliest phases this development had much to do with imperialism: with the magnetic concentration of wealth and power in imperial capitals and the simultaneous cosmopolitan access to a wide variety of subordinate cultures. But it was always more than the orthodox colonial system. Within Europe itself there was a very marked unevenness of development, both within particular countries, where the distances between capitals and provinces widened, socially and culturally, in the uneven developments of industry and agriculture, and of a monetary economy and simple subsistence or market forms. Even more crucial differences emerged between individual countries, which came to compose a new kind of hierarchy, not simply, as in the old terms, of military power, but in terms of development and thence of perceived enlightenment and modernity.

Moreover, both within many capital cities, and especially within the major metropolises, there was at once a complexity and a sophistication of social relations, supplemented in the most important cases – Paris, above all – by exceptional liberties of expression. This complex and open milieu

contrasted very sharply with the persistence of traditional social, cultural and intellectual forms in the provinces and in the less developed countries. Again, in what was not only the complexity but the miscellaneity of the metropolis, so different in these respects from traditional cultures and societies beyond it, the whole range of cultural activity could be accommodated.

The metropolis housed the great traditional academies and museums and their orthodoxies; their very proximity and powers of control were both a standard and a challenge. But also, within the new kind of open, complex and mobile society, small groups in any form of divergence or dissent could find some kind of foothold, in ways that would not have been possible if the artists and thinkers composing them had been scattered in more traditional, closed societies. Moreover, within both the miscellaneity of the metropolis – which in the course of capitalist and imperialist development had characteristically attracted a very mixed population, from a variety of social and cultural origins – and its concentration of wealth and thus opportunities of patronage, such groups could hope to attract, indeed to form, new kinds of audience. In the early stages the foothold was usually precarious. There is a radical contrast between these often struggling (and quarrelling and competitive) groups, who between them made what is now generally referred to as 'modern art', and the funded and trading institutions, academic and commercial, which were eventually to generalise and deal in them. The continuity is one of underlying ideology, but there is still a radical difference between the two generations: the struggling innovators and the modernist establishment which consolidated their achievement.

Thus the key cultural factor of the modernist shift is the character of the metropolis: in these general conditions but then, even more decisively, in its direct effects on form. The most important general element of the innovations in form is the fact of immigration to the metropolis, and it cannot too often be emphasised how many of the major innovators were, in this precise sense, immigrants. At the level of theme, this underlies, in an obvious way, the elements of strangeness and distance, indeed of alienation, which so regularly form part of the repertory. But the decisive aesthetic effect is at a deeper level. Liberated or breaking from their national or provincial cultures, placed in quite new relations to those other native languages or native visual traditions, encountering meanwhile a novel and dynamic common environment from which many of the older forms were obviously distant, the artists and writers and thinkers of this phase found the only community available to them: a community of the medium; of their own practices.

Thus language was perceived quite differently. It was no longer, in the old sense, customary and naturalised, but in many ways arbitrary and conventional. To the immigrants especially, with their new second common language, language was more evident as a medium – a medium that could be shaped and reshaped – than as a social custom. Even within a native language, the new relationships of the metropolis, and the inescapable new uses in newspapers and advertising attuned to it, forced certain productive kinds of strangeness and distance: a new consciousness of conventions and thus of changeable, because now open, conventions. There had long been pressures towards the work of art as artefact and commodity, but these now greatly intensified, and their combined pressures were very complex indeed. The preoccupying visual images and styles of particular cultures did not disappear, any more than the native languages, native tales, the native styles of music and dance, but all were now passed through this crucible of the metropolis, which was in the important cases no mere melting-pot but an intense and visually and linguistically exciting process in its own right, from which remarkable new forms emerged.

At the same time, within the very openness and complexity of the metropolis, there was no formed and settled society to which the new kinds of work could be related. The relationships were to the open and complex and dynamic social process itself, and the only accessible form of this practice was an emphasis on the medium: the medium as that which, in an unprecedented way, defined art. Over a wide and diverse range of practice this emphasis on the medium, and on what can be done in the medium, became dominant. Moreover, alongside the practice, theoretical positions of the same kind, most notably the new linguistics, but also the new aesthetics of significant form and structure, rose to direct, to support, to reinforce and to recommend. So nearly complete was this vast cultural reformation that, at the levels directly concerned – the succeeding metropolitan formations of learning and practice – what had once been defiantly marginal and oppositional became, in its turn, orthodox, although the distance of both from other cultures and peoples remained wide. The key to this persistence is again the social form of the metropolis, for the facts of increasing mobility and social diversity, passing through a continuing dominance of certain metropolitan centres and a related unevenness of all other social and cultural development, led to a major expansion of metropolitan forms of perception, both internal and imposed. Many of the direct forms and media-processes of the minority phase of modern art thus became what could be seen as the common currency of majority communication, especially in films (an art form created, in all important respects, by these perceptions) and in advertising.

It is then necessary to explore, in all its complexity of detail, the many variations in this decisive phase of modern practice and theory. But it is also time to explore it with something of its own sense of strangeness and distance, rather than with the comfortable and now internally accommodated forms of its incorporation and naturalisation. This means, above all, seeing the imperial and capitalist metropolis as a specific historical form, at different stages: Paris, London, Berlin, New York. It involves looking, from time to time, from outside the metropolis: from the deprived hinterlands, where different forces are moving, and from the poor world which has always been peripheral to the metropolitan systems. This need involve no reduction of the importance of the major artistic and literary works which were shaped within metropolitan perceptions. But one level has certainly to be challenged: the metropolitan interpretation of its own processes as universals.

The power of metropolitan development is not to be denied. The excitements and challenges of its intricate processes of liberation and alienation, contact and strangeness, stimulation and standardisation, are still powerfully available. But it should no longer be possible to present these specific and traceable processes as if they were universals, not only in history but as it were above and beyond it. The formulation of the modernist universals is in every case a productive but imperfect and in the end fallacious response to particular conditions of closure, breakdown, failure and frustration. From the necessary negations of these conditions, and from the stimulating strangeness of a new and (as it seemed) unbonded social form, the creative leap to the only available universality – of raw material, of medium, of process – was impressively and influentially made.

At this level as at others – 'modernisation' for example – the supposed universals belong to a phase of history which was both creatively preceded and creatively succeeded. While the universals are still accepted as standard intellectual procedures, the answers come out as impressively as the questions determine. But then it is characteristic of any major cultural phase that it takes its local and traceable positions as universal. This, which Modernism saw so clearly in the past which it was rejecting, remains true for itself. What is succeeding it is still uncertain and precarious, as in its own initial phases. But it can be foreseen that the period in which social strangeness and exposure isolated art as only a medium is due to end, even within the metropolis, leaving from its most active phases the new cultural monuments and their academies which in their turn are being challenged.

Notes to chapter 1

1 *Prelude, VII; Wordsworth: Poetical Works*, ed. de Selincourt and Darbishire, London, 1949, p. 261.
2 *Poems and Some Letters of James Thomson*, ed. Ridler, London, 1963, p. 25.
3 *Ibid.*, p. 180.
4 *The Condition of the Working Class in England in 1844*, transl. F. K. Wischnewetzky, London, 1934, p. 24.
5 Henry Fielding, Inquiry into the Cause of the Late Increase of Robbers, (1751) p. 76.
6 Wordsworth, *op.cit.*, p. 286.
7 *Ibid.*, p. 292.
8 *Greater London*, C. Trent, London, 1965, p. 200.

Nineteenth-century Paris: vision and nightmare

Throughout the nineteenth century French society and culture were in a state of crisis. After the great Revolution of 1789 and the Restoration of 1815, there were still three revolutions to come: those of 1830, 1848 and 1871. In a society so divided against itself it was hardly surprising that every artistic movement had as many detractors as proponents. Romanticism, Impressionism, Realism and Symbolism were never simple expressions of any generally agreed ideology or aesthetic – they were battlegrounds. The divorce between the artist and his public was perhaps most dramatically expressed in the year 1857 when both *Madame Bovary*[1] and *Les Fleurs du Mal*[2] were prosecuted by the State. In response to these social and political tensions some writers opted for psychological and aesthetic experiment, others for direct protest. But in many works of the century the frontiers are eroded between the political, the moral, and the aesthetic, and the new aesthetic forms of Baudelaire, Rimbaud and Laforgue express the new anguish and alienation of French society. Their emotion, whatever the social origins of its revolt, becomes new vision, their revolution becomes linguistic.

Paris is at the heart of this phenomenon. It was the capital of Europe's most highly centralised government, but also of experimental revolution. Baron Haussmann's monumental Boulevards challenged the secret city of dark alleyways and instant barricades. Its culture too was fundamentally divided: Gautier and Flaubert fawned on Princess Mathilde in her salon, but a counter-culture sprang up around the cafés and cabarets of Montmartre. A series of Universal Exhibitions, culminating in the flamboyantly symbolic engineering of the Eiffel Tower, were subtly undermined by the labyrinthine underground narratives of Lautréamont's *Maldoror*[3] and the caustic irony of Laforgue. Walter Benjamin has analysed these paradoxes with particular reference to the closed arcades, or 'passages', built off the new boulevards near the Opera. In a later chapter, on Surrealist narrative, we shall see that these arcades form the narrative heart of the

ideal city of the twentieth century. Benjamin's *Paris: the capital of the nineteenth century*, was unfinished, but was intended to be the summum of his ideas on culture and society. Benjamin saw exemplary connections between 'lyric poetry' and an age of 'high capitalism', relating Baudelaire's verse to Second Empire France.[14]

Benjamin notes how the explosion of activity in Paris created by the arrival of the railway necessitated the creation of Haussmann's boulevards, which also conveniently cleared a warren of dangerously barricade-prone, working-class alleys. The arcades themselves, situated just off the boulevards, had glass roofs and marble paving. They provided a new, traffic-free, weatherless luxury shopping centre. They were lit by the first gas lights, which banished the rustic starry sky from Paris and opened up its streets for safe evening strolls.

Benjamin acknowledges the excitement created by the new nexus of trade and human communications, which incited the writer to desert his study and go out into the street as a *flâneur* (a sort of voyeuristic observer and idle gossip) and journalist. The lyric poet then takes on a new role. Rather than passively recording privileged experience, he sees himself as a 'fencer', engaged in whimsical raids on the richness and variety of urban and suburban experience (*Les Fleurs du Mal*, 'Le soleil'). Rather than true love, it is the erotic encounters thrown up by chance contact with the crowd that excite him (*FM*, 'A une passante'). The metropolis creates increasing quantities of desirable objects, but also of material rubbish, as the increased rhythms of selling demand an increased rhythm of disposal. Baudelaire identifies with the rag-picker, collecting the curious flotsam of the new Babylon (*FM*, 'Le vin des chiffonniers'). But the new concentrations of commerce, transport and people, with their expropriations and uprootings, undermined traditional relationships, as Raymond Williams has pointed out. The industrial society produces its *human* rejects – and the poet himself joins the beggar, the rag-picker and the prostitute in becoming a commodity necessary to the functioning of that society, but rejected to the margins of the conscience of this society, which devalues love and commercialises desire. Although for Benjamin the prostitute is both seller and commodity in one, it is the poet himself who is ultimately the most devalued commodity, abandoned and offered to the crowd.

Benjamin's historical pessimism is mitigated by the idea that while the poet is reduced to this marginal role, he evolves a language and an imagery which suit the recording of rapid, multiple everyday experience, banal or sensational, by developing his consciousness to be able to register events and expressions, moods and impressions instantaneously, like the contemporary camera: 'A touch of the finger now sufficed to fix an event for an

unlimited period of time. The camera gave the moment a posthumous shock, as it were' (Benjamin, p. 132).

The 'snapshot' techniques of lyric poetry are of course only one aspect of this new response to the metropolis. The novelists and the painters of nineteenth-century Paris aimed at a more comprehensive vision. The nineteenth-century novel is conventionally said to convey a picture of its age with photographic realism. And Balzac and Zola certainly create powerful and easily readable images of the social tensions and political conflicts of their times. But there is also an awareness of the more problematic aspects of fictional mimesis, and of the need to evolve new artistic forms to express new modes of urban experience. This is particularly evident in the work of Flaubert, whose comprehensive critique of urban decadence implies a concomitant critique of fictional form. The significance of Flaubert's innovations in *L'Education Sentimentale* (1869)[5] for the experimental novel of the twentieth century is noted by Michael Long in Chapter 9. Flaubert's ironic reconstruction of the Paris of the 1848 Revolution is also a work which dramatically establishes Impressionism as a possible style for fiction (just before Monet's *Impression: soleil levant* caused a contemporary art critic to coin the, at first pejorative, term 'Impressionism'). The impressionistic style of Flaubert, however, goes deeper than a series of subjective pictures of elegant Parisian races and balls, pretty faces, battles and furnishings. Individual psychology, love affairs, and political action are fragmented, as events become a jumble of incoherent and illogical disasters. The ideology of urban progress and metropolitan culture is subverted by the novel's flickering parade of seductions, riots and discussions. Using Frédéric Moreau as a focus of the narration, Flaubert deliberately reads the world-view of the novel through his atrophied will and moral inertia. Mid-nineteenth-century France is seen as a gyroscopically revolving, immobile chaos, where semblances of action – revolution, repression – lead always to the same play of social forces. And in this centrifugal world, the motivation of the plot appears passive and random, breaking with the teleological tradition of the novel: the outbreak of street fighting has no significance for Frédéric other than its interruption of his intended seduction of Marie; conversely, he decides to return with Rosanette from Fontainebleau to the Paris of the barricades largely because they are bored with each other and with nature, and feel the need for some metropolitan entertainment: like a revolution. In the twentieth century Döblin's *Alexanderplatz* (1929)[6] and Céline's *Voyage au bout de la nuit* (1932)[7] were to adopt Flaubert's principle of alienated narrator and structurally disintegrating narrative, in order to express nihilistic visions of Berlin and Paris.

In painting too, this ambivalent response to the city finds expression in a variety of forms and moods. Paris is sometimes prettified by the Impressionists. In Manet's *La Musique aux Tuileries* or Renoir's *Le Bal au Moulin de la Galette* we see the brilliant composition of the fine clothes and the café tables imposing a vision of fashionable city gardens or popular Montmartre festivities as exemplary of Parisian sophistication: a symphony of colour and movement against a highly decorative and artificial background. Symptomatically, the Impressionists appear to relocate the centre of Parisian luxury and leisure in the nearby suburban countryside. Perhaps because of the increasing urbanisation of the city itself, we find the middle classes taking their leisure a little further down the Seine, at *La Grenouillère*, where Monet's bathers parade in Victorian swimwear along neat, wooden promenades between their rowing boats, or at a nearby open-air restaurant, where Renoir's *Déjeuner des Canotiers* shows the elegant casualness of his Sunday sportsmen and women. They lounge in fashionable informal clothes at the terrace of a riverside restaurant. The brightly-striped awnings and the colourful hats entirely eclipse the natural scene, reduced to a symbolic boat and a sketchy stretch of water glimpsed between the trees, which are themselves a vestigial decor. Even the flowers have been appropriated to decorate the ladies' hats. This is no longer the mythical countryside of seventeenth-century French painting, nor the pastoral allegory of the eighteenth century, let alone a real countryside of cows and peasants. Manet's modern picnic, *Le Déjeuner sur l'Herbe* was more violently controversial in its time, although its composition of two respectably clothed gentlemen relaxing in the company of two freshly undraped women had been consecrated centuries earlier by Titian in a famous *Festa campagna*. The men in Manet's painting are so obviously unbucolic in their city suits, and their companions have so clearly brought as little clothing as possible to take off, that the painting loses any symbolic pretence and proclaims its blatant realism: these are two modern men taking a day away from the city to have a little erotic fun in the nearest suburban woods. This grafting of conventional eroticism onto the mythical subject of Nausicaa paves the way for the more radical twentieth-century deconstructions, exemplified by Picasso's savagely formalist, but erotically dionysiac *Demoiselles d'Avignon*.

Rather than morally ambiguous, Seurat's work is socially and aesthetically ambivalent. In *Un Dimanche Après-midi à l'Ile de la Grande Jatte*,[8] the French Sunday promenade has left the muddy, smoky streets of Paris and is stageing its pageant on an island in the Seine. Massive, confident human slabs and cylinders stake out the landscape. The top hat and the bustle, the cane and the parasol, impose their formal grid to such an extent that the trees and bushes and river bank are a pale, almost artificial

4. Seurat, *Bathers, Asnières*
5. Manet, *The Bar at the Folies-Bergere*

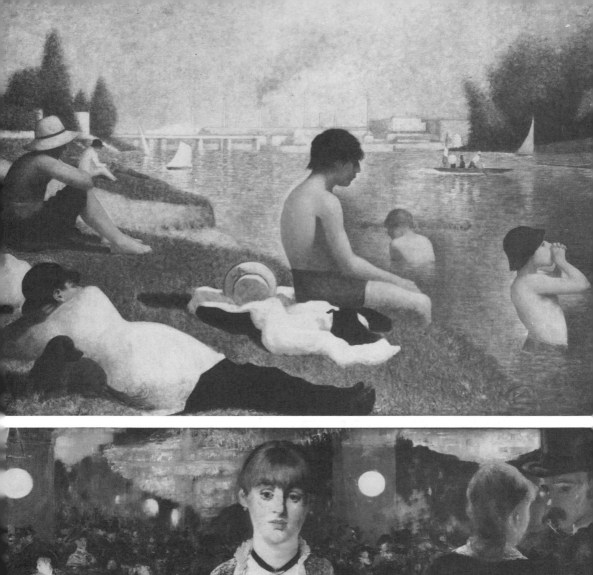

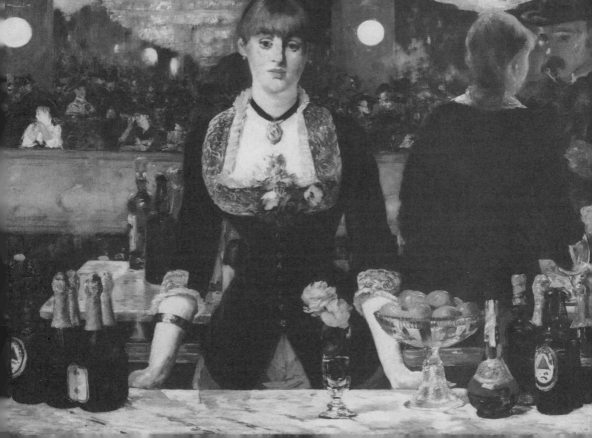

reflection of their forms, which seem to partake half of the plant, half of the building. At the same time, Seurat's *pointilliste* technique blurs distinctions of texture between citizens and countryside – the same solid blobs of colour compose the people and the landscape, naturalising the people, urbanising the riverside. Thus, too, in Seurat's *Une Baignade, Asnières*[9] (Fig. 4) delicately drawn factory chimneys on the skyline are arranged like a line of trees, and they share the pale pink tones of the bathers' flesh. They also neatly prolong the rising lines of the sails and the masts, and their smoke is formulated with the same intermittent patches and the same overall shape as the neighbouring trees. The reflection of the chimneys in the water is very similar to that of three people in a boat; the bald earth of a slipway cut into the turf is almost an echo of the bare legs and arms that frame it. Seurat's languid workers appear as natural as cattle, just as his bourgeois poseurs in *La Grande Jatte* borrowed a fabricated geometry. These paintings by Seurat help to restructure our vision of urban and suburban society, by transgressing conventions separating city and country, but also man and machine – which latter tendency was to be generalised in the paintings of Fernand Léger, and of the Italian and Russian Futurists.

Paris itself, as well as being decked with fashion and festivity, is disguised as landscape. Pissarro's *Le Boulevard Montmartre le Nuit* is painted in terms of a starry night sky – the boulevard is ultramarine, the street-lamps twinkle indistinctly. The same painter's *Le Louvre, Matin de Neige* shows an open vista of what appear to be snowy fields. The trains in Monet's *Gare St. Lazare* are like smudged impressions of tree-trunks, while the steam is indistinguishable from a Constable cloudscape. Renoir's *Les Parapluies* takes a concentration of urban umbrellas and makes so many violet-grey petunias of them and the matching dresses and coats of their elegant owners – anything less like a real, bedraggled, rain-soaked town scene can hardly be imagined.

Alternatively, the most haunting images of the anguish and vacuity of the capital are to be found in some of the paintings of Manet and Toulouse-Lautrec, the more moving because the images are derived from the heart of the entertainment industry, the mass culture, of the 'ville-lumières'. Manet's *Le Bar aux Folies-Bergère* shows a neatly-dressed barmaid behind a well-stocked counter. (Fig. 5). The painting, as a portrait and a still-life, is a rich, warm composition, with an imposing harmony between the shape of the attractive young lady and the forms around her – flowers, bottles, mirror. However, the spectator's eyes are drawn to the natural, central focus of the painting: the girl's eyes. They evade contact. And this may then alert us to a strangely disturbing feature of the painting. Although the girl is viewed full face, her head is reflected obliquely behind her to the right. We

can see in the mirror, beyond the back of her head, the faintly bloated face of a well-dressed gentleman customer. Reflecting back to our own posture as spectator, we are surprised to find no spectator's back placed between us and the girl. But then why should we? It is ourselves that we see standing there patronisingly, ogling. Manet's painting uses a structural device, the *mise en abyme*, which is traditional enough. In the *Arnolfini Portrait* by Jan Van Eyck or *Las Meninas* by Velazquez, a mirror brings into the scope of the painting a space which should logically remain beyond its frame. The mirror is a telescopic frame within a frame. But Manet's modernist gesture is to extend this formal device to include a critique of the act of the artist and spectator in adopting a voyeuristic posture, in remaining passive, in turning culture into a question of self-regarding prettification and consumption.

Toulouse-Lautrec's posters remind us that advertising, as an art, was born at the end of the nineteenth century. Wine, women and song were attractively packaged. But in some of his pastels and lithographs he suggests the anguish and exploitation behind the scenes. In *Clownesse* the music-hall artist sits unkempt, legs rudely parted, shoulders drooping, expression awry, while an elegantly dressed couple of spectators glides off smoothly into the background. The disparity is underlined by the clash of the girl's crude yellow *maillot* and garish green tights, as opposed to the harmonious grey and lilac of the departing bourgeois public. In *Rolande au lit* on the other hand, the reclining prostitute is ironically the subject of a grey and lilac symphony of colours: only the ugliness of her face, the frumpishness of her posture and the ambiguity of her activity show up the falseness of the image of beauty. In *Le Divan* the loneliness of the professional entertainer is emphasised both by the absent looks and the fixed smiles of the girls awaiting their clients, and by the ghastly clashes of colour between virtually every dress and the bright mauve divan. It is difficult to escape the conclusion, faced with Toulouse-Lautrec's variety of fine pastel harmonies and electric colour-clashes, that he is knowingly using colour in a way later to be generalised by the Fauves and the German Expressionists, to express mood. That mood may range from pathos to protest.

Manet's self-referential imagery and Toulouse-Lautrec's expressionistic colours alert us to the fact that the value-free excitement of Paris, the worship of fame, money, power, sex, leisure and entertainment, cannot be contained within a closed system, even in the plastic arts. But, just as important for the twentieth century, the inclusion of the artist's and spectator's viewpoints within the field of the represented was to become one of the driving forces of analytical Cubist painting, whose internal formal echoes establish *mise en abyme* as a structural principle. Moreover, the alliance of colour with mood, and its disjunction from representation, were to be

developed by Matisse to the point where they sketch the beginnings of abstract art.

But the most radical attempts in the nineteenth century to formalise a new urban world are those of the poets. Within the scope of the single poem a whole vision or a whole history can be focused sharply and coherently. In 1831 Alfred de Vigny, in a poem entitled simply 'Paris', paints a lurid picture of post-revolutionary Paris.[11] He adopts the Biblical posture of a prophet swept up above the city to observe its turmoil, and he sees various Apocalyptic visions. He adds a complex, allusive theoretical framework exploiting the ideas of radical and utopian thinkers such as Benjamin Constant and Saint-Simon. Vigny's visions suggest Armageddon – smashed statues, seething crowds, blazing furnaces. But he argues against pessimism, linking building repairs and constructions with the renewal of society operated by the July Revolution. Vigny's verse is rarely smooth, but in this poem the strain occasioned by the marriage of vatic urban optimism and visionary catastrophism is particularly intense:

> Cela reluit, cela flambe et glisse dans l'air,
> Eclate en pluie ardente ou serpente en éclair.
> Oeuvre, ouvriers, tout brûle; au feu tout se féconde:
> Salamandres partout! Enfer! Eden du monde!
> Paris! principe et fin! ombre et flambeau! . . .
> – Je ne sais si c'est mal, tout cela; mais c'est beau!
> Mais c'est grand! mais on sent jusqu'au fond de son âme
> Qu'un monde nouveau se forge à cette flamme

> (The air around, all shining, blazing, dashes
> And explodes in burning rain or snakey flashes.
> Both fertilised by fire, together works and workers burn.
> Salamanders everywhere! This Eden is the world's Inferno!
> Paris! Alpha and Omega! Shadow and brand! . . .
> – I don't know if all this is bad; but it is grand
> And beautiful! And in your heart the feeling must remain,
> That in this forge the world is born again).

Somehow Vigny's sloppy, awkward and repetitive diction cannot quite annul the power of his emotional response to the birth of a new city.

However, in 1844 a more conventionally pessimistic and conservative Alfred de Vigny greeted the arrival of the railway in France with melodramatic horror. He saw it as a 'thunderbolt of steam' tearing through the landscape, a 'wolf with blazing fangs' biting into cities. He called on God to send angels to guard the train, since its great machinery is at the mercy of the merest stone thrown on the track. In 'La Maison du berger'[11] there is more than circumstantial revulsion at a nasty new invention. Vigny believes that

man has made a historic mistake in his development. He ascribes this both
to man's overweening inventive urge, and to the lure of mercantile profit.[12]

But despite his reactionary lament for the loss of rustic experiences like
the ring of horses' hooves on cobbles and the pleasures of journeys uninten-
tionally retarded (here Vigny underestimated the resistance of tradition to
the railway age!), Vigny has an astonishingly prophetic and visionary idea
of the impact of mechanised transport on society:

> La distance et le temps sont vaincus. La science
> Trace autour de la terre un chemin triste et droit.
> La monde est rétréci par notre expérience,
> Et l'équateur n'est plus qu'un anneau trop étroit.
> Plus de hasard. Chacun glissera sur sa ligne,
> Immobile au seul rang que le départ assigne,
> Plongé dans un calcul silencieux et froid

(Distance, and time, are done for. Science scores around the globe its dull
and linear track. The world has shrunk in our experiments, the equator's
belt's too tight. No more chance. Each one of us will sit in line and slide
immobile forward in the order of departure, lost in our cold and silent
calculations).

By the 1860s the industrial age was a *fait accompli*. Baudelaire in his
Spleen de Paris or *Petits Poèmes en Prose*[13] bases a whole collection of
prose poems on the new urban world. His picture is of a paradoxical urban
jungle. The madness of Christmas shopping is a 'délire officiel' ('official
delirium'), where collective commercial greed accentuates individual lone-
liness ('Un plaisant'). Human behaviour is so disturbed that the lonely
individual may suddenly embrace a passing stranger ('Le mauvais vitrier'),
and yet, fleeing the oppressive crowd, the poet needs to lock himself in at
night for safety, after a day spent placating theatre and review directors,
and indulging in inconsequential fornication ('A une heure du matin'). The
solitary pedestrian may *imagine* talking to strangers – but the real strangers
are dehumanised: they are beggars foraging for scraps of food in cabarets or
a wild woman shown in a cage in the suburbs ('La femme sauvage et la
petite maîtresse'). In the public gardens of the city are human outcasts such
as the widow, followed voyeuristically by the poet in her sad meandering
from café to reading room to public park ('Les veuves'). Children fight
savagely for a dirty crust of bread: Paris is a 'pays superbe où le pain
s'appelle gâteau' ('a superb land where bread is called cake') ('Le gâteau').

Boredom and mortality lurk amid leisure: the rifle range kills time only
temporarily, as the setting of one of these ranges alongside a cemetery
implies ('Le tir et le cimetière'). The poet is slyly accosted in a gaslit suburb
by a woman who is obsessed with doctors and will persuade any stranger he

is one – she is, however, one of the city's more friendly and innocent monsters ('Mademoiselle Bistouri'). Indeed, prostitution is noted as the warmest example of urban fraternity ('La solitude'). In short, city man is a wolf, or rather a city dog, unto his fellow man. In his hymn to city dogs ('Les bons chiens') Baudelaire sees them as exemplary of the human wanderer, lost and wretched amid the ravines of his cities, a prey to sudden accidents and futile passions. In his epilogue Baudelaire hardly needs to summarise the city as brothel, hospital and penal colony, peopled by whores and bandits ('Epilogue').

The poet's moral attitudes are determined by his anguish at the intolerable nature of life when seen through clear rather than tinted glass – hence his destruction of the plain variety peddled by the 'mauvais vitrier', and hence his bullying of a beggar in 'Assommons les pauvres', teaching him the lesson of self-sufficiency and self-defence in a cruel world.

Despite Benjamin's valuable insights, Baudelaire is no systematically detached *flâneur*. In story after story he shows that vice results from poverty, oppression and despair. The morality of Baudelaire's Dantesque encounters and visions is, however, disguised behind a screen of self-irony and a fascination for the illogical antitheses of city life.

These brief parables are also an exercise in style – that is, an exercise in creating a poetic vision and a style of narrative discourse adequate for the modern city. The tones of the poems are as various as the experiences related. Some are elaborately developed, highly dramatic and atmospheric short stories worthy of Baudelaire's mentor Edgar Allan Poe, with their aura of penurious domestic horror or corrupt suburban mystery ('La Corde', 'Mademoiselle Bistouri'). Some are overtly symbolic, like 'Perte d'auréole' and 'Le Joueur généreux', where a saint and the devil appear equally uncomfortable when faced with the prospect of an urban hell. But if Satanism or the Faustian pact here seem to be natural consequences of living in an inhuman metropolis, one or two prose poems propose an alternative to this dramatisation of modern life's problems, and project gentle, lyrical, escapist dreams: of desire, of travel, or of poetry, expressed in a more fluid and euphonious prose poetry ('Une Hémisphère dans une chevelure', 'Invitation au voyage', 'L'Etranger').

Generally, however, the prose poems are characterised by their disjunctions. The ironies and antitheses of industrial civilisation enter into the heart of the poet's imagery. The very blaze of artificial light squandered on a new café cannot help lighting up the envious, starving 'Yeux des pauvres'. The explosion of lights in Paris at night rivals the twinkling of the stars – but the plain beneath them is only the 'stony labyrinth of a capital city'.

Baudelaire is both voyeur and critic of the invigorating but corrupting

vitality of the Second Empire's mercantile expansion and cultural atomi-
sation. He has little in common with the ingenuous enthusiasm of Apolli-
naire, but points forward to the fascinated disgust for the city shown by
Eliot in *The Waste Land*[15] and Pound in his *Cantos*.[15] The spotlighting of
lurid, gaslight images against a background of dingy and desolate reality is a
projection of the discordant, violent moods of the poet, deriving from the
contradictory experience of the city, with its multiple associations, its
overlapping sensations, its syncopated rhythms, its dramatic or desultory
exchanges of dialogue, its fragmented music of discrete image and sound.
Phonetic euphony and syntactical rhythm are now deployed, now subver-
ted by confrontation with violent argument, vision and event.

 'Le mauvais vitrier' exemplifies this collision of lyrical vision and ironic
narrative:

> Je m'approachai du balcon et je me saisis d'un petit pot de fleurs, et quand
> l'homme reparut au débouché de la porte, je laissai tomber perpendicu-
> lairement mon engin de guerre sur le rebord postérieur de ses crochets; et le
> choc le renversant, il acheva de briser sous son dos toute sa pauvre fortune
> ambulatoire . . .

> (I moved towards the balcony and grasped a small flower pot, and when
> the man reappeared on exiting from the doorway I dropped my weapon
> perpendicularly on to the rear edge of his hooks; and, being knocked over
> by the blow, he completed beneath his own back the smashing of his poor
> peripatetic fortune . . .).

The ironically precise and mock-heroic description vehicles the greater
irony of the event – the glass-seller being forced to crush his own glass and
destroy his own livelihood. But a sudden, extravagant metaphor interrupts:
'. . . qui rendit le bruit éclatant d'un palais de cristal crevé par la foudre'
(amid the explosive sound of a crystal palace burst by lightning). The crystal
palace shattered by lightning is a rich and complex figure, which superfi-
cially joins a poet's Olympian thunderbolt and man's Tower-of-Babel
constructions. But there are also overtones of Promethean revolt in its
evocation of an image of the fragile, untenable dream-castle of the frus-
trated poet, at the same time as the harsh, jagged, falsely-reflecting con-
structions of the city (man's materialist aspirations, exemplified in the
contemporary creation of railway stations and commercial arcades, being
paradoxically expressed in vast new expanses of glass). The poet's own
interpretation of his meaning is however incoherent and stammering: 'Et,
ivre de ma folie, je lui criai furieusement: "La vie en beau! la vie en beau!" '
(And, intoxicated by my own madness, I shouted wildly at him: "Lovelier
life! Lovelier life!"). Whilst the metaphor is savagely ironised by its lyrical
hyperbole being placed in a mundane, or even sordid context, the Faustian

conclusion to the text then imposes an ironically disproportionate moral: 'qu'importe l'éternité de la damnation à qui a trouvé dans une seconde l'infini dc la jouissance?' (what avails the eternity of damnation for one who has discovered if but for a moment the infinity of bliss?).

Baudelaire's preface confirms his awareness that his text is both fluid and discontinuous, that the individual act of reading can reorganise it at will into segments which are separately viable, severally associable or randomly dispensable:

> tout . . . y est à la fois tête et queue, alternativement et réciproquement . . . Nous pouvons couper où nous voulons, moi ma rêverie, vous le manuscrit, le lecteur sa lecture; car je ne suspends pas la volonté rétive de celui-ci au fil interminable d'une intrigue superflue. Enlevez une vertèbre, et les deux morceaux de cette tortueuse fantaisie se rejoindront sans peine. Hachez-la en de nombreux fragments, et vous verrez que chacun peut exister à part.

> (everything in it is both head and tail, alternatively and reciprocally. Wherever we like, I can cut into my daydreams, you into the manuscript, the reader his reading; for I do not make the reader's restless desire hang on the interminable thread of a superflous plot. Remove one vertebra, and the two halves of this tortuous fantasia will have no difficulty in coming together again. Hack it up into numerous sections, and you will see that each one can live on its own).

Although Baudelaire evokes the serpent wittily enough (Boileau had declared that no serpent was so vile that it could not be transformed into beauty through art), the image of the listless modern reader evokes more the curious child chopping up a worm, and sharing Baudelaire's cruelty, curiosity and experimentation, directed at an aesthetic grasping of the squirming, shifting forms of human relationships in the modern city:

> C'est surtout de la fréquentation des villes énormes, c'est du croisement de leurs innombrables rapports que naît cet idéal obsédant

> (It is above all in frequenting enormous cities and being involved in their innumerable relationships that this obsessive ideal is born).

This ideal form will be a poetic prose,

> musicale sans rythme et sans rime, assez souple et assez heurté pour s'adapter aux mouvements lyriques de l'âme, aux ondulations de la rêverie, aux soubresauts de la conscience

> (musical but lacking rhyme and rhythm, supple and jerky enough to marry the lyrical impulses of the soul, the meanderings of the daydream, and the twitchings of consciousness).

However fractured into ill-fitting zones of spirit, dream and episodic intellect the city mind has become, it demands a new lyricism that will

subsume and sublimate the fragmentation and desolation of modern urban life.

Eliot's task half a century later in *The Waste Land* would be very similar, and indeed Eliot may well be expressing his own aims in his appreciation of Baudelaire:

> It is not merely in the use of imagery of the sordid life of a great metropolis, but in the elevation of such imagery to the *first intensity* – presenting it as it is, and yet making it represent something much more than itself – that Baudelaire has created a mode of release and expression for other men.[16]

This statement pinpoints the significance of Baudelaire for the poets of the early twentieth century (not least for the work of Rilke, which is analysed by Naomi Segal in Chapter 6).

This elevation of urban imagery to the status of a transcendental concern is further developed in Rimbaud's *Illuminations*,[17] where the process of 'presenting' and 'representing' that imagery (rather than the real city provoking it) becomes itself the source of the visionary experience, which aspires to the condition of 'a mode of release and expression'.

The nostalgic, unreal evocations of 'Enfance' lead up to a more concrete view of a nightmare city, characterised by mist, mud and sewers, but in other poems the tension is less between the gutter and the dream than between the town and the country. 'Départ' suggests, perhaps, a flight from the town, and 'Ouvriers' evokes the noise and smoke of the city invading the suburbs, subverting suburban attempts to countrify the city. The social criticism implicit in these impressionistic glimpses of the workers' polluted environment becomes explicit in 'Ville', where visual ugliness reflects the city's spiritual emptiness and physical oppressiveness. Here death, crime and pollution appear clearly linked as the products of a certain industrial society. Elsewhere Rimbaud notes the attempt to compensate with artificial leisure for the cancerous growth of smog. His critique is typically oblique and ambiguous, albeit euphonious:

> Un cheval détale sur le turf suburbain, et le long des cultures et des boisements, percé par la peste carbonique ('Jeunesse: I. Dimanche')
>
> (A horse disports on suburban turf and along the crops and woodlands, spurred by the spores of carboniferous plague).

There are two city poets, at least, in Rimbaud. Against this social critic can be set the Futurist enthusiast, the creator of an urban fantasia. 'Villes: I' displays a vision which marries the technological future with the romantic Middle Ages, in its utopian liberation from topographical, social and even logical forces:

Ce sont des villes! . . . Des chalets de cristal et de bois qui se meuvent sur des rails et des poulies invisibles . . . Des fêtes amoureuses sonnent sur les canaux pendus derrière des chalets – La chasse des carillons crie dans les gorges . . . Sur les plates-formes au milieu des gouffres les Rolands sonnent leur bravoure – Sur les passerelles de l'abîme et les toits des auberges l'ardeur du ciel pavoise les mâts . . . Les Bacchantes des banlieues sanglotent et la lune brûle et hurle.

(What towns! Chalets of crystal and wood roll down invisible pulleys and rails. Erotic festivities ring through canals hanging behind the chalets – a pack of bells halloos through ravines. On platforms half-way down chasms Rolands sing out their bravado – Over the footbridges of the abyss and the roofs of the inns flagstaffs unfurl with celestial ardour. Small-town Sabines sob and the moon burns and screams).

'Villes: II' combines a similar concoction of utopian engineering (based on a child's distortion of perspective?) and fairytale or mythical nostalgia. This time it is the mercantile city, rather than the toytown train, which appears to generate the vision:

Le haut quartier a des parties inexplicables: un bras de mer, sans bateaux, roule sa nappe de grésil bleu entre des quais chargés de candélabres géants. Un pont court conduit à une poterne immédiatement sous le dôme de la Sainte-Chapelle. Ce dôme est une armature d'acier artistique de quinze mille pieds de diamètre environ . . . Le quartier commerçant est un circus d'un seul style, avec galeries à arcades. On ne voit pas de boutiques, mais la neige de la chaussée est écrasée; . . . Quelques divans de velours rouge: on sert des boissons polaires dont le prix varie de huits cents à huit mille roupies.

(The upper town has illogical areas: a stretch of boatless sea unreels its cloak of blue drizzle between quays laden with enormous candelabras. A short bridge leads to a postern just below the dome of the Holy Chapel. This dome is an artistic steel framework with a diameter of roughly fifteen thousand feet. The shopping centre is a circus of uniform design, with vaulted arcades. No shops are visible but the snow on the road has been compressed. (On) red velvet divans are served Antarctic drinks whose prices vary from eight hundred to eight thousand rupees).

In 'Promontoire' and in 'Scènes' realistic elements of coastal towns – canals, embankments, hotels, promontories, piers, railways, balconies, outdoor theatres – are combined in unrealistic ways. But Rimbaud's most sophisticated urban insight appears in 'Les Ponts', where he explores the process whereby his visual and linguistic dialectic creates a visionary townscape. The townscape arises, avowedly imagined, with its vocabulary of painting and drawing: 'Des ciels gris de cristal. Un bizarre dessin de ponts' ('Crystal-grey, painted skies. A strange design of bridges'). It continues in terms of

pure geometry becoming movement: 'ceux-ci droits, ceux-la bombés, d'autres descendant ou obliquant en angles sur les premiers' ('some straight, some curved, others dropping directly or doubling back slantwise across the former') while the glass-textured skyscapes are reflected and represented to the second degree in the mirroring water beneath: 'et ces figures se renouvelant dans les autres circuits éclairés du canal' ('and these compositions regenerated in the equivalent, shining trajectories of the canal'). As in the paintings of Proust's Elstir some decades later (*A l'Ombre des Jeunes Filles en Fleurs*),[18] land and water take on each other's attributes: 'Quelques-uns de ces ponts sont encore chargés de masures. D'autres soutiennent des mâts, des signaux, de frêles parapets' ('Some of these bridges are still laden with farmsteads. Others underpin masts, or signals, or frail parapets'). The self-reflecting, self-generating structures are then transported again, but this time into the medium of music, whose language is evoked through the violin-string-like associations of the struts or the wires of the bridges or the masts and rigging that frame them: 'Des accords mineurs se croisent, et filent, des cordes montent des berges' ('Minor chords are crossed, and spun away, cords arise from canal banks'). That this proliferation of linear motifs is a self-generating fantasia, rather than reality observed, is signalled now in the belated, hypothetical derivation of the musical instruments by the observer-creator: 'On distingue une veste rouge, peut-être d'autres costumes et des instruments de musique' ('We pick out a red tunic, perhaps other costumes, and musical instruments'), with the instruments secondary to the splash of colour retrospectively motivating the transition of painting and drawing into music. And what has been created by the vision of the observer and the controlled skid of his language can be cancelled with a similar stroke of the brush or the pen: 'Un rayon blanc, tombant du haut du ciel, anéantit cette comédie' ('A ray of white light, falling from the highest sky, annuls our play'). Rimbaud liberated prose poetry from the framework of representation which Baudelaire had retained. He initiated a kind a self-reflexive writing which was later developed in Laforgue's and Apollinaire's *vers libre*. In Apollinaire's 'Liens' and 'Les Fenêtres', notably, urban imagery is generated as much from linguistic processes as from referential observation.[19] The city as comedy, play or fantasy ought to be at the farthest extreme from social, economic and political criticism. But even in Marx, not to mention the French nineteenth-century utopian socialists like Fourier, there is a necessary element of fantasy and vision, projecting what is not in the place of what is. There may well be a necessarily schizophrenic reaction in any writer who totally rejects the existing city, and yet naively embraces the urban and the technological. Rimbaud himself does, however, transcend

this contradiction, looking forward to Apollinaire and the Futurists in his creation of a new language as well as a new urban mythology, in his founding of a new city.

Rimbaud, like Marx, was inspired by the Paris Commune of 1871. But the overthrow of the Second Empire and its replacement by a bourgeois republic did little to stem the advance of capitalism. The Parisian department store, which makes every product of mankind available for cash, is based on a rigorous hierarchy of functions, microcosmic of the social order. This provides a marvellous metaphor of the Babylonian city, engaged in a frenzied round of exploitation and exchange, reducing everyone concerned to the alienated role of buyer or seller, anxiously performing amid a babble of voices. In Zola's novel *Au Bonheur des dames* (1883)[20] and, later, in the magnificent Soviet film *New Babylon* (1929), this global metaphor was brilliantly used. But Laforgue perhaps provided the most succinct attempt in nineteenth-century French literature to translate that metaphor into a new language. In his 'Grand lament for the city of Paris', published as one of his *Complaintes* of 1884,[22] Laforgue takes as his model the 'sales' in a department store, but incorporates a whole cityful of commercialised advertising, sexuality and finance, including marriage, funerals, religion, nature, history and even writing in his purview. He creates for the occasion what he calls a 'blank prose', which uses a complex web of fragmentation and collage, text and intertext, and constitutes a sustained assault on sematic and syntactical propriety:

GRANDE COMPLAINTE DE LA VILLE DE PARIS
PROSE BLANCHE

Bonne gens qui m'écoutes, c'est Paris, Charenton compris. Maison fondée en . . . à louer. Médailles à toutes les expositions et des mentions. Bail immortel. Chantiers en gros et en détail de bonheurs sur mesure. Fournisseurs brevetés d'un tas de majestés. Maison recommandée. Prévient la chute des cheveux. En loteries! Envoie en province. Pas de morte-saison. Abonnements. Dépôt, sans garantie de l'humanité, des ennuis les plus comme il faut et d'occasion. Facilités de paiement, mais de l'argent. De l'argent, bonne gens!

Et ça se ravitaille, import et export, par vingt gares et douanes. Que tristes, sous la pluie, les trains de merchandise! A vous, dieux, chasublerie, ameublements d'église, dragées pour baptêmes, le culte est au troisième, clientèle ineffable! Amour, à toi, des maisons d'or aux hospices dont les langes et loques feront le papier des billets doux à monogrammes, trousseaux et layettes, seules eaux alcalines reconstituantes, ô chlorose! bijoux de sérail, falbalas, tramways, miroirs de poches, romances! Et à l'antipode, qu'y fait-on? Ça travaille, pour que Paris se ravitaille . . .

Mais l'inextirpable élite, d'où? pour où? Maisons de blanc: pompes

voluptiales; maisons de deuil: spleenuosités, rancoeurs à la carte. Et les banlieues adoptives, humus teigneux, haridelles paissant bris de vaisselles, tessons, semelles, de profil sur l'horizon des remparts. Et la pluie! trois torchons à une claire-voie de mansarde. Un chien aboie à un ballon là haut. Et des coins claustrals, cloches exilescentes des *dies iræmissibles*. Couchants d'aquarelliste distinguée, ou de lapidaire en liquidation. Génie au prix de fabrique, et ces jeunes gens s'entraînent en auto-litanies et formules vaines, par vaines cigarettes. Que les vingt-quatre heures vont vite à la discrète élite! . . .

Mais les cris publics reprennent. Avis important! l'Amortissable a fléchi, ferme le Panama. Enchères, experts. Avances sur titres cotés ou non cotés, achat de nu-propriétés, de viagers, d'usufruit; avances sur successions ouvertes et autres; indicateurs, annuaires, étrennes. Voyages circulaires à prix réduits. Madame Ludovic prédit l'avenir de 2 à 4. Jouets *Au Paradis des enfants* et accessoires pour cotillons aux grandes personnes. Grand choix de principes à l'épreuve. Encore des cris! Seul dépôt! soupers de centième! Machines cylindriques Marinoni! Tout garanti, tout pour rien! Ah! la rapidité de la vie aussi seul dépôt . . .

Des mois, les ans, calendriers d'occasion. Et l'automne s'engrandeuille au bois de Boulogne, l'hiver gèle les fricots des pauvres aux assiettes sans fleurs peintes. Mai purge, la canicule aux brises frivoles des plages fane les toilettes coûteuses. Puis, comme nous existons dans l'existence où l'on paie comptant, s'amènent ces messieurs courtois des Pompes Funèbres, autopsies et convois salués sous la vieille Monotopaze du soleil. Et l'histoire va toujours dressant, raturant ses Tables criblées de piteux *idem*, – ô Bilan, va quelconque! ô Bilan, va quelconque . . .

(Listen, my friends, I give you Paris, including loony bins. Founded in the year dot, going cheap. Winner or universal runner-up in every exhibition. 9,000-year lease. Wholesale and retail building sites of hand-made happiness. By appointment to throne-loads of royals. Highly recommended. Prevents precocious balding. Lotteries! Expeditions to the provinces. We never close. Subscriptions. Agent for genteel second-hand suffering, guaranteed untouched by human heart. Credit given as long as it's cash. Cash, my friends!

And it feeds and importexports through a score of customstations. Sad rain, goods train. All yours, gods and other surplices, church props and confetti, service on the third floor, going up, ineffable customer! All yours, darling, love, its golden sickbeds and ragged nappies will do for monogrammed loveletters, bottom drawers and babyclothes, the only salts that really cleanse, oh anorexia! Harem jewels, tassels, trams and pocket mirrors, fiction! And down under by the way, they're working so that Paris eats . . .

By the unuprootable elite, but whence?, but whose? Linen whorehouses, wedding derangements, mourning unlimited, bitchuperation, à la carte resentments. And foster suburbs, lice-ridden peat, old nags munching broken crocks, and shards and soles and silhouettes across the fortified

skyline. And rain! Three tea towels in an attic fanlight. A dog is barking at that ball up there. And cloisterphobic corners, clanging inconciliable *dies wearies*. Sunsets in society pastels of bankrupt gemstock. Genius at factory prices, juggling with empty authorial jingles by cigarette-light. Twenty-four hours a day aren't enough for the discreet elite!

Again the public cries arise. Please note, mortgages are off, float the Panama Canal. Good buys, wise guys. Credit on or off demand, purchase of real and ephemeral estate and usury; loans on life or otherwise insurance; timetables, directories, gifts. Round trips at reduced prices. Mme Ludovic foretells the future from 2 to 4. Toys in the *Childrens' paradise* and party accessories for grown-ups. Large selection of battered principles. More cries! Sole agent! Celebratory suppers for the nth performance. Marinoni circular machines! Everything guaranteed, everything free! And life goes faster! Sole agent . . .

Second-hand calendars, months and years. And autumn sods off into the Bois de Boulogne, winter freezes the pauper's beans on flower-paintless plates. May's a laxative, the heatwave's dirty beachy breezes bleach expensive dresses. Then as we live in cashdown times there come the courteous guys who undertake and autopsy and raise their hats to the old one-cat's-eyed sun. And history goes on making up and crossing out its moth-holed repetitive accounts – Down, balance-sheet, down boy!)

In the vital creativity of Laforgue's telescopic neologisms and absurdly collocated images, we scent the arrival of Apollinaire and Joyce. And we can no doubt see the roots of Eliot's 'modernism' in such a juxtaposition of traditional love, commercial energy and everyday objects in one ironic voice:

> The sound of horns and motors, which shall bring
> Sweeney to Mrs Porter in the Spring . . .
> Unreal City
> Under the brown fog of a winter noon
> Mr Eugenides, the Smyrna merchant
> Unshaven, with a pocket full of currants
> C.i.f. London . . . (*The Waste Land*)

Like Laforgue, Eliot dissects the problems of the alienated city-dweller, with an irony made crueller by its insertion of the clutter of the city into a mythical, pastoral and romantic tradition. And Eliot shares Baudelaire's vision of a city which undermines not only man's soul but also his traditional relationship with nature. We may also detect a parallel with Rimbaud in the way he creates a new lyricism from his 'heap of broken images', incorporating the heteroclite, the urban and the everyday into a new poetic vision.

The implications of Eliot's 'modernism' are analysed by Michael Long in Chapter 9. And in other chapters of this book we shall also have occasion

to note the indebtedness of writers and artists of the early twentieth century to 'Paris: the capital of the nineteenth century'. From their experiences of the metropolis Baudelaire, Rimbaud and Laforgue perversely produced what Benjamin would see as 'residues of a dream world'. But, as Benjamin also said, 'Every epoch not only dreams the next, but while dreaming impels it into wakefulness'.[24] The early twentieth-century avant-garde found themselves reenacting the nightmare visions of the nineteenth century on a new plane of intellectual and artistic sophistication. In their attempt to impel the modern world towards wakefulness, artists like Eliot, Pound, Joyce, Apollinaire, and the French surrealists first had to rework the fragmentary visions bequeathed by their great predecessors.

Notes to chapter 2

1 G. Flaubert, *Madame Bovary*, 1857. Available in Gallimard 'Folio' paperback.
2 C. Baudelaire, *Les Fleurs du Mal*, 1857. Available in Gallimard 'Poésie' paperback.
3 Lautréamont, *Les Chants de Maldoror*, 1869. Available in *Oeuvres complètes*, Garnier 'Flammarion' paperback.
4 W. Benjamin, 'Paris: the capital of the nineteenth century', 1935, in *Charles Baudelaire*, Verso Editions, 1983.
5 G. Flaubert, *L'Education sentimentale*, 1869. Available in Gallimard 'Folio' paperback.
6 A. Döblin, *Berlin Alexanderplatz*, 1929, reprinted 1982.
7 L.–F. Céline, *Voyage au bout de la nuit*, 1932, Gallimard 'Folio' 1975.
8 Seurat's *Sunday Afternoon on the Island of the Grande Jatte* is in the Art Institute of Chicago.
9 Seurat's *Bathers, Asnières* is in the National Gallery, London.
10 Manet's *The Bar at the Folies-Bergère* is in the Courtauld Institute Galleries, London.
11 A. de Vigny, *Paris* (1831) and *La Maison du berger* (1844), available in *Poèmes Antiques et Modernes; Les Destinées*, Gallimard 'Poésie' paperback.
12 It was an English writer on aesthetics whose views made him perhaps the most articulate theorist of the reaction to the ravages of industrial and capitalist progress. J. Ruskin's *The Stones of Venice* (1852–3, reprinted Faber, 1981, ed. J. Morris) is a work of social and aesthetic militancy. He attacks English as well as Italian social structures wherever they appear to undermine an inhabitable urban landscape, and debase popular taste. Venice is introduced as a modern catastrophe, a once-beautiful monument to man's harmony with nature, now ruined by industry and the railway. Ruskin regrets the homogenisation of townscape – instead of the 'towers of some famed city', the traveller sees the *same* railway station, ironically expressed by Ruskin as a '*new* arrangement of glass roofing and iron girder' (p. 53). Ruskin sees the topography of the city – and Venice is only the most spectacular example for Ruskin of a universal phenomenon – as the result of centuries of co-operation between a people and its artefacts on the one hand, and nature on the other.
13 C. Baudelaire, *Petits poèmes en prose (Le Spleen de Paris)*, 1856–67. Available in 'Livre de Poche' paperback.
14 T. S. Eliot, *The Waste Land* (1922), in *Collected Poems*, Faber, 1963.
15 E. Pound, *Selected Cantos of Ezra Pound*, Faber, 1967.

16 T. S. Eliot, 'Baudelaire' (1930), in *Selected Prose*, Peregrine 1963 (p. 182).
17 A. Rimbaud, *Illuminations* (1872–5). Available in *Poésies; Une Saison en enfer; Illuminations*, Gallimard 'Poésie' paperback; *Illuminations*, ed. N. Osmond, Athlone Press, 1976.
18 M. Proust, *A l'Ombre des jeunes filles en fleurs* (1919). Available in Gallimard 'Folio' paperback.
19 G. Apollinaire, *Calligrammes* (1918). Available in Gallimard 'Poésie' paperback.
20 E. Zola, *Au Bonheur des dames* (1883). Available in 'Livre de Poche' paperback.
21 *New Babylon*, Soviet film directed by Kozintsev and Trauberg, with original music by Dimitri Shostakovich (1929). Recently restored and screened by the British Film Institute.
22 J. Laforgue, 'Grande Complainte pour la ville de Paris', in *Les Complaintes* (1884). Available in *Poésies complètes*, 'Livre de Poche' paperback.
23 In *Collected Poems*, Faber, 1963.
24 Benjamin, *Charles Baudelaire*, p. 175.

Suggestions for background reading:

J. Rewald, *A History of Impressionism*, Secker & Warburg, 4th ed., 1973. T. Zeldin, *France 1848–1945*, I, *Ambition, Love and Politics*, II, *Intellect, Taste and Anxiety*, Oxford University Press, 1973 and 1977.

The city in
painting

In his review of the 1846 Paris Salon Baudelaire affirms 'the epic quality of modern life' and urges artists to make it the subject of their work: 'Scenes of high life and of the thousands of uprooted lives that haunt the underworld of a great city . . . are there to show us that we have only to open our eyes to see and know the heroism of our day.'[1]

As usual, Baudelaire was being provocative. Contemporary subject matter – 'modern life' – was thought by the artistic arbiters of the time to have no place in serious painting. They viewed the growing interest in 'realism' with alarm. Subject matter even more than style sparked off those celebrated and noisy disputes around the middle of the century in which pictures by artists as different as Courbet, Manet and Degas were ridiculed for their obsession with the mundane, the squalid and the familiar.

For Baudelaire 'modern life' was exclusively urban. It was in Paris that 'poetic and wonderful' motifs could be found, where 'the marvellous envelops and saturates us like the atmosphere'.[2] However, no major French painters produced work of the kind Baudelaire demanded until nearly two decades later. In spite of the activities around 1850 of illustrators like Daumier, Doré and Guys, city life only emerged as a major subject in painting with the Impressionists: with Degas, Renoir and Monet, who variously celebrated the mundane lives, menial tasks, entertainments and other pursuits of their fellow city-dwellers and made them seem 'poetic and wonderful'.

When Monet painted a view of the Boulevard des Capucines in 1873 (Fig. 6) his choice of subject was therefore still quite novel. However the motif was new for another reason. The Boulevard des Capucines had recently been rebuilt as part of Baron Haussmann's plan for Paris which, during the Second Empire, had begun to transform the centre of the city by introducing long, straight, broad, tree-lined avenues into the medieval chaos of small streets and alleys.

Haussmann's plan also involved the erection of many new private and

public buildings and the introduction of modern systems of sewage disposal and water supply. These innovations, together with new railway stations and other, strikingly novel constructions of iron and glass, made Paris the most modern city in Europe and, with the expansion of rail travel and the telegraph, the hub of a nationwide communications network. The new Paris provided dramatic visual evidence of the way in which life was being transformed by technical advances, rapid industrialisation and the subsequent shift of population from the country to the town. Truly it was in Paris that the wonderful and the marvellous could be found.

Monet's picture shimmers with the excitement engendered by the look of the new city. Hundreds of tiny people, their bodies blurred in a way suggested by photography (itself a recent innovation), crowd the spacious pavements, while the street itself bustles with horse-drawn cabs. Everything is on the move; everything is constantly changing. The high viewpoint contributes to the excitement, as does the golden glow in which the buildings and trees are bathed. Like the top-hatted gentlemen at the right of the canvas, we look down on a marvellous and memorable spectacle.

The painting struck some of Monet's contemporaries in the same way. As the critic Ernest Chesneau commented:

> Never has the prodigious animation of the public thoroughfare, the swarming of the crowd on the pavement and the carriages in the street, the movement of the trees in the dust and light along the boulevard; never has the elusive, the fleeting, the instantaneous character of movement been caught and fixed in its wonderful fluidity as it is in this extraordinary, this marvellous sketch.[3]

Monet painted several other pictures of streets in Paris and a series of views of the Gare St Lazare, another obviously modern and urban motif. But he remained chiefly a painter of landscape and his city pictures are like his landscapes in all important respects. Whether he depicted streets, steam trains, poppy fields or rivers, his true subject remained the elusive effects of light and subtle shifts of atmosphere. People interested him no more than trees or haystacks: their forms are blurred and dissolved by the same light that flickers on the surface of grass and the façades of buildings. It was the constantly shifting appearance of the city which concerned him, not the experience of living in it.

In 1914, forty years after the first Impressionist exhibition (at which the *Boulevard des Capucines* was shown), the German artist Ludwig Meidner published an essay about painting urban subjects which begins with an attack on Monet and Pissarro. For Meidner they were 'two lyricists who belonged out in the country with trees and bushes. The sweetness and fluffiness of these agrarian painters can also be seen in their cityscapes.'[4]

6. Monet, *Boulevard des Capucines*
7. Meidner, *I and the City*

In the vehement style typical of Expressionist prose, Meidner asserts that the painting of cities and the experience of life in them demands an approach quite different from that adopted by Monet and his friends. The modern city is an entirely new phenomenon and cannot be painted with old-fashioned means. Vagueness of description, traditional methods of perspective, the practice of working directly from the motif (all hallmarks of Impressionism) are irrelevant to the modern artist whose subjects should be drawn exclusively from 'our only true home, the city'.[5] Only a new formal language could, according to Meidner, adequately capture the atmosphere of the city which consists as much of the emotions it generates as the optical sensations it provides:

> Let us paint what is close to us, our city world! the wild streets, the elegance of iron suspension bridges, gas tanks which hang in white-cloud mountains, the roaring colours of buses and express locomotives, the rushing telephone wires (aren't they like music?), the harlequinade of advertising pillars, and then night . . . big city night . . .[6]

Most of the paintings and drawings Meidner produced between 1911 and 1915 are of city subjects. A self-portrait of 1913, *I and the City* (Fig. 7), although not entirely typical of Meidner's urban pictures, is very revealing of his attitude to the city and the powerful feelings it inspired. The ragged, windswept clouds, the splintered, heaving forms of the buildings, the entire shuddering panorama, rise like a fevered dream behind the tilted head of the artist himself who, his face transfixed with astonishment and horror, seems intoxicated by his imaginings.

Unlike Monet, Meidner was not primarily concerned with the way the city looked. He wanted rather to reveal the scarcely comprehensible forces concentrated within it and the chaotic and contradictory impressions it presented. Unlike Monet, for whom the high vantage point provided a coherent view of a complex scene, Meidner conceived his subject in terms of shifting focal points surrounded by ferment. As he says in his essay, 'the focal point is the most intense part of the picture' and should be 'clear, sharp and unmystical', whereas details outside it should be chaotic and ambiguous. Cityscapes should be 'battlefields filled with mathematical shapes. What triangles, quadrilaterals, polygons, and circles rush out at us in the streets. Straight lines rush past us on all sides. Many-pointed shapes stab at us.'[7]

During the forty years between Monet's painting and Meidner's essay there had been a fundamental change not merely in artists' attitudes to the city but, more importantly, in the way life in general was construed. Monet was a detached observer organising what he saw into coherent composi-

tions. For Meidner, such detachment was not longer possible. His concep-
tion of the city, far more complex and confusing, had to be thoroughly
subjective and could be depicted only in a fragmentary and metaphorical
way.

Meidner's metaphorical language frequently employs violent images
which dramatise the insignificance of the individual in the face of the
vastness of the urban scene. The superhuman forces which shake the houses
to their very foundations in *I and the City* erupt completely in other
paintings which present the spectacle of entire cities collapsing, being torn
apart by earthquakes, inundated by tidal waves or bombarded by comets
and meteors. The figures in such paintings (some of them self-portraits) do
not dominate the composition as Meidner's head does here. They are on the
contrary insignificant and are frequently shown fleeing for their lives.[8]

In spite of Meidner's obsession with disaster, his apocalyptic cityscapes
do not unambiguously reflect a pessimistic view of urban life. Rather, they
express a sense of boundless wonder at the energies which the modern city
generates and the excessive emotions it inspires.

The depressing aspects of life in big cities were often revealed in paint-
ings produced during the forty years between Monet's fresh and positive
response to the new Paris and Meidner's apocalyptic visions. French artists
like Théophile Steinlen, Britons like Luke Fildes and Germans like Max
Klinger looked beyond the fashionable districts of the city and examined
the plight of the urban poor, often in semi-documentary fashion. They were
concerned above all with individuals, with the absinthe-drinker, the prosti-
tute, the entertainer in tawdry cabarets, the impoverished widow and her
children, the lunatic or the beggar. For such artists the city was not the
playground of a leisured class but the reef on which the hopes of those lured
to the metropolis by the promise of a better life had foundered.

The city as cul-de-sac, as an impersonal, dehumanised purgatory, pro-
vides the setting for some of the most considerable literature of the later
nineteenth century. Yet with two major exceptions (to which we shall come
later) city motifs are almost entirely absent from the work of the greatest
painters of the later nineteenth century. Seurat transformed the leisure
activities of the bourgeoisie and manual workers into monumental and
timeless compositions and even painted the Eiffel Tower in construction,
but his great contemporaries, Cézanne, Van Gogh and Gauguin, all of
whom lived and worked in Paris for a time, chose to flee the metropolis, to
escape from the pressures it exerted: Cézanne and Van Gogh to Provence,
Gauguin first to Brittany and then the South Seas.

The two major exceptions to this retreat into nature were not French
painters at all: the Belgian James Ensor and the Norwegian Edvard Munch.

In 1888, while Van Gogh was painting the heat and primeval power of the landscape around Arles and Gauguin was investigating the primitive life of the peasants at Pont Aven, Ensor produced a colossal canvas called *The Entry of Christ into Brussels* in which the figure of Jesus on a donkey, translated into a modern, urban environment, almost disappears in the midst of a jubilant and terrifying mob.[9]

In 1891, while Cézanne was repeatedly painting the Montagne Sainte-Victoire outside Aix, Munch depicted a *Spring Evening on Karl Johan*, a street in the city now called Oslo (Fig. 8).

Instead of adopting a high viewpoint like Monet, Munch shows us the street from a low, but more natural angle, so that the crowd of people which dominates the scene seems to advance directly and threateningly towards us. They do not look at us. Their bleached, summarily described faces are drained of life. It is indeed a crowd, an endless river of people which disappears at the perspectival vanishing point in the centre of the composition. But although these people are pressed closely together, they appear to have no contact with each other. Like sleepwalkers, they are withdrawn into themselves, condemned to spiritual solitude. The feeling of loneliness is heightened by the single, full-length figure in black who, seen from the rear, walks away from us in the middle of the street.

The painting concentrates not on buildings but on figures, yet the façades of the houses on the left have their part to play in the composition and thus the meaning of the painting. The line of the roofs plunges down to the vanishing point where it meets the line of the far edge of the street at an obtuse angle. This creates the impression of great distance and, in spite of the dark mass of figures, of great emptiness. The people are out walking in the spring air but they have no destination.

Like Meidner's *I and the City*, *Spring Evening on Karl Johan* is concerned with the feelings the city engenders in those who live in it. And those feelings are of depression and alienation. Meidner was intoxicated by the energies he sensed everywhere around him; Munch felt the city to be a place in which all energy slowly ebbed away, even − perhaps especially − in spring.

Munch's neurotic images find their echo in the work of the Expressionists, where they reappear transformed in various ways. Why it should have been Germany, and especially Berlin, which inspired a concern for the negative effects of city life is a question too large to be answered satisfactorily in the scope of this essay. Berlin's slums were no worse than those of Paris or London; the effects of poverty or of the soulless toil in grimy factories no more acute than anywhere else in the industrialised world; the results of technology were manifest and as capable of inspiring faith in

8. Munch, *Spring Evening on Karl Johan*

progress as they were elsewhere.

Germany had become industrialised relatively late: not until the *Grün-derzeit* — the years following national reunification in 1871 — when the growth of cities was dramatic and sudden. Denied the gradual industrial expansion experienced in Britain and, to a lesser extent, in France, German economic growth, together with the authoritarian political system largely responsible for it, caused a deep intellectual crisis. Signs of this crisis can be seen in painting as early as the 1870s in the uneasy mixture of historicism and realism in the work of Adolph Menzel.

Different signs of the same crisis are evident in the work of Ernst Ludwig Kirchner who as a young artist in Dresden was deeply impressed by the work of Munch. Before Kirchner moved from the Baroque city of Dresden to the modern metropolis of Berlin in 1911, he was chiefly interested as a painter in the landscape and the human figure. In the capital he began to concentrate on urban motifs, painting the landmarks and scenes in cafés, dance halls and cabarets. Such works reveal less of Kirchner's attitude to the city and of his feelings about it than does the group of street scenes which date from 1913–14 (and are thus exactly contemporary with Meidner's cityscapes).

The Street of 1913 (Fig. 9) is typical of Kirchner's street scenes in all important respects. Figures dominate the composition. There are no buildings. The only hints of the scene's location are provided by the front of a motor car on the left and the hint of the side of another on the right. But the fashionable clothes are more than enough to make the urban setting clear.

Like Meidner, Kirchner wrote about the problems involved in painting city subjects, and what he said sounds rather like Meidner in a sober and less expansive mood:

> If we now look at . . . a modern big city street with its thousands of light sources, some of them coloured, we must surely understand that to construct everything objectively is in vain, since even a passing taxi, a bright or dark evening dress changes the entire, painstaking construction.[10]

The visual spectacle of the city is so complex, Kirchner argues, so different from one second to the next, that the painter must resort to exaggeration and other kinds of distortion in order to convey an authentic impression of it.

In spite of what Kirchner wrote, the nature of the distortions he employs makes it clear that he was not primarily interested in what he saw but what he felt. The clashing, acidic colours (here a pungent combination of cerulean blue, dark mauve and various shades of pink), the spiky, knife-

9. Kirchner, *The Street*

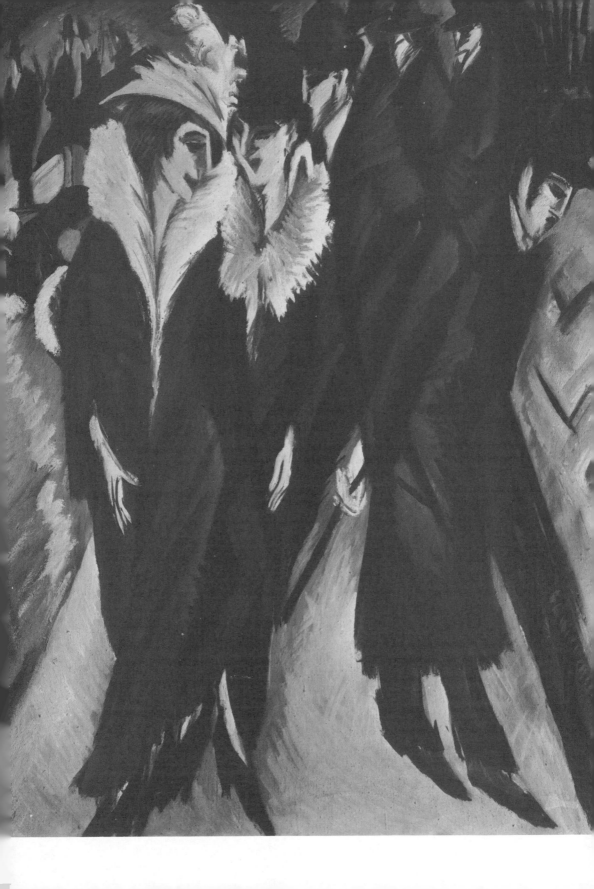

edged shapes of the figures, the bristling brushwork and above all, the tottering, acutely angular composition in which the people seem crazily off-balance, all contribute to the evocation of a nervy, hostile atmosphere. The figures (clearly two prostitutes and a group of prospective clients) seem predatory. The make-up on the women's hatchet-shaped faces has turned them into masks.

Kirchner began to paint his street scenes after he had been living in Berlin for about a year. Clearly it was the experience of the metropolis, so different a city from Dresden, which moved Kirchner (already on the brink of the mental crisis which eventually drove him to suicide) to conceive such repellent images. Yet there was another, less personal reason for Kirchner's growing interest in urban subjects and for the peculiarities of his style.

In 1912 the leading avant-garde gallery in Berlin, *Der Sturm* (run by Herwarth Walden, the founder and editor of the literary and artistic review of the same name) showed a large exhibition of Italian Futurist painting, which had already been seen in Paris and London and would progress to Amsterdam, Zurich, Vienna and Budapest. Wherever it went it provoked controversy and exerted an enormous influence on younger artists. In Paris they sensed the first serious challenge to the previously unquestioned dominance of French painting; in London they were astonished by the versatility of what seemed to be a newly-minted pictorial language; in Berlin they began to modify their styles under its influence.

Meidner's angular forms provide the most obvious German example of such influence and his essay 'On the painting of cityscapes' reads in part like a Futurist manifesto. Kirchner's street scenes also betray a large debt to Futurism, especially in their loose geometric construction. Yet Kirchner, like Meidner, was more interested in the formal language than in the message of the Italian movement. That message glorified the city, the anonymity of its crowds, the energies and technological miracles concentrated within it (that 'mechanical millenium' analysed by Judy Davies in Chapter 4).

One of the paintings shown in the 1912 Futurist exhibition was *The Street Enters the House* by Umberto Boccioni (Fig. 10). In a catalogue note 'the dominating sensation' of the picture was described as:

> that which one would experience on opening a window: all life and the noises of the street rush in at the same time as the movement and the reality of the objects outside. The painter does not limit himself to what he sees in the square frame of the window as would a mere photographer, but he also reproduces what he would see by looking out on every side from the balcony.[11]

The inclusion of things perceived on the periphery of vision is only the

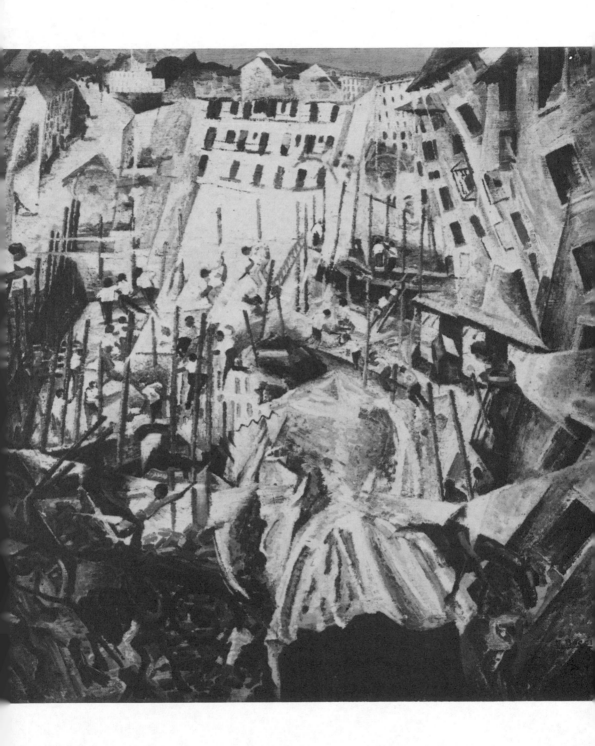

10. Boccioni, *The Street Enters the House*

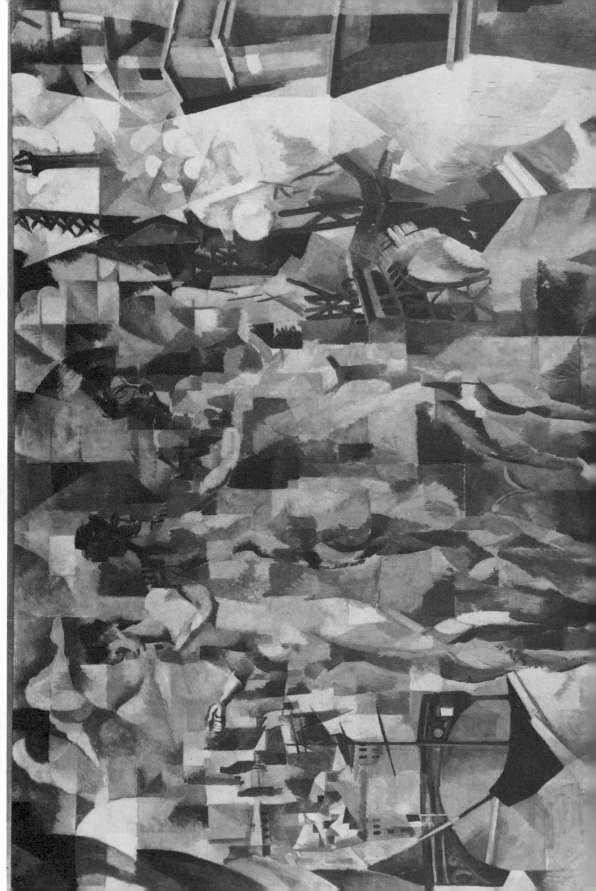

half of it. Boccioni also attempts to evoke the sensation of noise and movement by employing exaggerated colours and distorted forms. Horizontals and verticals are excluded from a composition based on a spiralling arrangement of angular forms which begin in the woman's body and fragment the scene into a mass of details as it proceeds on its course. In spite of this fragmentation the important parts of the painting can be easily read. It is no ordinary urban scene which 'enters the house' but a view of a building site, a scene common enough in 1912 in Milan, a city which was expanding rapidly. The city in Boccioni's painting is growing before the woman's eyes.

The notion of change, of constant renewal, is central to Italian Futurism. So too is the conviction that modern art should concern intself exclusively with modern life: not only by painting manifestly modern subjects (trains, racing cars, crowded streets) but by inventing a language capable of expressing peculiarly modern sensations, above all of speed, superhuman energy and what the Futurists called simultaneity – a multiplicity of disparate experiences simultaneously bombarding the senses.

It was not by chance that such a self-consciously modern artistic movement began in Italy. Around 1909, when the writer F. T. Marinetti published the first Futurist manifesto, Italy's late industrialisation was rapidly bearing fruit. In the north of the country the impact of modern technology was astonishingly sudden. As Reyner Banham puts it:

> It was this manifest and radical change-over to a technological society which animated the whole of Futurist thought, and it was the sense of a sudden change which, in all probability enabled (the Futurists) to exploit more quickly than other European intellectuals the new experiences which they had in common with the poets and painters of Paris, London, New York, Brussels and Berlin.[12]

Those new experiences included a seemingly endless stream of quite new inventions. The period between 1860 and 1903 was extraordinarily rich in the kind of technical innovation which transformed human life, especially in cities. Gas and electric lights in streets and in the home turned night into day; the telephone was invented and a telegraph cable spanned the Atlantic; the gramophone and wireless brought strange and distant voices into the living room; cars with petrol motors appeared on the boulevards; X-rays revealed the previously invisible; aeroplanes took to the sky. Such inventions, many of which transformed general perceptions of time and space, were accompanied by similarly dramatic advances in medicine. Nature now seemed finally to have been mastered. The city, in which nature was most obviously tamed, confined in parks, tubs and pots, seemed to be the symbol of that mastery.

11. Delaunay, *The City of Paris*

Marinetti's first manifesto makes it clear that Futurism was an exclusively urban movement intoxicated by technological innovation.

> We will sing of the multicoloured polyphonic tides of revolution in the modern capitals . . . of the vibrant nightly fervour of arsenals and shipyards blazing with violent electric moons; greedy railway stations that devour smoke-plumed serpents; factories hung from clouds by the crooked lines of their smoke; bridges that stride the rivers like giant gymnasts, flashing in the sun with the glitter of knives; adventurous steamers that sniff the horizon; deep-chested locomotives whose wheels paw the tracks like the hooves of enormous steel horses bridled by tubing; and the sleek flight of planes whose propellers chatter in the wind like banners and seem to cheer like an enthusiastic crowd.[13]

This heady poetic language, which makes use of personification and violent, aggressive imagery, reveals that for Marinetti the modern city consisted not so much of the fabric of its buildings as of the technological miracles hourly performed within it. The city is a living thing, a restless, superhuman creature in whose presence puny man can only stand and wonder.

When Marinetti wrote the first Futurist manifesto he had little knowledge of painting. However, painters were quickly attracted by his message, and a year later, in February 1910, Boccioni, Carrà and Russolo wrote a 'Manifesto of Futurist painters' and then, two months later, a 'Technical manifesto of Futurist painting'. This announced that the major element of the new art was to be 'universal dynamism', a concept which embraced movement, the interpenetration of objects and the effect on perception of memory. Inevitably, this manifesto draws heavily on technical and urban imagery:

> Space no longer exists: the street pavement, soaked by rain beneath the glare of electric lamps, becomes immensely deep and gapes to the very centre of the earth. Thousands of miles divide us from the sun; yet the house in front of us fits into the solar disc . . .

But the manifesto also refers to the confusing sensations the city provides and the simultaneity with which a wide vareity of impressions are perceived:

> The sixteen people around you in a rolling motor bus are in turn and at the same time one, ten, four, three; they are motionless and they change places; they come and go, bound into the street. . . . How often have we seen upon the cheek of the person with whom we are talking the horse which passes at the end of the street?[14]

Boccioni's painting *The Street Enters the House* is an attempt to realise

the most important of the aims set out in the *Technical Manifesto*. Even the horse can be seen (albeit not easily, in a small, monochrome reproduction) emerging from the woman's lower body at the right-hand side. Such literalism detracts from the force of Boccioni's painting, but even so it remains one of the more successful Futurist pictures, most of which failed to find a sufficiently versatile repertory of images or a sufficiently resourceful means of representing them.

Nevertheless the style and the ideas exerted an irresistible attraction on artists far beyond Italy: in Germany, in the United States, in Russia, in Britain (where it was transformed by Wyndham Lewis and others into Vorticism) and in France. It was the Futurist exhibition of 1912 which spurred Robert Delaunay on to modify and complete his vast canvas (about thirteen feet long) *The City of Paris* (Fig. 11) in the same year. In a composition which alludes to the form of the triptych he evokes the past, present and future of the city by combining images in a way which relies on Futurist devices for illustrating simultaneous sensations.

The structure of the painting underpins the meaning of the imagery. The old part of town on the left is relatively static while, on the right, the Eiffel Tower seems shaken by irresistible forces. In the centre, and linking these rhythmically contrasting areas, stand the Three Graces (a Classical allusion as repellent to a 'proper' Futurist as anything else from the past) who are no doubt intended to symbolise the eternal beauty of the French capital, as thrillingly evident in Eiffel's engineering masterpiece as in the more conventionally charming bridges and buildings. What Delaunay himself described as a 'living and simultaneous' surface, an 'ensemble of rhythms'[15] help evoke a vital, optimistic mood. The fragmentation, juxtaposition and overlapping of the imagery, together with the bright, prismatic colours, communicate an energy and dynamism and suggest the energies of modern city life.

In 1912 the Eiffel Tower was still popularly regarded as an archetypal symbol of the modern world. It remained the tallest structure outside North America and, in use as a radio mast from 1909, proclaimed the new unity of the world and the scarcely comprehensible speed of modern communications. It also provided a vantage point from which a new kind of city spectacle could be observed and was, in that sense, the next best thing to a trip in an aeroplane.

In painting after painting Delaunay celebrates the Eiffel Tower and combines it with other symbols of modernity – the aeroplane (Blériot crossed the Channel by air in 1909) and the Great Wheel which, built as a fairground attraction for one of the Great Exhibitions, moved in a way which was seen by some to be analogous to that of the earth itself perpetually spinning through space.

Although Delaunay's city paintings owe much in their conception to Futurism they are in every way more impressive than anything produced by the Italians. Their imagery is more coherent, their style more consistent. Their message, although less complex, is broadly the same: it is optimistic, affirmative, enchanted by the miracle of the modern city and of modern life.

In this they are fundamentally different from paintings produced by other, especially German painters which, although heavily indebted to Futurist pictorial conventions, express a quite different view of city life. *The Big City* (Fig. 12), which the Berlin artist George Grosz painted in 1916–17, employs the giddy perspective created by long diagonal lines and the fragmented, overlapping imagery introduced by the Futurists. At first sight the scene pulsates with the excitement of hurrying crowds, speeding vehicles, huge buildings and flashing neon signs. A closer look reveals something closer to pandemonium. Figures collide, a tram seems out of control, a hearse is pitched over, everything is in uproar as though the asylums had opened their doors and the streets were suddenly full of lunatics running riot.

Grosz produced many other paintings and drawings of city subjects at about the same time which, by narrowing their focus, show us more of the inhabitants of Grosz's Berlin: they are typically murderers and their victims, prostitutes with their pimps, robbers and suicides. Scavenging dogs prowl, snarl and piss while solitary, neurotic men sit in bars and cafés. In this grim, concrete city nature is entirely absent or reduced to a few pollarded or bare-branched trees.[16]

Curiously, Grosz's attitude to the city was by no means as negative as a painting like *The Big City* suggests. He was a dandy and a *flâneur*, in love with Berlin, who could not imagine living anywhere else but who, like so many Europeans of his generation, nevertheless dreamed of the vast cities of North America. Like his friend Bertolt Brecht, he was entranced by the idea of skyscrapers, of department stores stretching for several blocks, of boxing matches, jazz, film stars and gangsters.

Grosz's view of the city was as ambiguous as his politics. A Communist who hated the working class, a savage satirist of the bourgeoisie with whom he nonetheless secretly identified, Grosz was a Berliner down to his patent-leather bootstraps who simultaneously loved and loathed the city: it was the only place to be, yet it eventually corrupted and destroyed those who lived in it.

No such ambiguities can be found in the work of Grosz's contemporary Otto Dix who, having first succumbed to the influence of Futurism as completely as Grosz, turned to realism and anatomised the city with an eye voracious for the tiny but telling detail. Dix used the city as the setting for an

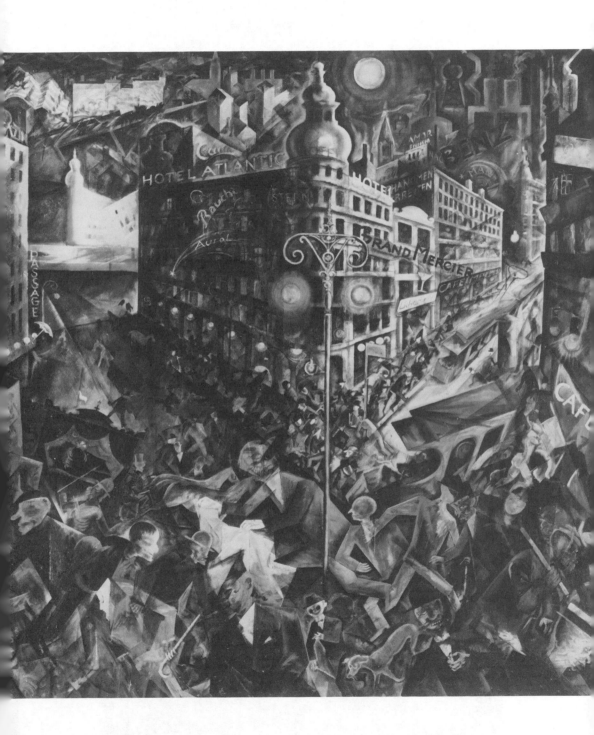

12. Grosz, *The Big City*

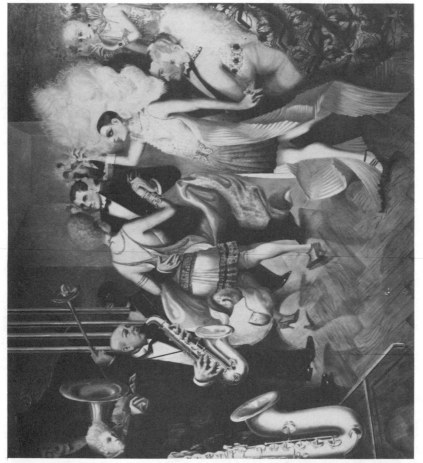

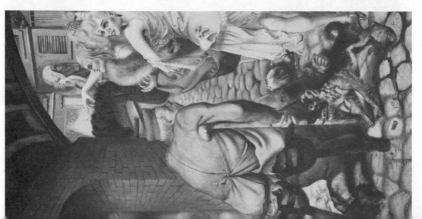

13. Dix, *Big City Triptych*

indictment of the scandalous inequalities, the exploitation and degradation that were daily visible on its streets. Dix's *Big City Triptych* of 1927–8 (Fig. 13) is the summation of a series of paintings of similar themes which date from 1920. In the centre a jazz band entertains a group of men and their ridiculously dressed women in a nightclub. The panels to the left and right reveal the scene outside. On the left, a legless war veteran observes some whores parading in an alley, scarcely distinguishable in their appearance from the women in the club. He is about to trip over the corpse of a man lying on the cobblestones while a dog snaps savagely at him. On the right, more whores, one of them grossly fat and powdered white, walk along a street while a beggar, his legs reduced to stumps, his face horrifyingly mutilated, salutes.

The figures in this painting are caricatures; the colours are hot and sickly; the atmosphere, especially that of the right-hand panel with its exaggerated, baroque marble facades, is dreamlike. Yet Dix's purpose is to confront us with a truth more fundamental than that of a realistic cityscape. This, more than the splendid hotels on the Potsdamer Platz or the luxurious shops on the Kurfürstendamm, is the capital of the Weimar Republic, in which the fixers and profiteers flourish while the majority has to beg or prostitute itself to make a living.[17]

The *Big City Triptych* provides a perfect comparison for Delaunay's *City of Paris*, and not only because of the scale and the triptych format. They stand at opposite poles of modern city painting: the Delaunay affirmative, optimistic and celebratory, the Dix accusatory, negative and horrifying. Between these two poles, between the idea of the city as a kind of man-made Arcadia and the conception of it as hell on earth, can be located all the art which has employed urban imagery during the last hundred years.

However, most of that art is neither entirely positive nor entirely negative, and in that it reflects feelings about city life that are widely shared. The excitement of cities, the cultural advantages of large populations and easy communications can exact a high price in terms of physical and, above all, mental well-being. This may explain why, in spite of the wealth of modern city painting, so many artists have preferred not to paint the city at all.

Notes to chapter 3

1 Baudelaire, *Selected Writings on Art and artists*, trans. and with an intro. by P. E. Charvet, Harmondsworth, 1972, p. 106.
2 *Ibid.*, p. 107.
3 Quoted in Joel Isaacson, *Observation and Reflection: Claude Monet*, New York and Oxford, 1978, p. 205.

4 Ludwig Meidner, 'An introduction to painting big cities', English trans. in Victor
 H. Miesel (ed.), *Voices of German Expressionism*, Englewood Cliffs, 1970, p. 111.
5 *Ibid.*, p. 111.
6 *Ibid.*, pp. 114–15.
7 *Ibid.*, p. 113.
8 See, for example, *Apocalyptic landscape* 1913, Saarländisches Museum Saar-
 brücken. This and other related paintings are reproduced in T. Grochowiak,
 Ludwig Meidner, (Recklinghausen, 1966), where the essay 'An introduction to
 painting big cities' is printed in full, in German.
9 The painting is now in the Antwerp Museum. For a reproduction and a discussion
 see Frank Whitford, 'Ensor's *Entry of Christ into Brussels*' in *Studio International*,
 183, 936, Sept. 1971, pp. 80–83.
10 Quoted from the catalogue 'Ernst Ludwig Kirchner', Nationalgalerie Berlin, Haus
 der Kunst Munich, Museum Ludwig Cologne, Kunsthaus Zurich, 1980, 182, p.
 190. The catalogue reproduces most of Kirchner's street scenes in colour.
11 Quoted in Caroline Tisdall and Angelo Bozzolla, *Futurism* (London, 1977), p. 43.
12 Reyner Banham, *Theory and Design in the First Machine Age* (London, 1960), p.
 101.
13 Quoted in Tisdall and Bozzolla, p. 7.
14 Quoted in Tisdall and Bozzolla, pp. 33–4.
15 Quoted in Virginia Spate, *Orphism* (Oxford, 1979), p. 205, where this painting
 and others related to it are reproduced and discussed.
16 See, for example, *Suicide* 1916, Tate Gallery, London; *The Lovesick Man* 1916,
 Kunstsammlung Nordrhein-Westfalen, Dusseldorf; and *Metropolis* 1917,
 Museum of Modern Art, New York. For Grosz in general see Uwe M. Schneede,
 George Grosz: Life and Work, London, 1977.
17 For Dix see Fritz Löffler, *Otto Dix: Life and Work*, trans. R. J. Hollingdale, New
 York, 1982.

Mechanical millenium: Sant'Elia and the poetry of Futurism

The founding manifesto of Italian Futurism was published on 20 February 1909. A paean to modernity, it appeared not in Italy, a country whose late unification had left its fragmented and provincial nature relatively untouched, but on the front page of Paris's *Le Figaro*, and in French.[1] When Paris spoke, the rest of Europe listened. The manifesto's author, Filippo Tommaso Marinetti – born in Alexandria, educated in Paris, resident in Milan – was a man of exuberant energy (and considerable financial resources) who well understood the value of publicity. This was soon to be proved by the institution of riotous *serate futuriste* during which members of the group – musicians, painters, poets – performed enthusiastically and – to judge from Boccioni's famous cartoon – all at once; and by their controversial tours of the cultural capitals of Europe. With Marinetti art and action became inseparable.

This first manifesto contained an eleven-point programme tumultuously heralding a new, danger-loving literature tuned to the exciting realities of the modern industrial city. A mere generation earlier the day-to-day pace of life was measured against the steady progress of the horse; its flavour for most people was that imparted by conditions of existence in the village. It is not surprising that Marinetti's supreme symbol in the manifesto is the speeding motor car, an example of the modern machinery that had suddenly and radically altered man's perception of himself, and of his relationship with his environment. He was no longer a creature subject to the limitations of his flesh. In prose sometimes heavy-laden with symbols, Marinetti rejoiced that 'Time and Space died yesterday'; it seemed to him that his own generation stood on the 'last promontory of the centuries' knocking on the 'mysterious doors of the Impossible' (p. 10): gravity seemed conquered, and the magical goal of ubiquity was in sight.

The subjects of the new, aggressive poetry are to be urban or

mechanised, eminently modern – 'great crowds excited by work, by pleasure, and by riot', 'the vibrant nightly fervour of arsenals and shipyards', 'greedy railway stations', factories, steamers, locomotives and planes. At the conclusion of this catalogue comes a reminder that 'it is from Italy that we launch upon the world this violently upsetting incendiary manifesto of ours'. The implication may well be that the modernist message owes its urgency to the fact that (as a French observer ruefully remarked) 'in the eyes of the foreigner Italy's greatest attraction lies in her being behind-the-times' (pp. 10–11, xvi–xvii). But like other Modernists, Marinetti stresses a total rupture with the past; and indeed the most disturbing passage in a document designed as a whole to enrage the cultural establishment must have been the section which invokes the destruction of Italy's libraries, museums, galleries and palaces, seeing in them only gangrenous monuments to a fossilised tradition.

This same insistence on a sensibility irrevocably transformed by the explosive growth of the urban conglomeration, and freed of all debt to the past, marks Antonio Sant'Elia's manifesto of *Futurist Architecture* of July 1914. It also inspires his prophetic designs for the city of the future, shown at the *Nuove Tendenze* exhibition earlier that year, and the *Messaggio* which accompanied them.[2] His drawing *The New City* (Fig. 14) exemplifies these principles: the modern building is to be like 'a gigantic machine', built of 'cement, iron and glass, without ornament', and 'brutish in its mechanical simplicity'. Sant'Elia's contribution comes at the apex of the so-called 'heroic' period of Futurism, when its influence abroad (though often angrily contested at the time) was greatest, and before war had felled some prominent adherents, including Sant'Elia. Like Marinetti, Sant'Elia has a sweeping gaze. His manifesto does not contain the recipes of a town planner, still less is it concerned with individual buildings. It speaks of nothing less than a new humanity which shall express itself in a city which is without precedent. Yet it is more than a chronological point of arrival, for in certain respects it radicalises the founding manifesto of Futurism.

Sant'Elia champions a functional architecture based on new materials. Two years earlier he had still been playing with the kind of decorative detail illustrated in Fig. 15. Now he treats historically allusive styles with scorn. His own architecture, he writes, 'cannot be subject to any law of historical continuity. It must be new, just as our state of mind is new'.[3] His emphasis on a hiatus in the unfolding of time, on a rebirth *ex novo*, makes Marinetti's concessions to tradition, however grudging and marginal (the yearly visit to the *Mona Lisa* for example), seem almost conciliatory. Where Marinetti envisages a ten-year campaign in the cause of modernity, to be violently terminated by a savage younger generation, but one nonetheless filled with

Sant'Elia: 14. *The New City*
15. Study for a building 16. Project for an electric generating station

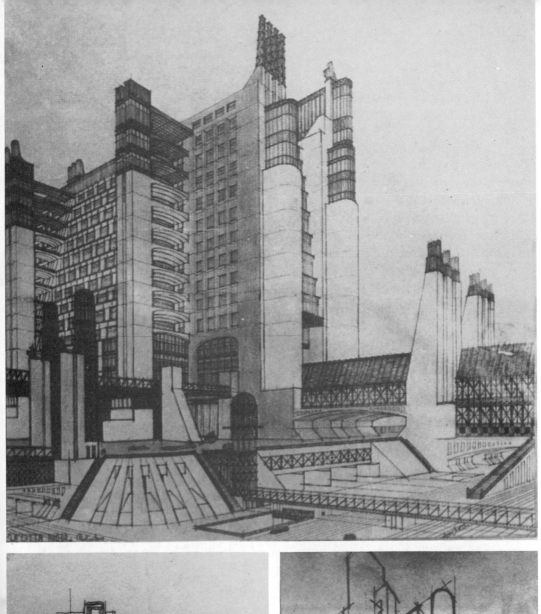

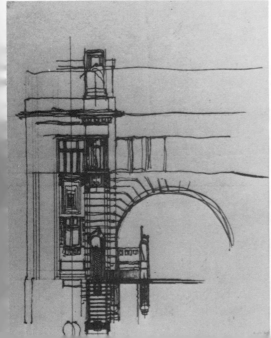

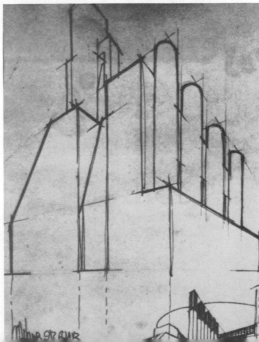

'love' and 'admiration' for the first modernolatrists (p. 13), Sant'Elia sees
only perishable materials, buildings that will 'endure less than ourselves',
each generation constructing its own city from the base.[4] If for Marinetti
one may speak of a New Tradition founded upon the ruins of the past, for
Sant'Elia there is only a succession of present moments. Both writers face
the inevitability, and assert the desirability, of their own extinction. It was
no accident that from the outset war was deemed a hygiene, or that when it
came there was a *course-à-la-mort* among Futurist volunteers.

The battle-unto-death of the generations became a topos in Futurist
manifestos: so did the preoccupation – in poetry – with mortality, although
the demise of the old self, the flirtations with danger and death, were to be
viewed in an ostensibly triumphal light. From the beginning this had been
the case. In the opening sequence of Marinetti's manifesto the men who
have spent the night pushing their discourse to the 'extreme limits of logic',
who finally abandon the oriental splendours of Marinetti's drawing-room
for their motor cars, are explicitly courting their own annihilation.
Marinetti lies in his machine like a 'corpse in its coffin', the steering-wheel
is like a guillotine blade threatening his stomach (pp. 7, 8); and the race
across the sleeping suburbs is a process of growing familiar with death
which menaces and beckons at every crossroad. The accident in the ditch is
a symbolic death, and the prelude to a rebirth ritually celebrated in the
gulping down of factory sludge. But even then the state of non-being is
close, and in a regression to the natural, Marinetti recalls the breast of his
Sudanese wet-nurse.

To many writers discussed in this book, the great industrial city
signified suffocation by the multitude (and between 1881 and 1914 Milan
increased its population two-fold to 640,000); it involved migration and an
accompanying sense of rootlessness and anonymity; its accelerated tempos
threatened and dehumanised. The Futurists, by contrast, seem to express
only feelings of exhiliration and liberation. Yet beneath the affirmative and
aggressive surface of Futurist writing there is often, as in Marinetti's car
ride, a subtext which suggests the exorcism of a fear, or a lurking ambiguity
of response held in check by an energy of volition that is reflected in the
hectic and hectoring tenor of much of the Futurist output. In the spectrum
of reactions to the new urban reality, they are perhaps less exceptional than
they appear. At all events it was a taste for danger that seemed to determine
in part a problematic and rapidly evolving relationship with mechanisation
in particular. Within a short space the conquering hero at the steering-
wheel was thoroughly absorbed into a mechanised environment, a *città
nuova* aspiring to flawless efficiency and unconcerned with the individual
and his human dimensions. Sant'Elia's multi-layered structures are

designed for high-density living; yet no human figures ride his elevators or his mobile walkways.

In attempting to illustrate the Futurists' attitudes to mechanisation, it may be as well to remember that they are contemporaries of the *crepuscolari*, or 'Twilight' poets. Though not a co-ordinated group in the Modernist sense, they shared a predilection for the everyday and the mundane, the 'good things in bad taste' described in the self-ironic verses of Guido Gozzano. They chose to ignore the modern city, preferring (as Nino Oxilia put it), 'the provinces, the tragedies of puppets, the sound of the Ave Maria', 'Sundays filled with sun and melancholy'.⁵ But what both Futurists and *crepuscolari* registered was a sense of crisis about the artist's role in modern society. Belonging to a generation disenchanted with Reason and Science, both were anti-intellectual; and the *crepuscolari* in particular acknowledged – along with a sense of spiritual vacuum – their inability to identify with a society increasingly run along technocratic and bourgeois-imperialistic lines. They consciously took up the position of self-doubting outsiders: Corrazzini's most famous poem, 'Despair of the Poor Sentimental Poet', runs: 'Don't you see, I have only tears to offer the Silence. Why do you call me poet?'. Though in practice the dividing line between *crepuscolarismo* and *futurismo* was not at first absolutely distinct, there was something in the nature of a division of labour: in the ironic renunciation and withdrawal of the *crepuscolari* one may detect a deliberate refusal of modernity, where the Futurists were bent on adherence.

The Futurists indeed sought energetically to close the rift between the artist and his world. Not for them the provinces, but the city; and an abiding scorn for the economic and intellectual tyranny of institutions – the gallery or the academy – that mediated between the work of art and its destinatees. The Futurists, through Marinetti, own their own means of production; they insist not only that they have a role to play, but that it is the only one worth playing. Their relationship with Fascism apart, the Futurists' noisy invasion of areas like business, dress and cookery may seem a matter for amused exasperation. Yet this expansion was perhaps a defensive ploy. If the quiescent society of the Giolittian era offered the artist only Corrazzini's *Silence*, then the answer lay perhaps (and here D'Annunzio's example served) in arranging the greatest possible overlap between Life and Art. When, in 1913, Corradini and Settimelli expatiate on the *Weight, Measure and Price of Artistic Genius*, their anti-elitist profanities are deliberate. But they are presumably a good deal less conscious that their provocative definition of *passéiste* art as 'the aenemic melancholy of the spineless who cut themselves off from real life *because they cannot face it*' (my italics) reveals precisely the horror of being met by silence. Equally they

are unaware of the extent to which their treatment of genius as a 'commo-
dity' on offer in the 'marketplaces of the world'⁶ chimes in with values that
are anything but subversive.

This, however, is to anticipate the future course of events. Initially
Futurism took upon itself a task of desecration. In Aldo Palazzeschi, the
'acrobat of (his) own soul', as the studiously low-key 'Chi sono?' ('Who am
I?') has it, the self-doubt of *crepuscolarismo* can still be felt. The *faux naïf*
of some of his poems in *L'Incendiario* (published by Marinetti's Poesia
press in 1910, with a revised edition in 1913), his willingness to place on
record the petty everyday needs, the *convoitises*, of a soul unsupported by
moral certainties, may recall the masochism of the 'honest bourgeois' Goz-
zano. But Marinetti was correct in underlining the corrosiveness of Palaz-
zeschi's mockery (p. 56). It took as target the self-congratulatory pieties,
the sentimentality, the spiritual and fleshly enslavement of the *piccola
borghesia*. The incendiary of Palazzeschi's title poem is the poet's *alter ego*.
A butt of trivial curiosity and outrage as long as he is caged and publicly
displayed, he becomes at the close of the poem the agent of a purifying
destructiveness, as the old city is engulfed in flame. 'Un casina di cristallo'
('A house of glass') is another aggressively exhibitionist fantasy. The house,
situated in the middle of the city, has nothing to do with Sant'Elia's passion
for modern building materials. Instead, what the glass walls reveal to each
scandalised passer-by is a mirror of his own grotesque existence, con-
strained and defined by the bodily needs so shamelessly displayed by the
inhabiting poet.

Like Palazzeschi, other poets project fantasies of liberation onto the
outcasts of society. The city 'made for crime' becomes a reservoir of strange
and subversive energies. The madman, the criminal, even the maimed and
deformed – as in Buzzi's 'Mortorio di Bibia' ('Bibia's funeral') – are cele-
brated for their reckless and perverse vitality. Buzzi's hideous cortège is the
sign of a resilient, chaotic energy subsisting amid corruption and disease. In
Dinamo Correnti's 'Serrature' ('Padlocks'), the hero is the burglar, the
breaker of barriers that hide bigotry, avarice, sexual inhibition. Such
poems, grounded as they were in the reality of bourgeois conformism, and
seeking to expose it, tended to follow an affirmative, ascensional pattern,
ending typically in apotheosis or epiphany, in vision and unreality.

But even where no such visionary pattern existed, representations of the
real city were frequently transformed by vigorous injections of figurative
language. This is true, for instance, of Govoni's 'Venezia elettrica' ('Electric
Venice'), a poem which (despite its Futurist title) looks at a city of fabled
conviviality and illustrious antiquity. Yet its images engineer a collision
between the 'poetry' of Venice and its sordid present: the lagoon swallows

down its 'inspiring moon' like a 'quinine pastille', pieces of floating orange-peel are the 'Turkish slippers discarded by some Doge's lady'. In the end Venice offers a hallucinated spectacle of sickness and decay. Cangiullo's 'Notturno inzaccherato' ('Mud-splashed nocturne') also provides a degraded vision of the city. Lashed by a chemical rain, illuminated by the poison-green of lamplight, its scurrying nocturnal life suggests bats, cockroaches, rats. In the similar contexts of 'Temporale' ('Rainstorm'), the seething humanity of the city street provokes a sense of the grotesque in Libero Altomare:

> sbocciano, s'aprono, grondano
> come funghi neri gli ombrelli:
> flosce ali di mantelli
> si profilano gambe e deretani.

(Like black mushrooms, umbrellas bud, open and drip: limp coat panels outline legs and posteriors.)

Such representations seems as far removed as possible from what Marinetti might have called the 'mechanical and geometric splendour' of Sant'Elia's cityscapes. And yet this self-punishing scorn for a humanity unable to transcend itself was perhaps an indispensable preliminary factor in the Futurist aspiration to mechanical perfection.

While Palazzeschi flaunts the inglorious routines of the body in his 'House of Glass', in 'I fiori' ('The flowers') he dismisses the notion of a pure, restorative nature as mawkish nonsense: a rose-prostitute encountering a would-be dreamer on an evening stroll, forces on him elaborate accounts of the sexual perversions of the flowers. Sexual and bodily imagery is used frequently in Futurist verse, not only for its power to produce a liberating shock, but in order to explode what it sees as the sentimental mythologies attaching to sexual passion in both life and art. In condemning the mendacity of an Arcadian and decadent sensibility that seems to him to have turned the world into a 'corrupt convent', Cavacchioli in 'Maledetta la luna!' ('To hell with the moon!') focuses on that romantic symbol so vilified by Futurists in general:

> Maledetta la luna! Che s'indugia nel trivio,
> sgonnellando, come una meretrice gaglioffa:
> e non vuole interrompere questa cristianità
> che ci suggella a fuoco le midolla ammarcite.

(To hell with the moon! that lingers at the crossroads, swinging its skirts like a graceless prostitute; that won't put a stop to the Christianity that leaves its stamps in the marrow of our rotting bones.)

After the night of wearisome sexual corruption comes the 'truthful' dawn;

and 'lo spettro del mio desiderio/ come un eroe futuro va: cavalcando il sole' ('the spectre of my desire like a future hero goes, riding the sun'). The fissures opened in the compact façade of bourgeois society were to be further widened by Pirandello and the exponents of the 'Theatre of the Grotesque'. What matters here, however, is the repudiation of a sexuality whose sentimental encrustations are felt to hamper and emasculate the affirmative Futurist self.

The complexities of sexual involvement are, in fact, threats that need deflecting. When the *Futurist Manifesto of Lust* came to be written, Valentine de Saint-Point saw the sexual urge in terms reminiscent of Marinetti's earlier treatment of machines. Like the machine, lust is a 'force' which permits the orderly expression of a man's will to 'expand and surpass himself'.[7] In Mario Bètuda's 'Voluttà' ('Carnal pleasure'), it also involves an annihilation of the self, lost in an experience of the universal. It is this sense of an ordered participation in the non-individual and the beyond-individual that provides a bridge between these attitudes of the Futurists to their physical selves and the new architecture.

When Marinetti wrote of the great city in *War Only Hygiene of the World*, like Sant'Elia a little later, he rejected the idea of huge, ornate buildings expressing monarchical authority and theocracy. For the masses converging on the urban centre something quite different was needed. Habits of hygiene and comfort required 'large well-ventilated blocks of flats ... supremely comfortable trains ... villas carefully constructed on hillsides to get the best of the breezes and the view, enormous meeting halls, and bathrooms designed for the rapid daily care of the body'. Marinetti's view is not that the body and its needs should dictate the shape of the environment, with emphasis on convenience and comfort; but that these needs are catered for with maximum efficiency precisely in order that the earth-bound integument of the Futurist self may be forgotten. Trains, for instance, are to be comfortable not for comfort's sake, but in the interests of imperceptible transit. Developments in communications and transport allow Marinetti to dream of the 'ubiquity of multiplied man' (pp. 269–70). Sant'Elia in his turn will bring systems of transport, walkways, railways, even aircraft landing-strips, into the heart of his residential areas.

Contemporary town-planning had begun to replace the traditional multi-purpose living area of the Italian home with designs that took account of distinct activities in daily life: it too subscribed to a functional model of human behaviour. And like Marinetti with his hillside villas, it also recognised the role of recreation, tending to substitute the old arrangement of housing round a closed courtyard with interrelated pavilion-style structures offering wide access onto garden areas. In Sant'Elia, on

the other hand, these concessions to the flesh have disappeared. He incorporates no green spaces into his schemes. The natural need for exercise is not contemplated in his vision of the future, even the walk to work relegated to the past as the transition from home to factory becomes imperceptible.

The poets, sharing in this depreciation of the natural, welcome the energies that power the city, the inventions – the car and the plane – that permit a 'simultaneous' perception of reality, the efficient strength of factory machines. They rebaptise themselves in honour of modernity. On the whole, however, they stop short of Sant'Elia's vision of abstract perfection. The new theories of consciousness referred to in an earlier chapter, as well as the Futurist emphasis on the individual and the vigorous assertion of his will, made for a primarily subjective approach.

The noctambulists of the movement stepped out into an illuminated night (Milan benefited from a second power station in 1904) which permitted twenty-four hour activity. Sleep was a deplorable admission of the imperfect, non-mechanical nature of man. 'I love the brazen lights that rape the soft bejewelled night', begins Libero Altomare in 'Sinfonia luminosa' ('Symphony in light'); 'rosaries' of streetlamps have turned the city into a mirror-image of the starlit sky. Heaven has come to earth and it is man-made. The static, monumental city becomes in Buzzi's 'Lucciole' ('Fireflies') an unstable 'arena of fireworks'. Here 'cielo e terra si copiano. Le costellazioni giocano all'altalena' ('sky and earth imitate each other. The constellations play upon a swing'). Time and time again the Futurists try to capture the subjective sensation of a vibrant illumination such as Balla depicted in Divisionist fashion in 'Streetlamp' of 1909. Sant'Elia crowns one of his triumphantly soaring structures with an illuminated advertisement. While painters and poets alike opt for the most artificial areas of the chromatic scale – for yellows and violets – or for the energy of reds, Sant'Elia wants his buildings 'violently coloured'.[8] And the poets feel the influence of the painters whose aim is to 'place the spectator in the centre of the picture,'[9] to register not the object, but its interactions with the viewing subject.

In the work of Luciano Folgore, for instance, there is an attempt to convey the exhilaration and the multiformity of urban experience. In a moment of suspenseful excitement between dusk and nightfall, the materiality of objects is destroyed:

> Crollo morbido delle linee dei palazzi,
> che s'abbassano nell'ombra.
> Divengo un punto d'incrocio,
> acutamente aspettando
> il giungere delle delizie

> il partire dei desideri.
> ('Svolto crepuscolare di strada')

(The soft collapse of the outlines of buildings, sinking into shade. I become a meeting-point, alert to the coming of delight, the setting forth of desires. ('Street corner at Dusk').)

The dictates of Boccioni and his colleagues are observed in the destruction of normal spatial relationships, the 'interpenetration' of objects, and the dynamic 'lines of force' of 'Torrefazione' ('Burning'):

> D'intorno le case,
> affondate
> nei marciapiedi
> liquefatti dal caldo.
> Camminare evitando
> colonne ubbriache di rosso,
> sfondare col petto,
> semicerchi di solleone,
> e invidiare l'ombra di un ragnatelo
> ad un insetto addormentato.

(Around me houses sunk into pavements liquified by heat. To walk avoiding columns drunk with red; my chest bursting through semicircles of hot sun, envying the shadow of a spider's web where an insect sleeps.)

These relatively meditative 'states of mind' are perhaps some of the most limpid examples of Futurist writing. The self, as so often, is projected onto the outward environment. Yet the series of fragments leads back constantly to the subjectivity of the poet, so that inside and outside are held in equilibrium. Much the same is true of the painter-poet Soffici. His 'Crocicchio' ('Crossroads'), for instance, is a montage of visual and aural perceptions – a snatch of speech, a public notice, effects of lighting: an attempt to register an open consciousness in contact with a complex urban reality. Despite the opening announcement of desubjectivisation – 'Dissolversi nella cipria dell'ordinotte/con l'improvviso clamore dell'elettricità, del gas, dell'acetilene' ('to dissolve into the powdery evening hour with the sudden clamour of electricity, gas, acetilene') – the composition, like others by Soffici, retains a cultural memory owing something to Apollinaire. The 'aeroplane of the firmament', the noise of traffic likened to a 'squawking of machine-gunned birds', the faintly disturbing 'nous n'avons plus d'amour que pour nous-mêmes, enfin', reveal a controlling presence which emerges – deliberately positive – in a final image not of absorption, but of consumption: the enamoured fish that drinks and swims, in a 'net of perfumes and fireworks'. In a number of Futurist poems the old 'literary I' stigmatised by Marinetti was replaced by the 'voice' of the object. Auro D'Alba's 'Battute

di automobile' ('What the motor car said') takes one of the privileged topics of the movement. It records a series of fleeting outward impressions that seek to scatter and depersonalise the perceiving consciousness. Yet the effect is finally not one of fragmentation, nor of fear. The perceptions are registered in a sequence of metaphors which connote violent authority (a headlight is a 'dagger thrust into the bosom of the night', the evening is the 'assassin' of day, the pavements 'incandescent guillotine blades', the rising sun a 'halberdier'): and thus a species of stability re-enters the poem.

Though the poets of early Futurism speak with many voices – and for some Futurism was a passing phase, or an influence among several – it is generally true that when they confront the city and its technology they affirm their ability to control their experience of the new environment. It is an ability not undermined but asserted rather in their deliberately dis-ordered culling from distinct sectors of language, and their sense of absolute expressive freedom.

But that persisting subjectivity, though no longer the product of the private, inward processes of a traditional art, depended in large part for its assertiveness on a sense of enhanced human potential made possible by modern inventions. As his creation, machinery was logically man's subord-inate. Yet from the outset the machine was felt to be more than this: it was a kind of fetish endowed with magical powers that took man beyond the human, into a mystical meeting with himself where he was perceived both as a creature of infinite possibilities and as subject to a frail mortality. Straining towards a glorious mechanised future, Buzzi's 'Song of Mann-heim' blandly acknowledges that mass society makes sacrifice of the indi-vidual, but catches too something of the ambiguity of the Futurist position. The city addresses factory machinery: 'if you catch up a man's body you crush it like an insect and you give life to torrents of men like a Providence of the antheap.' And elsewhere, conjuring perhaps with unspoken fears, it still measures the machine against the human: 'slipping in and out of sheaths of iron, you imitate the ceaseless effort of muscles.' In the first manifesto of Futurism Marinetti himself had spoken of the machine in zoomorphic or erotic terms – in terms, that is to say, of the already familiar; and Luciano Folgore's horrified lament, for example, on the 'Incendio dell'opificio' ('Factory fire') depends in the final stanza on an image of violated mater-nity, the 'ripped belly' that shrivels the soul as though it heard the deep thud of a boulder tumbling into a distant 'uncharted chasm'. A residual human-ity and humanism were difficult to eliminate.

Yet if machinery had the perfect strength, the tireless energy, the perpe-tual readiness to function that humans lacked, the way to exorcise its magic was to promote not the likeness of machines to men, but the likeness of man

to machines. Marinetti wrote in the *Technical Manifesto of Futurist Litera-ture* of 1912 that the movement was preparing the way for the creation of 'mechanical man with replaceable parts', a man who would be liberated from the 'idea of death, and thus from death itself'. Though his own anthropocentrism was persistent, as in the manifesto *Man Multiplied and the Reign of the Machine*, where he spoke of the 'mysteriousness' of machines and credited them with 'true sensibility', the general trend of his thinking was clear. He continued:

> we must prepare for the imminent and inevitable identification of men with motors . . . we aspire to the creation of a non-human type in whom will be abolished moral pain, kindness, affection and love, the only poisons that corrode our inexhaustible vital energy, the only breakers in the circuit of our powerful electric physiology.

With acknowledgement to Lamarck, he makes the astonishing claim that 'in the flesh of man wings lie sleeping' (pp. 48,255,256).

To the coming of the man-aeroplane corresponded the gravity-defying verticality of the Futurist city. The poets too had purely visionary moments. Folgore, in his paean to coal ('Il carbone') writes of a 'city of the stars'. Altomare in 'Le case parlano' ('The houses speak') envisages nomadic 'flying pagodas' for the sons of the future; and Buzzi ('Song of Mannheim') sees them as having 'limbs of iron, yet ethereal' and 'energies of flame, yet unconsumed'. It is difficult to discount the ripples of anxiety that still circulate in Cavacchioli's 'Modern epilogue' to 'Maladetta la luna!'. But if for 'regulated, savage perfection' machinery has surpassed man, the remedy is plain:

> [. . .] devi creare un bel cuore meccanico,
> ed aspirar l'effluvio rovente delle fornaci [. . .]
> Quando il tuo cuore sarà come un rocchetto di Ruhmkorff
> e le tue mani tenaci avranno un furore metallico [. . .]
> oh, grida allora la tua vittoria definitiva!

> (You must make your heart a great machine, and breathe the burning discharge of furnaces. When your heart has become like an induction coil, and your clenching hands act with the fury of metal, oh then you may shout your final victory!)

This repudiation of the human emerged too in various manifestos by Marinetti in which he discussed innovations in expression. The experimentalism of the movement, for all its bluster and, sometimes, naiveté, was far-reaching in its implications. The 'free-word tables' of Futurism, for instance, with their graphic elements, their experimental typography and onomatopoeic effects, undermined the old, stable relationship of language

and its signification, and questioned the privileged role of the sequentially printed page as a vehicle of communication. One source of the Futurists' passionate experimentalism lay in the deliberately cosmopolitan nature of the movement which, as Raymond Williams observes of Modernist movements in general, forced them to eschew a language embedded in a specific cultural tradition in favour of a linguistic practice that could pass through national frontiers. In addition they found themselves confronted by a contradiction: on the one hand, a new and dynamic civilisation of machines, on the other, a poetic idiom which they perceived as threadbare and stereotyped. When codifying his innovations Marinetti never fails to stress the connection between a sensibility transformed by modern, urban existence and the need for new forms of expression. It is in the course of a flight above Milan that he suddenly realises the 'insanity of the old syntax inherited from Homer' (*Technical Manifesto*, p. 40); his praise of 'geometric and mechanical splendour' comes from the bridge of a dreadnought.

In his first 'technical' manifesto, Marinetti releases language from the prison of syntax and punctuation, from the meditative pauses of adjective and adverb; he suggests that the use of verbs in the infinitive will free them from the anecdotal 'I of the writer' and better convey the 'elasticity' of the poetic intuition; he requires that nouns should be doubled so as to render the profound interconnections between things in 'nets of images and analogies'. Metaphor becomes the natural and privileged means of the analogic sensibility as it records a 'simultaneous' reality. Marinetti's recommendations collectively contribute to the suppression of the traditional 'literary I', or 'human psychology', to be replaced by a 'lyrical obsession with matter'. Though this was not the elimination of the self as intuitor of reality, it was the end of a poetry that organised and expressed individual sensibility. Rather as Boccioni, in *Plastic Dynamism* (1913) came to reject any representation of movement as it appeared to the eye (analysed and subdivided into a 'photographic' sequence as in some of Balla's work), and wanted instead the intuition of its internal dynamism, Marinetti advises poets not to express the 'obsessive I' but the spirit of matter. Soon – in *Destruction of Syntax-Imagination Without Strings – Words in Freedom* (1913) – he prefers 'words-in-freedom' to the inescapable artificialities of free verse. He emphasises the importance of onomatopoeia, musical and mathematical symbols, variations in typeface and the free structuring of the printed page in the interests of a 'multilinear lyricism' capable of expressing the 'poetry of cosmic forces' that finally, in 1914, replaces the 'poetry of the human'. If his own composition 'Battaglia Peso + Odore' (Battle Weight + Smell) was the praxis cited to illustrate the *Technical Manifesto*, the ideal illustration for the third discussion of poetic medium, *Geometric and*

Mechanical Splendour and the Numerical Sensibility, is his long excursus in the onomatopetically named novel *Zang Tumb Tumb* on the heating of molecules of metal in the barrel of a gun. In celebration of what Marinetti calls the 'universal vibration' of the 'infinitely small' (pp. 41, 43, 44, 64, 68, 86), Folgore produces a poem entitled 'La cellula' ('The cell').

Sant'Elia's own preoccupation with medium was not simply the result of a passion for all things modern. It sprang too from a contradiction similar to that faced by the poets of Futurism. In Milan fellow professionals had begun to use the new materials, and yet they continued to mask them coyly with decorative features that served no structural purpose. Sant'Elia transfers aesthetic value from detailing to the total concept, from 'fussy mouldings, finicky capitals and neat doorways' to '*bold groupings and masses and large-scale disposition of planes*'. Raw materials, when not painted in violent colours, were to be left to speak for themselves; and functional elements, such as the lift-shafts that climbed façades like 'iron and glass serpents', were to be undisguised. The Futurist building will be 'like a great machine'; and yet the assimilation of form to function remains an aesthetic expression, corresponding to the modern 'taste for the light, the practical, the ephemeral and the swift'.[10] Sant'Elia's projects are based on abstract geometrical forms, exemplified by his sketch for an electric generating station (Fig. 16). Human beings become functions of this vision of mechanical perfection. Marinetti strains towards a poetic practice in which the individual voice is suppressed, the poem becoming the efficient transmitter of the vibrating energies of the modern world.

Architect and poets meet on the common ground of an austere discipline in which the 'human' is construed as weak and de-energising. Where the accent of the *Technical Manifesto* still falls on the anarchic intervention of the Futurist few into the order and the logic of traditional poetic discourse, the vision of *Geometric and Mechanical Splendour* is one of increased order. Reyner Banham quotes a characteristic passage:

> Nothing is more beautiful than a great humming electric power-station that holds the hydraulic pressure of a whole mountain range and the electric power of a vast horizon, synthesized in marble control-panels bristling with dials, keyboards and shining commutators. These panels are the only models for our poetry. (p. 86)

This image of abstract immensity, Banham remarks, argues for a more restrained and adult view of technology in Marinetti.[11] It is also an aestheticising view which ignores the human needs which these great powers are harnessed to serve, much as Sant-Elia's vision of the city contemplates men only in as far as they are – as Marinetti put it – 'multiplied', an endless series.

The Futurists had started out using a provocative rhetoric of self-aggrandisement, freely dubbing each other geniuses; and yet they had no time for individual endeavour or nice critical distinctions. Increasingly they emphasise the collective, impersonal experience. The demon of mortality, and the threat of the urban crowd and its proliferating machinery, are not so much unfelt by the Futurists as deflected towards a compensatory faith in man as a reproducible entity contributing to a vast global energy, and so participating in a species of transcendence. Futurism is inseparable from the expansion of the industrial city: in a sense the movement makes a virtue of necessity. The Futurists discover the exhilaration and the instinctuality, which their more prudent and introspective contemporaries seemed to have lost, within the very environment which might have been expected to leave them with a sense of bewilderment and dehumanisation.

Notes to chapter 4

1 For the Italian text of the *Manifesto* see *Teoria e invenzione futurista*, pp. 7–13, Vol. II of *Opere di F. T. Marinetti*, ed. Luciano De Maria, 4 vols. (Milan, 1968). For convenience, page references to this volume are given in the text, and where the volume is repeatedly cited within the same paragraph references are grouped together. For an easily available English translation of this and other manifestos see *Futurist Manifestos*, ed. Umbro Apollonio, London, 1973.
2 For an English version of the *Messaggio*, see Reyner Banham, *Theory and Design in the First Machine Age*, reprint of the 1960 edition, London, 1980, pp. 128–30. Sant'Elia's *Futurist Architecture* can be consulted in recent anthologies such as *Marinetti e il futurismo*, ed. Luciano De Maria, 3rd edition (Milan, 1977), pp. 148–52, and is reproduced in *Futurist Manifestos*, pp. 160–72.
3 Seè *Marinetti e il futurismo*, p. 149.
4 *Marinetti e il futurismo*, p. 152.
5 There are few modern editions of the poets cited in the rest of the text. Useful selections are to be found in modern anthologies such as *Poesia italiana del Novecento*, Edoardo Sanguineti, 2 vols. (Turin, 1969); *Marinetti e il futurismo; Poeti futuristi*, ed. Giuseppe Ravegnani (Milan, 1963); *I poeti de futurismo 1909–1944*, ed. Glauco Viazzi (Milan, 1978); and *Poeti futuristi dadaisti e modernisti in Italia*, ed. Glauco Viazzi and Vanni Scheiwiller (Milan, 1974). In English translation see *The Blue Moustache: Some Italian Futurist Poets*, ed. and trans. Felix Stefanile (Manchester, 1981).
6 *Futurist Manifestos*, p. 147.
7 *Futurist Manifestos*, p. 73.
8 *Marinetti e il futurismo*, p. 152.
9 See Boccioni, Carrà, Russolo, Balla, Severini, 'Futurist painting: technical manifesto', in *Futurist Manifestos*, p. 28.
10 *Marinetti e il futurismo*, pp. 151, 150.
11 *Theory and Design in the First Machine Age*, p. 125.

Defeat and rebirth: the city poetry of Apollinaire

Both the importance of the city in Apollinaire's work and the complex ambivalence of his attitude towards it are suggested by the two long poems which open and close the collection *Alcools* (1913), that is, 'Zone' and 'Vendémiaire'. For, however exaggerated it might be to talk of an 'architecture secrète' of the kind which underlies Baudelaire's *Fleurs du Mal*, Apollinaire clearly took some care in the ordering of the pieces contained within his first major collection, and the reader is certainly led to compare and contrast the two poems I have referred to, if only by the different moods evoked by the walk back along the Seine embankment to Auteuil:

> Tu marches vers Auteuil tu veux aller chez toi à pied
> Dormir parmi tes fétiches d'Océanie et de Guinée
> Ils sont des Christ d'une autre forme et d'une autre croyance
> Ce sont les Christ inférieurs des obscures espérances.

> (You walk back to Auteuil you want to walk home
> To sleep in the midst of your fetishes from Guinea and the South Sea Isles
> They are the Christs of another form and another faith
> These are the lesser Christs of obscure aspirations) (*A*, 14)

and:

> Un soir passant le long des quais déserts et sombres
> En rentrant à Auteuil j'entendis une voix
> Qui chantait gravement se taisant quelquefois
> Pour que parvînt aussi sur les bords de la Seine
> La plainte d'autres voix limpides et lointaines

> (One evening wandering along the deserted darkened embankment
> Walking back towards Auteuil I heard a voice
> Singing with solemnity now and then falling silent
> To allow to be heard on the banks of the Seine
> The lament of other limpid and far-flung voices) (*A*, 136)

To make the walk through Paris the central theme of both poems is clearly to emphasise the significance of the city in *Alcools*, even if the poems within the collection dealing with specifically urban themes are probably in the minority. But it is also interesting that the dominant experience of the city in the opening poem, 'Zone' should be one of fragmentation and desolation, and that of 'Vendémaire' one of cosmic intoxication, whereas in formal and stylistic terms 'Zone' – which was probably the last poem in *Alcools* to be written – is extremely 'modern', and the concluding poem seems often to remain anchored in the aesthetic and the rhetoric of a Victor Hugo.

In some ways this paradox should not surprise us. As Peter Collier has shown in Chapter 2, both of these responses to the city are part of an existing tradition in French poetry. Baudelaire in particular, was able to perceive life in Paris both as an image of human exile in the imperfect – as in 'Le Cygne' ('The Swan') – and as the potential source of a kind of imaginative intoxication – as in the prose poem 'Les Foules' ('Crowds'). It is nevertheless interesting that many of the poems which derive from the kind of aesthetic outlined in 'Les Foules' – notably 'Les Petites Vieilles' – tend also to present images of human desolation and alienation. Indeed, for the French Romantics and Symbolists, the city, however fascinating as an accumulation of cultures and individuals, tended to be used as an image of the world-weariness of an old civilisation, one which was felt to have lost its faith, and one in which an excess of knowledge had alienated men from themselves and from the natural world. And technical progress, of which the urban metropolis was the high temple, was associated with that sense of alienation.

But the uneasy sense of self and its relationship with actuality and relativity of an experience in which God might no longer be in his heaven that defines so much French Romantic writing did not inevitably lead poets to seek escape from the realities of their experience in nostalgia or exoticism. For some – notably Gautier, Nerval and Baudelaire – it led instead to the attempt both to confront and transcend urban experience with and through language. And this involved them in a radical redefinition of the process of writing and reading which is central to the emergence of what is termed Modernism.

For Baudelaire's theory of 'correspondances' and his practice of writing, both of which are seminal to Symbolist poetry, are intimately related to the problem which confronted most nineteenth-century poets and painters in one way or another, that of creating an 'absolute' beauty out of a finite experience which appeared almost unutterably trivial or ugly. Whereas the 'naïve' poet of Antiquity was considered to have been able to arrive at 'beauty' by the direct expression of his harmonious relationship with the

natural world, the modern poet, faced with an incoherent and fragmented experience of the 'real', manifested most acutely in the modern city, was obliged to construct a harmonious pattern of *verbal* relationships and meanings. And precisely because Baudelaire sought to create, on the level of language, a state of absolute intensity, the poem became important, not so much for its capacity to evoke specific relationships or to state specific meanings, as for its ability to create patterns of dense and complex meaning. With Mallarmé, of course, this process is carried much further, and these lines from his famous 'Sonnet en x':

> Sur les crédences, au salon vide, nul ptyx,
> Aboli bibelot d'inanité sonore,
>
> (On the shelves, in the empty drawing room, no ptyxia,
> Negated knick-knack of sonorous stupidity.)[2]

exploit to the full the capacity of language both to negate the real and to create a mental reality, and at the same time to discover meaning in the assertion of its own meaninglessness.

Around the turn of the century a rather more positive perception of modern experience began to be more current in poetic writing. Those aspects of urban and industrial life, the sense of physical and intellectual relativity engendered by technological advance and by modifications in scientific and philosophical ideas which poets had seen as negative, began to be much more currently a source of enthusiasm for poets. This is of course most evident in the case of the Italian Futurists who, largely thanks to the publicising zeal of their leader Marinetti, had considerable influence in France. Their violent attack on all forms of 'passéiste' culture singled out for particular attention the moonlight which epitomised for them the nostalgic and sentimental attitudes of Romanticism and Symbolism. To the moonlight of the Romantics they oppose the dynamism of the sun and the brilliance of modern electric lighting. For central to their preoccupations was the notion that the whole sensibility of man was being changed by scientific and technological discoveries – life was at once more multiple and dynamic than it had been before. A new, heroic, Nietzschean man was being born, participating of the strength and violent beauty of the machines he had created. And the similarity between such ideas and those current in France is suggested by the very nature of some of the contemporary poetic 'movements' – Dynamisme, Machinisme, Paroxysme, Impulsionnisme. . . .

The relationship between the Futurists and their French equivalents and the poetry of the previous century is, however, a more complex one than their own more aggressive remarks might suggest. I have already hinted at an important sense in which the central question which preoccupied

Romantic writers and artists was precisely that of modernity – that is, the feeling that conditions of life in the nineteenth century are different to those of preceding ages, and that traditional notions of beauty and modes of representation are no longer adequate. Their nostalgia and their exoticism, derided by the Futurists, were more often than not the manifestation of an aspiration towards vitality, dynamism, and a naïve and total engagement with the present, which they felt to be impossible in the post-Christian urban culture in which they lived. In this sense, the aggressive endorsement of the immediacy, dynamism and energy of the machine culture on the part of the Futurists can be perceived as a displacement of Romantic values on to the present, and their formal experiments as an attempt to forge a language capable of recreating a naïve and direct relationship – that of traditional lyric poetry – between experience, language and poetic form, of a kind which a Baudelaire or a Mallarmé had felt to be impossible.

The Futurists therefore proposed a whole series of apparently extremely radical linguistic and formal experiments – but with interesting exceptions, those experiments are to do with expression. They do not perceive language itself as being problematic in the ways in which it can refer to the outside world. And this is perhaps one of the reasons why so much of their writing appears dated to our generation, which is no longer filled with a sense of wonder at the sensation of speed and the consciousness of spatial and temporal relativity. The ambition to sweep away the past implies an attempt to wish away the cultural conflicts engendered by new modes of perception and a new technology, which is perhaps what remains interesting to us today. The phenomena they are writing about now seem quaint rather than exciting, the experience they evoke everyday, and to be taken for granted, and the words have little ambition beyond the representation of those phenomena and the expression of that experience. The texts therefore have little more than archeological interest.

And many of the attempts on the part of their French contemporaries to create a lyricism adequate to the new age derive from what seems to be a rather forced desire to percieve in the new technology the means to a heroic totalisation of the fragmentation of the world. In formal terms, they often consist of tacking onomatopaeic effects of the kind recommended by Marinetti and his followers onto a very dated poetic rhetoric. As in the case of this experiment with polyphonic voices by Henri-Martin Barzun, in which the Modernism is fundamentally superficial, the feelings conventional, the personification banal:

Le Chef pilote: Que les moteurs *vrombissent* et rugissent
Les moteurs: — Vrom vromb, vreu, vron, ron ou, or ou, or meu
Les Chef pilote: Que les hélices *tournent* follement

Les moteurs:	— Ronvronronvron dron, vreu — oo, ouaarr
Le Chef pilote:	Que le sillage d'air *baigne* les faces qui se lèvent
Les helices le vent:	— wirl, wou, wirl, wou-ll, woua, wirl — weu ll
Les pavillons:	— clac, *clac* — fro *ou* clac — rrou sss
Le Chef pilote:	En avant! au-dessus des cités! et saluons l'oeuvre des hommes . . .
La Sirene du bord:	— Ho! huu — uu — ho! hohu! huohuohuoho -hu
First pilot:	Let the engines *throb* and roar
Engines:	— Throb throb throarr ouarrr orr
First pilot:	Let the propellors *rotate* frenetically
Engines:	— Robthrobthrobthrob from, throarr, oo, ouarr
First pilot:	Let the wake of air *bathe* the upturned faces
Propellors wind:	— whirl, wow, wheerl, wow-ll wowah, wheerl — whir
Flags:	— flap, *flap* — fro *ow* flap — rroo sss
First pilot:	Forward! over the cities! and let us salute the works of men.
Airship siren:	— ho! huu — uu — ho! hohu! huohuohuoho — hu[3]

The initial impression 'Zone' creates is one of aggressive modernity of a rather dated kind, with its references to the trappings of early twentieth-century technology, deliberately used in incongruous metaphorical relationships: 'Bergère ô tour Eiffel le troupeau des ponts bêle ce matin' (Shepherdess O Eiffel Tower the flock of bridges baas this morning'; A, 7); telescoped images reminiscent of the Futurist attempts to renew syntax: 'Soleil cou coupé' ('Sun severed neck' A; 14); the construction of the poem as a whole in terms of fragmentary, disconnected images, apparently suggesting temporal and spatial ubiquity or interpenetration between inner and outer worlds.

In fact 'Zone' reveals a very complex engagement with the experience of time, past and present, in both cultural and personal terms, and with that of poetic language and form. The deliberately incongruous associations of the Eiffel Tower with pastoral shepherdesses, of religion with aircraft hangars, of Christ with the first aeroplane, of childhood piety and innocence with the brash brightness of an industrial street in the morning sunlight, all occurring in the opening sequences of the poem, are part of a subtle play with the private and cultural associations of youth and age, innocence and world-weariness, modern and ancient. Within the history of Western culture, what might appear to be the freshest and most vital manifestations of the present can also be perceived as the all too predictable effects of decadence: 'Ici même les automobiles ont l'air anciennes' ('Here even the motor-cars seem old-fashioned'; A, 7), and what might appear to be oldest and most irrelevant – Christianity – as a lost innocence and freshness of civilisation.

Towards the end of the first part of the poem, however, there is an

attempt to reconcile the terms of the opening paradox, and arrive at a synthesis. The new century, like Christ, the first aeroplane, rises in a glorious ascension, accompanied by the high-flyers of mythology – Icarus, Enoch, Eliah, Apollonius of Thyana – and a whole host of real and mythical birds. It is, perhaps, the search to find in a synthesis of Christian culture and technological innovation the basis for an artistic rebirth parallel to the synthesis of Christian and pagan cultures which had marked the Renaissance. But the interpenetration of memories of the past and perception of the Parisian present which constitute the remainder of the poem reverse this positive movement, offering an overwhelming sense of nostalgic sexual and religious guilt which culminates in the horrifying image of the rising sun – traditionally an image of hope and rebirth – as an image of death: 'Soleil cou coupé'.

The poem thus resumes the ambiguity of the urban present as it was experienced by poets of the late nineteenth and early twentieth centuries: on the one hand as fragmentation and absence, on the other as a source of exhilaration – or, perhaps most authentically, as both. And this ambiguity is also present in the formal structure and language of the poem, as is clearly revealed by the final line which I have just quoted. The initial impression which it creates is one of striking modernity – the simple and jarring juxtaposition of two visual images, the disk of the sun against the skyline and a neck from which the head has been severed – the alliterative and onomatopaeic effects of 'cou coupé' contributing to the impression of shock which the image produces. But the line is probably the deliberate inversion of a metaphor deriving from the Romantic and Symbolist tradition. Its direct origin, via a series of reworkings by Apollinaire himself, would appear to be found in the famous line from Baudelaire's 'Harmonie du soir': 'Le soleil s'est noyé dans son sang qui se fige' ('The sun is drowned in its setting blood').[4] And the Baudelaire poem can be seen as a kind of model for the Symbolist practice of exploiting linguistic ambiguity to create, by a play on the associative memory, an impression in the reader of total harmony of spirit and senses, and to recreate, in the poem, a transcendent unity, a more perfect world.

The quite opposite effect of disruption and surprise which the line 'Soleil cou coupé' has on the reader derives at least in part from that inversion, from the fact that both formally and significatively it is working both against and within the tradition from which it derives. For it also acts on many levels to draw together the divergent strands of the poem. It focuses the references to blood scattered throughout – the blood of the Sacred Heart, the blood of women. And by its contrast with the sunrise in the 'industrial street' of the beginning of the poem – a sunrise full of hope,

prefiguring the glorious ascension of the new century – it helps to define the narrative and symbolic structure of the text as a walk through Paris, beginning one morning and continuing through a whole day and night until the next morning, the image of an Orphic journey to the Underworld from which there is no triumphant return, the image of the traditional cycle of birth, death and renaissance figured by the cyclic rising and setting of the sun, but with the conventional image of rebirth transformed into an image of death.

So the line plays an important part in a narrative and symbolic structure which makes the poem legible in traditional terms, and contributes to the transcendence of the sense of fragmentation which it powerfully expresses. Nevertheless its powerful ellipsis also corresponds to the positive aesthetic of the city which it appears to be denying – I noted earlier its resemblance to the Futurist telegraphic techniques. Indeed the primitive sculptures, 'lesser Christs of obscure aspirations', which in the context of the poem appear to suggest the nadir of metaphysical confidence, are of course one of the models that Derain, Picasso and Braque were, to Apollinaire's knowledge, using as the basis for an artistic rebirth. The final image of 'Zone', like the poem as whole, demonstrates in its functioning the problematic sense of the relationship between language and an experience of the actual which is, perhaps, the principal subject of the text. Both work within limits and tend to extend those limits.

In this sense 'Zone' is a paradigm of the volume *Alcools*. The superficially heterogeneous appearance of the collection led it to be seen on publication as an assembly of literary bric-à-brac.[5] The traditions of the German folk-lyric, Graeco-Roman mythology, Romantic and Symbolist preoccupations with medieval allegory and legend, are all to be found in conjunction with contemporary urban or machinist images, whose register varies from that of Baudelairian/Laforguian kitsch to the Expressionism *avant la lettre* of:

> Soirs de Paris ivres du gin
> Flambant de l'electricité
> Les tramways feux verts sur l'échine
> Musiquent au long des portées
> De rails leurs folies de machine
>
> Paris evenings drunk on gin
> Blazing with electricity
> Trams green lights along the spine
> Scream to the score of their lines
> The music of the madness of machines (A, 31)

And indeed, in the poem from which these lines are taken, 'La Chanson du

Mal-Aimé', all these occur within the same text.

Nevertheless, even where Apollinaire seems to be working within a tradition which would seem to be at the opposite extreme from a poetry of the city – that of the German *Volkslied* for example – he tends also to be doing something with that tradition which can only be read within the context of a modern, urban, experience. In 'Nuit rhénane' ('Rhineland Night'), elements of German myth and legend, the picturesque enchantment of the decor as perceived by a city-dwelling tourist, combine to create magic intoxication:

> Le Rhin le Rhin est ivre où les vignes se mirent
> Tout l'or des nuits tombe en tremblant s'y refléter
> La voix chante toujours à en râle-mourir
>
> The Rhine the Rhine is drunk where the vines are mirrored
> All the gold of the nights falls in flickering reflections
> The voice still sings to its dying fall, A, 94)

an intoxication which is broken by the jarringly eliptical image of the glass breaking: 'Mon verre s'est brisé comme un éclat de rire' ('My glass shattered like a burst of laughter'). The disjunctive narrative structure of the *Volkslied* is exploited to the ironic ends of a post-symbolist neurosis.

'Marizibill' appears to be an ironically sentimental evocation of the alienation of city life, playing on the cliché of the golden-hearted whore. But in the concluding lines of the poem the terms of the problem are thrown into question:

> Je connais gens de toutes sortes
> Ils n'égalent pas leurs destins
> Indécis comme feuilles mortes
> Leurs yeux sont des feux mal éteints
> Leurs coeurs bougent comme leurs portes
>
> (I know people of every kind
> They are not equal to their destiny
> Indecisive as dead leaves
> Their eyes are ill extinguished fires
> Their hearts flutter like their doors) (A, 51)

The apprent drift of the poem would seem to imply that the haphazardness of Marizibill's sexual encounters is an image of emotional fragmentation, of the inadequacy of destiny to the personal qualities of the individual. But the word 'égalent' subverts such a reading, suggesting on the contrary, that the multiplicity and indeterminacy of existence are precisely what people cannot face up to. So that Marizibill's problem is the absurd nostalgia for emotional security which makes her faithful to her grotesque pimp, her inability to espouse the relativity of urban experience.

If the problematic attitude towards modern urban experience and the formal and liguistic ambivalence which characterise 'Zone' make it an excellent introduction to *Alcools*, 'Vendémiaire' would seem to be a no less apt conclusion. The modern city is perceived positively, as a source of dionysiac intoxication for the poet. But the experience of Paris as presented in the poem is in no way a simple affirmation of the present or a rejection of the cultural traditions of the past like that of the Futurists. Certainly it contains aggressively modern images – like the factory chimneys of the north of France:

> Les viriles cités où dégoisent et chantent
> Les métalliques saints de nos saintes usines
> Nos cheminées à ciel ouvert engrossent les nuées
> Comme fit autrefois l'Ixion mécanique

> The virile cities where belch forth and sing
> The metallic saints of our holy factories
> Our chimneys open to the sky impregnate the clouds
> As did in days gone by the mechanical Ixion) (*A*, 137)

But the association of the phallic chimneys with the Ixion of Classical mythology places this reference in a similar context to that of the opening passages of 'Zone'. The intoxication offered by Paris and its variety and multiplicity derives not from its opposition to past cultures, but, on the contrary, from its position as the vat in which multiple and various cultural traditions are pressed and fermented to produce a uniquely heady poetic wine.

The blending and fermenting of cultural traditions within the vast human agglomeration which is Paris corresponds to the blending and fermenting of poetic themes, traditions, and techniques which is the collection *Alcools*. It is matched by the interplay of codes within the poem. The title, 'Vendémiaire', situates it as an autumnal poem, with the ambivalent significations of the season, period of nostalgia and regret, but also season of fruition, and more particularly, the making of wine. But *vendémiaire* is of course also a month in the revolutionary calendar, and the *13 vendémiaire* the date of an unsuccessful Royalist revolt. And this helps to give sense to the opening lines of the poem:

> Hommes de l'avenir souvenez-vous de moi
> Je vivais à l'époque où finissaient les rois
> Tour à tour ils mouraient silencieux et tristes
> Et trois fois courageux devenaient trismégistes

(Men of the future remember me
I lived at the time when kings were coming to an end
In turn they died silent and sad
And three times courageous became trismegistic) (*A*, 136)

particularly if they are read in conjunction with the text of the crown motif
from 'Coeur couronne et miroir': 'Les rois qui meurent tour à tour renaiss-
ent au coeur des poètes' ('The kings who die in turn are reborn in the hearts
of the poets' *C*, 58). The revolution which marked the end of kings and the
old ordered universe can be seen in relation to the poetic revolution which is
also a poetic rebirth or Renaissance. And, like the culture of the Renaiss-
ance, the fusion of diverse strands of civilisation, the new poetic culture of
which Paris is the centre represents the bringing together, not only of Pagan
and Christian traditions – and the poem plays heavily on the role of wine
and the notion of rebirth or recuscitation in both – but also of the new
technological civilisation manifested by the factory chimneys to which I
have just referred.

 If, however, the poem offers a positive resolution of some of the tensions
and problems introduced by 'Zone', and worked out in the course of the
volume, it is nevertheless a more dated and less satisfactory poem than
'Zone'. It endorses the cultural relativity of the metropolis, but only by
totalising it. It reaches back to the Baudelairian sense of intoxication to be
derived from experience of the city. And if it avoids the narrowness of the
Futurist refusal of tradition and culture in its accumulation of the past
which is the present, it nevertheless does so in terms of the kind of vitalism
which I suggested to be, in the case of the Futurists, a retarded Romantic
trait. Indeed, if its difficulty as a poem derives from the density and intricacy
of reference that characterises the 1907–8 poems by Apollinaire, 'Le Bra-
sier' and 'Les Fiançailles', it reaches back, formally, even further than
Baudelaire. For its basic metaphorical structure, founded on the multiple
voices that the poet hears on his way home to Auteuil in the lines quoted at
the beginning of this essay, voices whose songs and cries then constitute the
body of the poem, has something of the literal-mindedness of Victor Hugo's
'Ce qu'on entend sur la montagne' ('What is heard on the mountain') of
1829 and, as I noted at the beginning of this chapter, something of its
rhetorical pomposity.

 It marks, however, the transition between *Alcools* and the first section
of *Calligrammes*, 'Ondes' ('Waves')[6]. For if it expresses an affirmative
attitude to the city, what it fails to register is the acceptance of the variability
and indeterminacy of urban experience which is hinted at in 'Marizibill'.
And in the small group of poems collected in *Calligrammes* under the title
'Ondes', mostly written between the publication of *Alcools* and the out-

break of war', Apollinaire seems to be striving, in a number of ways, to discover a lyricism of modern urban experience which is neither transcendence through language in the sense in which I have described it in Baudelaire, nor vitalistic totalisation, nor simply celebratory in the innocently expressive sense, but one which is founded on the creation of an affirmative poetic unreality out of the transient and fragmentary nature of twentieth-century city life.

The kind of reading which Philippe Renaud proposes of 'Lundi rue Christine' (C, 40–2)[7] goes in this sense. Apollinaire referred to this kind of poem as a 'poème conversation', defined in the following terms: 'The poet at the centre of life records so to speak the ambient lyricism.' Looked at in conjunction with the lyrical ideogram 'Lettre-Océan' (C, 43–5), in which the Eiffel Tower radio transmitter sends out simultaneous 'poetic' messages to all parts of the world, this suggests a relationship with the Futurist notion of 'simultaneity' and the technological means of its production. But the Apollinaire poem does not itself reveal this. It is – or could be thought to be – the simple and direct notation of a specific place – rue Christine – at a specific time – Monday. What is interesting is the ambiguity of these notations. They fall into several different categories – notations of décor, or of fragments of conversations picked up in the room, or magisterial pronouncements on the part of the poet, or comments on its development. But it is often extremely difficult to ascribe any particular line to any specific category – 'Ça a l'air de rimer' ('That seems to rhyme/make sense'), for example, could be either a piece of conversation or a wry comment on the text itself.

In this way, the solidity of the real, apparently simply transcribed with the utmost immediacy, is dissolved. Its hard edges, the contours by which we can situate ourselves in it according to any fixed perspective, are blurred, and a strange dreamlike world is created in which everything is also *un*real. In a sense it recalls the Mallarmé sonnet quoted earlier. But Mallarmé's text literally negates the contingency of the world in order to create an absolute reality of the text in metaphysical terms. What is excitingly new about the Apollinairian poem is that it neither laments the fragmentation of self and world, nor attempts to totalise or transcend it. It is a lyrical affirmation of the incidental and arbitrary nature of experience within time, and within the specific time of the present which does not negate the conditions of that experience. Without direct reference to the trappings of modern city life, and working almost uniquely in terms of a play with the ways in which language conventionally refers to the outside world – since the poetic unreality I have alluded to derives principally from the multiple and unstable possibilities of reading which the poem offers – he arrives at a poetic

articulation of an experience of city life.

In certain ways 'Lundi rue Christine' might be compared to certain contemporary works by Picasso and Braque, particularly the *papiers collés*, which offer a similar play of ambiguities deriving from a use of the actual and the everyday. The materials used, scraps of newspaper or pieces of *trompe-l'oeil*, like the false panelling in the Braque *Bottle, Glass and Pipe* illustrated in Fig. 17, are there in their materiality and at the same time made to represent an accidental reality of the moment. But they relate in an ambiguous and unstable way to other elements in the work – to the clearly representational drawing of the bottle and the glass, or to the pipe, which exists like the Mallarméan 'ptyx' as an absence, since its form is cut out of a piece of newspaper. And a similar ambiguity and instability define the spatial relationships of the picture. The dark brown piece of real false panelling is foregrounded to appear to be in front of the bottle, but the drawing of the bottle is continued over it to contradict this indication of depth. Elements of the real and representations of the real are ambiguously combined to create an autonomous reality which refers to the real in its most everyday manifestations and which nevertheless refuses any simply realistic interpretation.

Another poem from 'Ondes', 'Un Fantôme de nuées' ('A Phantom of Clouds'; C, 54–7), confirms, by a discreet homage to Picasso, this connection between Apollinaire's poetic experiments of 1913–14 and the contemporary development of Cubism. Like 'Lundi rue Christine', 'Fantôme de nuées' is firmly fixed in the actuality of a Paris experience. The subject of the poem is a chance encounter with a group of street acrobats. The time and place are firmly foregrounded – four o'clock on 13th July between Saint-German-des-Prés and the statue of Danton. But that time and place – near the statue of Danton on the day before the anniversary of the taking of the Bastille – recall the references to the revolution in 'Vendémiaire', and imply the desire to lend some kind of legendary or mythical significance to the chance everyday occurrence. And, since the 'fantôme de nuées' of the title, associated in the last line with the art of the new century, 'Siècle ô siècle des nuages' ('Century O century of clouds' C, 57) is an allusion to the apparition of Juno constructed out of clouds to deceive Ixion, the poem is also centred on a reference to the myths of classical antiquity which play such a large part in *Alcools*. Indeed, if the poem is perhaps above all an 'art poétique' defining the kind of poetic revolution that Apollinaire is attempting to conduct in 'Ondes', it also suggests the continuity of the intellectual preoccupations of both poet and painters' in spite of the apparent stylistic voltes-face in which they had been engaged over the preceding decade.

For there is a resemblance which seems to be too close to be accidental between the acrobats of Apollinaire's poem and those of Picasso's paintings of 1905. The first of Apollinaire's acrobats carries the ashes of his forefathers on his face in the form of a grey beard, and is grinding out on his barrel organ a music of ironic lament, while looking towards the future. He is followed by another, who is faceless, and dressed only in his shadow, and finally by a young acrobat described in the following terms:

> Une jambe en arrière prête à la génuflexion
> Il salua ainsi aux quatre points cardinaux
> Et quand il marcha sur une boule
> Son corps mince devint une musique si délicate que nul parmi les spectateurs n'y fut insensible
>
> Un petit esprit sans aucune humanité
> Pensa chacun
> Et cette musique des formes
> Détruisit celle de l'orgue mécanique
> Que moulait l'homme au visage couvert d'ancêtres
>
> (One leg behind ready to kneel
> He made his bow thus to the four cardinal points
> And when he walked upon a sphere
> His slim body became a music so delicate that no-one amongst the spectators could be insensitive to it
>
> A tiny spirit completely bereft of humanity
> Thought everyone
> And that music of forms
> Destroyed that of the barrel organ
> Ground out by the man whose face was covered by his ancestors) (C, 56–7)

And one of the 1905 Picassos (Fig. 18) shows a child acrobat balanced on a sphere with an older male figure in the foreground seated with his back to the spectator on a cube, while another contemporary painting depicts an ancient hurdy-gurdy player. What is even more interesting, is that the first of these two paintings shows a resemblance that is also too close to be accidental to an image from a sixteenth-century emblem book by Alciati of the kind on which Apollinaire's 'Bestiaire' is clearly based (Fig. 19)[8]. The Alciati emblem shows Hermes, god the arts, sitting on a cube, together with Fortune, balancing on a sphere, the image is accompanied by the following text:

> Sur vng boulet Fortune a tous hasards:
> Sur un quadragle, Hermes preside aulx ars
> Contre Fortune est faict art pour remede

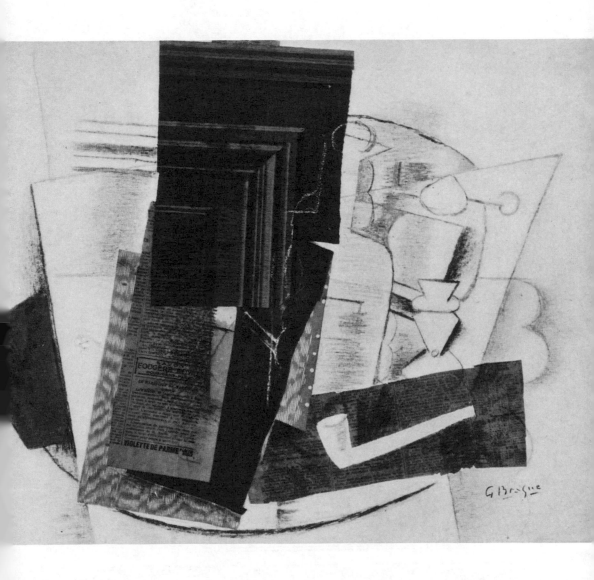

17. Braque, *Bottle, Glass and Pipe*

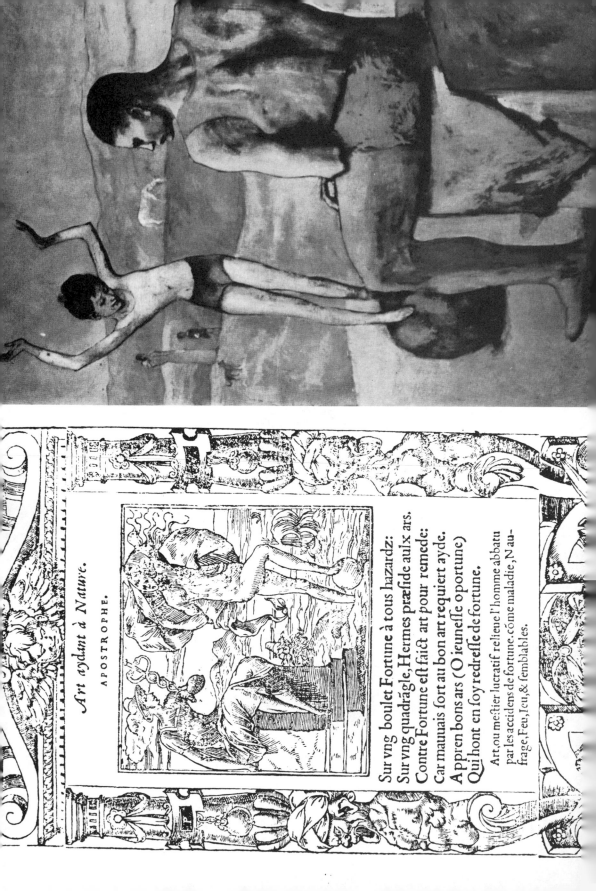

Art aydant à Nature.

APOSTROPHE.

Sur vng boulet Fortune à tous hazardz:
Sur vng quadrãgle, Hermes præfide aulx ars.
Contre Fortune eſt faict art pour remede:
Car mauuais fort au bon art requiert ayde.
Appren bons ars (O ieuneſſe oportune)
Qui hont en foy redreſſe de fortune.

Art, ou meſtier lucratif relieue l'homme abbatu
par les accidens de fortune. côme maladie, Nau—
frage, Feu, Ieu, & ſemblables.

Car mauvais sort au bon art requiert ayde
Appren bon ars (O ieunesse opportune)
Qui hont en soy redresse de Fortune.

(On a ball Fortune open to chance:
On a quadrangle, Hermes presides over the arts
Art is made as remedy for fortune.
For the misfortunes of fate require help from skilful art
Learn skilful arts (O likely lads)
Who have it in them to redress Fortune.)

The text from the Alciati emblem book corresponds very closely to the preoccupations of the Apollinaire of *Alcools* as I defined them in my comments on 'Marizibill'. But in 'Un Fantôme de nuées' he is voluntarily misreading it, or inverting its implications. The lines from the Alciati text encourage the pursuit of art – in the sense of useful and lucrative skills – as a way of redressing fate and dominating the vagaries of chance. Whereas in Apollinaire's poem the infant acrobat is not Fortune as such, but the representative of an alternative form of art – an art which espouses the apparently haphazard relativity of urban experience, and whose precarious balancing act produces a formal music – literally a music of the spheres? – capable of destroying and replacing the traditional plaintive music of the barrel-organ played by the Harlequin/Hermes, which, within the Symbolist tradition had precisely the function of transcending the chance contingencies of finite experience. And when, at the end of the poem, the child acrobat disappears, the reaction of the spectators is one of almost religious awe:

Mais chaque spectateur cherchait en soi l'enfant miraculeux
Siècle ô siècle des nuages

(But each spectator sought within himself the miraculous child
Century O century of clouds) (C, 56–7)

in which hints of the Christian Nativity and Ascension are associated both with the Classical myth of Ixion and the new century.

The positive note on which the poem ends suggests that the aesthetic adumbrated and practiced in the poem is perceived as a resolution of some of the problems posed in 'Zone' – and particularly in the opening sequences. That is, how to find a poetic language capable of affirming without contradicting by the nature of that affirmation, the conditions of modern urban experience, one which can accommodate the sense of cultural fragmentation which is an important element in that experience – the 'heap of broken images' of which Eliot speaks in *The Waste Land* – without attempting to totalise it in a way which belies its nature, one which can replace the perspectives of European civilisation since the Renaissance

18. Picasso, *The Acrobat with a Ball*
19. Alciati, *Art Assisting Nature*

without denying the significance of its cultural inheritance or residue, which can make out of what had been perceived as an artistic decadence, artistic rebirth.

Notes to chapter 5

1 References to Apollinaire's poems are to the editions of *Alcools* and *Calligrammes* (*A* and *C*) published in the Gallimard 'Collection Poésie', Paris, n.d. *Zone* was first published in the *Soirées de Paris* of December 1912; *Vendémiaire* appeared a month earlier in the same review, but may well have been written before.
2 Mallarmé, *Poésies*, Gallimard, 'Collection Poésie', Paris, n.d., p. 00.
3 Henri-Martin Barzun, 'L'Universal poème', *Poème et Drame*, October 1913, cit. Pär Bergman, *'Modernolatrià' et 'Simultaneità'*, Stockholm, 1962, p. 300.
4 See Marie-Jeanne Durry, *Guillaume Apollinaire: Alcools*, Paris, 1956–64), vol. I, p. 43.
5 Georges Duhamel, *Mercure de France*, 384, 15 June 1913.
6 *Calligrammes* contains poems written between the end of 1912 and 1917. Almost all of the poems in the first section, *Ondes*, were written before the outbreak of war in 1914.
7 Philippe Renaud, *Lecture d'Apollinaire*, Lausanne, 1969, pp. 314–24. This book contains one of the first serious attempts to come to grips with *Caligrammes*, and has generated considerable interest in the period of experimentation represented by *Ondes*. It remains perhaps the most enlightening book on Apollinaire.
8 A. Alciati, 'Art aydant a Nature', in *Emblemes* de nouueau Trāslatez en Frācois vers pour vers iouxte les Latins (Lyon, 1549), p. 120. The relationship between these two images was first pointed out to me by George Noszlopy, who has been working for many years on a book on the relations between literature and visual arts at this period. When it appears it will be of immense value. See his 'Apollinaire, allegorical imagery and the visual arts', *Forum for Modern Language Studies*, 9, 1 (1973), 49–74. On Apollinaire's Bestiaire and the Renaissance emblem books, see A. H. Greet, *Apollinaire et le livre du peintre*, 'Interférences arts lettres' 4, Bibl. Guillaume Apollinaire, 9, Paris, 1977.

Rilke's Paris – 'cité pleine de rêves'

It was in 1859 that Baudelaire first published the most haunting and powerful of his 'Tableaux parisiens' ('Parisian pictures'), 'Les sept vieill-ards' ('The seven old men'). Although the Paris it evokes belongs to a world two generations before the arrival there of Rilke in 1902, this poem is the most obvious, and the most challenging model for Rilke's Paris.

'Les sept vieillards' appears in the section of *Les Fleurs du mal* (*The Flowers of Evil*) in which, it is popularly thought, Baudelaire comes closest to realism: an idler or *flâneur*, the poet scrutinises the city and its people, and even if he poses as a melancholic or half-crazed outsider, it is a recognisable world that he haunts. In this respect he resembles the protago-nist of Rilke's Paris, literally a foreigner, who grapples with the material difficulties of any newcomer in a city. But what releases the imagination of both writers is not so much the painful material realities of the city as its unrealities, qualities that both inspire poetry and almost pre-empt it, make it redundant. Baudelaire's poem begins:

> Fourmillante cité, cité pleine de rêves,
> Où le spectre en plein jour raccroche le passant!
>
> (Swarming city, city full of dreams,
> Where the spectre in broad daylight accosts the passer-by!)[1]

Here not only the city is unreal, but the poet is equally so, glimpsed by his own eyes as a 'passer-by'. The poem ends on this ambiguity: the protagonist runs away home not just because he cannot trust what he has apparently seen but also because, more disturbingly, the weird old man has stolen the poetic attribute of self-generation – 'dégoûtant Phénix, fils et père de lui-même' ('loathsome Phoenix, son and father of himself', OC 98) – and the gift of transcending everyday time – 'ces sept monstres avaient l'air éternel' ('these seven monsters had the look of eternity', OC 98). What Baudelaire terms 'prostitution', a desire to 'sortir de soi' ('get out of oneself', OC 623, 635) which love sometimes achieves and art seeks to

imitate, is here discovered in the end to belong only to the ghosts or to the city which seems to generate them.

The unreality of the city, then, is both an inspiration and a threat to the poet: it appears to do unbidden what he considers his godlike prerogative. This is the central issue of 'Les sept vieillards', but there are other aspects also which can help anticipate Rilke's recreation of Paris. Let me rapidly reiterate the poem's 'plot'. After declaiming the hallucinatory quality of Paris, the poet wandering sunk in introspection in a foggy *faubourg* is suddenly stopped by a grotesque old man, his spine 'faisant avec sa jambe un parfait angle droit' ('forming a perfect right angle with his legs', *OC* 98) and less pathetic than sinister and menacing. Comparisons proliferate to liken him to everything hellish. Then he is uncannily followed by six more identical figures, making a silent cortège of 'spectres baroques' ('baroque spectres', *OC* 98). The protagonist, uncertain whether he is drunk, inspired or mad, runs home and locks the door, but his soul, a ship loosed from its navigating reason, dances away on a 'mer monstrueuse et sans bords' ('monstrous and shoreless sea', *OC* 98). My narrative reconstruction necessarily fails to convey the most striking aspect of the poem, its radical defiance of a realist reading. We can at no point say, here is an event and here is an account of it; the city, the old man, even the protagonist, are all as spectral and fictitious as poetry – the very first words, quoted above, deny a materially given world.

Freud, in his article 'Das Unheimliche' ('The uncanny', 1919) points out that things will appear uncanny in fiction only under circumstances that would make them so in material reality, that is, only if their context is realistic. Ghosts and fairies are at home in fairy tales, and therefore not frightening. Baudelaire's poem teases at this distinction – it seems to say, look what creepy places these modern cities are, but its atmosphere has an unreality belonging to the world of folk tale, a literature of childhood and the countryside. We cannot ignore the debt that modern urban writing owes to the village it appears to have left. What are the 'sept vieillards' but an uncanny version of the seven dwarfs? Transplantation from country to city changes them from jolly sprites into demons, and the collective fantasy of the rural community, displaced onto the urban scenery, becomes aesthetic, ironic, personalised and sadistic. Fairy tale becomes the private hell, a childhood recreated as frightening and alien.

Secondly, when the 'real world' is puffed away by hallucination, the first thing to vanish is inevitably politics. For whom else do the seven old men recall (anachronistically), if not Zola's tormented Bonnemort, the spectre of *Germinal*? He too is distorted by poverty and suffering – crippled, stoic, spitting coal dust – and he too has a clearly mythical function; but his

significance is primarily political. His hideousness emanates not from pur-
gatory but from 'fifty years work in the pit, forty-five of them
underground!':[2] the mine is hell because it is hell to work there. The
political and causal reasoning of Zola is entirely lacking in Baudelaire, who
disposes of urban deprivation with a sadistic irony in 'Assommons les
pauvres' ('Let's batter the poor', OC 182–3). And what about Rilke? The
destitute *clochards* of Paris whom Malte terms 'die Fortgeworfenen' ('the
castoffs') – are they just bats out of hell? Like Baudelaire, Rilke carefully
avoids the political conclusion that urban destitution morally implicates its
observer. Poverty becomes first a poetic, then a saintly, form of suffering.

There is another question which this analysis of Rilke must try to
answer. This book deals mainly with writers who identified themselves as
avant-garde, modernist. Is Rilke an avant-garde artist? A writer like him
poses problems in a period of movements and -isms that share a strident
modernity, a concern to function as groups, an interest in publicity and
happenings, and above all a focus on politics. How into this scene can we fit
Proust, Gide, Woolf, Rilke? Are they marginal, or are their works experi-
mental in a genuinely modernist way? Have they anything to contribute to
the politics of Modernism? (Let's remember that such conservatives as
Woolf and Proust gave a voice – and not just a confessional one – to women
and homosexuals.) Rilke's claims to Modernism rest on his evocations of
Paris. However much he, like Baudelaire, may present a hallucinatory,
self-recreative city, they are both fictionalising a world we know to exist
also outside anybody's imagination. The Seine flows under the Pont Saint-
Michel, if we care to go and check. We can, as with Bloom's Dublin, retrace
the itinerary of Malte's walks through Paris. Therefore the poetry of the city
is always contemporary, whatever else it might also be.

Elsewhere in this book we see broadly how the city gives rise to a
visionary art. By examining now the work of a single writer, I hope to
explore the detailed process by which immediate, concrete experience is
transmuted into a dreamlike fiction.

Rilke arrived in Paris in August 1902, fresh from the folksy, vegetarian
idylls of Russia and Westerwede, worlds he had shared with his mentor Lou
Andreas-Salomé and his wife Clara Westhoff. In Paris he was not only alone
but also suddenly and violently confronted by an overwhelming material
environment. In a letter he complained: 'everything is exposed, in the
language, the faces, the hair – even in the clothing; everything is in the air,
left out in the air, abandoned' (17 September 1902).[3] Two years later he
looked back to a Paris 'where I felt as if I were hung out in space' (17
October 1904).[4] Elsewhere this sense of violent reality is presented with
expressionistic force: 'cars drove straight through me and if they were in a

hurry they took no detour but sped across me contemptuously as if I were a nasty patch where stale water had gathered' (*BL* 53, 18 July 1903). Or the image of the city becomes a metaphor: 'a thousand hands helped to build my fear, and it has grown from an outlying village into a city, a great city in which unspeakable things happen' (*BL* 54, 18 July 1903). This anxiety, he writes, was already present in the village of Westerwede, but 'when Paris came along, it quickly grew very big' (*BL* 55, 18 July 1903). In these lines we find two sides to Rilke's reception of Paris: first, his sense of threatening exposure, but secondly, an integration of that feeling already into a counter-attack, wherein he uses the imagery of the city to make expressionistic or imagistic poetry.

Let us pause for a moment and see what it was like to come to Paris in autumn 1902. In May, the *bloc républicain* had won elections in a Third Republic recovering from the gruesome revelations of the Dreyfus affair; as for the look of the place, the Eiffel Tower had dominated the skyline since 1889, a reinforced-concrete church stood in Montmartre, and several metro stations, ornate with their art nouveau ironwork, peered up from underground. But in Rilke's writings we see nothing of either the political mood or the modern appearance of the city; instead it is the chilling, busy 'fourmillante cité' of Baudelaire.

In later years Rilke came to look on Paris as his favourite home, but it was the early painful months that produced what we could properly call the Paris writing. A sense of failure, almost of punishment – he called it 'this terrible, heavy town, for which I was too soft, too pathetic' (*BL* 48, 30 June 1903), 'a galley' (*BL* 39, 17 September 1902) – seems to have provided a necessary stimulus. Specifically, his own depression made him sorely aware of the tramps and destitutes of the city, its barely human detritus that appeared 'like a new species of animal in which suffering has developed special organs, organs of hunger and death . . . the dreary, ill-coloured mimicry of overlarge cities' (*BL* 55, 18 July 1903). These figures, with whom he felt an uneasy affinity, seemed the symptom of a diseased modernity. Like Baudelaire's old men, they seemed to pre-empt the poet by generating themselves, growing new limbs and faculties; and just as Baudelaire's Paris is full of arbitrary groups designated simply by a common noun and article – 'les aveugles . . . les petites vieilles . . . une passante' ('the blind . . . the little old women . . . a woman passing by') – so Rilke's ghostlike, witchlike men and women are grouped anonymously as 'die Fortgeworfenen'.

The powerful impressions of Paris were noted down not just in letters but also in poetry and prose. The poems appear in three collections, *Das Buch der Bilder* (*The Book of Images*, 1902, 1906), *Das Stundenbuch* (*The*

Book of Hours, 1905) and *Neue Gedichte* (*New Poems*, 1907, 1908). These poems, for all their qualities, are less interesting for my purpose than the prose, for each collection, in a different way, is less concerned to treat the Paris that tormented Rilke than to supersede it.

In *Das Buch der Bilder* the Paris destitutes reappear given a sentimental rather than archetypal voice in the series 'Die Stimmen' ('Voices'): a blind man, a drunkard, a beggar, a widow, a leper, all speak or rather sing a version of their plight; and while this aestheticising of suffering has none of the sadistic solipsism of Baudelaire's, it still bespeaks a certain human indifference – 'und da hört man noch guten Gesang' ('from them you still hear good songs').[5]

In the third section of the *Stundenbuch*, the hard Paris days are seen as a solid mountain through which the poet has toiled like ore; the poems are to face and express 'die tiefe Angst der übergroßen Städte' ('the deep anxiety of overlarge cities', *SW* 343), and yet the writing is less expression than exorcism. This leads to an ill-conceived and ill-digested mythology in which we meet a new Messiah of whom the author will be the Baptist – the 'Tod-Gebärer' ('he who shall give birth to death', *SW* 350). This figure is the *reductio ad absurdum* of an idea drawn from Jacobsen and elaborated fruitfully in *Malte*: the idea that each one of us should die our 'own death', a death we have gestated throughout our life. A lugubrious but existentially suggestive image is distorted here into the weird fantasy of male moth- erhood as redemptive of the hollow modern world. As for the politics of poverty and death, these are swept away in the dazzling one-line poem: 'Denn Armut ist ein großer Glanz aus innen . . .' ('for poverty is a great brightness from within . . .', *SW* 356). In the religious tone of the book this harmonises and resonates, and the image of saintly poverty helps Rilke recover the manner of the earlier *Stundenbuch* poems, a rich multiplication of epithets linked by a repeated 'du bist' ('thou art', *SW* 276–7, 283–4, 357–9). But the imagery is too easy, too Biblical and rural, and too much is left to the deity that these lines conspire to create. 'Mach, daß die Armen nicht mehr fortgeschmissen/und eingetreten werden in Verdruß' ('let the poor be no more slung out/or trodden down in frustration', *SW* 358), prays Rilke trustfully to his own creature. This is no reply to the challenge of the *clochards*.

The third collection of poems that grew directly out of the early Paris experience is the *Neue Gedichte*, pearls and cameos of verse in which a familiar object, legend or figure is recreated from an unexpected angle, made new and somehow dematerialised. This work is the product of a theory of art borrowed from Rodin, whom Rilke had come to Paris chiefly to meet and study. It stressed the superiority of daily labour over the

unreliable joy of inspiration and, alongside this work-aesthetic, the idea
that poetry should somehow make objects as concrete and tangible as those
of sculpture. How clear Rilke was that this aim could only be metaphorical
is hard to tell; in writing 'Dinggedichte' ('thing-poems') he vaguely
expected to be redeemed from insecurities both personal and creative, and
yet he realised that the finest achievements in the volume were those which
superseded the materiality of the pretext-object – in 1918 he called 'Der
Ball' ('The ball') his best poem because in it he had expressed 'nothing but
the almost inexpressible, a pure movement.'⁶ But for this very reason we
cannot look to these poems for a transformation of urban experience into
fiction: their subjects and treatment could belong to any time or place, and
that lack of context is essential to the achievement; thus they evade even the
residue of the specifically Parisian anxiety which made them possible and
necessary.

 Where then did the immediacy of the city's shock receive the response it
demanded? In the prose-text *Die Aufzeichnungen des Malte Laurids Brigge*
(*The Notebooks of Malte Laurids Brigge*, 1910),⁷ passages of which
almost directly reproduce lines of Rilke's letters from Paris. If in July 1903
he pleaded to Lou his need to 'Dinge machen aus Angst' ('make things out
of fear', *BL* 64), it is here alone that the aesthetic object clearly emerges *out
of* the anxiety. In order to see how this happens, we must start by seeing
what the text consists of.

 The earliest entries in Malte's notebook are stark evocations of a Paris
both physically immediate and hallucinatory in its effects. 'So, also hierher
kommen die Leute, um zu leben, ich würde eher meinen, es stürbe sich hier'
('So this is where people come to live; I'd have thought it was a place to
come and die', 7), the text grimly begins. A pregnant woman staggering, a
child with a boil on its forehead, someone dying in a cab bound for the
common hospital, these glimpsed figures populate the first pages. The city
is audible at all hours of the night: 'elektrische Bahnen rasen läutend durch
meine Stube. Automobile gehen über mich hin' ('electric trams hurtle
ringing through my room. Automobiles ride across me', 8) – an echo of the
letter quoted earlier. But the terror felt so intensely begins almost at once to
generate its own vocation: 'habe ich es schon gesagt? Ich lerne sehen. Ja, ich
fange an. Es geht noch schlecht. Aber ich will meine Zeit ausnutzen' ('have I
said already? I'm learning to see. Yes, I am beginning. It's not going very
well yet. But I intend to make the most of my time', 9).

 This sense of new sight is a direct effect of the bombardment of
impressions; here, it is the protagonist who begins to acquire new faculties.
These impressions are both exciting and horrific. What Malte begins to see
is the ubiquity and anonymity of urban death, the masks people wear, an

unpoetic poverty that accosts and undermines him. He longs for a home, for his own things and people, and finds himself recalling the protracted death of his paternal grandfather, one who died his 'own death', in a narrative measuring several absorbing pages. After writing this, Malte comments warmly: 'ich habe etwas getan gegen die Furcht. Ich habe die ganze Nacht gesessen und geschrieben, und jetzt bin ich so gut müde wie nach einem weiten Weg über die Felder von Ulsgaard' ('I have taken action against my fear. I sat up all night writing, and now I feel quite tired out, like after a long walk across the fields at Ulsgaard', 19).

But the anxiety of the present still remains. 'Hätte man doch wenigstens seine Erinnerungen. Aber wer hat sie? Wäre die Kindheit da, sie ist wie vergraben' ('if only one had one's memories. But who does? If only one's childhood were still there; it seems to be buried', 19). And here another development is suggested – the recovery, through recollection, of childhood out of the depths of memory and retelling it in narrative, in coherent utterance. Gradually the greater part of the text is taken up with recollections of Malte's past. These stories are rarely pleasant or soothing; many retell uncanny or painful experiences which subtly echo the present situation in Paris. Ghosts walk, a skinny hand emerges from a wall, Malte's fey mother dresses him in girls' clothes and calls him 'Sophie'. The past then, as it reappears, is linked to the present in two ways – first by similarity of detail and atmosphere, and secondly by a sort of double-faced causality: we must ask ourselves whether this strange, often grim childhood produced an adult destined to receive Paris in precisely this way, or whether the stimuli of Paris induced him to remember certain things in a certain way. These two causalities cannot be reliably distinguished; our understanding of any utterance or character (fictitious or not) always involves them both. Certainly both of them are intimately assumed in the methods of Freud.

The importance of Freud in the art of this period cannot be overstressed. But, as we shall see presently, many writers who claimed to know and use his ideas misunderstood or misused them; I shall try to argue that Rilke, who made no such claim, actually displays a full understanding of what Freud meant. Though he knew something of Freud through Lou, I am not thinking here of direct influence. Rather, Rilke debates the same issues and the same methods in *Malte*, and turns them in his own, creative direction.

Freud's patient, seeking a cure for symptoms unbearable in the present, is encouraged to relate her dreams and associated thoughts, moving as the apparently arbitrary logic of the mind bids; this method, similar indeed to that of Malte's diary, is bound, says Freud, sooner or later to uncover memories of a troubled and essential infancy. When the originating trauma was vividly re-experienced the hysteric's symptom usually disappeared. An

early patient of Breuer's called this process the 'talking-cure'.[8] Talking could cure not just because of the relief of utterance, but essentially because of the function of the hearer who, as analyst, interpreted the patient's words on the basis of the double causality I outlined above. With interpretation came release.

What are the similarities and differences between Freud's therapeutic method and Malte's attempt to counteract the anxiety of Paris? Some similarities have already been indicated. In addition, Malte comes gradually to see the possibility that, if nowadays a personalised death is rare, there might nevertheless be, for each individual, a unique illness:

> und jetzt auch noch diese Krankheit, die mich immer schon so eigentüm-lich berührt hat. Ich bin sicher, daß man sie unterschätzt. Genau wie man die Bedeutung anderer Krankheiten übertreibt. Diese Krankheit hat keine bestimmten Eigenheiten, sie nimmt die Eigenheiten dessen an, den sie ergreift. Mit einer somnambulen Sicherheit holt sie aus einem jeden seine tiefste Gefahr heraus, die vergangen schien

> (and now there's this illness too, the one that always affected me so peculiarly. I'm sure people underestimate it, just as they tend to exaggerate the significance of other illnesses. This illness has no specific character-istics, it takes on the characteristics of the person it attacks. With somnam-bulistic assurance, it drags up out of each person the deepest-laid danger, that he thought was past, 61).

A pretty exact description of the Freudian view of hysteria: that illness whose manifestations vary with each patient and express her individual problems in a sign-system which psychoanalysis must learn to read. And what are the differences between Freud's and Malte's talking-cures? Like his author – who refused the analysis Lou urged on him, arguing that he had always found his writing 'a sort of self-treatment' (BL 261, 20 January 1912) – Malte chooses not to speak but to write. Even more boldly, he chooses to write for and to nobody: there is no-one to interpret the confess-ion, no hearer or analyst. So this is a talking-cure with no talking. It is also a talking-cure without a cure. What becomes of the Malte who turns to his childhood from the terrors of Paris?

The answer is, nothing becomes of him because he disappears from view during the course of the book. While the middle part consists of a mixture of Parisian experiences and childhood recollections, the last part is taken up almost entirely with a different sort of narrative: stories retold from legend or medieval history. These narratives present a stage beyond the self-ther-apy that had gone more or less as far as it could. Malte found his memories clustering around the pain of the present, multiplying rather than dimi-nishing it because by both analogy and contiguity they were too close for

comfort. Lacking the interpretative key that only another person can give, there is nothing he could do with his memories except be further oppressed by them: 'alle verlorenen Ängste sind wieder da' ('all the lost anxieties are back', 62). So at this point he opts to go beyond therapy into creativity. As an 'Erzähler', a teller of stories, he must stop being confessional and begin telling about other people, people who have never known him and whom he has never known.

But no creative writing is really the story of other people. The characters we invent or reinterpret are imprinted with our interests, fears and desires. Like his recollections, Malte's tales from history are inevitably written out of his obsessions; they are simply more aesthetically digested and reformed. Rilke put this admirably when he wrote to his Polish translator that the historical figures were not significant in a self-justifying novelistic way but as the 'Vokabeln seiner Not' ('the vocabulary of Malte's anxiety').[9] In them the material of the Paris nightmare appears reordered into a new context, carrying a new valency of narrative significance. A few examples must suffice. In the Paris street Malte seems to see the stricken face of a woman gape up from her cupped hands like a 'blosse[r] wunde[r] Kopf ohne Gesicht' ('naked sore head without a face', 10); and at the death of Duke Charles the Bold, his corpse is discovered half-frozen into snow, one cheek eaten by predators and the other torn out by the ice 'so daß von einem Gesicht keine Rede sein konnte' ('so that one could not speak of a face', 180). Or the expectant mother seen staggering near the *Maison d'Accouchement* becomes, via the ambiguous figure of Malte's mother, the mother of a false Czar whose word denies him just when he has come to believe in his truth: 'ich bin nicht abgeneigt zu glauben, die Kraft seiner Verwandlung hätte darin beruht, niemandes Sohn mehr zu sein' ('I'm not disinclined to believe that the force of his metamorphosis lay in the sense of being no longer anybody's son', 173). And this echo of the Romantic motif of privileged bastardy is in its turn the basic theme of Malte's last and most comprehensive story, a new version of the Prodigal Son, in which his own exile and possible return, poverty, isolation and glimpses of sanctity, are displaced, condensed (to borrow Freudian terms) and given an archetypal value. The prodigal son can go back to his family because he has changed so fundamentally that their love can no longer limit him. In imaginative creation then Malte has gone through and beyond even the wish to be understood; and it is left to the reader, startlingly, to provide this negative response – to be, by the end, no more obliging than the deity of the last line, who alone could love him without limitation but who 'wollte noch nicht' ('did not yet want to', 234).

If, then, to follow the schema I borrowed earlier from 'Les sept

vieillards', Rilke's Paris is childhood corrupted into adult nightmare, this is a Freudian nightmare and the reader of the text is naturally tempted towards a Freudian interpretative act. The text's unreality would simply be the tip of the unconscious iceberg. But, as I hinted above, Malte escapes the readerly cure. Rilke, more than many other artists of this period – and, one suspects, more truly to Freud's own understanding of the difference between art and science – parts company with psychoanalysis in an art that refuses, however hard the world of concrete experience, to be therapy. Creativity is the opposite of cure, a 'sortir de soi' which is the reverse of therapy's self-restoration.

What of the other two questions with which I began, that of Rilke's place in the modernist canon, and that of politics? To look at the first of these, I want to make a comparison between Rilke and the Surrealists, and to see how far Rilke's writing could justly be called 'experimental'.

After writing *Malte*, Rilke willingly admitted that aesthetically it was an 'inadequate unity' (*HE* 82, 11 April 1910). He offered various models for its idiosyncratic shape: papers found in a drawer, the chance configuration glimpsed through the door of a dance-hall; and critics since have called it lyrical, kaleidoscopic or mosaic-like.[10] We have seen that the apparent incoherence is that of dream and the unifying factor a single embattled psyche, and it is this which allows (or demands) a narrative full of 'experimental' devices. For example, the first person narrator is used in a challenging way, with little preliminary contextualising and no development into plot. Other grammatical persons are also employed 'obscurely': just as we glimpse acquaintances in the street, a cauliflower-seller or Beethoven or Ibsen is introduced simply by 'he' or 'you', with no concession to readerly impatience. This is not wilful. It is true to the manner of utterance that the text is presenting: the stream of consciousness of one who, even to himself, does not talk but write – a nuance which the Surrealists might envy.

Equally shocking initially is the wide variety of stylistic manners. Sometimes description is consciously 'impressionistic' – thus Paris on a bright but hazy morning is shown like 'das Gesicht in einem Manetschen Bildnis' ('the face in a portrait by Manet', 20). Sometimes we find expressionistic writing, as in the passage about the rampaging trams, where autobiographical urgency overrides Rilke's avowed dislike of the Expressionists. At other times, the text runs as smoothly as any novel; then again it will crack, as when the child dressing up in front of a mirror seems to see his reflection take flight: 'ich rannte davon, aber nun war er es, der rannte. Er stieß überall an, er kannte das Haus nicht, er wußte nicht wohin' ('I ran away, but now it was him that was running. He kept banging into things,

he didn't know the house, he had no idea where he was going', 102); or to present Malte's diffidence and inexperience as a narrator:

> habe ich schon gesagt, daß er blind war? Nein? Also er war blind. Er war blind und schrie. Ich fälsche, wenn ich das sage, ich unterschlage den Wagen, den er schob, ich tue, als hätte ich nicht bemerkt, daß er Blumen-kohl ausrief. Aber ist das wesentlich?

> (have I said he was blind? No? Well he was blind. He was blind and shouting. I'm distorting if I say that, I'm forgetting the cart he was pushing, I'm pretending I hadn't noticed that he was calling out Cauliflower. But is that essential?, 45).

So much for the manner of the text; the matter is often startling in a similar way. Objects, events, people, appear detached from their expected context. Let's take just two examples – *disjecta membra* and mirthless laughter. We frequently come upon limbs oddly independent of the person: faces stripped off as masks, blood dominating its host, Malte's own hand seen as an unfamiliar creature or, glimpsed in a clinic, a single eye, vivid gums, a hand 'die keine mehr war' ('that no longer was one', 55) or a leg 'das aus der Reihe stand, groß wie ein ganzer Mensch' ('standing out from the row, as big as a whole person', 55). Laughter appears similarly bereft of its accustomed cheerfulness; during carnival, 'die Leute hielten mich auf und lachten, und ich fühlte, daß ich auch lachen sollte, aber ich konnte es nicht' ('people accosted me, laughing, and I felt I was supposed to laugh too but I couldn't', 48); or, chillingly, in the overheard instruction to a mental patient: ' "Riez!" Pause. "Riez. Mais riez, riez." Ich lachte schon. Es war unerklärlich, warum der Mann da drüben nicht lachen wollte' (' "Laugh!" Pause. "Laugh. Come on, laugh, laugh!" I was already laughing. It was inexplicable why the man on the other side wouldn't laugh', 59). Both these motifs are instances of what Freud calls 'displacement', elements detached and given a new value as the coinage of dream. In Freud such displacement is part of the dream-work which interpretation retraces in its quest for meaning. However, as we have seen, Rilke invites but does not allow a Freudian interpretation, and thus the effect of unfamiliarity, unreality, remains powerful. For, as he wrote in the first Elegy, interpretation is only ever provisional: 'wir [sind] nicht sehr verläßlich zu Haus/in der gedeuteten Welt' ('we are not very reliably at home/in the interpreted world', SW 685).

If we compare Rilke with the Surrealists, having established that his writing is indeed 'experimental', what differences do we find? First, it is important to remember that where they were self-consciously innovative, Rilke's prose-writing made no claim to being revolutionary; on the contrary, he had no novelist's axe to grind and was, as it were, generically innocent.

Secondly, while Breton claimed in his manifestos to use Freud's ideas and method, and specifically to be a scientist rather than an artist, surrealist texts omit precisely that element in Freud which makes him scientific: the aspect of interpretation, of cure. It is only interpretation that makes utterance into evidence; savoured for itself, it must be art. The Surrealists failed to tackle coherently this question begged by their homage to Freud. They claimed to be gathering data 'at the source of the poetic imagination',[11] but of what and for what they never mention. Rilke, while he borrows the imagery of scientific precision in the key definition of Ibsen's art in *Malte*, never called himself a scientist and, as we have seen, he avoids the issue by refusing the element of interpretation that makes talking into cure. We have also seen how this allows an implicit differentiation of science and art, leaving each with its own version of exactitude – 'er war ein Dichter und haßte das Ungefähre' ('he was a poet and hated the approximate', 155).

Another flaw in the Surrealists' reasoning is their essentially Romantic and unFreudian view of childhood. Breton writes: 'the mind absorbed in surrealism joyfully relives the best of its childhood . . . childhood where everything worked together to make you effectively and without risk the possessor of yourself' (*MS* 54–5). This quality of freshness and completeness, designated as a 'precious terror' (*MS* 55) is linked to the pervasive surrealist quality of 'le merveilleux' ('the wonderful', *MS* 24) which transforms the everyday into the poetic. This is not at all Freud's conception of childhood, just as it is not Rilke's in *Malte*. For the Surrealists persist in seeing in childhood experience a quality of innocence, of poetic wholeness entirely absent from Freud's complex and riven infant-psyche. Associated with this is a deeper and more significant difference: to the Surrealists, the arbitrary and everyday, discovered as 'merveilleux', is similarly innocent, whereas to Freud it is a fundamental hypothesis that the arbitrary is never innocent, that the simplest accidents of everyday life are interpretable, even psychopathic. In Rilke's Paris, too, street-objects and street-figures do not, like Apollinaire's or Aragon's, offer their own version of pastoral; they are pathological, uncanny, pointing to something 'zu Hause in mir' ('at home inside me', 47).

These issues are argued out in greater detail in Chapter 13. My own suggestion is that Rilke is more radical than the Surrealists, who – for all their apparent modernity – reverted to a pastoral mode which Baudelaire had already discredited. Yet despite this, Rilke's text finally invokes a vaguely-perceived religion, while theirs at least tried to incorporate a political dimension. And yet, what can we make of the vociferous politics of Modernism? Generally, it is strangely ambivalent, as easily married to

fascism as to socialism; and the Surrealists in particular made a spectacular mess of their attempt to affiance politics with literature. This failure of matchmaking was a local and specific problem; but we can also, I think, find in it the problematic crux of modernist writing about the city. To go back to our Baudelaire poem: in Bonnemort, disguised as poetic hobgoblin, we have a model for the visionary reinterpretation of political issues. For surely the 'visionary' precludes the 'political'. Action and effect are to the latter what dream and mystification are to the former. If the modernist image of the city is visionary, that is because art and politics are unhappy bedfellows. If it is an anxious city, that is because art knows that politics matters, that urban destitution is never pretty and that even Baudelaire's stylish evasions will no longer do. But Modernism generally found no more of an answer than Rilke in his open-ended text. In the end the sickness is so severe that if there is no doctor the patient will hallucinate a God. This evasion seems characteristic of modernist visionary literature of the city (as can be seen from subsequent chapters in this volume).

And what became of Rilke's Paris? Vanished from the legendary landscape that closes *Malte*, it reappears as that most visionary of cities, the 'Leid-Stadt' ('pain-city', *SW* 721–2) of the tenth *Duineser Elegie*. An allegory for modern life, it is rapidly left behind by the dying who wander out towards the holy mountain of death. This is a topography of evasion, far away from the original stimulus of a Paris 'voll merkwürdiger Versuchungen' ('full of strange temptations', 70) and 'pleine de rêves'.

Notes to chapter 6

All translations are my own; reference is to the original text, even where the translation alone is given.
1 C. Baudelaire, *Œuvres complètes*, Paris, 1968, p. 97. Further references to this text are abbreviated *OC*.
2 E. Zola, *Germinal*, Paris, 1973, first published 1885, p. 13.
3 R. M. Rilke, *Briefe I: 1897–1914*, Wiesbaden, 1950, p. 40. Further references to this text are abbreviated *BI*.
4 R. M. Rilke – L. Andreas-Salomé, *Briefwechsel*, Zurich–Wiesbaden, 1952, p. 190. Further references to this text are abbreviated *BL*.
5 R. M. Rilke, *Sämtliche Werke I*, Frankfurt, 1955, p. 448. Further references to this text are abbreviated *SW*.
6 E. von Schmidt-Pauli, *Rainer Maria Rilke: Ein Gedenkbuch*, Stuttgart, 1946, p. 20.
7 References are to the Suhrkamp edition of 1975 and appear as page numbers following quotations. The novel has been translated into English by J. Linton (London, 1972).
8 Bertha Pappenheim, referred to as 'Anna O.' in the first of the *Studies on Hysteria*.
9 Letter to W. von Hulewicz of 10 November 1925 quoted in *Materialien zu Rainer Maria Rilke: Die Aufzeichnungen des Malte Laurids Brigge*, ed. H. Engelhardt,

Frankfurt, 1974, p. 131. Further references: *HE*.

10 See R. Freedman, *The Lyrical Novel*, Princeton, 1963; U. Fülleborn, 'Form und Sinn der Aufzeichnungen des Malte Laurids Brigge: Rilkes Prosabuch und der moderne Roman', *HF* 178.

11 A. Breton, *Manifestes du surréalisme*, Paris, 1979, first published 1924, 1930, p. 29. Futher references: *MS*.

Expressionists and Georgians: demonic city and enchanted village

It was to Berlin that the young writers and artists of the Expressionist generation were irresistibly drawn. For by 1910 Berlin was indisputably the cultural as well as political capital of the German Reich. It was now a metropolis of four million inhabitants, dynamo of a great European power which had overtaken Britain in industrial production and was challenging for political supremacy. Berlin was thus the centre of state-supported *Kultur*. But it was also the rallying-place for avant-garde alternatives. Around 1890 the Naturalists had gathered in Berlin to challenge the cultural establishment with their socially committed poetry and plays. The Expressionist revolt of the period after 1910 drew to the city an even more gifted generation of artists and anarchists, poets and philosophers.[1]

In the coffee-houses of the capital, especially the celebrated Café des Westens, they found their meeting place. And Kurt Hiller's 'Neuer Club', founded in March 1909, provided them with a more public forum – a kind of literary cabaret where poets like Jakob van Hoddis and Georg Heym could declaim their verses. More important still were the two periodicals which gave direction to the Expressionist movement as a whole: *Der Sturm*, founded by Herwarth Walden in 1910, and *Die Aktion*, founded by Franz Pfemfert in the following year. Pfemfert's journal was more politically orientated, sharply criticising the drift towards war in the crisis years 1911–14. Walden's programme gave precedence to aesthetic values and to experimentation in the visual arts. But however varied their individual dispositions, the Expressionists were united in their antagonism to the Prussian imperatives of discipline, service to the state, military power and industrial production. Reacting against the materialism of an increasingly technocratic society, they sought to articulate a more humane alternative. The Berlin of their artistic vision is thus not the proud capital of a dynamically expanding empire. It is a city transfigured by the

visionary imagination and abounding in apocalyptic portents.

Let us imagine our young poet, newly arrived in this aggressively industrial metropolis, sitting at a table in the Café des Westens, pen in hand. What kind of poetry does he write? My first answer may seem frivolous. But its value lies in the fact that it helps to put the poetry of the Expressionists into a wider European context. For it is a poem written not by a German Expressionist, but by an English Georgian, Rupert Brooke:

> *The Old Vicarage, Grantchester*
> *(Café des Westens, Berlin)*
> Just now the lilac is in bloom,
> All before my little room;
> And in my flower-beds, I think,
> Smile the carnation and the pink . . .
> Oh, damn! I know it! and I know
> How the May fields all golden show,
> And when the day is young and sweet,
> Gild gloriously the bare feet
> That run to bathe . . .
> *Du lieber Gott!*
> Here am I, sweating, sick and hot,
> And there the shadowed waters fresh
> Lean up to embrace the naked flesh.
> *Temperamentvoll* German Jews
> Drink beer around; and *there* the dews
> Are soft beneath a morn of gold . . .

The movement of the imagination carries us out of the hostile German city and into the harmonious English countryside:

> Ah God, to see the branches stir
> Across the moon at Grantchester! . . .
> Oh, is the water sweet and cool
> Gentle and brown, above the pool? . . .
> Deep meadows yet, for to forget
> The lies, the truths, and pain? . . . oh! yet
> Stands the Church clock at ten to three?
> And is there honey still for tea? (*GP*, I, 33–9)

There is a tongue-in-cheek quality about this poem which saves it from mere escapism (the original title was 'The sentimental exile'). Its humorous invocation of the villages of Cambridgeshire is not to be taken too seriously. Nevertheless, the movement of this poem – away from the city and into a rural England where clocks have stopped – is symptomatic. It exemplifies a predominant mood in English poetry around 1910, which

found expression in the five volumes of *Georgian Poetry* published bet-
ween 1912 and 1922.[2] For more than a decade the Georgian poets set the
tone of English literary sensibility. They were indeed quintessentially 'Eng-
lish' poets in a sense that does not apply to vagrant cosmopolitans like T. S.
Eliot and Ezra Pound.

The Georgian poets cultivated a myth of rural England. They include
names which read like a roll of honour of early twentieth century English
poetry: Edmund Blunden, Rupert Brooke, W. H. Davies, Walter de la
Mare, John Drinkwater, Robert Graves, Ivor Gurney, D. H. Lawrence,
John Masefield, Wilfred Owen, Siegfried Sassoon and Charles Sorley.
Edward Thomas, although not a contributor to the anthologies,
exemplifies the strengths of the Georgian idiom. At best it combines close
observation of nature with a homespun verbal texture rich in personal
associations. The invocation of the countryside, which seems facile in
Brooke, becomes fraught with inner meaning in the poetry of Edward
Thomas. And Thomas Hardy's poetry certainly has profounder
undertones. For the poets of the First World War this pastoral idiom was to
prove a particular source of strength. Writers schooled in the observation
of nature responded to the war-torn landscape of France with visions of the
countryside which carry imaginative and moral conviction.[3]

The reader of *Georgian Poetry* is nevertheless left with a sense of
limitation. It is not merely a question of subject matter. There is a narrow-
ing of imaginative vision and a reliance on outworn pastoral conventions.
It seems surprising now that the Georgians thought of themselves as
'modern' poets and were even credited with 'realism'.[4] So remote is their
work from that metropolitan sensibility analysed by Raymond Williams in
Chapter 1. But these were not really country poets. They were (for the most
part) city-dwellers who sought refuge in the countryside from the strains of
urban life.[5] Like Brooke, they were trying to 'forget/The lies, the truths,
and pain'. In *Georgian Poetry* there is scarcely a glimpse of city life, let
alone an acknowledgement that both author and reader are living in a
modern industrial society. Ploughmen still plod their weary way through
the pages of Edward Thomas, as if no social changes had occurred since
Gray's 'Elegy in a Country Churchyard' (1750). Country folk are staunch
and rugged. Poverty is quaint because it is rural. The countryside abounds
in 'characters' full of rustic wisdom, reminiscent of Wordsworth's 'Old
Cumberland Beggar' (1800). But of Baudelaire's city rag-pickers there is no
sign.

These are poets who have closed their minds not merely to social
change, but to the transformation of discourse which accompanied it. They
are refugees, not merely from the city but from the twentieth century. In the

countryside they sought emblems of timelessness to counteract the distur-
bing ideological changes of their own day. In this sense too Brooke is
exemplary. He was well-travelled and widely-read, and had immersed
himself in the socially advanced ideas of the Fabians. He certainly knew his
Baudelaire, and indeed had first-hand knowledge of the avant-garde
movements which were transforming European art. In letters and in articles
for the *Cambridge Magazine* he discussed the French Post-Impressionists,
the German Expressionists and the Italian Futurists. And he was impressed
by the dramatic experiments of Strindberg, Schnitzler and Wedekind.

It is possible that Brooke might have responded more positively to these
trends if his career had not been cut short by the War. There were others of
his generation (notably the Imagists) who did respond more enthusiasti-
cally to literary innovations abroad.[6] But on the evidence of Brooke's work
as it stands, he seems consciously to have closed his mind against foreign
influences and taken refuge in an England of the imagination. Visiting
Munich in March 1911, he wrote letters home which reflect the cosmopoli-
tan turmoil of the city. But there is a characteristic reservation: 'I'm here;
only – England's central. And I feel rather on the edge' (*L* 292).[7] Reporting
to Edward Marsh (with whose aid he was shortly to launch *Georgian
Poetry*), he was even more emphatic: 'German culture must never, never
prevail' (*L* 300). His visits to Berlin in May and November 1912 produced
comments that were equally patronising. Encountering in Berlin the exhi-
bition of the Italian Futurists, which had already been to London, he was
able to declare: 'Berlin, you know, is *frightfully* out of date' (*L* 377). A letter
which mentions the idea of writing an article on *Georgian Poetry* for a
Berlin paper is even more revealing: 'German literary circles are so entirely
cut off from English that it's difficult to get any connection' (*L* 408). One is
reminded of the joke about a headline in an English newspaper: 'Fog in the
Channel – continent cut off'!

There were indeed striking divergences between the intellectual climate
in England and in Germany. But with a little more effort they might have
been overcome. This becomes clear when we turn to the German Expres-
sionists. What kind of poetry was being written by those '*temperamentvoll*
German Jews' who were sitting near Brooke's table in the Café des
Westens? Not all of them in fact were Jews, although they were certainly
'temperamentvoll' – full of intellectual energy. Among the Expressionists
the poet most directly comparable with Rupert Brooke is Ernst Stadler.

The careers of Brooke and Stadler form a symmetrical pattern. Born in
the mid-1880s, they were both men of exceptional gifts who seemed
destined for an academic career. While Brooke was writing his Fellowship
dissertation on Webster in Cambridge, Stadler was in Oxford as a Rhodes

Scholar, studying early German translations of Shakespeare. Both men travelled widely and were able to draw on a sophisticated knowledge of European culture. Above all, each in his own country had a seminal influence as a poet. In each case, however, a brilliant career was cut short by death during the first year of the War.

Stadler, like Brooke, was nurtured on traditional nature poetry. His first volume of verse, *Praeludien* (1905) was written in a style that might even be called 'Georgian' – or rather 'Georg-ian' (with two hard 'g's). For his model was Stefan George, whose poetry of the 1890s had focused on formal landscapes. The third strophe of the poem 'Mittag' ('Noon') exemplifies Stadler's style at this stage:

> Die Efeulauben flimmern. Schwäne wiegen
> und spiegeln sich in grundlos grünen Weihern,
> und große fremde Sonnenfalter fliegen
> traumhaft und schillernd zwischen Düfteschleiern.
>
> (The ivy arbours shimmer. Swaying swans
> are mirrored in unfathomed pools of green,
> and great exotic butterflies flit past
> glistening 'mid veils of haze as in a dream) (*D*, II, 206).[8]

This invocation of a formal garden synthesises George's esoteric manner with dream-motifs from the poetry of Hofmannsthal. No human beings are visible in this enchanted garden (although 'the gravel crunches softly' in the distance). The mood is one of elegant withdrawal.

Stadler's poetic development diverges from that of Brooke in his second volume *Der Aufbruch* (1914). The title itself suggests a 'breakthrough' to a more vigorous style. And his success was largely due to his eager assimilation of the poetry of his European contemporaries. Where Brooke withdrew into insularity, Stadler responded with excitement to the challenge of European Modernism. A recent study has shown how avidly he assimilated the work of French poets: Baudelaire and Verhaeren, Péguy and Claudel, Henri de Régnier and Francis Jammes.[9] Stadler's openness to foreign influences was characteristic of the whole Expressionist movement. Although they had a strong sense of rootedness in earlier German art (particularly the art of the Middle Ages), the Expressionists were equally open to the latest ideas from Paris, Petersburg or Milan. The enthusiasm with which the Futurists were received in Berlin in 1912, and their ideas propagated through the columns of *Der Sturm*, forms a striking contrast to the dismissive reactions in England.[10] The Expressionists took up the challenge of the Futurist cult of the city, but adapted it to their own purposes.

Stadler's position was exceptional only in that he had the advantage of growing up in the bilingual environment of Alsace. But where the German annexation of Alsace-Lorraine in 1871 had caused a curtain of enmity to fall between France and Germany, Stadler responded to this situation with great generosity of spirit. During his short career he was one of the most active intermediaries between French and German culture. Moreover, his horizons also extended to include the English-speaking world, in particular the poetry of Whitman. Through his reading of Whitman and Baudelaire, Verhaeren and Jammes he was thus soon equipped for a new poetic task: to become one of the pioneering city poets of the Expressionist generation.

Rupert Brooke went to Berlin and saw nothing – nothing that seemed to him poetically significant. So he indulged in escapist dreams. Ernst Stadler went to London and wandered through the slums of the East End with his senses attuned to new modes of literary expression. He wrote the following poem about the market in Whitechapel, an area that was just being settled by Jewish refugees:

Judenviertel in London

Dicht an den Glanz der Plätze fressen sich und wühlen
Die Winkelgassen, wüst in sich verbissen,
Wie Narben in das nackte Fleisch der Häuser eingerissen
Und angefüllt von Kehricht, den die schmutzigen Gassen überspülen.

Die vollgestopften Läden drängen sich ins Freie.
Auf langen Tischen staut sich Plunder wirr zusammen:
Kattun und Kleider, Fische, Früchte, Fleisch, in ekler Reihe
Verstapelt und bespritzt mit gelben Naphtaflammen.

Gestank von faulem Fleisch und Fischen klebt an Wänden.
Süßlicher Brodem tränkt die Luft, die leise nachtet.
Ein altes Weib scharrt Abfall ein mit gierigen Händen,
Ein blinder Bettler plärrt ein Lied, das keiner achtet.

Man sitzt von Türen, drückt sich um die Karren.
Zerlumpte Kinder kreischen über dürftigem Spiele.
Ein Grammophon quäkt auf, zerbrochene Weiberstimmen knarren,
Und fern erdröhnt die Stadt im Donner der Automobile.

(D, I, 165)

Jewish quarter in London

(Hard against the gleaming squares the tortuous alleys
burrow and gnaw their way, locked in sullen conflict,
gaping like scars torn into the naked flesh of the houses
and choked with garbage over which the filthy gutters flow.

Shops bursting at the seams spill out into the open.
On long tables trashy goods are crammed into a confusing
jumble: calico and clothes, fish, fruit, meat, stacked
in nauseous rows and bespattered with yellow naphtha flames.

Stench of putrid meat and fish clings to the walls.
Sickly-sweet vapours saturate the air as darkness falls.
An old woman scrapes up refuse with eager hands,
a blind beggar bawls a song which no one heeds.

People sit on doorsteps, jostle round the barrows.
Ragged children screech over makeshift games.
A gramophone squawks up, broken female voices grate,
and in the distance the city resounds with the thunder of automobiles.)

The immediate gain is in social realism. We are slap in the middle of a
crowded market, such as may be encountered in the run-down areas of any
large city. But the breakthrough marked by this poem is not merely one of
subject matter. The Naturalist poets of the 1880s, led by Arno Holz, had
already written poetry of urban deprivation.[11] More striking still is the new
stylistic energy with which Stadler attacks his theme. His dynamic verbs
and disconcerting juxtapositions not only convey the vivid surface impres-
sions of the scene but also alert us to its more disturbing implications.

The opening lines exemplify this new Expressionist idiom. The poet is
no longer a passive receiver of impressions. His imagination galvanises
poetic discourse into a compressed collocation of images conveying an
underlying sense of tension, menace and conflict. The burrowing alleys are
seen as animals locked in self-destructive conflict: 'wüst in sich verbissen'.
There are hints of Brecht's 'asphalt jungle' (analysed by David Midgley in
Chapter 11). Social interaction has become animalised, a desperate struggle
for survival. Human beings are thrust into the sidelines, although not for
the reasons that applied to Stadler's earlier poem 'Mittag'. The intrusion of
human beings into that enchanted garden would have broken its spell. But
in 'Judenviertel' they are suppressed not by foibles of the poet, but by the
pressures of the market place. The jumbled goods expand until they almost
fill the poem. They seem to have acquired a life of their own, like the
commodities analysed by Karl Marx in a famous chapter.[12] Human beings
by contrast seem reduced to the status of objects. The voices of women and
children screech and grate, as metallic as the gramophone.

Stadler, though no Marxist, integrates into his poetry a radical social
critique. In this too he exemplifies the more committed forms of Expres-
sionist writing. Social criticism is integrated into artistic form in a way that
avoids the crass political contrasts of Naturalism. In 'Judenviertel' this
effect is achieved by a framing device, which unobtrusively relates the

specific locality of Whitechapel to the opulence of more privileged areas. The conflict which rends the alleyways is not only self-destructive; it is gnawing away at the gleaming squares – the glamorous façade of Edwardian London. The opening attack of the poem ('Dicht an den Glanz der Plätze') has a social as well as imaginative thrust. And the distant thunder of automobiles with which it closes reverberates with unresolved social tension. Where the Naturalists had directed sympathy towards a specific social class, Expressionist urban anxiety embraces all mankind.

The position of the poet makes this clear. He is no longer the detached social observer who can withdraw into the security of bourgeois existence, nor the *flâneur* who finds refuge in aesthetic contemplation. The Expressionist poet is himself the prisoner of the city, like the hero of Rilke's *Malte Laurids Brigge* (discussed in Chapter 6). He is inextricably caught up in the urban turmoil he portrays. The Futurist city painters tried to place the observer at the centre of their canvas (as Frank Whitford shows in Chapter 3). The city is felt to be so dynamic that *The Street Enters the House* in Boccioni's painting (Fig. 10). Similarly the Expressionist painter or poet is overwhelmed by the turmoil of the city, although he may turn his back and make a desperate attempt to escape, as in Ludwig Meidner's *I and the city* (Fig. 7). For the Futurists the city is dynamic; for the Expressionists it is demonic.

Stadler would not be an Expressionist if social realism were his exclusive aim. The Expressionists (according to a famous definition) were not photographers; they were visionaries.[13] This visionary quality is evident in one of Stadler's best-known poems, 'Fahrt über die Kölner Rheinbrücke bei Nacht' (*D*, I, 161). Here the thrust of the express train across the bridge is endowed with unprecedented emotional potency, and a railway journey is transformed into a moment of heightened consciousness. In another poem a similar radiance is glimpsed in the faces of shop assistants, momentarily transfigured as they emerge from the gloom of their workplaces on to the sunlit city streets ('Abendschluß', *D*, I, 162). But although Stadler's poetry offers momentary epiphanies, it is the impoverishment of urban experience that he most powerfully conveys. It is this negative vision that links him with other early Expressionists like Jakob van Hoddis, Georg Heym and Gottfried Benn. 'We are from the gigantic cities', Benn declared, 'and in the city, only there do the muses inspire enthusiasm and lament.'[14] In their memoirs the Expressionists acknowledge the exhilaration of life in the modern city, particularly Berlin. But in their poetry the city becomes the emblem of an insoluble historical crisis, with undertones of impending disaster. The vibrant modern city becomes (in another formulation by Benn) 'bearer of the myth that began in Babylon'.[15]

In the first phase of Expressionist poetry (1910–14) we repeatedly find intuitions of the impending collapse of European civilisation. They seem to have anticipated the end of that era of relative political stability and social advance which was marked by the outbreak of war in 1914. The English Georgians, by contrast, seem reluctant to acknowledge that the old order has ended. Even in 1922, when the final volume of *Georgian Poetry* appeared, we still find Graves and Blunden celebrating the rhythms of the English countryside. But the German Expressionists, even in 1912, were already portraying a civilisation on the point of collapse.

'Weltende' ('End of the World') is the title of a poem by Jakob van Hoddis which sets the tone of the representative anthology of Expressionist poetry *Menschheitsdämmerung* ('Twilight of humanity'), published in Berlin in 1920:

> Dem Bürger fleigt vom spitzen Kopf der Hut,
> in allen Lüften hallt es wie Geschrei.
> Dachdecker stürzen ab und gehn entzwei,
> und an den Küsten – liest man – steigt die Flut.
>
> Der Sturm ist da, die wilden Meere hupfen
> an Land, um dicke Dämme zu zerdrücken.
> Die meisten Menschen haben einen Schnupfen.
> Die Eisenbahnen fallen von den Brücken. (M 39)[16]
>
> (The bourgeois' hat flies off his pointed head,
> the air re-echoes with a screaming sound.
> Tilers plunge from roofs and hit the ground,
> and seas are rising round the coasts (you read).
>
> The storm is here, crushed dams no longer hold,
> the savage seas come inland with a hop.
> The greater part of people have a cold.
> Off bridges everywhere the railroads drop.)[17]

This poem, first published in January 1911, became a *locus classicus* for Expressionist poetry. In the memoirs of another member of the Berlin group, Johannes Becher, we are told that it became a kind of cult poem. It epitomised a new metropolitan sensibility: 'We seemed to be in the grip of a new universal awareness, namely the sense of the simultaneity of events.'[18] The urban sensibility is bombarded by random stimuli: newspaper reports of accidents or impending disasters juxtaposed with immediate sense impressions (screams and sniffles). Using a montage technique that anticipates Dada, van Hoddis endows these impressions with a dynamic incongruity. The result is a poem of disconcerting originality in which humour only accentuates the existential unease.

These intuitions of disaster find their most powerful expression in the

poetry of Georg Heym. Through his brief and meteoric career (he died in a skating accident in January 1912), Heym became the exemplary Expressionist poet.[19] More compellingly than that of any other German poet, his vision is centred on the city. Like van Hoddis, he accentuates the disconnectedness of urban experience, as in the sequence of eight sonnets with the title 'Berlin' begun in April 1910. The effect is enhanced by the tension between fragmented theme and tautness of artistic form. This disconnectedness became a conscious aesthetic principle, as is clear from a diary entry of July 1910: 'I believe that my greatness lies in my recognition that there is little connected causality ["Nacheinander"]. Most things lie in a single plane. Everything is in a spatial relationship ["ein Nebeneinander"].'[20] The terms derive from Lessing, who had argued that spatial relationships are the province of the visual arts, while poetry should aim at a causally connected narrative. Heym reverses the relationship, thereby undermining the rationalist view of experience as a coherent sequence.

Heym's images of the city do indeed achieve effects reminiscent of the visual arts. Here we see the reciprocal interaction between poetry and painting which is so characteristic of German Expressionism. The angular figures of early Expressionist poetry with their 'pointed heads' (van Hoddis) recur in visual terms in the Berlin paintings of Kirchner. And Heym's apocalyptic cityscapes find their visual equivalent in the graphic art of his contemporary, Ludwig Meidner (both of these artists are discussed by Frank Whitford in Chapter 3). Heym consciously aimed at visual effects in his poetry, citing Van Gogh as a model. Another possible source for his poetry's graphic power has been identified in the cartoons of Heinrich Kley,[21] published in the magazine *Simplicissimus* (Fig. 20). The leering demons who cause fire and panic in Kley's satirical drawings become pagan gods towering over the city in Heym's poems 'Der Gott der Stadt' and 'Die Dämonen der Städte' (*M* 42 & 51). Heym pictures the great cities kneeling at the feet of this awesome deity, while smoke rises like incense from factory chimneys and the movement of the crowds becomes a ritual dance. But where Kley's drawings have humorous undertones, Heym's demon has a brooding power reminiscent of the 'Colossus' who towers over human habitations in a famous print by Goya (another artist whom Heym admired).

A more subtle instance of this 'demonic city' motif occurs in the poem 'Die Stadt' ('The city'):

> Sehr weit ist diese Nacht. Und Wolkenschein
> Zerreißet vor des Mondes Untergang.
> Und tausend Fenster stehn die Nacht entlang
> Und blinzeln mit den Lidern, rot und klein.

20. Kley, *Industrial Breakdown*
21. Kirchner, *The City*

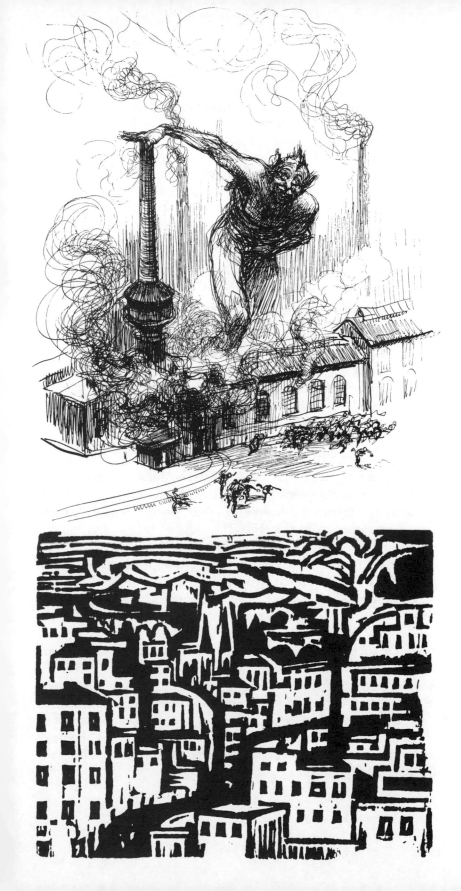

Wie Aderwerk gehn Straßen durch die Stadt,
Unzählig Menschen schwemmen aus und ein.
Und ewig stumpfer Ton vom stumpfen Sein
Eintönig kommt heraus in Stille matt.

Gebären, Tod, gewirktes Einerlei,
Lallen der Wehen, langer Sterbeschrei,
Im blinden Wechsel geht es dumpf vorbei.

Und Schein und Feuer, Fackeln rot und Brand,
Die drohn im Weiten mit gezückter Hand
Und scheinen hoch von dunkler Wolkenwand.

(This night is vast. The gleaming cloud-banks shred
Apart before the sinking of the moon.
Along the night a thousand windows run;
Their blinking eyelids flicker, small and red.

The city's streets — a tracery of veins,
Through which an endless stream of people flow,
A dull pulse beating out, feeble and slow,
The ceaseless rhythm of their joys and pains.

Birth, death, a sameness woven drearily,
Babble of child-bed, drawn-out dying cry,
Pass in blind muffled alternation by.

And torches blazing red, and fiery light,
With hand unsheathed, menace in distant might
And shine down from the cloud-wall's darkened height.)[22]

The dehumanising turmoil of city life which forms the poem's central theme is again framed by arrestingly visual motifs. Kirchner later did a series of woodcuts illustrating Heym's work, one of which brings out the graphic quality of this poem rather strikingly (Fig. 21).

The windows blink out at us under a tumultous sky. The streets with their shadowy figures are transformed into a pattern of pulsing veins. Even more striking is the way the vertical street-line on the right seems to enter the sky like a gigantic hand. This visionary element, in the woodcut as in the poem, fills the sky with flames, like a torch brandished threateningly over the city.[23]

In this poem the social-critical motifs of an earlier Naturalistic idiom are assimilated into a compelling panoramic vision. Heym portrays a city in the grip of demonic forces which threaten to engulf it. Human beings, by contrast, are reduced to mere shadows, swept helplessly along by the city's impersonal pulse or gazing into the murky skies in a desperate attempt to comprehened the forces which oppress them. This is the opening theme of one of Heym's finest poems, printed in *Menschheitsdämmerung* under the title 'Umbra vitae' (*M* 39):

> Die Menschen stehen vorwärts in den Straßen
> Und sehen auf die großen Himmelszeichen,
> Wo die Kometen mit den Feuernasen
> Um die gezackten Türme drohend schleichen.
>
> (Upon the streets the people stand and gaze
> Transfixed at monstrous portents in the sky,
> Where creeping fiery-snouted comets blaze,
> Threatening the jagged towers as they fly.)

Van Hoddis's 'End of the world' theme is extended and intensified. Astrologers appear on every rooftop and magicians spring up from underground in an effort to comprehend the portents, while in subsequent strophes all organic life suffers a surrealistic transformation.

What force is it that threatens them? The answer is provided, both in Heym's *oeuvre* and within the poetic logic of *Menschheitsdämmerung*, by the poem 'Der Krieg' ('War'), written in September 1911 (M 79). Kurt Pinthus, editor of *Menschheitsdämmerung*, so structures his anthology that the implication is unmistakeable. The city, explored from a variety of angles, is seen as crippling in its effect on individual life and threatening to disintegrate under the pressures of modern civilisation. It is only through destruction that there can be any possibility of renewal. Thus Heym's poem 'Der Krieg' provides the culmination of the Expressionist city theme, as war rises like a giant to sweep away an irretrievably corrupted civilisation:

> Aufgestanden ist er, welcher lange schlief,
> Aufgestanden unten aus Gewölben tief.
> In der Dämmerung steht er, groß und unbekannt,
> Und den Mond zerdrückt er in der schwarzen Hand.
>
> In den Abendlärm der Städte fällt es weit,
> Frost and Schatten einer fremden Dunkelheit.
> Und der Märkte runder Wirbel stockt zu Eis.
> Es wird still. Sie sehn sich um. Und keiner weiß.
>
> (He is arisen after a long sleep,
> He is arisen out of dungeons deep.
> A stranger in the twilight, there he stands,
> Crushing the moon between his huge black hands.
>
> The cities' evening noises now subside,
> Dark, icy shadows scatter far and wide.
> The turmoil of the market's gripped by frost.
> Silence. They glance behind them. All are lost.)

The poetic landscape is engulfed in flames, And the poem ends with a great city sinking into the abyss, a Gomorrah buried under fire and brimstone.

Heym's demonic city is clearly no less mythical than Brooke's

enchanted village. Recoiling from the metropolis, their imaginations carry us towards the archetypal extremes of apocalypse and arcadia. But the paradox of Heym's myth lies in its historical appositeness. So accurately does 'Der Krieg' express the mood of August 1914 that it takes an effort to remember that it was actually written three years earlier. Indeed, it became the model for countless other German poems which hailed the war as a form of divine intervention – most notably Rilke's 'Fünf Gesänge' ('Five songs'). Rilke in August 1914 greeted the God of War with exultation: 'Endlich ein Gott' ('A God at last').[24] Heym's vision is more powerful because it envisages not only the superhuman scale of modern warfare but also its total destructiveness. His images seem to anticipate the incendiary bombs which destroyed European cities during World War II and even the nuclear conflagration with which it ended.

This is not to credit Heym with prophetic powers. He was a writer of his own age, responding to a Prussianised social and educational system which (as his diaries show) he felt to be intolerably oppressive. That system was dominated by a fatal alliance of militarists and technocrats which prefigured the military-industrial complex of our own day. It is this that gives his poems their prophetic force. But Heym was exceptionally *temperamentvoll* – endowed with an imaginative vitality which enabled him to read the signs of the times. Underlying the Morocco crisis of September 1911 he detected, not merely a fear of war, but a suppressed longing for destruction. And for this irrational impulse he found objective correlatives in the historical events of his day. In April 1906 a violent earthquake followed by fire destroyed the central districts of San Fransisco. In December 1908 the city of Messina was obliterated by an earthquake, with the loss of 84,000 lives. In May 1910 Halley's Comet appeared, provoking all too plausible predictions that it might collide with the earth. And the excavations at Pompeii were bringing home to Heym's contemporaries how completely a civilisation could be obliterated by an act of god. Meanwhile war was rumbling in the Balkans and threatening to erupt over Morocco. These were the portents which Heym transposed into compelling poetic images.

Menschheitsdämmerung and *Georgian Poetry* explore different universes. And yet these poets were contemporaries, responding to the same historical events. Halley's Comet was also sighted in England. Did no English poet perceive it as the correlative of impending cataclysm? The answer is provided by the longest single text in *Georgian Poetry*, 'The End of the World' by Lascelles Abercrombie (*GP*, II, 195–239). Abercrombie too saw the comet as catalyst for a visionary day of judgment. But, characteristically, he locates the action not in the demonic city but in the

enchanted village. His moral fable is set in a country pub. It is a dialogue between characters with homely names like Huff the Farmer, Sollers the Wainwright and Shale the Labourer. Their alarm at reports of the approaching comet is intensified when a mysterious stranger, the Dowser, proclaims that the comet is about to hit the earth, bringing hell fire and the end of the world. An enchantment seems to seize the villagers as, in the grip of his prophecy, they review their sinful lives. At times the Dowser's language approaches the incandescence of Georg Heym:

> . . . I'll blind my brain
> With fancying the splendours of destruction;
> When like a burr in the star's fiery mane
> The crackling earth is caught and rushed along,
> The forests on the mountains blazing so,
> That from the rocks of ore beneath them come
> White-hot rivers of smelted metal pouring
> Across the plains to roar into the sea . . . (*GP*, II, 216)

The alarm is electric while it lasts, but the mood is not sustained. The vision ends in bathos. Warp the Molecatcher arrives to announce that the flames on the horizon are not caused by any comet; it is only Huff's haystack which is on fire! The moment of existential anxiety is safely over – for the reader as for the villagers. The enchanted village is not seriously threatened.

This contrast between Expressionist and Georgian attitudes might be extended to other fields. Expressionistic tendencies inspire not only German poetry and painting of the early twentieth century, but music and the theatre, architecture and political theory. The arts in England in this same period are characterised by an insular resistance to European Modernism: Elgar rather than Schoenberg, Lutyens rather than Gropius, Stanley Spencer rather than George Grosz. It was only in the late 1920s that the Georgian ethos in English poetry was superseded, under the impact of Eliot's *Waste Land* (analysed in Chapter 9). The influence of Georgianism also extended to other spheres of discourse. The 'fireside chats' over the radio, with which Prime Minister Baldwin sought to reassure an England threatened by social and political strife, were Georgian in their homeliness of tone and their invocations of his beloved Worcestershire.[25] Goebbels's speeches of the same period, blaring out over the loudspeaker systems of German cities, have undertones of Expressionist frenzy. But the contrast can best be summed up by two answers given during the First World War to the question: What are we fighting for? For they show that public attitudes on both sides were shaped less by political analysis than by poetic myth. In a letter of 30 May 1915 the young German socialist Otto Braun justifies the war by quoting Rilke: ' "Endlich ein Gott"!'[26] It is the Expressionist vision

of war as a divine visitation, called down upon itself by a civilisation too barbaric to be regenerated in any other way. Such cosmic arguments could of course also be found on the other side. But the answer given by the painter William Rothenstein is perhaps more typical of English attitudes. For it shows how potent was the Georgian myth. The war is being fought to preserve the enchanted village. 'I hope' (Rothenstein writes to Edward Marsh in 1918) 'we are fighting for Grantchester.'[27]

Notes to chapter 7

1 John Willett, *Expressionism*, London, 1970, contains a map illustrating the geographical distribution of Expressionist groups. The concentration in Berlin is analysed in Roy F. Allen, *Literary Life in German Expressionism and the Berlin Circles*, Göppingen, 1974. The general importance of Berlin as a cultural centre is described in *Berlin 1910–1933*, ed. Eberhard Roters, Fribourg, 1982; translated by Marguerite Mounier, New York, 1982.

2 References to the five volumes of *Georgian Poetry* are identified by *GP*, followed by volume and page number.

3 Paul Fussell, *The Great War and Modern Memory*, New York and London, 1975.

4 Robert H. Ross, *The Georgian Revolt: Rise and Fall of a Poetic Ideal*, London, 1967, p. 146.

5 Raymond Williams, *The Country and the City*, St Albans, 1975, p. 306. This evasiveness may be contrasted with the more active response of earlier English poets, analysed in William B. Thesing, *The London Muse: Victorian Poetic Responses to the City*, Georgia, 1982.

6 Cyrena N. Pondrom, *The Road from Paris: French Influence on English Poetry 1900–1920*, Cambridge, 1974.

7 *The Letters of Rupert Brooke*, ed. Geoffrey Keynes, London, 1968, are identified by *L*, followed by page number.

8 References introduced by the letter *D* are to Ernst Stadler, *Dichtungen*, edited by Karl Ludwig Schneider, Hamburg, 1954, two volumes.

9 Helmut Gier, *Die Entstehung des deutschen Expressionismus und ... die literarische Entwicklung Ernst Stadlers*, Munich, 1977.

10 English reactions to Futurism are documented in *Futurismo/Vorticismo*, ed. Giovanni Cianci (Palermo, 1979).

11 Holz is rightly given pride of place in the anthology *Deutsche Großstadtlyrik vom Naturalismus bis zur Gegenwart*, ed. Wolfgang Rothe (Stuttgart, 1973).

12 Karl Marx, *Capital*, London, 1977, pp. 76–87: 'The fetishism of commodities'.

13 Kasimir Edschmid, *Über den Expressionismus in der Literatur*, Berlin, 1920, p. 52.

14 Quoted in Heinz Rölleke's seminal study of Expressionist city poetry, *Die Stadt bei Stadler, Heym und Trakl*, Berlin, 1966, p. 27.

15 Quoted in Rölleke, p. 146. The intensity of German anti-urbanism is contrasted with the more moderate English response in Andrew Lees, 'Perceptions of cities in Britain and Germany 1820–1914', in *The Pursuit of Urban History*, ed. Derek Fraser and Anthony Sutcliffe, London, 1983, pp. 151–165.

16 References to *Menschheitsdämmerung*, ed. Kurt Pinthus, reprinted Hamburg, 1959, are identified by the letter *M* followed by page reference. The sales of this anthology (20,000 copies between 1920 and 1922) make it as representative of German taste as *Georgian Poetry* is for England (*GP* II sold 19,000 copies).

17 This translation is reprinted (by kind permission of the translator Christopher

Middleton) from *Modern German Poetry 1910–1960*, ed. Michael Hamburger and Christopher Middleton, London, 1963, p. 49.

18 *The Era of Expressionism*, edited by Paul Raabe, London, 1974, p. 46.

19 It was Heym's dynamic style which led Kurt Hiller in July 1911 to claim the title 'Expressionisten' (previously applied only to painters) for his group. See Karl Ludwig Schneider, *Zerbrochene Formen: Wort und Bild im Expressionismus*, Hamburg, 1967, p. 9.

20 Georg Heym, *Dichtungen und Schriften*, Darmstadt, 1960, III, 140.

21 Heinrich Kley, *Drawings*, New York, 1961, p. 17. The link between Heym and Kley was first suggested in Schneider, *Zerbrochene Formen*, p. 130.

22 Heym, *Dichtungen*, I, 452. I am grateful to Anthony Hasler for help with the translation of this poem.

23 The woodcuts which Kirchner made for a special edition of Heym's *Umbra Vitae* are reproduced in Ernst Ludwig Kirchner, *Das graphische Werk*, ed. Annemarie and Wolf-Dieter Dube, Munich, 1967.

24 Rilke, *Sämtliche Werke* (Wiesbaden, 1956), II, 87.

25 Baldwin invoked the 'ploughman' and the 'English meadow' in a widely applauded speech delivered to the Peace Society on 31 October 1935, quoted in Keith Middlemas and John Barnes, *Baldwin: A Biography*, London, 1969, pp. 867–8.

26 Otto Braun, *Aus nachgelassenen Schriften eines Frühvollendeten*, Berlin, 1920, p. 143.

27 Quoted in Meirion and Susie Harries, *The War Artists*, London, 1983, p. 61.

Occupied City: Ostaijen's Antwerp and the impact ⎡of the First World War⎤

Paul van Ostaijen (1896–1928) was the most comprehensive Modernist writer in Belgium and the Netherlands in the early twentieth century. His poetry, prose and critical writings reflect his interest in contemporary literary and artistic issues.[1] He was one of the best-informed writers about Modernist theories and practices in literature and the visual arts. He was a Flemish poet, but his work synthesises a strong regional consciousness with the ideas of the European avant-garde: Cubism and Futurism, Expressionism and Dada.

Van Ostaijen grew up in Antwerp, not one of the great metropolitan cities, but nevertheless a lively and cosmopolitan commercial centre with an important port. In the years before the First World War the economic point of gravity of Belgium was gradually shifting from the southern industrial provinces towards the north, bringing a slowly increasing prosperity to a previously impoverished region. The many warships visiting Antwerp in these years intensified its liveliness. Brussels was an international cultural centre, whereas Antwerp had a narrower regional distinction as the heart of the Dutch-speaking provinces.[2]

A small history lesson might not come amiss here. It must be remembered that the medieval Low Countries had consisted of the provinces constituting the present-day Netherlands and the greater part of present-day Belgium, with a majority of Dutch-speaking provinces over French- and Walloon-speaking areas. The separation of these provinces was the result of the revolt of some of the Low Countries against Spain in the sixteenth century, and the frontier as it came into being during the Eighty Years' War (1568–1648) was determined by various military campaigns dividing Flanders, Brabant and Limburg in an arbitrary and artificial way. A reunion of all the Low Countries was effected by the Vienna Conference after Napoleon's defeat in 1815, but came to an end in 1830 largely because

of the dissatisfaction of the Belgians with Dutch economic and cultural policies. The newly-created Belgian monarchy consisted of an industrially expanding, urban, French-speaking southern part and an economically stunted (apart from Antwerp), backward, rural, Flemish-speaking northern part.

The language of the dominant political and cultural institutions was French, though the Flemish speakers outnumbered the French speakers by more than half a million in 1830. No particular policy with regard to the two languages existed, but the expectation was that the Flemish dialects would gradually disappear, as had happened with the Walloon dialects, and be replaced by French.[3] To everybody's surprise, however, two and a half million Flemish speakers continued to cling tenaciously to their mother-tongue, the Flemish and Brabant dialects. In the Netherlands the welter of dialects had, from the sixteenth century onwards, gradually grown into a uniform language, but in Flanders and Brabant the rich variety of regional and local dialects continued to exist.

A first sign of self-awareness was the foundation of an antiquarian, folkloristic society, the Flemish Movement, which notwithstanding its romantic, rather reactionary character, did much for the revival of Flemish literature later in the nineteenth century.[4] This sudden and delightful flourishing of Flemish poetry and prose after four fallow centuries was followed soon after by the involvement of some people in the Flemish Movement with social and political issues; a fundamental change which was reflected in the literature.

Most of the prose-writing had been *Heimatkunst* at its cuddliest, but the poetry was European in every respect. An important force in the literary revival was the periodical *Van Nu en Straks* (*Of Now and Later*) and the person of August Vermeylen, the visionary educator of the Flemish people. Vermeylen clearly saw the need for Flanders to create a cultural identity and thus participate in European culture. His rousing manifesto *Over de Vlaamsche en Europeesche Beweging*[5] (*About the Flemish and European Movement*) was written in 1896 and its effective slogan, 'Wij willen Vlamingen zijn om Europeeërs te worden!' ('We want to be Flemings in order to become Europeans'), gave a direction to a whole literary generation and to the Flemish Movement as a whole. Echoes of this missionary zeal can clearly be heard in Van Ostaijen's critical writings, twenty years later. The very heterogeneous group of writers and artists connected with *Van Nu en Straks* had one common credo: art for life's sake! This contrasted with the 'other' Dutch literature of the period which was dominated by the so-called *Tachtigers* ('Eightiers') and the periodical *De Nieuwe Gids* ('The New Guide') in which the young poets of the 1880s proclaimed the principles of

art for art's sake and soon stagnated in extreme individualism. The writers of *Van Nu en Straks*, though still heavily involved with symbolism and impressionism, were conscious of the social, political and cultural influence they could exert and they saw art as having a social and ethical function.[6]

The general turbulence in Europe at the turn of the century was in Belgium given a particular focus in the uneasy co-existence of French and Dutch speakers. This situation was moreover aggravated by the fact that the divisions between the two languages all too often coincided with the divisions between upper and lower classes, educated and illiterate. Flemish nationalism and militancy came to the fore particularly in Antwerp and Ghent in the years just before the First World War. Tragically, the Flemish Movement found itself trapped between loyalty to the Belgian state and loyalty to the Flemish cause, when a long-cherished wish, the changing of Ghent University from a French- into a Dutch-speaking institution, was at last fulfilled. The change could only be effected, however, because the German occupiers enforced it. The result was that the existing complex animosity between French and Flemish Belgians worsened. After the War a number of leaders and adherents of the Movement were put on trial, some fled, and it took years to restore the credibility and the strength of the Flemish cause.[7]

Van Ostaijen grew up in this peculiar climate of cosmopolitanism and regionalism. Given his involvement with the Flemish cause and the prevailing regional consciousness, it would not have been surprising if he had become one of the *Heimatkunst* poets. But in fact, only a few poems explicitly show his concern for the Flemish situation.[8] In his critical writings, party politics as such play a very small role. Van Ostaijen, in the tradition of Vermeylen, seeks to educate and instruct culturally. A young artist living in the environment I have sketched could, however, hardly escape politics entirely, and it was indeed Van Ostaijen's slight involvement with the Flemish activists which was one of the reasons why he left Antwerp after the War.[9] That he chose Berlin, the Mecca of Expressionism, is due to artistic rather than political reasons. Van Ostaijen had been vehemently anti-German, though he had a great admiration for many German writers, especially Hofmannsthal. Moreover, before the War there had been many links between Belgium and Germany and in Flanders a particularly strong affinity existed, as between fellow Germanic peoples. If the Netherlands had not been so lacking in sympathy for the Flemish cause, these natural affinities might not have had such tragic results in the War, when some Flemish leaders came to accept the help of the Germans as a last resort. Van Ostaijen had never had any sympathy with that point of view. He hoped to benefit artistically from the Berlin environment. Van Ostaijen lived in Berlin

from 1918 to 1922. In a short and mischievous autobiography he wrote:

> After carefree existence, struggle for life in Berlin, Potsdam and Spandau.
> Not romantic. It is a myth that I would have made it from liftboy to owner
> of a nightclub. Am much too primitive to occupy eminent position in
> society. In spite of strong desire to reach the level of Flemish decadents, I
> understand my *Unfähigkeit*. On the point of being appointed as teacher
> for rhythmic-typographical poetry, I had to decline the offer on account of
> not possessing a frock-coat. If only I had a frock-coat. Entangled in the
> struggle f.l. cigarette-vendor, employed as tout in a nightclub with
> striptease. Finally decent employment through the intercession of eminent
> art-criticizer: salesman in shoe-shop, ladies department. From there strong
> influence.[10]

The chaotic conditions in Berlin after 1918 made unusual demands on the
artist, but it was largely due to Van Ostaijen's girlfriend Emmeke that he
was able to survive in the 'asphalt jungle'.[11]

The November Resolution of 1918 occurred just after Van Ostaijen's
arrival in Berlin. He was not involved in political activism, but sympathised
very much with the USPD (*Unabhängige Sozialdemokratische Partei Deut-
schlands*). The murders of Rosa Luxemburg and Karl Liebknecht made a
deep impression on him. He was also caught up by the artistic turmoil
created by the Berlin Dadaists. As his biographer wrote: 'Berlin caused a
widening and intensifying of Van Ostaijen's contact with modern art, but
also confronted him with a revolutionary situation, both politically and
artistically.'[12]

The Berlin years brought about a rapid transformation in Van
Ostaijen's style and outlook. In his first collection of poetry, *Music-Hall*
(1916), the title poem expresses a *fin de siècle* attitude to the city as a place
where the individual can feel lost but the crowd can feel united. In *Het
Sienjaal* (1918) ('The Signal') we still encounter a scout-like Edwardian
optimism about city life, whereas *De Feesten van Angst en Pijn* ('The Feasts
of Fear and Pain'), (written 1918–21, published posthumously) is full of the
nervous perception of life as chaotic, aggressive and destructive. The titles
of the poems written in the first year in Berlin are significant. Poems like
'The Murderers' and 'Masks' seem to be the verbal equivalent of George
Grosz's drawings (*GBI* 196). The title of the whole collection, 'The feasts of
fear and pain', sums up precisely the duality of the modern artist's percep-
tion of his world: as an artist stimulated and excited to a high pitch, coping
with the birth-pangs of artistic renovation; and as a human being recoiling
in horror from a hostile social environment. In comparison to the rather
fluid, supple lines and rhythms of many of the earlier poems, the Berlin

poems often have the sharp-edged construction of Cubist painting and convulsive staccato rhythms.

One of the earliest preserved letters from this period shows a personal and artistic enthusiasm which contrasts sharply with the tormented world of his poetry:

> Friends, I am progressing, my concept of life and art is becoming more absolute and clearer. I hope (oh with such a strong hope) that the bond we have concluded without any official seals will not perish. You too, I hope, have developed further towards Expressionism, the true path to salvation. Do read and re-read, study and re-examine *Le Cubisme* by Jean Metzinger. As I have now seen, Cubism is the clearest, most exact trend. It must bring the new style to the new world. Kandinsky is a great, exquisite artist . . . Don't be afraid: create natural . . . forms, that is forms which have their own birth and life according to your own ethos. And first and foremost, oh my friends, my friends, do not be afraid. Never have I wanted to dedicate myself so completely to a cause as now. Allons travailler! (*GBI, 218*)

Van Ostaijen did get to know quite a number of avant-garde Berlin writers and artists, especially the group round *Der Sturm*, which frequented the Café des Westens, such as the painters Stuckenberg, Marc and Campendonk, the philosopher S. Friedländer, the poet and critic Theodor Däubler and also George Grosz. But Van Ostaijen remained rather aloof from the squabbling factions, as he explained in a letter to friends in Antwerp of April 1919:

> You write that one imagines in Antwerp: I am living here amidst the movement. That is not correct. There is no movement here. One seldom encounters two people here who can stand each other. . . . Furthermore that idea is not correct because one needs to push oneself here in fact quite a lot and I don't do that. Didn't do that in Flanders either. I am quite at peace. Let time do its work here as it did at home. I have a few good relationships: painters, literary people, only a few politicians (*GB I, 219*)

Van Ostaijen had brought German Expressionism and in particular the periodical *Der Sturm*, to the attention of the Flemish public by means of a long essay 'Expressionisme in Vlaanderen'.[13] Here he deplored the fact that Flanders was lagging behind other European countries in recognising the importance of modern art. The Impressionist exhibition in Brussels (1914) had indeed been a success; but two other exhibitions, one showing the Futurists and the other, paintings by Fauvists, Cubists and Russian Expressionists, did not get proper attention because the public was quite unprepared for this kind of art. Van Ostaijen blamed in particular the French art critics for this state of affairs. They had presented these exhibitions and the

artists to the public with a mocking contempt, and failed to discriminate between the really valuable artists, such as Boccioni and Archipenko, and mere charlatans.

Only two years separated the publication of Van Ostaijen's *Het Sienjaal* from the Berlin poems later published as *De Feesten van Angst en Pijn*. *Het Sienjaal* had been the first and remained the truest manifestation of humanitarian Expressionism in Belgium and the Netherlands. The title poem, the concluding one in the volume, ends with a declaration of love of life: 'We love the Earth. The round, fertile earth.' *De Feesten van Angst en Pijn* starts with 'The Murderers'. The shift from idealism to disillusionment seems incredibly rapid and radical, and one wonders how Van Ostaijen survived the shipwreck of his ideals and what he salvaged from the wreckage. The poetry of the Berlin years seemed to move in the direction of total abnegation and despair, yet there is no doubt that artistically these were fertile and rewarding years. This becomes apparent not only from the posthumously collected *Nagelaten Gedichten* ('Posthumous Poems'). Above all *De Feesten van Angst en Pijn* and *Bezette Stad* ('Occupied City') (1920–1) are important both as poetic statements about the human condition and also for their daring formal innovations. Constant renewal was necessary and natural for Van Ostaijen, and in this he is essentially avant-garde. The desire to break new ground is reflected most obviously in his critical and theoretical work, both in the demands he made on other artists and in his critical comments on his own poetic production. These theoretical interests account for the rapid development in his work. P. Hadermann pointed out in his excellent article 'Paul van Ostaijen and *Der Sturm*',[14] that, while Van Ostaijen was writing the humanitarian poetry collected in *Het Sienjaal*, his reading was already causing him to think along entirely different theoretical lines, away from the literature of involvement towards the literature of artistic autonomy. In 'Expressionisme in Vlaanderen' this change announced itself; Van Ostaijen implicitly defended the more aesthetic programme of *Der Sturm* against the strident left-wing position of *Die Aktion*. Hadermann wrote: 'His argument foreshadowed his later poetics: the work of art or the poem should be seen in the light of a humanitarian ideal' (Hadermann, 39). These 'later poetics' refer to the theoretical foundation of the *Nagelaten Gedichten*, poems written after *De Feesten van Angst en Pijn* and *Bezette Stad*. The two Berlin collections have an organic place in the development leading to the *Nagelaten Gedichten*, however startlingly they may contrast with the previous and the later work. Van Ostaijen himself saw *Bezette Stad* as a catalytic experience: 'a poison used as a counter-poison. The nihilism of *Occupied City* cured me of a dishonesty which I mistook for honesty, and it cured me of extravagant

lyrical pathos. After that, I became just an ordinary poet' (*Verzameld Werk, Proza II*, 330). The destruction of language as a means of expressing the destruction and disintegration of existence was an essential phase in his development.

In European poetry of the city *Bezette Stad* holds a unique position. It expresses a momentous historical event in memorable artistic form. Its subject is the siege, bombardment and capture of a major European city by means of the most advanced military technology and its subsequent occupation by an enemy army. Historically, the poem thus anticipates the fate that was to befall a vast number of European cities between 1939 and 1945 and which now hangs over every city of the world. The fall of Antwerp in October 1914 was a moment of truth in modern military history. It showed that even the most strongly fortified city is an easy target for enemy bombardment.

Formally, the poem is equally in advance of its time. For Van Ostaijen develops the typographical innovations of the Futurists, Cubists and Dadaists so that they convey the destructiveness and fragmentation of a war-torn city with unprecedented vividness. No doubt he was familiar with Marinetti's sound-poem about the siege of Adrianopolis during the Balkan Wars, *Zang Tumb Tumb* (1914). The similarity with Apollinaire's calligraphic treatment of the First World War which is often remarked upon is rather a superficial one; besides it is not sure whether Van Ostaijen knew this work by Apollinaire at the time he was working on *Bezette Stad*. But where the typographical experiments of Marinetti and Apollinaire present modern warfare as a spectacle to be enjoyed, like a grandiose firework display, Van Ostaijen's poem conveys exactly the opposite. It shows what modern warfare is like when you are on the receiving end, in images of nihilistic destruction and despair. It is a poem which deserves to be better known.

From the available documentation it seems that Van Ostaijen planned in *Bezette Stad* to give a picture 'of all that an Occupied City is' (*GB* I, 337 and 349). The titles of the planned poems show the collection to have a coherent narrative structure. Van Ostaijen's biographer, Gerrit Borgers, interprets the fragmented information as follows: 'This unity, "my poem", would be composed out of different parts, each of which would depict a certain aspect of his memories of wartime in Antwerp, as a snapshot' (*GB* I, 308). Also 'just as these poems consisted of isolated words and word-groups, thus would the history of the years of occupation be depicted in isolated moments and the development would mainly be suggested by the sequence of these moments' (*GB* I, 308). One criticism of this cinematographic technique was that it created a poetry of isolated instances, fleeting

situations without 'development, past or future'.[15] But it created more than that. This collage of impressions and experiences in strikingly concrete images is extraordinary effective and evocative war-photography: the marching enemy army, the outline of the burning city, the roads choked with military traffic and bedraggled lines of refugees. The new threat of aerial bombardment is typographically accentuated in Ostaijen's image of Zeppelins over London (Fig. 22). The juxtaposition of the Zeppelin attacks reported in the newspapers ('Dagbladen') with the refrain from a famous song indicates that it is 'Goodbye' not merely to Piccadilly, but to the security of the 'blessed island' of Britain as a whole.

The form of *Bezette Stad* is pure Dada, in its use of montage technique, including snatches of advertisements, film titles, popular songs – all that one might expect to hear and see in a big city, especially one in which entertainment is an important ingredient. The typography too, is that of the Berlin Dadaists: it provides rhythm, enforces punctuation, is onomatopoeic and it forces the reader to become a speaker, compels him to turn up or down the volume of the voice, to slur or to enunciate. The pages at times read like a musical score. The juxtaposition of different languages is also reminiscent of Dada, but in Ostaijen's poem it acquires a sharper political focus. The cumulative effect of these devices is illustrated by Fig. 23, which portrays the Prussian advance on the 'threatened city'. The initial viewpoint is Flemish: Liège, which has already succumbed to the German march and mortar fire, is identified by its Flemish name *Luik*. But the German breakthrough is also signalled linguistically, by the counterpoint between two German songs: the boldly accentuated patriotic anthem 'Hail to thee in victor's laurels', ironically, undercut by snatches from a vulgar song about the 'dear little doll' the German soldier really hopes to find as he marches through Brussels. An italicised phrase indicates the reactions of the Flemish populace ('Joe Joe Joe – a Zeppelin – creep quickly into the cellar'), while the Prussian troops advance with their relentless 'one-two, one-two'. In smaller type the defeated Belgian army retreats through the typographically disrupted 'flickering countryside' and 'raging fire'. And the disunity of Belgium is pinpointed by the linguistic disjunction 'mijn broer les hommes', which undermines the myth of national solidarity. Defeat is finally spelt out in French: 'débâcle', because that is precisely what it is: defeat for the *French* ruling class in Belgium. It was not so unambiguously a defeat for the Flemish, some of whose national aspirations (like the founding of a Flemish University at Ghent) were actually fulfilled under German occupation.

Van Ostaijen's theoretical explanation of the use of typography in *Bezette Stad* has fortunately been preserved. He had been accused of inconsistency: in using rhythmic typography he seemed to contradict his

Dagbladen

**ZEPPELIN
LONDEN**

good bye Piccadilly
SQUARE
farewell Leicester

BEATA INSULA

BEDREIGDE STAD

Visé marsj Luik mortieren

marsj mortieren

Puppchen Du bist mein Augenstirn **Heil Dir im Siegerkranz**

Puppchen mein liebes Puppchen

défilé van éen dag en éen nacht door Brussel

Armee von Kluck

jef jef jef'ne Zeppelin

kruipt al gauw de kelder in

eins zwei eins zwei eins zwei eins zwei

Pruisies Pruisies

marsj mortieren

Wij staan mijn broer les hommes au balcon

het flak-kerend land

de verre toren en de laaiende brand

de saKKaden van het vertraPte leger

de *Masochistiesemarsj*

de d é b â c l e

own statement that art needed to be kept pure. Van Ostaijen, in reply, stressed the necessity to see *Bezette Stad* not merely as poetry, but as a cumulative imaginative experience: 'The book stands in relation to the poetry as the written score to the instrumental performance' and 'It can not be denied that the printed word is a translation of the musical into the graphical'.[16] He furthermore stresses that the poet must be seen as an interpreter, an entertainer, who should not have the barrier of the written word between him and his audience. The modern poet is no longer speaking from a Dionysian trance, nor is he any longer able to reach his audience by means of the spoken word. The resulting loss of spontaneity and impact is counteracted by the typography in *Bezette Stad*. Van Ostaijen thought that the significance of his poetic experiment was that it created a form which eliminated the barrier between poet and audience and thus heightened the effect of the poetry on the reader.

Bezette Stad may be typographically disconcerting, but it has a clear narrative structure. The sequence is divided into three parts: (*a*) 'Dedication to Mr So-and-So', followed by eighteen poems (with 'Threatened City' setting the tone); (*b*) 'The Circles Turning Inward', consisting of ten poems, five of which share the same subtitle 'Music Hall'; and finally (*c*) a fifteen-page poem entitled 'The Retreat'. Part (*a*) portrays the German onslaught on the city; (*b*) shows the inner life of the city as it lies strangled under the occupation; part (*c*) describes the end of the War and the resulting situation in Antwerp as well as in Europe as a whole.

Mr. So-and-So, to whom the poem is dedicated, was a much-travelled friend of Van Ostaijen whose experiences inspired the erotic map of Europe which features in the 'Dedication'. The anonymity of the pseudonym adds to the nihilistic atmosphere of the poem in which different languages, different places are shown to yield nothing new, nothing meaningful: 'es ist alles schon dagewesen'. Even the unusual map of Europe, drawn according to erotic rather than political, geological, religious or commercial features, is not stimulating, but suggestive of the violation of the continent by the War and by the débâcle of our civilisation. This pseudo-voyage of discovery of Europe ends with a five-minute snapshot view of the city which stood model for all other cities, the Acropolis, the cradle of Western civilisation, here perceived as 'necropolis', city of the dead. Civilisation as we know it is declared null and void; the only solution seems to lie in total destruction, after which there will perhaps be a place for a new beginning.

Bezette Stad is, after all, not only a poetic experiment. It is a passionate protest about the human condition. Van Ostaijen's humanitarian ideals suffered a severe blow in the Berlin years, but they were not completely submerged by the nihilism which predominates in *Bezette Stad*. In the

22. Ostaijen, *Zeppelin over London*
23. Ostaijen, *Threatened City*

'Dedication' the Apocalypse is announced, in which God the Father will bring the last Act. The only positive thing left is to refuse to play along any further: 'Nihil in all directions'. But after the explosion of the destructive forces all is not yet lost. In serene normal typography the hope of a new beginning is expressed:

Zullen zijn gevallen alle katedralen	Will have fallen all cathedrals
kannibalen	cannibals
Hannibalen generalen	Hannibals generals
idealen	ideals
kolonels	colonels
bordels	brothels
misschien	perhaps
zal er plaats zijn	there will be a place
voor een vanzelfsprekende schoonheid	for a self-evident beauty
zuiver	pure
ongeweten	unconscious

After this evocation of a general spiritual destruction, be it with a small spark of hope amidst the chaos, we are shown more specific instances of the physical destruction brought about by the War. 'Threatened City', 'The Shell above the City', 'Deserted Fortresses', 'Lonely City', 'Hollow Harbour', 'Zeppelin' give us a series of pictures of the attack on Antwerp, the bombing, the desolate girdle of fortresses after the withdrawal of the defending troops, the deadness, emptiness, stillness in the strangled city in which all commercial and industrial life has come to a halt. 'Brothel', 'Empty Cinema', 'Nomenclature of deserted things', 'City Stillife', 'Deadsunday' all show the nightmarish wasteland atmosphere of the city under the corruption of foreign occupation, and the resulting disintegration of normality.

Everywhere is the implied contrast with the normal, pre-war situation. The brothels which are losing their 'bonne clientèle' of former days, now that queues of soldiers are waiting; the entertainment centre has been reduced to a few shabby cinemas after the bombing; the boulevard has nothing but a few shady cafés: 'Waar zijn de tijden van vroeger?' ('Où sont les neiges d'antan?'). In the 'Dedication' nihilism was an existential condition though even there hope of resurrection could be detected; in a poem such as 'Hollow Harbour' everything seems submerged by despair, but there is an implied temporariness through references to the past, which brings back a glimmer of hope. Thus, there is affectionate remembering of the now empty harbour in its heyday:

Ik heb gezien hoe van de holle haven kaseiden bewogen in alle richtingen
en sprongen
slag van het havenhart

grijze strook
magiese staf

(I have seen how from the hollow harbour boats moved out in all direc-
tions and jumped
beat of the harbour-heart

grey plume
magic wand)

This city is only unreal in the sense that it is experiencing an abnormal
phase. The horror, confusion and despair we encounter in these poems
seem to be strongly determined by the circumstances. The city is not felt to
be ugly, nightmarish, evil in essence. It has become so because of the War,
and it is the War which is in essence evil. But the power of war has grown
until it becomes the symbolic expression of the human condition.

'Sous les Ponts de Paris' by its very title, prevents our point of view being
solely directed towards the 'Occupied City Antwerp'; all cities, all life, are
under attack! Its content shows the reality of suffering embodied by the
all-pervading presence of Christ, as well as the meaninglessness of tradi-
tional religious beliefs and manifestations.

'Mourning City' describes the fear of the air-attacks on the darkened
city, and an attempt to escape the awareness of death is expressed in 'Banal
Dance'. The fear for the safety of the brothers and sons at the front and the
anguished waiting for news is reported in 'House City I' and 'Good News'
bitingly shows the ludicrousness of hero-worship and warfare in a snapshot
of the Belgian King and the Crown Prince, princes of German extraction,
defeating singlehandedly a battalion of German soldiers. This sense of the
grotesque culminates in the last poem of the first part of *Bezette Stad*; the
world has gone mad and the only reaction possible is to laugh about it: in
'The Great Circus of the Holy Ghost' performs the world famous Trio of
Religion, King, and State!

In the second part, 'Circles Turning Inward' we are shown life within
the Occupied City in a confined space, that of the music hall. In Van
Ostaijen's first collection, *Music-Hall*, at least in the title-poem, an atmos-
phere of lethargic boredom or a frenetic longing for forgetfulness prevails.
There the awareness of the paradox of solitude amidst the multitude, of the
individual trying to retain a sense of Self by merging with the crowds, is very
strong. Prominent too, in the *Music-Hall* collection of 1916, is the sense
that it is possible to believe in the victory of all that is good. In the five

'Music-Hall' poems in *Bezette Stad* entertainment does not function as a temporary refuge from pressurised ordinary city life but as a refuge from the strangled city under occupation. Here it does not foster the illusion of the victory of good, but works enslaving as a drug. The music hall entertainment can no longer be enjoyed or viewed without enormous scepsis and irony; the tension between the world inside the music hall and the world outside is unbearable and will burst like a balloon. Van Ostaijen's expression of that tension cannot be taken as a statement about the here and now only, but about existence as such.

There is a recurring widening of the frame of reference from actual to existential situations. One example of this is the poem celebrating the Danish film star Asta Nielsen who was particularly famous for her film *Abgrunden* 'The Abyss', (1910), and who became an idol for her generation. In Van Ostaijen's poem she is given almost cosmic significance and divine powers and comes to be seen as a means of salvation from all the evils of the world. Through the erotic fascination of this goddess of the white screen we are reminded of the erotic map of Europe in the 'Dedication' and via this again of the violation of Europe by the War and the failure of our civilisation.[17]

The third part of *Bezette Stad*, the single poem 'De Aftocht' ('The Retreat') expresses the effect of the War on Antwerp and the total havoc it wrought on Europe; everywhere people are suffering, feel displaced, without hope. Here the existential NIHIL of the 'Dedication' returns and once more the tempting idea is put forward that total destruction-as-cleansing is necessary, that a *tabula rasa* is the only state from which life can begin again. Against this strong seductive voice others can be heard, the chauvinistic voices, which, having learnt nothing, call for the cultivation of nationalism, and the feeble humanitarian voices, still clinging to the idea that the Word, i.e. communication, could be a possible road to salvation. Above the rattling of machine guns, the Word becomes a Voice, which, after a last explosion, 'KNAL', is given a name, 'LIEBKNECHT', thereby closing off the page, the Word, the Voice. The typography quiets down to a small expression of hope that perhaps the spirit of the martyr Liebknecht might live on amongst workers and soldiers. But the small voice is smothered under the hollow phrases taking possession first of the whole width of the following page, where in staccato rhythm more platitudes are delivered:

<div align="center">NOW</div>

the doctors the gentlemen doctors the gentlemen professors do not see do not hear get their wisdom of their own make from the Belgischen Kurier Victory Warsaw Grodno Kofno Brest-Litovsk Bucharest

and now and now
grain from the Ukraine?
bread
durchhalten aushalten
and then
aushalten
brave Pommeranians
the victory is for those who can suffer the most misery
soldiers
Berlin – Baghdad
the emperor declares
(all monarchs declare that is their style)
democratisation of the government
but keep heart
14 points
14 buttons
alle Männer saufen alle Männer saufen
 nur der kleine Wilson nicht

This passage, unexpectedly sober in its original typography, conveys the disillusionment of the Germans (and their Flemish sympathisers) during the final phases of the war. It is clear that in Van Ostaijen's view the destruction has not created a new world or a new sensibility. This moment, 'Now', should be the end of the war but is not the end of war. A further threat is posed by the intelligentsia which is just as self-opinionated as ever and gets its wisdom, home-made, from the *Belgischen Kurier*, a sneer in the direction of the many collaborators in Belgium. Who can talk of victory after the terrible suffering in Warsaw and all the other cities? The hungry millions are placated by the promise of grain from the Ukraine and by empty rhetoric; they are admonished to 'durchhalten aushalten' and after that they will have to endure even more. Victory is an empty word in the face of all the suffering; declarations by rulers, be they Emperor or President, i.e. the German Kaiser or President Wilson of America, are empty words, democratisation is an empty word. War is nothing but a power game between world powers, and ordinary people suffer for it. President Wilson's fourteen points for peace have no effect at all, they are worth no more than fourteen buttons (Flemish for 'not worth tuppence'). Wilson may believe in them, but everyone else is still sloganising about 'victory' and boozing German beer.

Bezette Stad ends on a wistful note, giving evidence of the awareness that the suffering was in vain, that even this destruction has not taught people a lesson, that an even greater disaster may be necessary, though we cannot be certain that a new beginning will ever be effected. With the

benefit of hindsight, with the Second World War behind us and a world seemingly bent on causing a Third, Van Ostaijen's poem takes on prophetic proportions.

The longing for a new beginning had been expressed in Van Ostaijen's earlier work. One poem in particular in *De Feesten van Angst en Pijn*, 'Vers 6' links the rejection of the old world with the longing for purification which was voiced by so many modernists. That poem ends with an expression of the desire for a personal renaissance 'Ik wil bloot zijn en beginnen' ('I want to be naked and begin'). At the end of *Bezette Stad* a desire for collective renaissance is expressed. We may recall the imminent deluge foreseen by Jakob van Hoddis in his 'Weltende' (1911):

> Der Sturm ist da, die wilden Meeren hupfen
> an Land, um dicke Dämme zu zerdrücken. . . .

> (The storm is here, crushed dams no longer hold,
> the savage seas come inland with a hop . . .)

This has now become reality. The flood has left nothing but waste land:

> Een stuk gereten arme grond
> een vertrapte grond
> een heide grond
> een bezette stad

> (a torn piece of land
> a crushed land
> a moor land
> an occupied city)

The only hope seems to lie in an even greater flood, which might provide the new beginning, sometime in the future:

> Misschien wordt eens
> alle dijken breken
> de nood zo groot

> (Perhaps sometime the need
> all dykes break
> becomes so great)

Notes to chapter 8

1 Paul van Ostaijen, *Verzameld Werk*, ed. Gerrit Borgers, sixth revised edition, 4 vols., Amsterdam, 1979 (hereafter *Verz. W.*) All translations by Elsa Strietman.
2 E. H. Kossmann, *The Low Countries 1780–1940*, Oxford, 1978.
3 A. van Elslander, 'Flemish literature in the first decades of the twentieth century', in *Nijhoff, Van Ostaijen, "De Stijl", Modernism in the Netherlands and Belgium in*

the first quarter of the 20th century. *Six Essays*, ed. Francis Bulhof, The Hague, 1976, pp. 23–37.

4 Reinder P. Meijer, *Literature of the Low Countries. A Short History of Dutch Literature in the Netherlands and Belgium*, Assen, 1971.

5 'Over de Vlaamsche en Europeesche Beweging' in *Strevend Vlaanderen, Spectrum van de Nederlandse Letterkunde*, 24, Utrecht, 1972, pp. 315–26.

6 See n. 3.

7 See Kossmann, chapters VIII; IX; X, 4.

8 *Verz.W*, Poezie, I, pp. 61, 115.

9 Gerrit Borgers, *Paul van Ostaijen. Een documentatie*, 2 vols., Den Haag, 1971, I, 185 (hereafter *GB*). All translations by Elsa Strietman.

10 *Verz.W., Proza*, III, p.

11 *GB*, I, pp. 187–8.

12 *GB*, I, p. 196.

13 *Verz.W.*, Proza, IV, p. 53ff.

14 *Nijhoff, Van Ostaijen, "De Stijl". Six Essays*, pp. 37–57.

15 *GB*, I, p. 309, quoting from H. Hunnekens '*De verstechniek van Paul van Ostaijen*' *Roeping* 28, no. 10, p. 513.

16 'Open Brief aan Jos. Leonard', *Verz.W., Proza* IV, p. 155.

17 For a detailed discussion see Johanna Prins, '*Unreal Cities: a Study of Modernist Nihilism in T. S. Eliot's 'The Waste Land' and Paul van Ostaijen's 'Occupied City''*, *Dutch Crossing*, 21, December 1983.

Eliot, Pound, Joyce: unreal city?

Suil, suil, suil arun, suil go siocair agus, suil go cuin (walk, walk, walk your way, walk in safety, walk with care).

(*Ulysses* – 'Ithaca')

We are used to the idea of Modernism as an art of disintegration; and to the idea that its typical location, the scene and the cause of the disintegration it records, is the city. An art of despair and pain; a dissonant, fragmented art that confronts meaninglessness; an art bred by the city where the scale of life dwarfs the individual and where each isolated person lives in bewildering, shifting patterns of relationship with others, or in no discernible patterns at all: this is probably the most prevalent view of Modernism.

The typical inhabitants of this urban wilderness are lonely, hunted and insignificant. They are victims, sub-tragic men like Prufrock and Joseph K. In English, Prufrock is the man for this season and this place. Prufrock is not Prince Hamlet, 'nor was meant to be';[1] and Eliot creates this small, sub-tragic man in a wonderfully unassertive verse, sensitive to every tiny movement of his mind, attentive to his 'pinned and wriggling' (*P*, 58) thoughts. A listener to the nearly inaudible, Eliot makes us hear Prufrock's every breath and step. He makes us feel a new kind of discomfort in which fragments of older poetic speech which once gave meaning and identity dissolve in a new medium which is not tragedy, nor elegy, nor comedy, though it brushes fretfully against all three.

Silence becomes an integral part of this astonishing new verse. Eliot's scrupulous reticence will not let him presume upon Prufrock's silences. In the gaps between his utterances he recedes and vanishes. His privacy stays intact. One cannot know what he is thinking. Literary language can seldom have got nearer to the inner being of a man than this, but such closeness confers no interpretive privileges. The unknowable is respected. There is no plucking out the heart of Prufrock's mystery.

Haunting, reverberative, but never quite assimilable, never ripe for

appropriation to some meaning or creed, the voice of Prufrock has hung suspended in our century's air. The bits and pieces of his city habitation, glimpsed and half seen behind him, have rested in the mind's eye, at once shadowy and eidetic.

This great poem proclaims the end of order, the end of style's ability to bring unity to the world we experience. It gives everything back, in large part, to the unknown. It respects the submerged. It disrupts many kinds of accord between person and person, between us and our environment. The city's isolating, fragmenting force is felt as never before in this broken poetic speech.

In Eliot it is felt predominantly as pain. Prufrock is passive and helpless in his pain. In the poems of failed love, from the same volume, guilt and self-accusation are added to the characteristic mix. The prose-poem 'Hysteria' adds grotesque humour and also fearful sharpness, and in the 'Gerontion' volume they become the norm. Nausea and acridity intensify as Eliot deploys his gallery of grotesques. Waste and corruption are sardonically observed in both English and French.

The Waste Land summarises this vision. Desire is unnerved in a hopelessly polluted world. Sad, bewildered people go through mechanical routines, sterile grotesques parody the erotic literature of the past. *Antony and Cleopatra* and *Tristan and Isolde* dissolve alike in an 'unreal city' (*WL* 60) owing debts to Baudelaire's city and Dante's *Inferno*. Shadowy myths of return and renewal have nothing like the force of the landscape of desolation.

The Modernist, fragmented city is virtually the poem's protagonist. The city's dirty buildings and polluted river, sweating oil and tar, the city's canal, gashouse and rats, those scarcely living roots in the winter ground or under the city's stones: all go to make up one of the great wilderness images of Modernism. In English this is the classic image of the Modernist city, and when it ends with fragments shored against ruins the stress is on the fragments and the ruins, not on any very successful shoring. Shoring sounds a fruitless sort of effort, trying to prop up endlessly crumbling structures. The task is hopeless, the effort vain:

> Falling towers
> Jerusalem Athens Alexandria
> Vienna London
> Unreal. (*WL* 373–6)

The force of Eliot's genius gave this image of the city as fragmentation and pain tremendous authority. For the next two generations it lived unrivalled in English readers' minds, and its hegemony was increased still further by the English, largely Leavisite, adoption of Eliot as the great

prophet of traditionalist, anti-urban values. He became one of the corner-stones of a vastly influential moral-educational enterprise, and his cityscape was one of that enterprise's leading images. Already a great poetic image it became also a received idea, adopted as English Modernism's definitive report on the city. Eliot himself was a little embarrassed by this adoption. The embarrassment can be felt in his calling *The Waste Land* a mere 'grouse against life'.[2] But the combined force of his genius and the ideology which had a use for it was too strong. *The Waste Land* kept its authority. So did its verdict on the city: 'unreal'.

Analogues for Eliot's famous city can be found, and were found, in Ezra Pound. The early Pound had once greeted the city of Venice with a hymn of thanksgiving. Modern New York stirred him similarly.[3] But matters were normally more sour. The degenerate London of *Hugh Selwyn Mauberley*, which Leavis linked with Eliot's 'Waste Land' London, constituted Pound's most influential report on the city. The *Cantos* endorse it. In *Canto III* Venice is going the way of London as the poet sits on the Dogana's steps and decides glumly that 'the gondolas cost too much'.[4] As the *Cantos* build up their imagery of the paradisal on the one hand and the degenerate on the other they create a vision of the city which corroborates Eliot's. The London of the *Hell Cantos* is a vision fuelled by nausea:

> Above the hell-rot
> the great arse-hole,
> broken with piles,
> hanging stalactites,
> greasy as sky over Westminster,
> the invisible, many English,
> the place lacking in interest,
> last squalor, utter decrepitude. (C. XIV, 62)

Opinions vary greatly as to whether this is another great poem of desolation of a mere jeremiad full of violence and phobias. However it may be, the model for a city set in the *Cantos* by the Siennese fathers has rarely been followed, except, rather quaintly, at Wörgl.[5] The hell-hole of London is the norm, rotted with usury; or, as the vision turns hideously racial, the 'hell's bog' of Vienna, 'the midden of Europe', whose inhabitants are 'embastardized cross-breeds'. (C. L, 247)

This vision never achieved, nor ever merited, the fame and authority of Eliot's; but it strengthened the received idea of Modernism's city, the received idea of the metropolis as a kind of hell.

A reader of Joyce's *Dubliners* might be forgiven for finding there another corroborating imagery of urban lifelessness. Joyce even provides a catchword for it in the first story, 'The Sisters': Dublin is a city in

'paralysis'.[6] The stifled lives of Joyce's Dubliners might seem fully and cogently to justify the notion of paralysis. The Dublin of *Dubliners* might well look like another sordid city where life is eaten away at the roots by dreary work, religious fear, social convention, drink and poverty.

In the 'Telemachia' of *Ulysses*, Dublin's paralysis seems to have locked fast on yet another soul. Another fragmented Modernist text sets forth another mind trying hopelessly to shore the fragments of his literary and theological culture against his ruins. Stephen as Prufrock ('I'm not a hero');[7] Stephen as Hamlet, brooding suicidally over 'Elsinore's tempting flood' (55); Stephen gripped by nausea on a seashore as foul as Eliot's Thames, where the 'bloated carcase of a dog lay lolled on bladderwrack' (55); Stephen with his feet sinking in 'damp crackling mast' and 'unwhole-some sandflats' (50); Stephen overwhelmed by guilt and anguish: one might be forgiven for finding here another sub-tragic victim of a city's paralysis.

There is perhaps enough 'Waste Land' in this, sufficient sense of a fragmented wilderness rotting the souls of its inhabitats, to begin to justify readings, even of *Ulysses*, which, like Eliot's own, put great stress on its portrayal of the 'futility and anarchy' of modern city life.[8] Early Joyce, from *Dubliners* to the 'Telemachia', might be assimilated, along with Pound, to Eliot's definitive report on the 'unreal city' of Modernism. One finds fear, nausea, revulsion in plenty in the Dedalus part of Joyce (for all that the wonderful humour is also apparent very early). Drink-soaked, poverty-stricken, priest-ridden Dublin is the recipient of a good deal of them.

Stephen Dedalus's response to Dublin's paralysis (and Joyce made the concept his, bequeathed it to him and left him with it) was to be nerved by it. In that his salvation lay. The artist as spiritual hero is nerved in recoil against a city which is seen as the agent of his destruction. He was nerved for flight at the end of the *Portrait*. In *Ulysses* his recoil nerves him to do battle with the church, with his family ('She is drowning . . . she will drown me with her', 313), with dangerous friends like Mulligan ('Hast thou found me, O mine enemy', 252), and with what he saw as the limited, provincial world of Irish letters which he scorned with his obstinate refusal to write.

Recoil was Eliot's salvation too. He recoiled from the desolate city of *The Waste Land*, where souls rotted, and set up, in the houses, gardens, cloisters, lawns and waters of the later religious verse, locations and figura-tive analogues for meditative self-composition. The vision of the squalid city had thus been spiritually urgent, portending an urgent transference of the mind away from an ugly wilderness to another location where frag-ments might indeed be shored against ruins. The shock of the vision of urban disintegration nerves the soul for a quest for reintegration. It horrifies the mind into some other wakefulness, or wakefulness in some other realm.

The sense of corruption thus is, as Eliot thought it had been for the Jacobean dramatists, the prelude to a spiritual rebirth. It shocks one, usefully. It shakes one from that lethargy (the Christian *accidia* or the Hindu *tamas*) which, for Eliot, was the greatest of all spiritual enemies and which the amorphous, fragmenting city bred prodigiously.

Remembered images of that fearful city pursued him all the way to the 'secluded chapel' (*4Q, LG*, 236) of 'Little Gidding'. But there the rebirth finally, and triumphantly, comes at the end of a long, patient spiritual quest, when

> the tongues of flame are infolded
> Into the crowned knot of fire
> And the fire and the rose are one. (*4Q, LG*, 257–9)

The last word, 'one', is significant. A wonderful transcendent unity has at last been reached and is asserted in that word against the chaos, ruin and fragmented polysemy of the city.

It is the end point of all of Eliot's work. All the poetry and all the literary and religious prose is written in quest of that 'one'. In Dante, in the *Bhagavad Gita*, in Lancelot Andrewes, he found his models, and also in poets in general whom he thought differed from ordinary men in that they made oneness out of their disparate experiences. Poets are men who make unity out of fragments, especially if they have 'wit', which draws varied things into harmony by means of swift intellectual toughness. It all leads to the triumphant ending of the *Four Quartets*: that momentous 'one'.

There is room to feel wistful about the author of the unassertive, open-ended *Prufrock* coming to a conclusion so singular, so 'infolded' upon itself. And there is room to feel a good deal more than wistful about such a quest, with such a conclusion, having been for so long accepted as the type and norm for Modernism's dealings with the city. Modernism offers so many exciting and creative possibilities for the exploration of the poly-valent, the relativistic, the open and the plural; why then, in England, were readers able to find Eliot so central to what Modernism had to offer? Why was he found so unproblematic? Why was his recoil, from the city to Little Gidding, taken as so definitive a model for what the city was and how it should be experienced?

The case of Pound makes one more than wistful too. He too recoils. His disgust is meant to nerve as well. The anathematisation of the city is made in conformity with Blake's dictum: Damn braces, whereas Bless relaxes. (Blake indeed is one of the prophets of light who leads Pound out of his hell 'howling against the evil', C. XVI, 68.) Braced against the city's hell Pound flees to the paradisal landscapes of light that punctuate the *Cantos*. But he

also flees to another kind of city, another kind of building.

These are elegant, shapely cities formed as a unity, cities 'whose terraces are the colour of stars' (C. LXXIV, 425). They are places where high rituals are enacted. Their builders are as heroic in Pound's eyes as Malatesta who built the Tempio. In recoil from London and Vienna Pound evoked clean, white cities and buildings as psalmodic objects. The builders and founders of such places 'gazing at the mounts of their cities' (C. XVI, 69) are among the makers of his new, bright 'paradiso terrestre' (C. CXVII et seq., 802).

Such an urban architecture is clean in line and free of excessive ornament. It also answers to the visionary force in the mind of a 'founder'. In this sense Pound is modern poetry's Le Corbusier, the dreamer of la ville radieuse, the admirer of its light, its line, its formal purity, its order, and its plastic testimony to the power and authority of its maker.

Pound and Le Corbusier, recoiling from the city's mess and chaos to these clean, glassy visions of architectural order and virtù, have not escaped censure. Nor have they deserved to escape it; for it is not hard to see, in the intial recoil, as much failure and phobia as spiritual courage, and, in the visionary product, as much brutality as beauty. It is also not hard to see something 'unreal' in another sense. Pound and Le Corbusier share an unreality which consists in a cool indifference to the unredeemed physicality of things, which is not far short of saying an indifference to the human condition. Unredeemed humanity has as hard a time of it in the Cantos as in the notorious unité d'habitation. Both make quite 'unreal' demands for uniform acquiescence in their imperiousness.

Such things make one more than wistful. They send one back to the initial recoil from the city and to the initial report on it as wilderness and hell; and in that they send one back to Eliot as well, for second thoughts. One can come to be very relieved by Eliot's embarrassment about The Waste Land's 'grouse against life'. One can come to hanker, with all due respect to the splendid Quartets, for numbers greater than the 'one' with which they close, for locations more populous than a 'secluded chapel', and for life just a little less redeemed than in 'midwinter spring' when there is 'no earth smell/or smell of living thing' (4Q. LG. 1, 12–13). One can begin to wonder whether the world was not enough with him. And one can regret that the occasional moments of affection for the city and its people were so occasional:

> (O City city, I can sometimes hear
> Beside a public bar in Lower Thames Street,
> The pleasant whining of a mandoline
> And a clatter and a chatter from within) (W.L. 259–62)

F

Such second thoughts send one back to Joyce, with a relieving sense of how different he is, or became, from his creature, Stephen, and from Stephen's fellow-recoilers, Eliot and Pound. Early baffled readers of Joyce were, like their forebears reading Flaubert, often persuaded of his work's sordidness. Such readers found a drab and tawdry cynicism in *Ulysses*. Like the novels of Flaubert, *Ulysses* seemed to have a mean streak in it. It offended against the wish to be allowed to have great feelings. The accents of hope seemed systematically flattened into something even worse than horror or nausea – worse because less bracing. An unrhetorical, unexcited, non-recoiling present continuous clung tenaciously to 'earth smells', denying and thwarting redemption. There was, and there remains, no urgency and no quest for unity. Joyce, like Flaubert, left dissonances dissonant. Neither of them protested or recoiled. They seemed reconciled to the flat continuum of things, or to be training themselves in acceptance of it.

Such continuous diffidence, such steady hesitation, such lack of urgency, must have seemed mean and apathetic. It was the apparently nerveless stoicism of their patience with the amorphousness of the city – Paris or Dublin – which gave offence. Such failure to recoil in the name of, or in quest of, higher feeling, was widely taken for spiritual poverty, especially in England. Patiently attuned to the fragmented and the flat, both were found mean and sterile.

Few readers of Joyce could share such a response now; but the sustained flatness of *Ulysses*, its deliberate freedom from recoil and from the promotion of high feeling, remain central to what it does and how it works. Joyce's lack of recoil, like Flaubert's, is prelude to an acceptance of the city. It may be a restless acceptance, an uncomfortable one; but it is a full and generous acceptance none the less.

Mr Bloom, a man of the city's mazes, can no more make harmony out of his life than can anyone else. He cannot make unity out of its disjunctions. What he can do is quite simply to live with the disjunctions of things, without recoil. He inhabits a world of crowding fragments without feeling, or indulging, the impulse to commanding ordonnance which sent Eliot from London to Little Gidding and Pound from London to *la ville radieuse*. For Joyce, salvation lay precisely in not being nerved for a quest, or for transference to another realm of wakefulness. His training of himself in that was, like Flaubert's, long and arduous. In the end the result was the creation of a city, Dublin, and a city-dweller, Mr Bloom. They are his two greatest gifts to our imaginations. They make English Modernism look quite different, taking from Eliot some of his authority as an obvious centre.

Once in *Ulysses* Bloom does entertain 'Waste Land' thoughts about his city:

> Cityful passing away, other cityful coming, passing away too: other coming on, passing on. Houses, lines of houses, streets, miles of pavements, piled up bricks, stones . . . Piled up in cities, worn away age after age. Pyramids in sand. (208)

That is in 'Lestrygonians', when a cloud covers the sun for a moment and his spirits drop. It echoes perhaps a moment in 'Hades' when he looked sadly at the graves of all those who 'once walked around Dublin' (144); and it anticipates a moment in 'Circe' when the myriad lives of all who have walked Dublin's pavements are seen as so many footmarks on a brothel floor: 'Footmarks are stamped over it in all senses, heel to heel, heel to hollow, toe to toe, feet locked, a morris of shuffling feet' (621).

Those are classic 'Waste Land' fears, city fears, analogous to Eliot's dejected record of the crowds flowing over London Bridge while 'each man fixed his eyes before his feet' (*WL*. 65). The solitary mind is overwhelmed by unreal and flowing crowds; each individual being is lost in the 'shuffling feet' that once walked Dublin's 'miles of pavements'.

But the depression of 'Lestrygonians' is brief, untypical, and soon shaken off; and the vanished walkers and shufflers of Glasnevin and Nighttown prompt more complicated reactions than simple dejection. There is as much dance as depression in the 'morris' of the brothel footmarks; and to have walked in *Ulysses'* Dublin, as all the Glasnevin dead have done, is to have lived in, and contributed to, a lively, differentiated, heterodox world. To have walked in Dublin is to have been wonderfully, idiosyncratically alive, irreducibly alive, more alive as a unique individual than any overarching vision of the city as Waste Land, hell or paralysis could ever know. For *Ulysses* is in many ways a book about walking, and a book about how no two people walk alike. Its celebratory portrait of Bloom and his city can be perceived in just how those 'miles of pavements' are walked by all manner of feet.

The 'Telemachia' starts it with Mulligan hopping and capering and Deasy stepping fussily on gaitered feet. Stephen's feet crunch sand 'a stride at a time' (45). Cocklepickers wade. A dog ambles, lopes, lollops, trots. But Bloom is the book's chief walker, and his preliminary sortie in 'Calypso' awakens the motif ritually. He walks 'in happy warmth' (68), thinking of other leisured walks, on beaches and 'through awned streets' (68), and devising his puzzle–walk: 'cross Dublin without passing a pub' (69). Unable to follow the interestingly 'moving hams' (71) of his neighbour, he strolls back 'reading gravely' (72). It is a quiet prelude to what will be a long and

fantastically varied promenade. At the end of 'Calypso', when he emerges from the jakes having 'girded up his trousers' (85), the action has a ritual feel. Those walking legs are accoutred. The knight is armed. The sortie proper can begin can begin with the grave opening chords of 'Lotus-Eaters': 'By lorries along Sir John Rogerson's Quay Mr Bloom walked soberly' (85).

In 'Lotus-Eaters' the book begins to deploy the riches of its pedestrian vocabulary as Bloom strolls, saunters, turns and (a much favoured word) halts. He daydreams about idle walking again, 'lobbing around in the sun' (87) and walking on rose leaves; and he ends walking 'cheerfully' (106). All is auspicious this sunny morning.

In 'Hades' and 'Aeolus' he is no longer alone. Others walk too, in thick crowds. And they ride. Wheeled locomotion, twin and contrasting motif with that of walking, governs 'Hades'. Doors, of walking egress and ingress, are the secret of 'Aeolus'.

In 'Hades' wheels creak and jolt. Passengers' knees jog, their bodies sway. Horses' feet step slowly, pull hard, or gallop. Bloom's carriage passes another, finer and faster; then another, empty. Other horses pull a load of granite 'with toiling plodding tread' (126–7). The carriage stops for a herd of cattle 'slouching by on padded hoofs' (122). At Glasnevin the coffin is put on a cart, the mourners walk behind – 'metal wheels' followed by 'blunt boots' (132). One man walks with his hands behind his back, others step 'with care' (138) round graves. Gravediggers walk shouldering spades, M'Intosh pops up, the mourners disperse 'slowly, without aim' (142), a rat toddles and wriggles. We are getting to be very conscious of locomotive styles, delighting in them as the book develops its celebration of personal idiosyncracy by means of the virtuoso mimesis of varied walks.

'Aeolus' begins its encomium of egress and ingress with barrels rolling out of one building and a 'stately figure' (149) entering another. The figure vanishes up a staircase, 'knees, legs, boots' (149). Messengers and newsboys rush in and out. Swingdoors and counter flaps are traversed. Offices are endlessly entered and left. Bloom is hit by an opening door. The pedestrian vocabulary stretches further, with hurrying, running, sidling, scampering, striding and gliding. One may just walk, or one may, like Lenehan, 'mazurka' (165). Elsewhere in *Ulysses* one will minuet, waltz, coranto, cakewalk, double-shuffle, keel row, galliard and cha-cha-cha (in addition to the brothel morris of footmarks). Things are getting more and more festive, and more and more elaborate.

'Lestrygonians', picking up this increasingly festive mood, features some spectacular walkers. HELY'S plod in line. Mad Farrell side-steps lamp-posts. Breen begins his long shuffle while his wife 'dodges' (201) behind. The blind stripling appears, on 'eyeless feet' (231). We catch our

first glimpse of Boylan's awesome 'tan shoes' (234), and of Parnell's brother
with his 'woebegone walk' (209). Two squads of police march. And we
begin to notice varied footwear to go with the varied walking styles: *Ulysses*
will give us boots, shoes, stockings, socks, gaiters, spats, buskins, brogues,
bath-slippers, 'high crooked French heels' (468), 'finespun hose with high
spliced heels' (455), 'jackboots cockspurred' (592), stilts and chopines.
Once Bloom feels overwhelmed, as we have seen; but for the rest he plays
his characteristic part, quiet and cautious, coasting 'warily' (229). 'Lestry-
gonians' is the book's first great carnival of perambulatory styles. It makes
everyone count. Everyone's footwork is worth watching.

In 'Scilla and Charybdis' we come indoors. But still there is the libra-
rian's 'sinkapace' (235), his 'softcreakfooted' (243) movements, his 'rectly
creaking' (270). And there is another kind of walking, metaphorical rather
than physical, given to Hamlet ('*il se promène*, reading the book of himself'
(239)) and to Stephen ('walking lonely in the chase . . . we walk through
ourselves' (247, 273)), and suggestive of isolation or blockage within one's
own head, aloof from the dance outside.

But in the end they emerge. 'Puck Mulligan footed featly' (277), and
Stephen follows, and both follow black-backed, 'step of a pard' (279)
Bloom out into the sun where the carnival of 'Lestrygonians' is renewed in
the grand climax of 'Wandering Rocks'.

Two great framing set-pieces, one pedestrian (Conmee's walk) the other
vehicular (the cavalcade), hold this festival of perambulation in their
embrace. Joyce's mimetic powers were never greater, nor his own delight in
what those powers can do. The long glide of Conmee, smooth, unhindered,
seemingly wheeled, Maginni's 'grave deportment' (282), Mrs McGuinness'
'queenly mien' (282); then the one-legged sailor crutching, jerking, swing-
ing; then Boylan's tan shoes again and HELY'S filing and plodding and,
when they turn back on themselves, eeling; then Artifoni trotting 'on stout
trousers' (293), Kernan with his 'fat strut' on 'spatted feet' (308), the huge
Dollard ambling and listing, Henry, who has corns, walking 'uncertainly'
(317), and Fanning advancing towards himself in a mirror; then Farrell
bumping into the blind stripling, and young Dignam dawdling; then a last
mention of Boylan's 'swell pair of kicks' (323) before the cavalcade; bet-
ween them they make the book's central cityscape incomparably diverse,
impossible to reduce to a mere crowd or mass. Its detailed, highly individua-
lised carnival delivers a myriad-footed answer to Eliot's strict 'one'. Joyce's
Flaubertian patience, his failure to recoil, has been rewarded with a new
vision of the city, with at least the authority of Eliot's, in which the variety
of people and the separateness and freedom of their comings and goings are
superbly caught in the imitation of their walking styles. The wonderfully

vital surface of life cannot be reduced to anything less than the big, messy sum of its resistant details. These manifold walkers guarantee heterodoxy. One's wistfulness about *The Waste Land* concerns Eliot's poor response to heterodoxy and his fearful underestimation of its value.

But *Ulysses* is not all festive, of course, nor its report on the city uniformly sunny. 'Sirens' and 'Cyclops', the two bar chapters that follow, both present poignant matters. Each however has its walking structure. In each case we have a series of entrances and then a dramatic escape-exit involving Bloom.

In 'Sirens' Dedalus strolls in first, then Lenehan. Then comes the magnificent Boylan: 'Blazes Boylan's smart tan shoes creaked on the barfloor where he strode' (340). Bloom comes, by contrast, 'walking warily' (340), a frightened and isolated figure. Under pressure from the events narrated in the chapter he will grow desperate, and make a highly agitated escape: 'Walk, walk, walk . . . waaaaaaalk'' (370). And in 'Cyclops' too the confident entrances of Joe and I, then of Bergan, Molloy, Nolan and Lenehan, are contrasted with Bloom's less poised efforts, as he 'slopes in with his cod's eye on the dog' (391). His exit, even more desperate than the last one, paints his separateness from his fellows in colours that contrast strongly with those of the carnival.

In 'Nausicaa' too an idiosyncratic walk betokens isolation and suffering. Gerty is lame, and in a book of walking, and in a chapter which makes play with footwear and its fashions, her limp is heightened in its poignancy. The chapter is static. She sits on a rock, Bloom leans on one. The sudden limping walk in the middle of it is all the more striking in such a calm context of repose. 'Oxen of the Sun' is static too, the least pedestrian chapter in the book with the exception of the recumbent 'Penelope'; but here too there is a sudden, though quite unproblematic, contrast with the prevailing stillness. At the end, in another fast exit, 'Slattery's mounted foot' (556) are encountered 'bravely legging it' (554) to Burke's and the book has found yet more locomotive resources.

'Circe' has yet another escape-exit ending, with fleeing, flitting, zigzag galloping from the hue and cry, 'helterskelterpelterwelter' (686), and Bloom's 'fleet step of a pard' (685). But its characteristic treatment of the motif is phantasmagoric. Walking regresses nightmarishly towards a state where misty forms crawl, lurch, stagger, stumble, creep, slew, swim, swerve, slide, sidle (there are many slime-primitive sibilants), slip, shuffle, swarm, sway, shamble and plodge while here and there in the viscous flow weird figures goosestep, trickleap, highkick, stilthop, chute and bolt in sudden spasms. The chapter threatens to erase the individuality of walking in orgiastic regression towards larval origins.

But the walkers come through, with Bloom upright and Stephen about to be so. The opening of 'Eumaeus', the closing of 'Eumaeus' and the opening of 'Ithaca' bring the book's story of walking to a fully restored conclusion as Bloom and Stephen 'foot it' (705) back to Eccles Street in three splendid, festive passages of walk-words. The opening of 'Eumaeus' has them bevelling around, dandering along and making a beeline in yet further deployments of pedestrian vocabulary. The closing gives vivid pictures of each of them separately (Bloom skipping around nimbly, Stephen 'weak on his pins' (796)), and then of the pair together as they 'made tracks arm in arm across Beresford Place' (770). The opening of 'Ithaca' gives them now separate now together, straggling, tiring, their courses still 'parallel' (776), but 'with interruptions of halt' (776), slowing all the time, but still smart enough to cross a circus diametrically since chords are shorter than subtended arcs.

This slow, lagging, late-night end, with two men who have walked alone all day linked briefly and precariously arm in arm, is a beautiful, muted reworking of the book's earlier carnivals. Walking unites them. Walking differently tells us how distinct they are. No triumphant end awaits them, for the book's flatness will permit no such great feelings. But each is given a final use of the motif which stays in the mind as a quiet insistence (since walking has had this meaning in the book) on their identity as separate, sentient beings. Bloom, 'the centripetal remainer' (826), is at home, so we are given, twice, an easeful picture of him 'removing in turn each of his two boots' (780). Stephen, 'the centrifugal departer' (826), has no home, so the last image we have of him concerns the 'double reverberation of retreating feet on the heavenborn earth' (827). Neither picture clamours to be taken as an emphatic or rhetorical conclusion. Neither attempts finality. But each is marvellously fitting, the more so in the opposite and balancing presence of the other. Both have that calm air of affection and acceptance which grew, slowly, from Joyce's lack of recoil from the city.

Joyce had Flaubert behind him. Flaubert's eye, in Paris or in the ancient cities of *Salammbô* and *La Tentation de saint Antoine*, was drawn to this incredible diversity of mobile, human forms. The Flaubert who listed all the different types of carriage to be seen in a traffic jam in the Champs Elysées: (berlines, calèches, briskas, wurts, tandems, tilburys, dog-carts etc.)[9] is a precursor of Joyce. So is the Flaubert whose hermit, Antoine, cannot shake off his longings for cities full of highly coloured crowds.[10] So is the Flaubert who noticed how the ample Bouvard bowled and strode along while the smaller, stiffer, thinner Pécuchet hurried along on tiny steps in a way that made him look as though he had wheels.[11]

It is a matter of an eye for the heterodox, an eye for comic-bizarre minutiae, an eye faithful to the tiny details and movements of things, including banal things, an eye too patient to feel Eliot's distaste and too fascinated by variety to wish to seek out his 'one'. It is an open, liberal and tolerant eye too, unimperious, patient with many perspectives. The political implications of such a manner are compelling, particularly with the dreadful example of the fascist Pound to hand, and the not very impressive example of Eliot with his fight against liberalism.

Such an eye was crucial for a comprehensive response to the city. It was shared by the Austrian novelist Robert Musil, whose *Man Without Qualities* conveniently summarises what there is to be found, and to be fascinated by, in a city: 'irregularity, change, sliding forward, not keeping in step, collisions of things and affairs' (*MQ*, I, 4).[12] City life is 'a tangle of forces' (*MQ*, I, 8), generating 'the well-known incoherency of ideas, with their way of spreading out without a central point . . . without a basic unity' (*MQ*, I, 17).

Musil, like Joyce, is patient with this life 'without a basic unity'. He knew, as Bloom knew on that dark occasion in 'Lestrygonians', that such a centreless and crowded life could bring the 'Waste Land' of spiritual drought: 'man's immense loneliness in a desert of detail' (*MQ*, I, 40). And (as Edward Timms suggests in Chapter 15) there is ultimately a movement in Musil's novel away from the specificity of city life into a realm of abstraction. But Musil also knows how to celebrate the pleasures of 'irregularity' and how to accommodate the dissonances and discontinuities involved.

In English Joyce is the master of this manner. He is the richest possessor of what he himself called 'tenacity of heterodox resistance' (777). That is the most important quality which Bloom and Stephen find themselves to have in common; and it is just the quality whose absence from the later Eliot gives one wistful afterthoughts, both about the direction taken by his poetic career and about the centrality given to his vision by English literary culture.

Notes to chapter 9

1 'The Love Song of J. Alfred Prufrock', in *Prufrock and Other Observations*, 1917, p. 114. Abbreviated as *P.* in the text.
2 From a Harvard lecture by Eliot, quoted in Valerie Eliot's facsimile edition of the *Waste Land* drafts, London, 1971, p. 1.
3 For Venice see 'Night Litany' from *A Quinzaine for this Yule*, London, 1908. For New York see *Patria Mia*, Chicago, 1950 [written 1931].

4 *The Cantos of Ezra Pound*, London, 1975, p. 11. I cite this edition throughout, abbreviated as C., giving Canto and page numbers. The decline of Venice is in Cantos XXV–XXVI.

5 The Siennese anti-usuary laws are expounded in Cantos XLII–LI. Wörgl, in the Austrian Tyrol, enters in XLI (p. 205) as a possible inheritor of the Siennese tradition and is still haunting him at Pisa (LXXIV, 441): 'a nice little town' whose mayor read Dante and was not afraid of hard work.

6 'The sisters', *Dubliners*, 1914. Earlier Joyce criticism tended to take the word as an open sesame to Joyce's vision of the modern city.

7 *Ulysses*, 1922, ch. 1 ('Telemachus'). I use throughout the corrected Bodley edition of 1967, page references to which are given in the text. This quotation is on p. 3.

8 T. S. Eliot, *Ulysses*, order and myth', *The Dial*, Nov. 1923.

9 *L'Education sentimentale*, 1869, Part Two, ch. 4.

10 *La Tentation de saint Antoine*, 1874. See, in scene 2, Alexandria ('des vendeurs ambulants, des portefaix, des âniers, courent, se heurtent') and Constantinople ('le clapotement des voix . . . des visages fardés, des vêtements bigarrés').

11 *Bouvard et Pécuchet*, 1881, ch. 1.

12 References to Musil, *The Man Without Qualities*, trans. Eithne Wilkins & Ernst Kaiser, London, 1953, are identified by *MQ*, followed by volume and page number.

Petersburg–Moscow–
Petropolis

'Now I am bidding the city goodbye forever. Never again will I enter that den of tigers. Their sole joy is in devouring one another; they delight in torturing the weak to their last gasp and in grovelling before the powers that be.'[1] This grim characterisation of the city comes from *The Journey from St Petersburg to Moscow* by Alexander Radishchev, published in 1790. Cast in the then popular mould of a 'sentimental journey', Radishchev's travelogue was a thinly disguised attack on the evils of Russian society. The Empress Catherine II understood its purpose well. 'The purpose of this book', she wrote, 'is clear on every page: its author, infected and full of French madness, is trying in every possible way to break down respect for authority and the authorities. To stir up in the people indignation against their superiors and against their government.'[2] Radischchev was arrested on her orders and condemned to death, a sentence later commuted to ten years' exile in Siberia. Though rehabilitated after Catherine's death in 1796 Radishchev, despairing of change in Russia, committed suicide in 1802.

Radishchev was the first in a long line of writers forced to test their convictions in a world of brutal political realities. In a society where the expression of ideas has always been circumscribed, art, and especially literature, became the vehicle for political debate. Only literature could circumvent restrictions placed upon political action by presenting political issues in the guise of personal conflicts.[3]

Politics is power, and in the centralised Russian state power was concentrated in the city. It is this which explains the city-oriented tradition of Russian literature, a tradition without which it is impossible to understand the treatment of the city in the work of the twentieth century avant-garde.

The modern Russian state has had two capitals. Moscow was the centre of the Tsardom from the sixteenth to the eighteenth century. When Peter the Great decided to found a new capital on the Baltic coast as part of his plan to create an Empire capable of becoming a European power, he moved his court to St Petersburg. He built this city on inhospitable swampland at

vast cost in terms of money and – more importantly from the point of view
of later literary representations – of human life. At the outbreak of the First
World War Petersburg was re-named Petrograd. In March 1918 the gov-
ernment of the new Soviet state moved to Moscow, like Peter emphasising
the break with the past by moving capitals.

The power concentrated in Petersburg and Moscow was out of all
proportion to their size. Even after Russia's industrial revolution in the late
nineteenth century only 15 per cent of its 160 million inhabitants lived in
towns or cities. Moscow and Petersburg twice doubled in size in the fifty
years after the abolition of serfdom in 1860, but the population of both
cities just touched two million in 1914.[4] Moreover, the majority of city
dwellers were peasants, immigrant workers who returned to the coun-
tryside at harvest time.[5] And it was the countryside which provided most of
the nation's wealth – spent by the small bureaucratic and military élite of
the capital.

This disproportionate command of wealth and power affected most
nineteenth-century literary views of the city. And from the beginning the
city is more than a background to events. It is a participant as important as
any of the characters, a symbol of Russia's historical and political
uniqueness. This can be seen in the first of the influential nineteenth century
writers, Pushkin. His 'Bronze Horseman', written in 1833, opens with a
Prologue lauding St Petersburg, and stressing its link with the past (purple
was the colour of Imperial robes, adopted by Muscovite Tsars from Byzan-
tine ceremonial):

> Before the younger capital
> Old Moscow faded,
> Like a purple-clad widow
> Before a young empress.

> I love you, Peter's creation,
> I love your stern and graceful sight,
> The imperious flow of the Neva
> Within your granite banks. (*BH* 3)[6]

The main part of the poem, however, is devoted to the story of the
destruction of a 'little man', Evgeny, by this very city. 'Glowering' Peters-
burg attacked by the flooding Neva 'swims like a Triton, waist deep in
water'. Evgeny sees the back of Falconet's equestrian statue of Peter:

> At an inaccessible height
> Above the roused river
> An idol of a bronze horse
> Stands, arm outstretched. (*BH*, 19)

Evgeny's beloved drowns in the floods and, mad with grief, he once again contemplates the statue:

> Where are you galloping, proud horse,
> And where will your hooves touch down?
> Oh powerful ruler of fate!
> Is this not the way you bridled Russia
> Above the brink of an abyss
> With an iron hand? (*BH* 24)

Evgeny's imprecations bring the statue to life. The bronze horseman pursues him until he dies, insane. The poem's symbolism was so suggestive that it was banned by Nicholas I. In 1837 Pushkin died in a duel which was an 'honourable suicide'.

The theme of the city as oppressor is equally strong in the work of Pushkin's close contemporary, Gogol. In Gogol's stories the shock of the city, rather like a physical shock, induces a state of detached disbelief which allows the author to reduce it to something absurd and unreal. *Nevsky Prospect*, the first of Gogol's *Petersburg Stories*, begins with a praise of the city's main thoroughfare, but after two anecdotes – one comic, one tragic – it ends on a sombre note:

> There is nothing stranger than the events which take place on Nevsky Prospect. Oh, do not believe that Nevsky Prospect . . . everything there breathes deceit. It is always lying, that Nevsky Prospect, but it is most false when overlain by the dense mass of night, which picks out the white and yellow of walls, when the whole city turns into thunder and lightning, when myriads of carriages tumble down bridges as postillions shout and leap up and down on the horses, and when the devil himself lights the lamps for the sole purpose of making everything appear other than it really is.[7]

This vision of the city as a symbol of Russia, and as a dangerous but exciting mirage, runs through nineteenth-century literature. The countryside, with its oppressed peasantry, could hardly be seen as a better alternative by any but the most insensitive observer – though it frequently appears as the dream of city dwellers. The Romantic concept of the ennobling qualities of life in the country did take hold after the emancipation of the serfs – but even then, as Dostoyevsky and Tolstoy show, it was only persuasive when observation was subordinated to a morally motivated imagination.

The twentieth-century Russian avant-garde, in common with their European counterparts, largely saw themselves as negating the nineteenth-century tradition. Though this is true of their treatment of form, their

treatment of ideas shows them to be remarkably bound to their literary heritage, and this continuity is particularly strong in images of the city.

To illustrate this point I have chosen three contemporaries, Andrey Bely (1880–1934), Vladimir Mayakovsky (1893–1930) and Osip Mandelshtam (1891–1938). No three writers can represent the whole of this prolific and heterogeneous generation, but they are key figures in three of the most influential movements of the period: Symbolism, Futurism and Acmeism.

Andrey Bely (the pseudonym of Boris Bugaev) was born in St Petersburg. His father was a mathematician, remembered by Bely as repressive and authoritarian. Perhaps Bely's wholehearted enthusiasms and tendency to mysticism were a reaction to the rational discipline of his childhood. As a student Bely discovered German romantic philosophy. His list of philosophers whose 'terminology he carried like an armour' – Kant, Schopenhauer, Hegel and Soloviev[8] – represents the idols of the Russian intelligentsia in the nineteenth century. From German philosophy Bely extracted the notion of the artist as visionary, and from Soloviev the concept of the special purpose of the Russian nation as a bastion of culture against the barbaric influence of civilised West and anarchic East. Between 1900 and 1909 Bely wrote poetry and literary criticism, and produced his key works on the nature of Russian symbolism. His essays show his increasing attachment to the Nietzschean concept of Superman and the sources of his nationalism and political conservatism.[9]

In 1908 Bely started work on a projected trilogy to be entitled *East or West*, which was to incorporate both his aesthetic and political ideas. The first volume, *The Silver Dove*, was published in 1909. In it Bely was more interested in developing Soloviev's theme of Russia's sacred role as a defender of true culture and of the threat of popular revolution as a manifestation of 'Pan-Mongolism', than in form. But already in 1911, as he started to work on *St Petersburg*, Bely wrote to his close friend and fellow Symbolist, Blok:

> 'On my desk at my house in the country lies an enormous book on *Freedom and the Jews* . . . Don't worry, I haven't joined the Black Hundreds [a monarchist group infamous as initiators of pogroms]. But through all the noise of the city and the musings of the countryside I can hear ever more clearly the coming migration of races. There'll come a day, soon, when nations, dropping their pursuits, will throw themselves at each other in destruction. . . . and I, listening to the noise of time, am absolutely deaf to all else.'[10]

So successful was Bely in creating the new form of literature he wanted – a verbal symphony responding to the music of time – that the racialist and

pessimistic message of the novel is submerged under the wealth of images and sounds he produces.

The novel opens with a Gogolian introduction on the subject of the Russian Empire and then focuses on the Nevsky Prospect: 'Nevsky Prospect is rectilineal (just between us), because it is a European prospect . . .'. (P, 2)[11] As Bely and his readers knew, the Prospect was meant to be rectilineal in Peter's city plan, but since it was built by two companies of soldiers starting from opposite ends of the three mile street, it has a kink in the middle, and is thus very Russian. The novel abounds in such contradictory statements, part of Bely's inheritance from Gogol. As a result, already at the end of the Prologue it is not clear whether Petersburg is, or is not, a real city: '. . . if Petersburg is not the capital, then there is no Petersburg. It only appears to exist.' (P, 2)

Having begun with a detailed description of a city which may not exist, the novel ends with a sketchy description of a countryside which patently does not exist. In between this romantic juxtaposition of town and country Bely applies his theory that 'the entire essence of man is expressed not by events, but by the *symbols* of the *other*' (A, 224). Hence the mysterious atmosphere and mystical undertones of the novel.

Three protagonists carry the narrative. The central figure is Nikolay Ableukhov. The surname is Tartar and links Ableukhov to his other self – a Mongol warrior. Nikolay is juxtaposed to his father Apollo Ableukhov, a figure of authority both historically, as Czarist Senator, and symbolically, as Saturn/Chronos and as the mythical Chinese emperor commanding Nikolay the warrior. The third protagonist is Dudkin – a terrorist and follower of Nietzsche, and in his second self, the luckless hero of Pushkin's 'Bronze Horseman'.

They are linked less by a plot than by the intertwining of their fates. All three are representatives of the Pan-Mongol threat to Aryanism because their present is shaped by an analogous past, in the case of the two Ableukhovs by ancestry, in the case of Dudkin by his Western education which led him to preach 'burning the libraries, universities, museums and summoning the Mongols.' (P, 203). The Mongolo-eschatological theme is here developed with the three main characters appearing to fulfil the prophecy in the *Silver Dove*: 'Russians are dying out; Europeans are dying out too. Only Mongols and Negroes are breeding . . . we all have Mongol blood in us and we won't be able to resist the invasion.'[12] The characterisation of Lippanchenko the double agent as a 'cross between a Semite and a Mongol' who 'passed for a Russian' (P, 42) 'is but one of several Semite/Mongol associations which show that Bely's disclaimer of anti-semitic sympathies was disingenuous.

It is not only their role as Mongol aggressors which links the three main characters – they are also victims. Throughout the novel they encounter Peter the Great, either as the Bronze Horseman or as the Flying Dutchman. His presence as the symbol of the city, both real and unreal, is clear through the merging of the sound of his pursuit with the sounds of the city. His presence as a symbol of Russia is spelt out through Dudkin/Evgeny, who sees the statue of Peter once again 'extending a heavy patinated hand', which gives the omnipresent commentators chance to answer the question posed by Pushkin in 'The Bronze Horseman':

> From that fecund time when the metallic horseman had galloped hither . . . Russia was divided in two. Divided in two as well were the destinies of the fatherland. Suffering and weeping, Russia was divided in two until the final hour.
> Russia, you are like a steed! Your two front hooves have leaped far off into the darkness, into the void, while your two rear hooves are firmly implanted in the granite soil.

The darkness and the void are the twin evils of East and West. The granite soil is the Russia of tradition, inhospitable but stable and strong. The consequences of losing touch with the soil are described in apocalyptic language:

> Once it has soared up on its hind legs . . . the bronze steed will not set down its hooves; There will be a great leap across history. Great shall be the turmoil. The earth shall be cleft. . . .
> As for Petersburg, it will sink.
> In those days all the peoples of the earth will rush forth from their dwelling places. Great will be the strife, strife the like of which has never been seen in this world. The yellow hordes of Asians will set forth from their age-old abodes and will encrimson the fields of Europe in oceans of blood . . . (P, 64–5).

Bely's style, to take an analogy from painting, is representational, meant to convey a specific vision of the world. But Bely's narrative constantly shifts from authorial and omniscient monogue to dialogue between, or interior monologue by, the protagonists. His technique is nearest to the post-Cubist approach. Bely fragments that which is seen in order to represent as many 'angles' possible as so to reconstruct a more complete and accurate representation. In the process the narrative line often vanishes, stressing the unreality of real events and the need for sublimation in the 'music of time', which speaks in the voices of the past, the present and the future.

The sense of spatial and temporal movement in the novel is increased by

his animation of objects and the use of colour imagery. The city is always on the move – as a whole or in its component parts:

> . . . the islands sank and cowered; and the buildings cowered; and the depths, the greenish blue might at any moment wash over them, might well surge over them. And over this greenish blue a pitiless sunset sent forth its reflections in all directions, and the Troitsky Bridge blushed crimson. The Palace blushed crimson. (*P*, 76).

> The rust red Palace bled . . . Under Alexander Pavlovich the Palace had been repainted yellow. Under Emperor Alexander the Second the Palace had been repainted a second time: it became rust red.
> The row of lines and walls was slowly darkening against the waning lilac sky. . . .
> And there the past was having its sunset. (*P*, 101)

> In the sky, somewhere off to the side, there was a spurt of flame. Everything was illuminated: a rosy pink ripple of tiny clouds, like a mother-of-pearl web, floated into the flames. The procession of lines and walls grew more massive and distinct. Heavy masses of some sort emerged – indentations and projections, entryways, caryatids, cornices of brick balconies.
> The lace metamorphosed into morning Petersburg. There stood the five-storeyed houses, the colour of sand. The rust red Palace was bedawned. (*P*, 140).

The structure and imagery of *Petersburg* successfully achieves that which Bely wanted – instead of a novel we are presented with a poetic fable without anchors in real time. But the ticking of the time bomb, which Dudkin has given to Nikolay with the aim of assassinating Ableukhov senior, carries the novel towards a grotesquely appropriate climax. Once set in motion, the bomb cannot be stopped and an explosion is inevitable.

Bely went on to write several more novels, none as successful as *Petersburg*. When the Revolution came in 1917 he saw it as the fulfilment of his apocalyptic prophecies and took a firmly anti-Soviet stance. He continued to publish in Russia, turning more and more in the direction of experiments in form. In 1921 he decided to emigrate, but after two years in Munich he returned. The last decade of his creative life was dominated by another city novel, *Moscow*.

The first volume of this was published in 1926, and the introduction to the second part demonstrates how far he had moved in his views since the publication of Petersburg:

> The first volume . . . shows the decay of the props of the pre-revolutionary way of life and individual consciousness – within a bourgeois group, a petit-bourgeois group and within the intelligentsia.

The second volume will attempt to give a picture of the rise of the new Moscow, no longer Tatar. In effect no longer Moscow, but a world centre.[14]

The novel shows the influence of Bely's enquiries into the nature of language and is more experimental than Petersburg in its use of neologisms. But it does not have the liveliness or conviction of his earlier work. The city he knew had sunk.

When Bely died in 1934 he was buried with honours and an obituary in *Pravda*. For our understanding of the Russian avant-garde he is interesting partly because his treatment of the city shows that while there is continuity in content, there will always be some continuity in form; partly because his example shows how mistaken it can be to identify avant-garde literature with left-wing political ideas.

If there is one Russian poet responsible for this identification it is Mayakovsky. He was a revolutionary by temperament. A year after his widowed mother brought him to Moscow he had been elected to the Moscow Committee of the illegal Bolshevik faction of the Russian Social Democrats. At fourteen he thus found himself in prison for the first time, an experience he was to repeat twice by the age of sixteen.[15]

In 1911 Mayakovsky entered an art school, where, together with David Burliuk, he founded the Futurists. He later claimed that this was done without knowledge of the Italian Futurist movement. The public 'events' organised by the Russian Futurists were designed to shock, and they did earn Burliuk and Mayakovsky explusion from art school. But Mayakovsky's early training remained with him in his visual approach to design and printing and their relationship to the printed text.

Mayakovsky's first poems were published in 1912, the same year as the First Futurist Manifesto, entitled *A Slap in the Face of Public Taste*. This, like all Mayakovsky's poems, expresses ideas in urban and industrial similes:

Only we represent our Time. The horn of Time speaks through us in the art of words.
The past constricts . . . From the tops of skyscrapers we look down at the significance of the writers of the past. (*LM*, 77)[16]

An aggressive dismissal of the experience of the past characterises many avant-garde groups, among them the Italian Futurists. Mayakovsky's unconventional education left him relatively little acquired cultural experience to reject, the one exception being language.

Mayakovsky's 1915 Futurist statement raises the 'glorious participants of Futurist publications to the rank of Martians', invites Marinetti and

H. G. Wells into the Martian government, and proclaims:

(1) All artistic canons freeze inspiration and should be banned;
(2) the language of the past, incapable of keeping pace with the speed of life, should be destroyed;
(3) the masters of the past should be thrown off the ship of modernity.
(*LM*, 88)

This radical stance might suggest that Mayakovsky wanted to invent a totally new language. This was done by his fellow Futurists Khlebnikov and Kruchenykh, whose *zaum* or transrational language disregarded conventional meaning. Mayakovsky himself used conventional language in unconventional ways:

I

On the road
of my soul outworn[a]
the steps of madmen
leave traces of hard phrases.
Where cities
hang
and in the
noose[b] of a cloud[b]
are stilled
the crooked[c] curlicues[c]
of spires –
I walk
to weep alone
over a policeman
crucified[d]
by the crossroads.[d] (*VM* I, 57)[17]

I love to see how children die.[e]
Have you noticed the misty wall of the tide-ing[f] of laughter behind the proboscis[g] of anguish? (*VM*, I, 59)

The dislocation of context (a); the creation of neologisms by changing or inventing accepted relations between prefix-root-suffix (b); the use of alliteration (c); play on words with meanings which are similar according to roots but not according to usage (d); shock (e); the creation of neologisms by changing the syntactic role of a part of speech (f) and absurd similes (g) – these are but some of the devices Mayakovsky employs in order to create a new language for the city.

Though the city excites and challenges, it can be lonely and hostile, as in 'The Inferno of the City' (*VM* I, 62) or 'The Last Petersburg Fairytale'. Written in 1916, the title was prophetic. Peter the Great re-appears in this

poem as a statue coming alive. The emperor, his horse and the snake holding up the horse's forelegs see the new Hotel Astoria in their Senate Square and decide to go in for a grenadine. At first the bourgeois clients take no notice, but when the horse starts eating the toothpicks the three are forced back on their pedestal:

> 'Chewing!
> It doesn't know what they are for.
> Peasants!
>
> And once again the emperor
> stands without a sceptre.
> A snake.
> Dejection on the horse's mug.
> And no one understands the misery of Peter –
> a prisoner
> held in irons in his own city. (*VM*, I, 124)

Like Bely, Mayakovsky saw the Revolution as the fulfilment of his prophecies, but unlike Bely he welcomed the chaos it brought as the first step towards the creation of a new world. In February 1917 he described his experiences as a driver for the medical corps in a Petrograd full of trigger-happy soldiers. The subtitle of the poem is a typical Mayakovsky neologism. It alludes to the popular cinema newsreels and reflects his fascination with film as a mass art. The poem itself tells the story of the destruction of the Tsar's two-headed eagle on the façades of the city's government buildings in a language which, like Eisenstein's 'October', overwhelms by the speed and volume of images.

<div align="center">

REVOLUTION
a poetoreel

</div>

> 26 February. Drunk, mixed with the police,
> the soldiers shot at the people.
> 27th.
>
> . . .
>
> 9 o'clock.
>
> We stand at our permanent places
> in the army driving school
> squeezed by the barrack fences.
> The dawn dilates,
> prickly with doubt,
> mingling fear and joy with foreboding.

To the window!
I see –
from over there,
where the sky is breaking through
the toothy lines of palaces,
up flies,
spreadeagled,
the autocrat's emblem,
blacker than before,
uglier,
eaglier.

The poem ends on a note of triumph:

It is not cowardice crying under the grey overcoats,
these are not the shouts of men with nothing to eat.
it is the roar of a powerful people:
– I believe
in the greatness of the human heart! –
Because above the battle-raised dust,
above all who wrangled savaged by love,
this day,
the fantastic becomes fact:
the great heresy of socialism! (*VM*, I, 129–34)

Like 'A Cloud in Trousers' (*VM* II, 7–26), 'Revolution' illustrates Maya-
kovsky's ability to combine the personal with the political. His political
commitment found practical expression in more than 3,000 posters which
he produced with a collective of writers, painters, designers and typogra-
phers working for *ROSTA*, the Russian Telegraph Agency. The experience
of 'communicating with blobs of colour and sound of slogans' is reflected in
Mayakovsky's *For the Voice*, an edition of poems written between 1917
and 1922 (Fig. 24). The title stressed the importance of sound in the poems,
and the bold layout of the pages provided visual excitement. The book itself
was indexed like an address book, so that any poem could be found without
leafing through. The design, typography and illustration were the work of
El Lissitzky and demonstrate the fruitfulness of collaboration between
artist and poet.

The poems in the book are exhortations and challenges – to fellow poets
who are to find 'new forms', to London, Paris, Berlin and Washington who
are warned that they will pay for their heartless attitude towards starving
Russia. In 1923 Mayakovsky extends the challenge to 'Paris', which like the
city of 'The Last Petersburg Poem', is lonely and oppressive:

24. Mayakovsky and Lissitzky, *For the Voice*

> Shuffled by millions of feet.
> Rustled through by thousands of tyres.
> I plough through Paris –
> frighteningly alone,
> frighteningly unpeopled,
> frighteningly soulless.

But the sight of the Eiffel Tower cheers the poet, and he appeals to the Tower to leave:

> the place of decomposition –
> the Paris of prostitutes,
> poets
> and stock exchanges.

and to come to Moscow:

> Decide, tower –
> get everything together now,
> turn Paris upside down from the highest to the lowest!
> Come with me!
> To us!
> To us in the USSR!
> Come to us –
> I will get you a visa.

Like all the poems of Mayakovsky's peak period in the middle twenties, 'Paris' is full of confidence. This is not surprising. His popularity was enormous, his audiences at his public readings vast. He could not have known that less than a decade later he himself would be unable to visit the Eiffel Tower: he was refused an exit visa.

In the years between 1922 and 1930 Mayakovsky spent much of his time abroad, with never more than 15 months between trips. His visits to America were recorded in a series of poems about New York. These show his ambivalent attitude to the city which epitomised capitalism and modernity at the same time. This is 'Broadway' through Mayakovsky's amazed eyes:

> Asphalt – glass . . .
> I walk and tremble.
> Forests and grass
> have been shaved off.
> To the north
> to the south
> there are avenues.
> From the east to the west
> streets.

And between them –
 (how did the builder get them there!)

houses
 stand impossibly tall . . .

At 7 a.m.
 the human tide comes in,

at 5 p.m.
 it goes out.

Machinery grits its teeth,
 racket and din,

but people
 are dumb in the noise . . .

I am thrilled
 by New York city.

But
 I won't take off
 my cap.
Soviet people
 have something of their own to be proud of:

We look down
 on the bourgeoisie. (*VM*, I, 492–5)

The same ambivalence is felt in 'Brooklyn Bridge':

I am proud
 of this
 steel mile,

my visions
 have come alive in it –

the struggle
 for construction
 instead of style . . .

Here
 life
 was
 carefree for some,

and for others
　　　　a long
　　　　　　　hungry moan. (*VM*, I, 519–23)

The technological glory of the Brooklyn Bridge, like that of the Eiffel
Tower, was Mayakovsky's because it was a human achievement which
belonged to everyone. But New York was not his city, it belonged to an
alien world. 'Good', written in 1927, shows Mayakovsky's attitude to his
own city:

I have
　　　seen

almost the whole
　　　　　　of the world, –

and life
　　　is good,

and to live
　　　　is good . . .

A snake-like street
　　　　　　　slithers.

Along the snake
　　　　　　are houses.

The street is
　　　　mine.

The houses are
　　　　mine. (*VM*, II, 257–332)

The poem shows Mayakovsky's command of rhythm, 'the main source of
power, the main energy of verse' (*VM*, II, 484). It is achieved by the
breaking of lines into 'sense groups', a technique as rigid in his later verse as
the rhyme he rejected. Mayakovsky was thus himself trapped in a canon
which 'froze inspiration', albeit one of his own devising.

'Good' was the last of his city poems. The poems of the last two years of
his life are the consequence of his belief that 'the best works of poetry are
those written on order for the Communist International' (*VM*, II, 472). The
Party's call for the 'unity of theory and practice', Sino-Soviet relations, the
building of the Kuznetsk metallurgical complex and Lenin were the subjects
which replaced the city in Mayakovsky's late verse. Much of this was well
crafted, but without the passion or inventiveness of his earlier work.

In his life, as in his work, Mayakovsky could not separate the public from the personal. It is impossible to tell what caused the depression which led to his suicide in 1930: his quarrels with an increasingly dogmatic literary establishment, or the problems created by his personal relationships. But the absence of the city from his verse in the last years of his life is significant. When Mayakovsky ceased to be interested in the city he ceased to be interested in life.

Bely and Mayakovsky were activists at opposite ends of the Russian political spectrum. Between them stands the figure of Osip Mandelshtam, the reluctant participant of a violent age.

Petersburg was the city of Mandelshtam's youth and the source of much of his inspiration. But he was fascinated by all cities with a past. The reasons for his fascination can best be understood from *The Dawn of Acmeism*, an article which defined the artistic credo of the group to which Mandelshtam belonged.

> Acmeism is for those who, seized by the spirit of construction, do not faint-heartedly reject the weight of their substance, but accept it joyfully, in order to awaken the forces dormant within and use them architecturally . . . Like Sebastian Bach, who established the Gothic in music, we have introduced the Gothic into the relationship of words. (*LM*, 46)

Mandelshtam's love of cities is rooted in the parallel between architecture and poetry as manifestations of culture. In *The Dawn of Acmeism* Mandelshtam cited Notre Dame cathedral as the epitome of art because it contained 'the noble mixture of intellect and mysticism and a sense of the world as a living equilibrium' valued by Acmeists. This was a re-statement of his poem 'Notre Dame', which so perfectly expresses Mandelshtam's view of beauty as a harmonious blend of the best in human tradition:

> There, where a Roman juror judged an alien people,
> Stands a basilica – the joyful and the first,
> Like Adam once, with nerves outspread,
> A light cruciform vault ripples its muscles . . .
>
> An elemental labyrinth, a forest transcending comprehension,
> The rational abyss of a gothic soul,
> Egyptian might and Christian timidity,
> Oak next to reed, and everywhere the perpendicular is king.
>
> But the more attentively, stronghold Notre Dame,
> I studied your monstrous ribs,
> The more I thought: from evil weight
> I too will one day create beauty. (*OM*, 74–5)[18]

Everything that Mandelshtam valued in cultural tradition is here: Roman

law, Greek classicism (basilica, Minoan labyrinth), Old Testament Judaism (Adam, Egyptian might), New Testament Christianity and the Gothic.

'Notre Dame' belongs to Mandelshtam's first published collection. This included *The Petersburg Strophes*, which opens with an architectural description of the city:

> Above the yellowness of government buildings . . .
>
> The ships are hibernating; the warm rays of the sun
> Light up the thick glass of a cabin.
> Monstrous – like a battleship in dry dock –
> Russia is heavily resting.
>
> Above the Neva the flags of half the world are flying.
> The Admiralty, silence, sun!
> And the harsh purple cloak of state,
> Is like a habit, coarse and poor . . .

The poem ends with a reference to Evgeny from Pushkin's 'Bronze Horseman':

> Processions of cars fly into fog.
> Evgeny, a touchy, humble pedestrian,
> An odd-man-out, ashamed of poverty,
> Inhales the petrol fumes and curses fate. (*OM*, 76–7)

Most of Mandelshtam's verse is written, like the *Petersburg Strophes*, in classic Pushkinian metre, with an ab ab rhyme. This makes his meaning apparently simple to understand. But even though Mandelshtam insisted that words should be used 'as they are' (*LM*, 45), rather than as symbols, his language is complicated by his reliance on allusions. Thus Evgeny is not only a reference to Pushkin: he shares his touchiness with Gogol's odd-men-out and with Mandelshtam himself, as portrayed in 'The Pedestrian', a poem published in the same collection. The poem identifies Petersburg not only with the fate of Russia but also with his own fate. The ambiguity of meaning increases the sense of foreboding which permeates Mandelshtam's verse.

The link between Petersburg and Mandelshtam is particularly clear in a short poem written in 1916 and published in the collection *Tristia*. Like Bely and Mayakovsky, Mandelshtam was sufficiently attuned to his time to expect violent change, but the poem is frighteningly prophetic of his fate:

> In translucent Petropolis we shall die,
> Where we are ruled by Prosperpine.
> We breathe in fatal air with every sigh,
> And every hour becomes a fatal year.

> Goddess of the sea, imperious Athena,
> Remove your mighty helmet of stone.
> In translucent Petropolis we shall die.
> It is not yours. Proserpine rules alone. (*OM*, 98)

Mandelshtam was in Petrograd when the Revolution broke out, but his experiences did nothing to change his vision of the city as a dying mirage, as can be seen from the first poem he wrote about the city in 1918. It calls into question the reality not just of the city, but of the cosmos.

> Earthly dreams burn at a fearful height,
> A green star is flying.
> If you are a star, brother to water and sky,
> Your brother, Petropolis, is dying. (*OM*, 108)

Though he was willing to co-operate with the Soviet government and even moved to Moscow with the Ministry of Education when the capital was transferred, his 'ode' to the Revolution showed his attitude was distinctly ambivalent:

> Let us praise, brethren, the twilight of freedom,
> The great twilit year!
> Into the seething night waters
> The heavy net of snares has been lowered.
> You are entering the dead years,
> Oh sun, oh judge, oh people! (*OM*, 109)

By 1920 he had returned to Petrograd. After 1914 Petersburg was as artificial a name for the city as Petropolis, but there is no doubt that his use of it was intentional:

> We will meet again in Petersburg,
> Just as if we had buried the sun there . . .

> The capital is crouching like a cat,
> A patrol stands on the bridge,
> Only an angry car hurtles past,
> shrill like a clockwork cuckoo.
> I do not need a night pass,
> I am not afraid of the guards:
> I will pray in the Soviet night,
> for the blessed, meaningless word . . . (*OM*, 117–18)[19]

Petropolis was the vision of an ideal city to which Mandelshtam retreated from reality. But as reality became increasingly obtrusive, old names and memories were an assurance that there had been a past. The search for escape and assurance is described in *The Noise of Time*, auto-

biographical essays published in 1924. He describes what Petersburg meant to him in childhood:

> The whole of the graceful mirage of Petersburg was just a dream, a sparkling cover thrown over the abyss. I was surrounded by the chaos of Jewishness. Not a homeland, not a home, not a hearth, but literally chaos, an unfamiliar womb world from which I had come, but which frightened me, which I vaguely guessed at, but ran, ran away from.[20]

But the 'noise of time' was too strong. Mandelshtam's last poems from his beloved city are anguished appeals, whose simplicity makes them all the more moving:

> Petersburg, I do not want to die yet
> you have my telephone numbers.
>
> Petersburg, I still know the addresses
> where I can find dead men's voices.
>
> I live by the servants' staircase, and the bell
> Torn out with the flesh, strikes my temple.
>
> All night I clank the fetters of my doorchain
> As I wait in expectation for dear friends. (OM, 150–1)
>
> Help me, oh Lord, to live through this night:
> I fear for my life – Thy slave.
>
> In Petersburg life is the sleep of the grave.[21]

In 1933 Mandelshtam wrote a poem about the 'fat-fingered Kremlin highlander' – Stalin.[22] For this he was condemned to three years' exile. He made an unsuccessful attempt to emulate his predecessors, but he was prevented from taking his own life. Instead he was arrested within a year of his release and condemned to five years hard labour for 'counter-revolutionary activities'. He died an unrecorded death in a camp sometime between October and December 1938.

Like Catherine the Great, Stalin knew that the only safe art was dead art. It is extraordinary how many of Mandelshtam's, Bely's and Mayakovsky's contemporaries felt that dead art was not worth living for.

Notes to chapter 10

1 Alexander Radishchev, *A Journey from St. Petersburg to Moscow*, trans. L. Wiener, ed. R. P. Thaler, Cambridge, Mass., 1958, p. 52.
2 *A Journey*, p. 239.
3 On the relationship between literature and politics in nineteenth century Russia see Isaiah Berlin, *Russian Thinkers*, pp. 127–31.
4 James H. Bater, *St. Petersburg*, London, 1976, p. 3.

5 *St. Petersburg*, p. 309: Richard Pipes, *Russia under the Old Regime*, London, 1974, p. 141.

6 *BH* = Alexander Pushkin, *The Bronze Horseman*, edited by E. Hill, London, 1961. This and all subsequent translations are mine, unless otherwise indicated.

7 Nikolay Gogol, *Sobranie sochineniy*, 1, Moscow, 1966, p. 459.

8 Andrey Bely, *Mezhdu dvukh revolyutsiy*, Leningrad, 1934, p. 7.

9 *A* = Andrey Bely, *Arabeski*, Moscow 1911.

10 Andrew Blok and Andrey Bely, *Perepiska*, Moscow, 1940, p. 269.

11 *P* = Andrew Bely, *Petersburg*, translated by R. A. Maguire and J. E. Malmsted, London, 1978. This translation, which has been reissued by Penguin, contains detailed notes and a useful introduction, including an account of the various editions of the novel.

12 Andrey Bely, *Serebryanny golub*, Munich, 1931, p. 93.

13 Anne Steinberg, *Word and Music in the Novels of Andrey Bely*, Cambridge, 1982.

14 Andrey Bely, *Moskva*, Moscow, 1926, pt. 2, p. 5.

15 Edward J. Brown, *Mayakovsky, a Poet in Revolution*, Princeton, 1973.

16 *LM* = *Literaturnye manifesty*, Moscow, 1929.

17 *VM* = Vladimir Mayakovsky, *Sochineniya*, 3 vols., Moscow, 1970.

18 *OM* = Osip Mandelshtam, *Stikhotvoreniya*, Leningrad, 1974.

19 In the 1928 edition Mandelshtam changed Soviet to January (see Clarence Brown, *Mandelshtam*, Cambridge 1973).

20 Osip Mandelshtam, *Egipetskaya marka*, Leningrad, 1928, p. 86.

21 Clarence Brown, p. 126.

22 Osip Mandelshtam, *Selected Poems*, trans. D. McDuff, London, 1983, p. 130.

Asphalt jungle: Brecht and German poetry of the 1920s

The outcome of the First World War brought disillusionment to German writers in a variety of senses. The human and material sacrifices made in the pursuit of military victory had proved ultimately to have been in vain, and the burden of reparation payments demanded by Britain and France exacerbated a mood of political resentment. The notorious inflation which had been set in train by the war effort, and which undermined the security of the middle classes in the early 1920s, also deprived many a literary figure of the financial independence which had previously sustained autonomous artistic creativity. And those whose opposition to the Wilhelmine state had led them to seek a revolutionary transformation of German society were confronted with the brutal suppression of insurrectionary regimes which might conceivably have provided a platform for radical change – a suppression instigated, moreover, by leaders of the main working-class party, the SPD. Idealistic appeals to the principle of universal brotherhood were no longer appropriate to the politically fraught world of the Weimar Republic, and socially engaged writers found themselves compelled to devise new litcrary strategies to fit their altered circumstances. As Michael Hamburger has noted, the dominant poetic trend in the 1920s is one of retrenchment.[1] It is worth considering some of the implications of this general trend before looking more closely at the young Brecht's poetic responses to the city.

The generic term most commonly applied to the literature of the period 1923–9 in particular is *Neue Sachlichkeit*. Like the terms Impressionism and Expressionism, it is a description which first became established in the sphere of the visual arts. Georg Friedrich Hartlaub, the director of the Mannheim municipal gallery, assembled an exhibition under this title in 1925 which, in contrast to the abstract and visionary qualities of Expressionism, firmly reasserted the claim of figurative art, of a style soberly

25. Grosz, *Cross-Section*

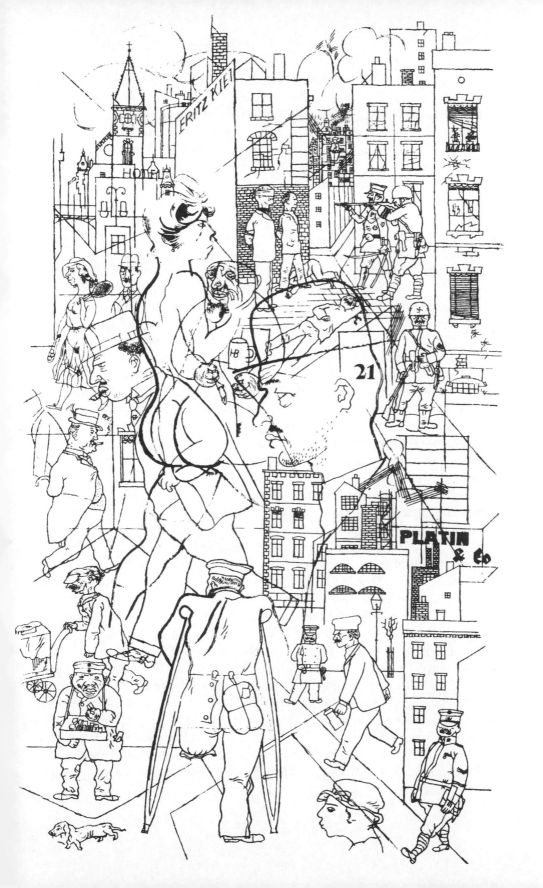

depicting recognisable subjects drawn from everyday life, and often con-
veying a clear comment on contemporary social reality. Max Beckmann,
Otto Dix and George Grosz are the best-known exponents of this 'new
objectivity' in art. But the term *Neue Sachlichkeit* rapidly came to be
applied to the general cultural atmosphere after the breaking of the Expres-
sionist wave, because the German adjective *sachlich* was taken to imply not
only a concern with hard facts and a new sobriety of approach to political
issues, but also a more general mood of disillusionment and cultivated
insouciance. 'Sachlichkeit' is the word which expresses, for example, the
callous disregard which Brecht's Baal shows for the emotions of the women
he takes to bed (*GW* 1, 20).[2] All these features of post-war Germany are
conveniently captured in Grosz's line drawing *Querschnitt* ('Cross-Sec-
tion') of 1920, which superimposes morose and single-minded civilian
figures, and unsentimental representations of carnal lust, upon images of
the war-wounded and of political violence (see Fig. 25). When applied to
the literature, *Neue Sachlichkeit* is not an adequate term to embrace the
wide variety of trends and developments which follow Expressionism, but
may be usefully applied to a new vein of (non-Marxist) critical realism
which manifests itself, for example, in the plays of Ferdinand Bruckner and
Ödön von Horváth, in the poetry of Erich Kästner (which is discussed
below), and in a host of social novels.[3]

It is true that the innovative techniques of Expressionism continued to
exert an influence in the 1920s, particularly in the theatre and in the rapidly
developing new medium of the film (see below, pp. 193–213). It is also
during the period of the Weimar Republic that the impact of modernist
developments elsewhere is keenly felt in the German novel. The stimulus of
Joyce's *Ulysses* and Dos Passos's *Manhattan Transfer*, for example, is
apparent in Alfred Döblin's *Berlin Alexanderplatz* (1929) and Hermann
Broch's *Die Schlafwandler* ('The Sleepwalkers,' 1930–2). The first volume
of Robert Musil's *Der Mann ohne Eigenschaften* (*The Man Without Qua-
lities*), which appeared in 1930, is more conservative technically, but might
be said to have taken to heart Ezra Pound's observation that city life had
become essentially 'unnarrative': Musil's early chapters offer rich and
amusing comment on the ways in which modern urban life presents itself as
diffuse and unpredictable, with 'experience' often derived from news-
papers, and ideas being simply 'in the air'. Döblin's *Berlin Alexanderplatz*
is often (rightly) seen as the most radical German attempt to incorporate
these diffuse city experiences in the framework of a novel, exploiting both a
variety of montage techniques and also a positively protean narrative per-
spective. Döblin was probably the most enthusiastic of all German writers
in his championing of Berlin as a thrilling centre of modern civilisation. But

his novel, as much as any other literary work of the period, also reflects in intensified form the mistrust, disorientation and insecurity which are the common negative aspects of urban humanity. For in *Berlin Alexanderplatz*, the multiplicity of city experiences is largely reflected through the eyes of a very bewildered ex-convict, Franz Biberkopf; the 'heartbeat' of the city is represented by the incessant pounding of a pile-driver, with its associations of uncontrolled disruption of familiar human environments; and the ultimate battle for Biberkopf's soul is depicted allegorically as a contest between the figure of Death and a biblical image redolent of the worst in urban depravity and corruption, the Whore of Babylon.[4] Brecht, too, was to look back on Berlin (and London) as 'impossible to live in, and impossible to leave' (*GW* 9,533).

In the ambivalence of literary representations of the city, there are often echoes of the political tensions which existed between Berlin in particular and the rest of the country. Between 1850 and 1910 the population of Berlin had grown rapidly from less than half a million to over four millions, in the course of Germany's belated industrial revolution. After the First World War, it came to be seen by many as a capital of an unpopular Republic (although we should remember that electoral support for the main Republican parties never fell below one third of the votes cast). Insofar as the abolition of censorship had encouraged an atmosphere of licentiousness, Berlin was often seen as a centre of depravity by contrast with the comforting traditional values of the provinces. And as the obvious focal point for the film, theatre, and publishing industries, Berlin engendered both awe and hostility as the breeding ground of a rampant cosmopolitanism which was stigmatised by right-wing nationalists as 'Asphaltliteratur' and 'cultural bolshevism'. The sense of irreconcilable antagonism between city and country became entrenched in conceptual categories which had been popularised by German sociologists since the turn of the century as an opposition between western, rational, individualistic 'society' (Gesellschaft) on the one hand, and an idealised organic 'community' (Gemeinschaft) on the other.[5]

The sense in which such inherited categories continue to influence the responses of writers to contemporary urban culture in the 1920s is apparent from the development of Georg Kaiser, whose plays dominated the theatre repertoires in the immediate post-war years. Kaiser had come to prominence with the surge of Expressionist productions which was unleashed in 1917. He was a socialist and pacifist, whose *Gas* trilogy (1917–20) presented in vividly abstracted form the major antinomies of modern society between capital and labour, between technological advance and civilised association. (The trilogy concludes, in fact, with a

G

terrible anticipation of the destructive potential which technology can acquire in the hands of centralised state power.) But civilised association already appears here in terms of a nostalgic dream of semi-rural, pre-industrial order; and when Kaiser comes to treat the social realities of the early 1920s in a play, *Nebeneinander* (1923), for which George Grosz designed characteristically stark sets, he relapses still more obviously into established thought patterns. Kaiser's title here is chosen to emphasise the sense in which city-dwellers live merely *alongside* each other, in a spirit of mutual indifference. The quixotic central figure of the play is the proprietor of a pawnshop who finds a suicide note in an article of clothing which has been surrendered to him, and embarks on a frantic search for the woman who wrote it. His quest provides for a systematic exposure of the harshly fragmented *Gesellschaft* of the city, by contrast with which the desperate young lady he seeks has found succour in a still intact, humane, rural *Gemeinschaft* downriver from Berlin. Even Kaiser, then, whose achievement in establishing the drama of ideas in the live theatre was later acknowledged by Brecht, remains imprisoned by received ideas which are decidedly biased against the ambience of the modern city.

With regard to the lyric poetry of the period, the term 'retrenchment' is appropriate not only to the retreat from technical innovation, but also to a widespread tendency to look to the world of nature for inspiration of a traditional kind. This point can be briefly illustrated from the works of Oskar Loerke. As a publisher's reader with the influential house of S. Fischer after the First World War Loerke had accorded recognition to the originality of younger poets such as Brecht. But his own poetry typifies the uneasy attempt to reabsorb urban experience into a language of 'eternal values' and established codes of beauty, tendencies which Brecht himself ruthlessly opposed. In the poem 'Berliner Winterabend' ('Winter evening in Berlin'), for example, which was published in 1934 but probably written earlier, Loerke evokes naked trees which bear a passing resemblance to the ones which appear in Georg Heym's 'Umbra Vitae' (see above, p. 000). He likens them to birch-twig brooms as wielded by the unemployed (Arbeitslose) — but instead of sustaining this image he pursues a compensating association in the fragrance carried on a southerly breeze, contriving what can only seem a disdainful rhyme: Arbeitslosen/Mimosen. More clearly still, the title poem of Loerke's 1926 collection, *Der längste Tag* ('The longest day'), compares electric lightbulbs hanging across a street with lemons in a 'primal glade of darkness' ('Urhain des Finsters').[6] When the periodical *Die literarische Welt* held a competition for young writers in 1927, all three judges (Brecht, Döblin, and the drama critic Herbert Ihering) commented on the overwhelmingly escapist tendency of the work submitted.[7] Such

manifestations of a literary retreat from the brutality of urban culture are not commonly associated with Germany in the 1920s, but it is necessary to be aware of them in order to understand the provocatively unsentimental tone which is assumed, in deliberate contrast, in much of the more familiar poetry of the period.

Erich Kästner's poem about pavement cafés reads almost like a conscious riposte to Loerke's 'Der längste Tag'. Kästner is insistent about the squalid origins of the artificial palm trees which decorate his café; and even if the balmy evening breeze might seem to trick the senses into thinking that the hats dangling from the hatstand are exotic fruits, the hats remain obstinately what they are:

> *Trottoircafés bei Nacht*
>
> Hinter sieben Palmenbesen,
> die der Wirt im Ausverkauf erstand,
> sitzt man und kann seine Zeitung lesen,
> und die Kellner lehnen an der Wand.
>
> An den Garderobenständern
> schaukeln Hüte, und der Abendwind
> möchte sie in Obst verändern.
> Aber Hüte bleiben, was sie sind . . . (*GSE* 1, 84)[8]

(Pavement cafés by Night.

Behind the seven broomstick palms that the landlord bought in a closing-down sale, you can sit and read the paper, and the waiters lounge against the wall.
Hats tremble on the hatstands, and the evening breeze is trying to transform them into fruits, but a hat's a hat for a' that.)

In the following stanza, the stars themselves appear to be colluding in a meretricious deception (posing as neon lights). And the sense in which Käster, here as elsewhere, is deliberately suppressing his own sentimentality is apparent when he goes on to picture an idyllic glade, with a roe deer emerging from the forest, and to imagine that its first communication would be to ask him how much he earns.

Kästner's disillusioning technique is frequently a simple inversion of the tendency we saw in Loerke: he absorbs the phenomena of nature into a terse commentary on the brittle human constructs of the city. The trees of the Berlin boulevards are made to exchange sentiments in the same abrupt argot as the human inhabitants (in the poem 'Atmosphärische Konflikte': *GSE* 1,104). The deliberate casualness of diction and seeming triviality of content in Kästner's poems produce a tone of sardonic familiarity and disrespectful irony well known to Berliners by the expressive term

Schnoddrigkeit. When he evokes the approach of spring, in the poem 'Besagter Lenz ist da', he presents it as the time of year when petty bourgeois partriarchs venture out onto balconies to survey the contents of their window boxes, and speaks of the world of nature getting a fresh coat of paint – rather like an amusement arcade (*GSE* 1, 60). But that title, 'Besagter Lenz ist da', is a pointer to the less superficial qualities in his poetry. A poetically clichéd term for spring (Lenz) is combined with an adjective heavily associated with bureaucratic parlance (besagt), producing an effect which we can only roughly approximate in English by imagining a burlesque reference to 'the aforesaid primavera'. Kästner's most trenchant lines are achieved by such confrontation of uncritically inherited formulae with the harsh realities of social injustice and economic oppression. Under the impact of the Great Depression, however, such confrontations themselves came to look like mere mannerisms. In the successive volumes of popular verses which Kästner published between 1929 and 1933 there is much mock-heroic posturing and general despair at an urban culture which is fully motorised but running out of control ('Die Zeit fährt Auto, aber kein Mensch kann lenken': *GSE* 1, 85); and it was these aspects of Kästner's work which led the critic Walter Benjamin, in a famous essay of 1931, to accuse Kästner of turning the stuff of legitimate social protest into a source of childish (and lucrative) amusement.[9]

Brecht's city poetry also begins by confronting and subverting outmoded conventional attitudes, but as time goes by he becomes increasingly engaged in the search for a means to go beyond the isolation, insecurity, cynicism and despair, which he, too, experienced as the brutal realities of Berlin in the 1920s. It is well known that Brecht's early plays, such as *Baal*, constitute a reaction against the vapid abstractness of Expressionist drama in their emphatic celebration of animal vitality and sensual appetites. His poetry, similarly, is often robustly colloquial (but without the flippancy to be found in Kästner), owing much to the earthy heritage of Martin Luther's sixteenth-century Bible translation, which was itself consciously modelled on the language of the common people, and was as yet unhampered by grammatical strictures which later helped to shape the standard German literary language. The Lutheran idiom is itself parodied, however, in the course of Brecht's assault on hollow idealism and conventional morality. A single line, modelled on Luther's hymn 'Lobet den Herrn' ('Praise to the Lord'), amply demonstrates the pungent effect of Brecht's combination of pagan vitalism with traditional rhythms: 'Lobet den Baum, der aus Aas aufwächst jauchzend zum Himmel' (Praise to the tree that grows joyously heavenwards feeding on corpses: *GW* 8,215).

The didactic tone with which Brecht's name is most frequently

associated also enters his poetry initially in the form of a parody of ecclesiastical idiom. His first major collection of poems, *Bertolt Brechts Hauspostille* (1927), derived both its title and much of its format from the domestic breviaries commonly kept in religious households. The line quoted at the end of the previous paragraph is taken, in fact, from a poem which appears in this collection under the title 'Großer Dankchoral' ('Great chorale of thanksgiving'). The collection also contains three 'psalms', which celebrate animal vigour every bit as robustly as the songs of Baal, some of which are also included. There is a 'final chapter' entitled 'Gegen Verführung' ('Against deception'), which inverts the sentiments of traditional moral injunctions, exhorting the reader instead to be undeceived about the non-existence of a hereafter, and about the need to grab all that is going in this life while it lasts. And there is a ballad which masquerades as a 'Liturgy of the breath of wind' ('Liturgie vom Hauch'), and which incorporates as the recurring chorus (or 'Response'!) a travesty of a famous poem by Goethe which evokes the atmosphere of dusk, when scarcely a breath of wind is felt in the forest: Brecht's poem tells instead of violent acts occurring in a wood on the edge of town, which carry echoes of the brutal imposition of 'law and order' in post-war Germany.

More obviously relevant to the theme of the city are those songs in the *Hauspostille* collection which were ultimately destined for inclusion in the opera about the rise and fall of the imaginary boom town Mahagonny, for which Kurt Weill wrote the music. The town's name is derived from that of the familiar South American hardwood, but its exotic quality, possibly combined with associations of 'agony' and 'agonistic', evidently suggested to Brecht a fitting term for the beery pipe dreams of disorientated petty bourgeois figures whom he had witnessed, in post-war Munich, already falling prey to the delusions of National Socialism. In the Mahagonny songs, the restless superfluous millions of Europe's cities are presented as drifting towards the New World in the hope of escaping the woes of civilisation or, as Brecht puts it in an unsavoury double entendre, to be cured of their 'Zivilis' (GW 8, 244). This restless nostalgia of rootless urban populations is invoked, and subverted, in various of Brecht's projects of the 1920s, through the recurring appearances of bizarre characters who seem to be permanently en route from Chicago to Alaska via Alabama and the Hindu Kush. There is no ultimate escape from the pressures of modern urban culture, however, as the *Mahagonny* opera was designed to show. One particularly colourful illustration of this point can be quoted in Brecht's original jolly English (and was to be sung, in Brecht's original setting, to a shanty tune resembling 'There is a tavern in the town'):

Benares-Song

1

There is no whisky in this town
There is no bar to sit us down
Oh!
Where is the telephone?
Is there no telephone?
Oh Sir, God damn it:
No!
Let's go to Benares
Where the bars are plenty
Let's go to Benares!
Jenny, let us go. (*GW* 8, 247)

The final stanza punctures this wistful whimsy with the news that an earthquake has destroyed the town of Benares and the dream of escape along with it.

In spicing his works with idioms culled from showbiz American English, Brecht was provocatively associating himself with that breezy modernity which was rippling the cultural backwaters of Central Europe in the 1920s. While he was soon to distance himself from an uncritical acceptance of technological innovations and the capitalist 'rationalisation' of industry, his poetry contains indications of a demonstrative affirmation of urban industrial culture which is quite unprecedented in German literature. We find him in eloquent control of the ambiguous emotions associated with city living, for example, in one of his best-known poems, 'Vom armen B. B.' ('The ballad of poor B. B.'), which is appended to the *Hauspostille* collection. Here Brecht presents a self-consciously stylised image of himself as one who has been carried in his mother's womb into the asphalt city, and who confronts it with the coolness of the forests she left behind. It is with evident self-satisfaction that he describes the rhythms of his daily life, the social encounters of an incurable sceptic and an undependable lover; and he flies in the face of poetic convention by referring to the dawn chorus as 'vermin' in the trees. But the final three stanzas assume an almost prophetic tone, emphasising the transience of human life and the precariousness of civilisation in terms which reflect his contemporaries' sense of (bourgeois) culture in decline and social upheavals ('earthquakes') to come:

7

Wir sind gesessen, ein leichtes Geschlechte
In Häusern, die für unzerstörbare galten
(So haben wir gebaut die langen Gehäuse des
 Eilands Manhattan
Und die dünnen Antennen, die das Atlantische Meer
 unterhalten).

8
Von diesen Städten wird bleiben: der durch sie
 hindurchging, der Wind!
Fröhlich machet das Haus den Esser: er leert es.
Wir wissen, daß wir Vorläufige sind
Und nach uns wird kommen: nichts Nennenswertes.

9
Bei den Erdbeben, die kommen werden, werde ich
 hoffentlich
Meine Virginia nicht ausgehen lassen durch Bitterkeit
Ich, Bertolt Brecht, in die Asphaltstädte verschlagen
Aus den schwarzen Wäldern in meiner Mutter in
 früher Zeit. (GW 8, 262–3)

(An insubstantial generation, we sat in houses which were considered indestructible. In this spirit we built the tall blocks on the Isle of Manhattan and the slender antennae which entertain the Atlantic Ocean.

All that will remain of these cities is what passed through them: the wind! The house maketh glad the man who doth eat, for he doth empty it. We know that our existence is a provisional one, and after us will come: nothing worth talking about.

In the earthquakes that are to come, I hope I shall not let my cheroot go out through bitterness – I, Bertolt Brecht, carried into the asphalt cities from the dark forests, inside my mother in times gone by.)

Brecht's first direct experience of Berlin happened to coincide roughly with his reading of Rudyard Kipling's stories of the British Raj. In a diary note of September 1921 he wrote:

When I considered what Kipling did for the nation which is engaged in 'civilising' the world, I made the historic discovery that nobody up till now has actually described the big city as a jungle. Where are the heroes, the colonisers, the victims of the metropolis? Its hostile atmosphere, its stony hardness, its Babel-like confusion, its poetry, in short, is something which has yet to be recorded. (cf. GW 18, 14)

In 1930 Brecht published a second collection of poems explicitly styled a 'Reader for city dwellers' (*Aus einem Lesebuch für Städtebewohner*). These compositions, accumulated in the mid-1920s, constitute a more determined and precisely-observed confrontation of a city experience which is recognised as entirely unheroic. Here Brecht's style systematically imitates the pithy prose rhythms of the city-dwellers themselves; and the content, too, is stripped down to the exposition of a simple socially significant action or relationship. In the context of his stage plays, Brecht was later to coin the

term 'Gestus' (from the same Latin root as the English 'gesture') to denote just such a focusing of attention on a single revealing aspect of human behaviour. The first poem of the *Lesebuch* is typical of the sombre tenor of the collection generally, and of the way that attitudes inculcated by the processes of urbanisation are held up for critical scrutiny. It evokes a city ethos which encourages the newcomer to insulate himself against the possibility of rebuff and betrayal, denying his friends, denying his parents, denying his own thoughts, in order not to be caught out. But then, in a final parenthesis, these attitudes of mind are themselves identified as examples of 'what experience has taught me'. The last two stanzas already contain intimations of the political dimension within which this evasive and dissimulatory behaviour needs to be understood:

> Was immer du sagst, sag es nicht zweimal
> Findest du deinen Gedanken bei einem andern: verleugne ihn.
> Wer seine Unterschrift nicht gegeben hat, wer kein Bild hinterließ
>
> Wer nicht dabei war, wer nichts gesagt hat
> Wie soll der zu fassen sein!
> Verwisch die Spuren!
>
> Sorge, wenn du zu sterben gedenkst
> Daß kein Grabmal steht und verrät, wo du liegst
> Mit einer deutlichen Schrift, die dich anzeigt
> Und dem Jahr deines Todes, das dich überführt!
> Noch einmal:
> Verwisch die Spuren!
>
> (Das wurde mir gelehrt.) (*GW* 8, 267–8)

(Whatever you say, don't repeat it. If you find one of your own thoughts on someone else's lips, deny it. If you haven't put your signature to anything, if you haven't left your picture anywhere, if you weren't there and didn't say anything, then you won't get caught! Cover your tracks!
Take care, when you are ready to die, that no monument stands and betrays where you lie, with a clear inscription that denounces you, and the year of your death which may be used in evidence against you! Once again: cover your tracks!
[This is what I have been taught.])

In the early 1930s, and again after 1945, Brecht was to become associated with a much more optimistic articulation of the political solidarity needed for the task of social reconstruction. But what distinguishes his political poetry generally from that of other class-conscious writers in Germany is the sense it conveys of the individual grappling with intractable realities, of the rugged path that leads to collective commitment.[10] What we

find expressed in Brecht's *Lesebuch*, and in poems related to it, is the determination of individual city-dwellers not to surrender to the hostile environment in which they find themselves, not to be listed among the casualties of the struggle (cf. *GW* 8, 291–2). The brutalisation of a mobile labour force is vividly evoked in the monologue of an overseer which begins, 'Tritt an! Warum kommst du so spät? Jetzt / Warte! Nein, du nicht, der da!' (Fall in! Why are you so late? Now you can wait! No, not you, the other one! (*GW* 8, 277)) Personal relationships are acknowledged to be interchangeable, and the loss of personal identity brings frequent anxiety dreams (*GW* 8, 279, 281). It is in the face of the knowledge that contracts are made to be broken, and even the word of one's nearest and dearest cannot be relied upon, that the need is asserted to learn the ABC of social oppression: there will be no immediate results, but analysis is a necessary step (*GW* 8, 274–5). And it is only slowly, and against great odds, that the thoughts of one woman can move from the categories of colloquial self-deprecation towards self-discipline and self-assertion in the image of a new civilisation fit to last, concluding:

> Ich bin ein Dreck; aber es müssen
> Alle Dinge mir zum besten dienen, ich
> Komme herauf, ich bin
> Unvermeidlich, das Geschlecht von morgen
> Bald schon kein Dreck mehr, sondern
> Der harte Mörtel, aus dem
> Die Städte gebaut sind.
>
> (Das habe ich eine Frau sagen hören.) (*GW* 8, 272–3)

(I am just trash; but I'll turn everything to my advantage, I'm on the way up, I won't be denied, the generation of tomorrow. Soon I won't be trash any more, but tough mortar for building cities out of.
[This is what I heard a woman say.])

There is a commonly held view, associated above all with the critic Martin Esslin, that Brecht was an anarchist at heart, but turned to Communism in order to impose an external discipline on his unruly nature.[11] The pattern of development which we find in Brecht's poetry of the city should lead us to modify this view. In the *Lesebuch für Städtebewohner* he is palpably working through the experiences of isolation and alienation in the attempt to understand and overcome them. The negative spirit of amoral cynicism which had earlier characterised his output is now itself subjected to critical appraisal as a product of social processes. Brecht's responses to the city, in other words, have developed in ways which ultimately make them compatible with a Marxist perspective. The political

principle involved is very simply summed up at the end of the film *Kuhle Wampe*, for which Brecht helped to write the script in 1931: the question 'Who is going to change the world?' is answered there with the words 'Those who don't like it the way it is.' Brecht's poetry of the mid-1920s expounds this precept in greater detail and with greater sophistication. His outlook was materialistic and dialectical before he became a dialectical materialist.

The kind of conscious resolve which led him from anarchic vitalism to political commitment is described in a poem of exile which is close in tone to those we have been considering, imitating the everyday prose, not of ordinary conversation this time, but of party-political resolutions. Even within this austere concentration of diction, however, the poem derives a remarkable potency from the sense of deliberate renunciation of which it speaks. It sharply illustrates the tension in Brecht's development between ebullient appreciation of the fullness of life on the one hand, and the restraint required for the political struggle on the other:

> Ausschließlich wegen der zunehmenden Unordnung
> In unseren Städten des Klassenkampfs
> Haben etliche von uns in diesen Jahren beschlossen
> Nicht mehr zu reden von Hafenstädten, Schnee auf den Dächern, Frauen
> Geruch reifer Äpfel im Keller, Empfindungen des Fleisches
> All dem, was den Menschen rund macht und menschlich
> Sondern zu reden nur mehr von der Unordnung
> Also einseitig zu werden, dürr, verstrickt in die Geschäfte
> Der Politik und das trockene 'unwürdige' Vokabular
> Der dialektischen Ökonomie
> Damit nicht dieses furchtbare gedrängte Zusammensein
> Von Schneefällen (sie sind nicht nur kalt, wir wissen's)
> Ausbeutung, verlocktem Fleisch und Klassenjustiz eine Billigung
> So vielseitiger Welt in uns erzeuge, Lust an
> Den Widersprüchen solch blutigen Lebens
> Ihr versteht. (*GW* 9, 519)

(Purely on account of the growing disorder
In our cities of the class struggle
Certain of us have resolved in recent years
To speak no more of picturesque harbours, snow on roofs, women
The smell of ripe apples in cellars, sensations of the flesh
All the things which make people well-rounded and human
But to speak henceforth only of disorder
That is, to become partial, pithy, implicated in the business
Of politics and the dry 'unworthy' vocabulary
Of dialectical economics
In order that this terrible concentration

> Of snow showers (they are not just cold, we know that)
> Exploitation, misappropriated flesh and class justice should not
> Produce in us approval of such a diverse world, joy in
> The contradictions of such a sanguinary existence
> You understand.)

Brecht's poetry stands out from other German literature of the 1920s, then, both in its robust affirmation of the present and in its keen analysis of future prospects. The particular significance of his *Lesebuch für Städtebewohner* lies in his ability to move beyond a posture of studious undeludedness and define the hard contours of life as it is (provisionally) lived by proletarian city-dwellers. With Brecht, the poetic experience of the city becomes something intensely real.

Notes to chapter 11

1 See Michael Hamburger, *The Truth of Poetry*, London, 1969, p. 181.
2 References for Brecht, indicated by volume and page numbers in the text, are to the *Gesammelte Werke* (Frankfurt am Main, 1966).
3 On the visual arts in Germany between 1917 and 1933, see John Willett, *The New Sobriety*, London, 1978. For discussion of 'Neue Sachlichkeit' in literature, see Jost Hermand, 'Unity within diversity? The history of the concept "Neue Sachlichkeit" ' in *Culture and Society in the Weimar Republic*, ed. Keith Bullivant, Manchester, 1977, pp. 166–82; also Klaus Petersen, ' "Neue Sachlichkeit": Stilbegriff, Epochenbezeichnung oder Gruppenphänomen?', *Deutsche Vierteljahresschrift* 56, 1982, pp. 463–77.
4 For a recent account in English of Döblin's novel, see A. F. Bance, 'Alfred Döblin's *Berlin Alexanderplatz* and literary modernism' in *Weimar Germany: Writers and Politics*, edited by A. F. Bance, Edinburgh, 1982, pp. 53–64.
5 On the importance of these categories for writers and intellectuals at the turn of the century, see Roy Pascal, *From Naturalism to Expressionism*, London, 1973, pp. 22–32. For a short account of the peculiar position of Berlin in the cultural life of the 1920s, see Alex Natan, 'The Twenties and Berlin' in *Affinities*, edited by R. W. Last, London, 1971, pp. 280–9.
6 Oskar Loerke, *Gedichte und Prosa*, Frankfurt am Main, 1958, vol. 1, pp. 441, 253.
7 *Die literarische Welt* III, 1927, nos. 5, 11 and 15/16.
8 References for Kästner are to the *Gesammelte Schriften für Erwachsene*, Zurich, 1969.
9 Walter Benjamin, 'Linke Melancholie', in *Angelus Novus*, Frankfurt am Main, 1966, pp. 457–61. For a more sympathetic account of Kästner's disillusioning techniques, see Egon Schwarz, 'Die strampelnde Seele: Erich Kästner in seiner Zeit' in *Die sogenannten Zwanziger Jahre*, edited by R. Grimm and J. Hermand, Bad Homburg, 1970, pp. 109–42; also R. W. Last, *Erich Kästner*, London, 1974, pp. 97–104.
10 See Fritz J. Raddatz, 'Lied und Gedicht der proletarisch-revolutionären Literatur' in: *Die deutsche Literatur in der Weimarer Republik*, ed. Wolfgang Rothe, Stuttgart, 1974, pp. 396–410 (p. 405).
11 Martin Esslin, *Brecht: A Choice of Evils*, third, revised edition, London, 1980, chap. VII.

Further reading

The poetry of Brecht and Kästner is available in English translation under the following titles: Bertolt Brecht, *Poems*, ed. J. Willett and R. Mannheim, London, 1976; Erich Kästner, *Let's Face It*, ed. Patrick Bridgwater, London, 1963.

In addition to items mentioned in the notes, the following secondary reading is recommended:

Walter Benjamin, *Understanding Brecht*, London, 1973, pp. 43–74.

Martin Esslin, *Brecht: A Choice of Evils*, third, revised edition, London, 1980, chap. V.

Jost Hermand and Frank Trommler, *Die Kultur der Weimarer Republik*, Munich, 1978.

Edgar Marsch, *Brecht-Kommentar zum lyrischen Werk*, Munich, 1974.

Deutsche Großstadtlyrik vom Naturalismus bis zur Gegenwart, ed. Wolfgang Rothe, Stuttgart, 1973.

Karl Riha, *Deutsche Großstadtlyrik*, Munich, 1983.

The city in early cinema: *Metropolis, Berlin* and *October*

The modern medium of the cinema has an obvious affinity with the modern city, with which it is intimately associated. I want to analyse three celebrated cinematic treatments of the theme of the city, which differ widely in their approaches, and which offer an introduction, in their variety, to the possibilities and difficulties of representing the city in its real constitution and complexity.

The argument concentrates on the *German* cinema of the Weimar Republic.[1] *Metropolis* was an obvious choice for inclusion, and *Berlin, die Symphonie der Großstadt* an almost equally obvious contrast. Eisenstein's *October* then offers a different aesthetic and political perspective, although it raises issues about the relationship between aesthetics and politics which this chapter cannot hope to address comprehensively.

Fritz Lang's *Metropolis* (1926)[2] creates an impression of 'the city' by cinematic means, and extends this realisation of the image of the metropolis to feature length by means of a narrative. By far the most remarkable aspect of the film is its visual construction of an imagined city.

The city constructed in *Metropolis* is not really the twentieth-century city, which is complex and resistant to artistic representation of a traditional type, but a city of the future. Lang's film has been called 'the first real science fiction film'.[3]

It is perhaps not the whole truth to say that Lang's city is solely a vision of the future, because there are several devices in the film which universalise this image of the *future* into an image of 'the city' *of all times*. Such is, for example, the memorable trick which changes the 'paternoster-Maschine', which dominates the machine-room, into the gaping jaws of a monster, devouring worker-slaves and identified by intertitle as 'Moloch', so that science fiction and paganism from the Old Testament are, quite literally, superimposed.

Lang also refers extensively to the idea of the Tower of Babel and of Babylon in general. The massive control tower of Metropolis is called 'The New Tower of Babel', and there is a sequence about the Biblical story of the Tower which, in its *mise-en-scène*, bears all the marks of Lang's mastery of the spectacular and the arresting, and thereby links the future powerfully with the past.

Metropolis thus has this use of underlying archetypes in common with other twentieth-century representations of the city, as different as *Ulysses* and *The Waste Land*. Indeed, as has been pointed out recently,[4] Babel and Babylon have been current as useful metaphors for the vast and indeterminate nature of the city, ever since it became too large for easy assimilation, in the first half of the nineteenth century.

Lang's way of representing the city in cinematic terms is, then, not to concentrate exclusively on the past, present or future, but to work out an impression of the city as 'idea'.

There is a further basic ingredient in Lang's presentation of a metropolis, apart from the sense of sheer scale, and that is the idea of the machine. The stylised New York of the above-ground city has a secret, namely, that it is driven by subterranean machines. This division into two is the key to both the visual and the thematic structure of the famous urban image. In adopting this bipartite form, Lang is picking up a topos of science fiction, familiar from H. G. Wells' *Time Machine*, in which there occurs a similar subterranean dimension to a city of the future.[5]

Although the idea (deriving from Thea von Harbou's novel) was not original, the notion of a contrast between above- and below-ground spaces is very fruitful cinematically. Both aspects of the city receive magnificent visual treatment, affording Lang and his team the opportunity of creating a number of uniquely eloquent images (Figs. 26 and 27).

The vision of above-ground Metropolis is an excellent example of the exploitation of the cinematic space of the frame. Lang's film notably lacks any sense of random, teeming urban crowd movements. Instead, we have the eerily uninhabited, totally mechanised cityscapes, which fill the frame and blot out sky and earth, as though nothing but humanly constructed space existed. Thus the limitlessness of modern cities, of which Mark Girouard speaks,[6] is brilliantly conveyed.

Below ground, the human body does figure as part of the realisation of the city-as-machine. Whereas the opening sequence of the film shows a montage of machinery in motion, to set the tone and focus for what is to come, later scenes bring machinery and human beings together. Here, humans are either themselves *part* of the machine, human cogs and pistons, as it were, or else, in the sequences showing the shift change, or the manned

dial, themselves fuel or 'Futter' (to use Frau von Harbou's word) for the great industrial monsters. Here too, Lang uses the medium of the silent cinema with mastery, to express the dehumanisation of men by machines. The body is related to implements via movement. These are either mechanical (when the machine is functioning properly), or else sudden and catastrophic when something goes wrong. That the only individualised movements in these sequences are expressive of exhaustion, despair or destruction, is a telling indication of technological reality's disregard for the human body.

We have mentioned some influences on and echoes in Lang's treatment of the metropolitan theme, but there remains one crucial and determining factor which we have not yet touched upon. This is the *style* of the early German cinema itself, of which *Metropolis* is usually regarded as both the highpoint and the end.

Notwithstanding Wells' *Time Machine*, the basic thematic structuring of the image of the city above and below ground owes much to a general strategy of the German silent cinema, which repeatedly made thematic points with the help of the contrast between above and below, and developed its famous fascination with staircases in the thematic space between the two. Jessner's *Hintertreppe* (1921) offers an early example, and Lang's own talkie, *M* (1931) a later one, but the motif is pervasive. So it is in *Metropolis* too, where we find a full range of staircases, from the spiral sort to the monumental sort (in the Babel sequence) one normally associates with Nuremberg rallies. Being a machine film, however, *Metropolis* makes a great deal of effective use of lifts, in the same sort of connection.

The persuasiveness with which the human body, deprived of speech, is shown in subjugation, is also an element of the German cinematic style before *Metropolis*. One thinks of the dejected villain in a cell of *The Cabinet of Dr Caligari* (1919), or the strait-jacket scenes in the same film, or else the wretched Renfield in Murnau's *Nosferatu* (1922). Typically, nobody did it on such a scale as Lang, but that is an aspect of his personal style, rather than of the dominant mode in which he worked.

A more far-reaching and significant effect of treating the topic of the modern city in the prevailing style of the Weimar Republic cinema is that of simplification. We argued above that Lang treats the city as idea. From the days of *The Cabinet of Dr Caligari*, the German cinema had concentrated upon the use of photographic moving images to approximate to mental states and to capitalise upon the medium's potential as an exploratory tool of perception, including the sort of perception involved in watching a film. Control of the means and form of representation – in practice the use of studio built sets – and a high degree of self-consciousness, both ironic and fraught – these are the main characteristics of the style. Lang was more

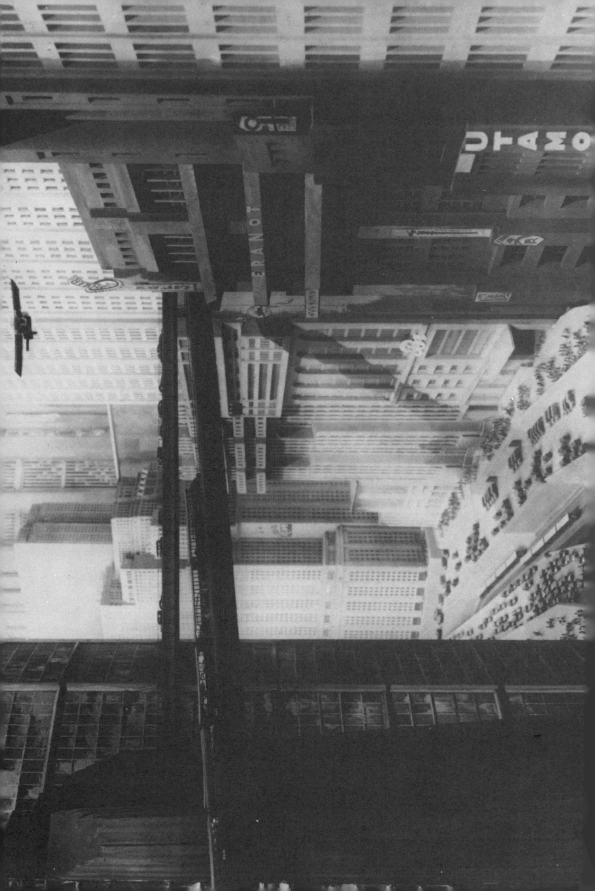

flamboyant and spectacular, to be sure, but he remained fundamentally rooted in this attitude. ('Self-consciousness' occurs in the several voyeur sequences, and the trick composition of a screen full of eyes, consuming Maria's babylonian performance as the robot.)

Clearly, this sort of style, while well-equipped to produce classic horror movies[7] or psychological studies, will encounter difficulties when taking on the subject of the modern city. It will seek an encompassing visual image for something which in reality is complex and varied, fragmented, scattered, stimulating, apparently random and often confusing.

For all its visual power and expressiveness in certain areas, *Metropolis* must be deemed an over-simplification of urban reality. The strategies for universalising the city, as well as the simple above/below contrast (most appropriate in a psychological context), which here is meant to express the relationship of capital to workers in an industrialised society, are more evasive than they are accurate. They are actually, I should argue, subordinate to another concern, which is also characteristic of the early German style.

For all the urban connections of any developed film industry, the German cinema of the first half of the 1920s retained a nostalgia for the aesthetically and economically humbler origins of the medium in the fairground sideshow.[8] What *Metropolis* is really about is given away by its title. Like the other films of the style, with its ironic memory of its origins in the sideshow, it is interested in *showing*. In this case it is a matter of showing Metropolis and its machines. Beyond that basic gesture (which is what the customers pay to see) there is only the exigency of a plot which will facilitate a longer showing, and which usually draws its dynamic from other elements which will satisfy an audience, namely sex and violence, often combined, and enacted, with typical self-consciousness, by *shadows* which are of course, like the medium itself, a matter of projection.[9]

It is interesting to observe that very little of the originally rather complicated plot[10] of *Metropolis* survives in the version of the film which we know today. This version is the result of editing for the American market, which removed nearly half the intended footage.[11] What is interesting about this disturbing fact is that it hardly troubles our attentiveness to the film as we know it, because silent cinema, as handled by the Germans in the earlier 1920s at least, does not need specific and complicated motivations of the kind originally supplied by Thea von Harbou. By its nature it reduces things to basics, rejoicing in its own inarticulateness. One of the first things discovered by iris-in in the German cinema is the organ-grinder's monkey in *Caligari*, which symbolises 'speech' as pointless chatter. The style portrays *genuine* human interaction in impenetrable, lingering and lingered-on

26. *Metropolis:* Above ground

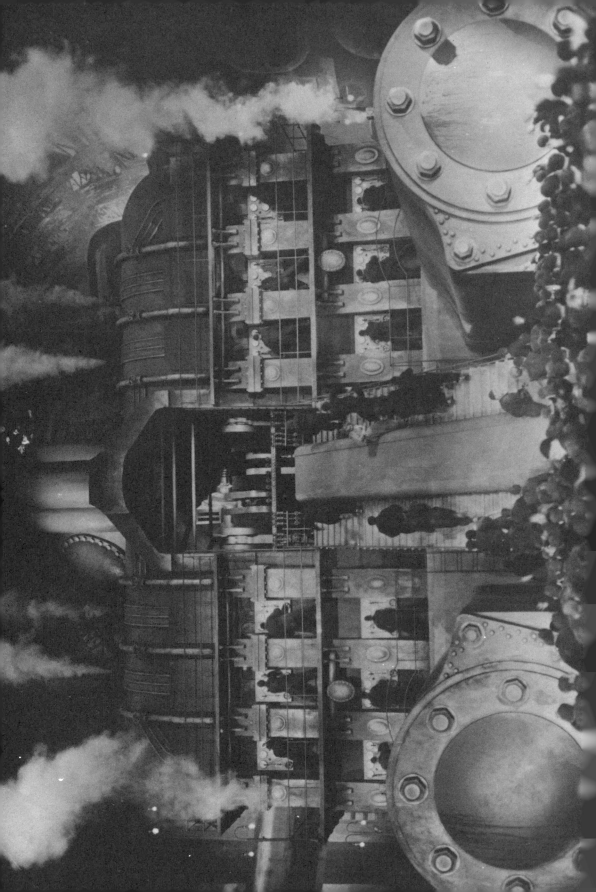

looks; facial expressions which, in their mute *presence*, resist banality because they do not need to explain themselves, but at the same time rapidly lead back to a basic range of possibilities in human relationships, which, though infinitely variable in the indirections of articulated speech, are distinctly limited in mime.

Hence we have no difficulty in 'understanding' the relationship between Rotwang, the magician and inventor, (himself a throwback to the earlier films of the genre) and Fredersen, The Master of Metropolis, or between Fredersen and his son, because they are simply matters of rivalry and aggression, and the chase among the catacombs involving Rotwang and Maria seems entirely in accordance with the expectations of the genre with regard to how males and females relate to each other, even though the film does nothing to convey the complex motivations in the novel which explain all these relationships. In the early German cinema, dialogues very often become confrontations.

The main axis of the plot is a more straightforward love story, between Freder (whose name is an interesting amalgam of 'brother' and 'father') and Maria, a mysterious beauty with an evangelical mission to the citizens of Metropolis.

If the *image* of the city is associated with Babylon and the sort of spectacular but generalised evil that goes with that, then the *plot* supplies the positive counter-value. The city is too big, it is incommensurate (that is what makes it worth showing). It fills the screen. The plot, on the other hand, is about people, individuals, and is therefore scaled down, the right size. The point is neatly made in the juxtaposition of two shots which make up part of the Tower of Babel sequence. The first shows the Tower itself in the centre of the frame, the second scales down the image of the city by surrounding the same image with figures who are the same size as it, thus revealing it to be a model. The cinematic possibilities of manipulating scale within the frame are exploited to relate the human form to the image of the city.

Maria's account of the Tower of Babel and its fate makes the point that cities are *planned* by people, but that problems arise as a matter of scale. Others have to be employed to execute the plans of the thinkers, which, so the parable explains, are entirely laudable in themselves, but get out of hand.

The whole problem is then scaled back down (or up) to the dimensions of the human body itself, in the metaphor used by Maria at this point, which reappears at the end of the film as its 'message': 'Between the brain that plans and the hands that build, there must be a mediator . . . it is the heart that must bring about an understanding between them.'

27. *Metropolis:* Machine room

The action of the film involves the spectacular but inhuman sequences, while the postive human values are enacted in the love-story of Freder and Maria. These values are a revealing mixture of sexual desire, sentimental love and Christianity, familiar from nineteenth-century German literature and Expressionist drama.

For the story, we have argued, is not the point in the film (although it may well have been in the novel). Stories easily fill up with oedipal patterns (at least we are spared Fredersen senior's mother, who plays a prominent part in the original).[12] The story-line is there to support and facilitate the showing of Metropolis and its machines. Lang himself reveals this in a retrospective statement: 'I wasn't as politically aware then as I am now. It isn't possible to make a socially aware film in which the heart is seen as the mediator between hand and brain. I really do think that is nonsense. But I *was* interested in machines . . .'.[13]

And the climax of what is *shown* is that most famous and dazzling of all sequences in the film (the one that founds its claim to being the first real science fiction film), in which the human form does *not* win out over the city's inhumanity, but quite the contrary; the city, as 'machine to be shown', wins out over the human body as the tired, naked, helpless figure of Brigitte Helm as Maria is *turned into a machine* in the pivotal laboratory sequence (Rotwang transfers his robot electronically into the body of Maria (Fig. 28).) The political intention of the film is in effect reversed by the power of its visual style.

Lang's city is not the modern city. The final chase on the cathedral roof evokes the *medieval* city. The Expressionist clutter and cliché of von Harbou's novel (already clearly out of date in the mid-twenties) is exploited by Lang for its sensational and commercial potential. In the language of Expressionism, the cathedral stands for a hope of spiritual renewal in the city; in Lang's cinematic language it supplies the setting for a cliff-hanger. The same can be said for the other Expressionist elements of the plot, such as the father-son conflict, the theme of the 'saviour', and the scenic uses of the symbol of the cross. These elements do not signify on their own account, but propel a succession of images. Only where the images themselves are eloquent, does Lang's film fascinate *and* move us.

The combination of the style of early German cinema, Lang's brilliant sensationalism, and the 'idea of the city' leads to a subversion of meaning. Instead of sympathising with the workers' plight, we *enjoy* their captivity (as we enjoy that of Brigitte Helm too, of course). For they are the captives of the camera, they are the slaves of *Lang's* hypnotic mechanical eye and choreographic control; they are Dr Mabuse's transfixed victims (Fig. 29).[14]

The great flood sequences towards the end of the film, which prompted

Kracauer to formulate the memorable judgement: 'cinematically an incomparable achievement ... humanly a shocking failure',[15] actually reveal how close Lang had brought the early German cinematic style to that of Hollywood (no doubt aided, we must emphasise, by Lang's American editors). Kracauer's judgement is too simply moralising. *Metropolis* is an entertainment film, a disaster movie. Large scale disaster and human interest combine in a way which makes it possible to satisfy the market's demands for spectacle, and offer a full range of shots.

Metropolis was a major commercial venture,[16] and never avant-garde. It is therefore instructive to turn now to a film which can be called avant-garde, produced, as it was, on the sidelines of the German film industry, at very nearly the same time as Lang's blockbuster came near to bankrupting it.

Berlin, die Symphonie der Großstadt (1927)[17] defines itself as an avant-garde film by its difference from the predominant style of the twenties. That style had outlived its novelty, reaching an apotheosis in *Metropolis*, completed the year before *Berlin* was made. *Berlin* was, however, very much the product of the talent and expertise involved in the earlier German style, for it was based on an idea of Carl Mayer's (who had co-written *The Cabinet of Dr Caligari*), and co-written by Karl Freund, who had photographed *Metropolis* itself.

The film's status as avant-garde is most clear in the absence of a plot, and in its dependence on external location shooting rather than the studio style of *Caligari* and its variants.

The film exhibits, therefore, a more direct encounter than did *Metropolis* between, on the one hand, the camera and the medium of silent cinema and, on the other, the peculiarly diverse randomness of the real-life metropolis.

Far from being visionary, *Berlin* is documentary in style. But its true subject is not only Berlin itself, but, and perhaps more prominently, *itself showing Berlin*. Each choice of image, duration of shot, each camera angle and each montage juxtaposition reveals and shows *itself*, at the same time as it records a moment in the life of a busy Berlin day.

It has this self-consciousness in common with the earlier style of German cinema, in which, as we saw, the topic of looking, seeing, revealing, was present within the *plot* in motifs like hypnotism, shadow-projection and fairground sideshows. The fairground motif is present in *Berlin* too, as we shall see, but it was undergoing a change of function within the German cinema. This is reflected most clearly in its appearance in a film of 1929, *Mutter Krausens Fahrt ins Glück*. Here, the socialist protagonist prominently walks out of, rejects, a sideshow performance, thus symbolically

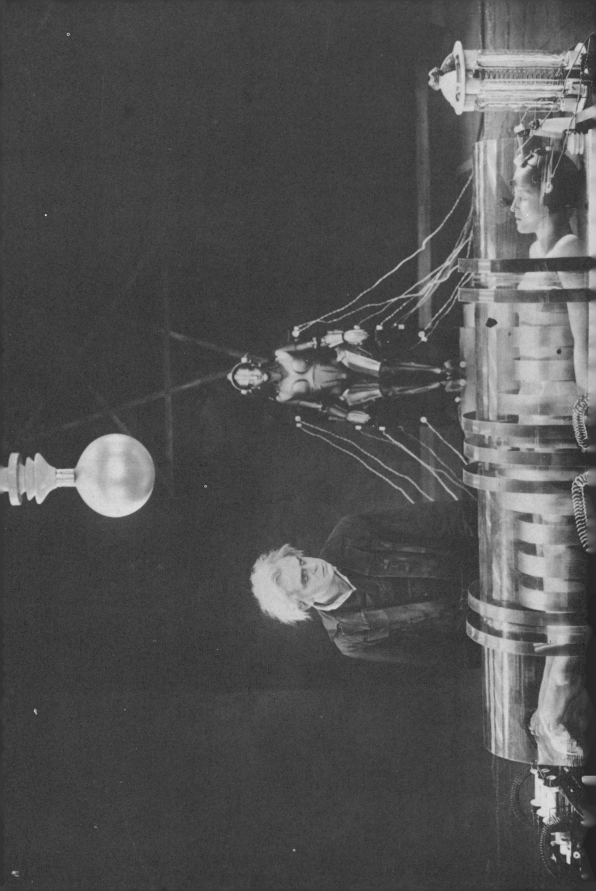

rejecting what is always implied in the image of the fairground; not only that it is an idle distraction for the working class, but also that it somehow stands for an apolitical view of life, in which the world is figured as an undifferentiated roundabout of vanity and foolishness. It is worth mentioning in passing that the sideshow performance in *Mutter Krause* involves particular emphasis on human indignity, and that the hero, in angrily rejecting it, is also rejecting the morbid monster and freakshow mentality of the early German style.

Berlin does have something like that sort of self-consciousness, in a sequence in which a woman and two girls are shown *being filmed* in an amusement park. The point here, however, is that this ironic self-reflection incorporates and understands the medium of film as part of the multifarious range of machinery which constitutes an important part of the reality of the city. It classifies it alongside the factory machinery, typewriters and the telephone system as a component of an actual infrastructure. This awareness of the cinema as having a part in the real and complex life of the city, its complex web of social, economic, imaginative determinations, is extended by the visual quotation of Charlie Chaplin's feet, echoing the countless other walking feet we have seen in the film, or the allusion to the cinema as entertainment *industry* contained in the neon advertisement for the latest Tom Mix movie. Film is part of the picture.

Film is also at home in the city because, used in a certain way, montage can approximate to the visual experience of being in a city. Of course, in a general sense, all films which have been edited involve montage. But where the juxtaposition of moving images is not subordinated to a plot, and where the cuts are apparent, rather than hidden in the folds of a flowing narrative, the effect can be like the subjective experience of the city, namely a succession of different images and angles constructing a perception in strong contrast to the unifying and uniform perception of a village or a landscape; a perception radically more rapid and less continuous than that encouraged by the traditional forms of literature, sculpture and painting. We are reminded of the words of Ezra Pound, cited earlier in this volume: 'The life of the village is narrative . . . In the city the visual impressions succeed each other, overlap, overcross, they are cinematographic.'[18]

Whereas traditional forms have to break themselves up in order to achieve this sort of perception (witness Döblin's destruction of the *Bildungs- roman* form and its unified perception in the cinematically influenced *Berlin Alexanderplatz*), the cinema is constitutionally able to work with this sort of medium or language. In *this* sense, urban experience and the silent cinema are happier together than the traditional media – including literary language.

28. *Metropolis:* Laboratory

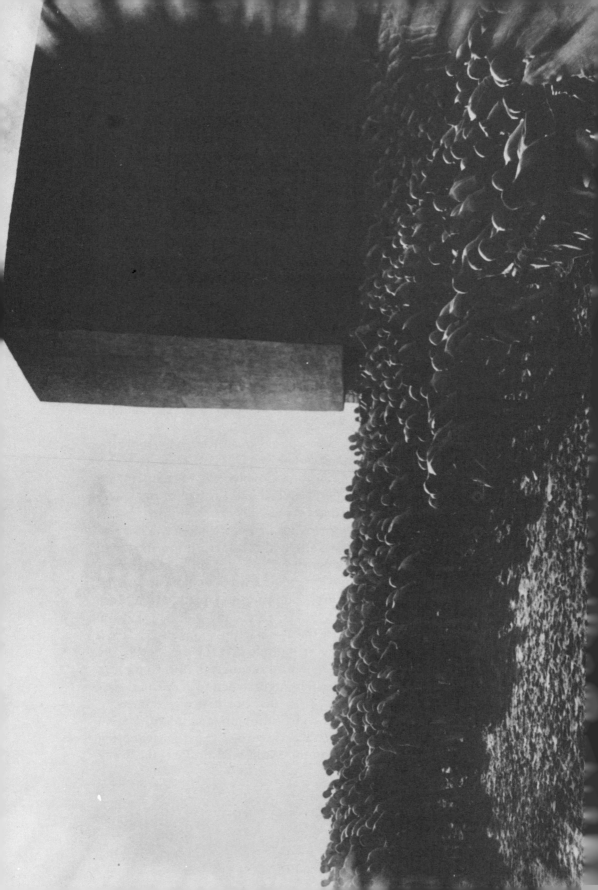

Berlin manifestly seizes upon this potential of film, and uses it with dexterity and humour. Sequences of juxtaposed images take on meanings transcending the individual images when, for instance, civilian walking feet are match cut with the feet of cattle symmetrically, to then give way to a further brief shot of marching soldiers. People are thus equated with cattle, cattle with soldiers; people are represented by their feet, fragmented, or by their movement through the frame, in the crisscrossing of which we discern the familiar urban bustle and purposeful directionlessness, which was notably absent from the narrative style of *Metropolis*.

A sequence of shots connected with office life is intercut with other images (notably that of the spiral) which convey not only the physical objects and form we associate with an office, but a sense of what it can be like to work in one. Further sorts of perspective are introduced by intercalated shots of animals; monkeys (speech as chatter again), or a dog fight (business is primitive and brutal behind and through the proliferation of machinery; the communication facilitated and demanded by typewriters and telephones is a mixture of chatter and brutality).

One notable series of images begins with the encounter between a prostitute and a prospective client. This takes place in a cleverly shot situation which allows the glances to meet through a shop-window on the corner of a street, thus tying the sexual encounter into the general commercial theme which the film mounts through the use of shop-windows and related phenomena. Another shop-window follows immediately, in which a dummy with a disgraceful leer on its face operates a piece of grinding apparatus with its foot. In true Brechtian spirit, a conventional shot recording a bourgeois wedding follows (bride and father emerge from limousine, shot from in front and slightly above – the big day), which is in turn followed by another shop-window dummy cleaning a collar and a shop-window full of model babies, and we finish with a return to the spiral (also, actually, a device in a shop-window). This sequence combines sexual, commercial, social and psychological perspectives with humour and insight, conveying a sense of complex interconnection, rather than a clear interpretation or evaluation.

The spiral is a leitmotif which indicates perceptual overloading. When the images become so rapid as to block one's ability to sustain, assimilate and align oneself with them, confusion intervenes. Urban experience can bewilder, it can even destroy the coherence of the mind. Hence the spiral is closely associated with the climactic suicide which occurs three-quarters of the way through the film. This, and the return to the spiral very near the end, marks the life of the city as both riotously enjoyable and varied but also as potentially destructive.

29. *Metropolis:* The slaves

Similarly, the film abounds most noticeably with artifacts representing human figures (such as the shop-window dummies we mentioned above or the grotesque negroes advertising a brand of epsom salts (Fig. 30).) This emphasis conveys the reduction of the human form to a counter in a commercial game, which is thereby offered as one overriding determination of the city's reality. This interpretation or reading of city life is reinforced, significantly, by the use of words, or, more precisely, the use of one word, 'Geld' ('money'). This word detaches itself from a newspaper and advances repeatedly and menacingly towards the camera. This 'subjective' trick shortly precedes a, for this film, unusually dramatic use of the moving camera (a roller-coaster ride; the fairground), leading up to the suicide mentioned before. In this way the two main interpretative emphases of the film are linked. The absence of a single psychological perspective, and of a narrative, make these connections that much more vital in the mind of an audience which has to supply links and make connections itself, these not being provided in the *form* of a story. Thus the city can be read, understood, at the same time as realised as a place in which a clamour of attitudes and interests co-exist, never falling together into a single clear message.

Ruttmann, Freund and their team do come up, however, against a fundamental problem associated with the artistic representation of modern cities. It is one of perspective. On one level Ruttmann's whole depersonalising strategy of montage recognises clearly, and successfully articulates, the problematic relationship between an individual and a city. The city is incommensurate with an individual's experience; overload is the key, the spiral. And if we take the function of the artist, as delivered by the nineteenth to the twentieth century, as being a guarantee of the power of the individual (to see, shape, form, feel, express himself, and so on), then we can easily see how this kind of art and this kind of artist will have difficulty with the metropolis of this century. As the reality of the modern city is political, social, economic, supra-individual and beyond control, the traditional artistic vision can *only* respond by making it, or seeing it as, *un*real. T. S. Eliot originally wrote 'terrible' city and, perhaps in a symptomatic gesture, typed it out in favour of 'unreal'.[19]

To *impose* an aesthetic vision upon the city in the authoritarian manner of Lang means (whatever the market determinations involved and notwithstanding all innocent fascination with machines) to move towards a political and economic reductionism which, not surprisingly filled Goebbels with enthusiasm,[20] and which is by implication anti-individualist without surrendering the aesthetic of individualism.

We have stressed that the medium of film, as used in *Berlin*, can help to realise the reality of the modern city. But how is such a film to define its *own*

30. *Berlin;* Placard-carrying Negroes

point of view? How will it situate itself? Two impulses vied in the making of *Berlin*, two different cinematic fascinations – Carl Mayer's interest in social criticism and awareness, and Walther Ruttmann's interest in abstraction. Mayer withdrew from the project, leaving the abstract film-maker in control. The result is that the vibrant mix of social, economic, technological and psychological references co-exists a little uneasily with an organisational will to form, to pattern and contrast, to the 'symphonic' (witness the film's subtitle). In this sense, the film draws its aesthetic justification from the sort of attitude which belongs more properly to 'pre-metropolitan' culture.

We can find this attitude exemplified clearly, to take a representative example, in the following words of Goethe: 'A perfect work of art is a product of the human mind and, in that sense, a product of nature. It needs to be understood by a mind which is itself harmoniously developed, and which will experience artistic perfection as corresponding to its own nature.'[21] We wonder, in reading Goethe's utterance, at the easy traffic between art, the perceiving subject and nature. The traffic in the Berlin of the 1920s flows less easily – a flow and counterflow which never stops. Nature is nowhere to be found or even imagined; all animals live in the zoo. The modern city is the manifest and pervasive absence of nature and the embodiment of a system or realities which may not be aesthetically immunised. There *is* no unreal city, although there may be many terrible ones.

There is no innocent pattern in the city. Even the format based on 'a day in the life' implies an attitude which understands the life of the city as organic and natural, a cycle like the hours and the seasons. And whilst marching feet, thundering trains and social contrasts may suggest historical and social specificity, the contrasting wheels and circles, even the spiral (always present as image *as well as* symbol), demanded by the very need, in the pattern, for contrast, cannot avoid a suggestion of timelessness, of eternal recurrence, of the city as Babylon or the site of 'teeming life'. For all its elegant abstraction and 'musical' composition, *Berlin* is ensnarled in a proliferation of meanings which it cannot contain or control.

How, then, *might* the silent cinema represent a modern city, without becoming involved with the difficulties of which we have been speaking? One answer is supplied by reference to the Russian cinema of the period (which also, of course, supplied the attitude to montage which characterises *Berlin* in distinction to the earlier style of German cinema).[22]

Eisenstein's *October* (1928)[23] is in no uncertainty about the *place* of its vision in the world which it represents. It assumes the values of the socialist revolution and the dominance of the proletariat; as post-revolutionary

31. *October:* Crowd scene

celebratory propaganda it assumes and encourages a similar attitude in its audience. As the details of city plans suggest, it represents St Petersburg as the specific historical, mapped and dated, location of the battle for the establishment of these values. This is not just *any* day in the life of the city, it is 25 October, 1917. The river Neva is not, like Ruttmann's Spree, an image of water which quickly becomes a symbol and a generalisation; it is the dividing line between provisional government and Bolsheviks, and every bridge is of strategic, and not symbolic, importance. The mystical and simplified above/below contrast which structured Lang's image of the city, is here transformed into two opposing topographical locations, the Winter Palace and the Smolny Institute, which are the headquarters or strongholds of named factions or groups involved in a complex and ramified political and military situation, and from where a battle for control of the city is fought. Machinery is not an object of fetishistic fascination of one sort or another, but either a symbol of the oppression of the common soldier by industry or else an indication of the power of the workers. It depends on who controls it: the imperial government or the organized working class (compare Fig. 31).

The point is that Eisenstein's clear sense of purpose and political point of view release the actual specificity of the city for cinematic and thematic use. In this context, the fact that no aspect of a city is ever merely natural, but always in some way socially, economically or politically marked, is no longer an embarrassment. The city is demystified, just as the 'unreal' reality of the Winter Palace, of the embodiment of Czarist political power (of what the Germans, significantly in this context, call 'Repräsentation), is confronted and countermanded by the palpably physical presence of ordinary people. Statues and bodies are juxtaposed in a more articulate language of montage than that in whose terms Ruttman equated civilian and bovine feet with those of Charlie Chaplin. And the *raising* of a bridge produces an image of destructive separation which surpasses even Lang in its spectacular clarity and strength.

The terms in which the various and hopelessly multifarious determinations and dimensions of a modern city may be seen as interrelating are those of a power struggle. In *October* the city is identified as the location of a struggle for power; this struggle is, after all, the very plot of the film, insofar as it can be said to have one. The reality of the city has a name – power. The city is seen for what it is: the centre of political power for a vast, war-ravaged Empire. And it is as real as who or what controls it. The Winter Palace, once displaced as the seat and representative form of authority, once abandoned by the power which once inhabited it, becomes empty theatricality, as the Kerensky sequence shows so clearly (Fig. 32).[24]

32. *October:* Kerensky going upstairs

Lang controls *his* city and Ruttmann implies stylistically that his is implanted unproblematically in nature. Eisenstein sees, and gives form to his vision, that the city can only truthfully be represented in moving pictures as a battleground, as the space of a struggle for control which does not end.

Notes to chapter 12

1 For a general survey of the representation of the city in the cinema (including the American cinema, an aspect which it has not been possible to deal with in the present essay), see Anthony Sutcliffe, 'The metropolis in the cinema', in *Metropolis 1890–1940*, ed. Anthony Sutcliffe, London, 1984, pp. 147–71.
2 *Metropolis*, Ufa, 1926, directed by Fritz Lang, script by Lang and Thea von Harbou, photography by Karl Freund, Günther Rittau, special effects by Eugen Schüfftan.
3 Leslie Fiedler, 'Mythicizing the city', in *Literature and the American Urban Experience*, Michael C. Jaye and Ann Chalmers Watts, Manchester, 1981, pp. 113–21 (p. 119).
4 Mark Girouard, 'Babylon revisited', *The Listener*, 6 October 1983, pp. 11–13.
5 Fiedler, pp. 118–19. For H. G. Wells' own reaction to *Metropolis*, see Sutcliffe, p. 149, and Herbert W. Franke, 'Nachwort', in Thea von Harbou, *Metropolis*, Berlin, 1984, pp. 198–205 (p. 201).
6 Girouard, *op.cit.*, p. 11.
7 See S. S. Prawer, *Caligari's Children: The Film as Tale of Terror.* Oxford, 1980.
8 Compare Prawer, p. 170.
9 For a more extended analysis of the film's plot and its relation to the theme of technology, see the ingenious and convincing piece by Andreas Huyssen, 'Technology and sexuality in Fritz Lang's *Metropolis*', *New German Critique*, 24–5, 1981–2, pp. 221–37.
10 Thea von Harbou's novel has recently been republished, see n. 5 above).
11 Fritz Lang, *Metropolis*, Classic Film Scripts, 39, London, 1973, p. 7.
12 For psychoanalytical readings of the plot, see Huyssen, and Stephen Jenkins, 'Lang: fear and desire', in *Fritz Lang: The Image and the Look*, ed. Stephen Jenkins, London, 1981, pp. 38–124 (pp. 82–7).
13 Franke, *op. cit.*, p. 201.
14 On the importance and place of vision in the film, see Huyssen's section 'The male gaze and the dialectic of discipline and desire', pp. 230–2.
15 Siegfried Kracauer, *From Caligari to Hitler. A Psychological History of the German Film*, Princeton, 1947, p. 150.
16 See Franke, *op. cit.*, p. 199.
17 *Berlin, die Symphonie der Grossstadt*, Deutsche-Verenis-Film, 1927, directed by Walther Ruttmann, script by Ruttmann and Karl Freund, from an idea by Carl Mayer, photography by Reimar Kuntze, Robert Babeske, Laszlo Schäffer.
18 See below, p. 000.
19 T. S. Eliot, *The Waste Land. A Facsimile and Transcript of the Original Drafts Including the Annotations of Ezra Pound*, ed. Valerie Eliot, London, 1971, pp. 8–9.
20 Kracauer *op. cit.*, p. 164; Franke, *op. cit.*, p. 200.
21 *Goethes Werke. Hamburger Ausgabe in 14 Bänden*, edited by Erich Trunz, XII, Munich, 1973, p. 72.
22 See Kracauer *op. cit.*, pp. 185–7.

23 *October*, Sovkino, 1928, directed by Sergei Eisenstein and Grigori Alexandrov, photography by Edward Tisse.
24 For an analysis of this sequence, see Karel Reisz and Gavin Millar, *The Technique of Film Editing*, second edition, London and Boston, 1968, pp. 33–40.

Surrealist city narrative:
Breton and Aragon

In French poetry of the second half of the nineteenth century urban motifs were easily recognisable as signs of street-corner realism (Baudelaire's cats, rats, bodies, jewels, mud, mobs, carriages, cafés, dogs, beggars) or of elevated symbolism (Mallarmé's drawing-room vases and fans). But the Surrealists' interest in the urban *per se* derives strictly from neither of these sources. Two aspects of city life were particularly likely to appeal to them: the presence in the city of a potentially revolutionary mass audience, exciting to poets who believed that they could change the real world – lying dismembered since the Great War – as well as people's inner lives, and who believed that poetry could and should be written by the people for the people; secondly, there was a concentration in the city of certain cultural and imaginative facilities – the theatre, cinema and music hall for passive consumption and stimulation of escapist dreaming, the café for the social congregation of artists and sometimes for their performances, the brothel and the street itself for possibilities of erotic liberty and random, adventurous encounter.

The paraphernalia of modern urban life are therefore little exploited for their own sake, and indeed, the most common approach was to turn the products of industry into derisorily useless 'ready-made' artefacts. Picasso turned a bicycle saddle and handlebars into a bull's head, and Marcel Duchamp outraged art critics by taking a urinal away from its rightful location and end and calling it 'Fontaine'. Meret Oppenheim's 'Fur cup and saucer' and Man Ray's 'Gift' – a smoothing iron bristling with spikes set in its sole – deliberately work not only against the utility of the real artefact but also against the normal, realistic, sensory reactions and expectations of the consumer. Industrial utility had contributed to the slaughter of the Great War. Official art had apparently upheld the social and moral values that underpinned such obscenity. Perhaps this new, ludic art deliberately subverted both industrial production and its cultural alibi. The cubist collage also takes the tissues and textures of town life (tickets, labels,

posters, newspapers) and subverts their text, making it impossible to use them commercially or read them functionally.

Two precursors of Surrealism, Blaise Cendrars and Guillaume Apollinaire, wrote poems which show them to be exhilarated by urban experience but swamped and depressed by its inhumanity. In these poems (Cendrars' 'Les Pâques à New York',[1] Apollinaire's 'Zone')[2] the urban is wrenched away from its functional rationale, and its myriad experience becomes the impetus for an oneiric, mythical lament. (See David Kelley's chapter for a discussion of 'Zone'.) Cendrars' narrator in 1912 New York is the alienated outsider, like Lorca's *Poeta in Nueva York* (described by Alison Sinclair in Chapter 14); but he is implicated in the very rhythms of the city life he finds so hostile. His vision is less fragmented than that of Apollinaire; he provides a more coherent vision of a clash between religious values and violent, spiritually empty metropolitan experience, where the metropolis is less a technological process than an expressionistic image of capitalist rapacity and social disintegration.

On to the basic form of the rhyming couplet, loosely grouped into paragraphs, Cendrars grafts a fluid narrative, whose metre varies to follow the restless wandering of the outsider, and whose rhyme is occasionally pulverised by the brutal heat, light, violence and sexual provocation assaulting the passer-by. Traditional imagery of stained-glass windows and communion wine is horrifyingly transposed into lipstick- and blood-stained visions, and the female depravity is explained by male exploitation, itself a product of despair. The whole city appears to be an apocalyptic, mercantile Babylon, torturing, scourging and sullying Christ anew, to the point where he is a victim of the birth of a hellish urban crescendo, orchestrated by the thundering subway trains, instead of ascending into heaven. The poet himself feels dawn enshroud him as in burial. Despite the basically simplistic verse form, there is great tension between its formulaic chant and the violent, irrational imagery, transgressing all bounds of taste and logic.

The shock of the images is accentuated by their ironically liturgical formulation; their nightmare illogicality is subverted by their verbal slickness. But the serious moral despair of this long narrative poem is underlined by an insistent refrain – 'je descends . . . je descends' – which reminds us that the poet plunging into the city is like Dante plumbing the successive depths of Inferno, or Christ himself descending into hell, as Europe would in 1914.

Despite the psychological decentring of Apollinaire and the moral alienation of Cendrars, their self-questioning narratives are still informed by the very urban forces which they represent and criticise. Apollinaire's

imagery integrates the city into a cultural tradition, Cendrars' violent, fantastical visions reflect both the violence of his anguish and the violence of the metropolitan threat to culture. Perversely, after 1918, the Surrealists in their revolt evolved a more celebratory attitude to the city, in a deliberate attempt to transcend its utilitarian limitations, and reject its industrial dictates. Aragon's *Le Paysan de Paris* (*Paris Peasant* 1926)[3] and Breton's *Nadja* (1928)[4] are certainly based on a specifically urban and indeed metropolitan projection of the imagination, but the fluid topos of the city is more urbanely integrated into a looser, more exploratory prose structure of fantasy and desire.

Breton's city reminds us of a medieval map of the world – it is a small, flat and patchy place, surrounded by nothingness. Only parts explored by Breton and Nadja seem to exist, in defiance of the map of Paris that a rational atlas would offer. Breton's writing is an avowedly 'anti-literary' attack on the traditional novel, and even of prose narrative in general, he says in his preface (p. 6). The simple certainties of description, plot and character have no place here. Rather than the novel's usual recreation of places, events and selves, the narrative becomes the record of a search for them. Breton rejects the convention of realism, that language transparently transcribes an external reality. In calling into question the conventions of prose fiction, he calls into question our perception and mental narration of reality.

Starting vitually at random in a Paris hotel where he lived in 1918, the 'hôtel des Grands Hommes', Breton relates a series of random wanderings and encounters. He addresses a total stranger (who then starts to fascinate him), a girl called Nadja. The random becomes more overtly coincidental when he keeps meeting her on the streets of Paris as if she were unable to escape the force of his desire. Breton's use of the random and coincidental is intended to show the power of desire over events and people: 'Voici deux jours consécutifs que je la rencontre; il est clair qu'elle est à ma merci' (p. 106), and the operation of this desire through the medium of chance rather than reason or logic is intended to undermine our belief in causal logic as applied to human behaviour; it is intended to persuade us to see rationalism as powerless in the face of passion; and to urge us to rush out onto the streets and act inconsequentially at random.

Nadja is so real that she escapes the control of the narrator. Despite his chance encounters which appear to circumscribe her, the places and events of the novel are invested with a reality, flatly alleged rather than described, as if they were too real to bear the conventional mimetic transposition into organised linguistic structure which we call 'realism'. Breton provides the complete text of a cinema programme which he did *not* read, a deliberately

undramatic description of a theatre he went to, and a prosaic account of the plot of the melodrama enacted there, which records some of the literal dialogues, but in no way seems to echo the suspense and emotions of the original – he gives the literal text of some lines of Jarry's poetry which appealed to Nadja – and records verbatim surrealistic phrases uttered by Nadja. The chosen impotence of the descriptive discourse is as it were underlined by the inclusion of such rival texts, and even more so by the inclusion of visual matter, such as the sketches Nadja drew, or the ubiquitous photographs of persons and places mentioned but hardly described by the narrative. Thus the non-assimilable nature of brute matter is emphasised, and we are offered, instead of transcription, a kind of documentary residue, or even, in some cases, a fetish-like substitute for experience (photographs of a glove, an advert, a sign, the suspender-clad thighs of a wax dummy), or alternative artistic renderings of experience (paintings by Uccello or Braque). This impossibility of the mode of 'realism' as a meaningful transposition of experience appears in *Nadja* to derive from the unpredictability and unknowability of the world. And this despite the role of the city of Paris as a kind of tame universe, its familiar landmarks and its apparent cooperation in facilitating encounters tending to suggest that reality should be domesticable.

This very schism in the texture of the narrative may perhaps alert us in advance to the likelihood that there will be no resolution to the quest – quest for Nadja, quest for Breton's own identity, quest for explanation of the mysteries of the magical city. On the contrary, the non-rational aura of the quest is consummated in the final discovery of the hypothetical madness of Nadja, consecrating the divorce between the individual, and objective reality.

The motive force linking Breton and Nadja to each other and to the city has been 'le hasard objectif' – objectified chance, whereby desire warps people, objects and events into coincidental configurations. It is in terms of objectified chance that Breton interprets Nadja's prophetic ability (she predicts that a dark window will suddenly light up), and her psychic gifts in developing the idea that a fountain expresses the circularity of thought, which Breton argues she has somehow derived from Berkeley without ever having read Berkeley.

The desire of the individual is mapped onto the city. Breton feels psychically affected by the statue of Etienne Dolet at the place Maubert, and Nadja hears voices coming from the bust of Henri Becque at the place Villiers. She even shows him a letter allegedly written by Becque, and Breton argues that there is no reason to be more disturbed by inspiration coming from such a source than that coming from God or a saint. Breton himself is

obsessively moved by a sign outside a coal-merchant's ('Bois-Charbons') to the point that he walks all round the city, haunted by this image, seeking out every coal-merchant's he can find – This force of the environment on Breton and Nadja has its counterpart in Nadja's own active gifts – her presence in a restaurant causes a waiter to keep dropping plates, and her appearance at a train window causes men who see her to suddenly turn and blow kisses at her. Breton argues that there is no clear or necessary frontier between her powers of desire and her possible madness. One might argue that the manifestation of her desire (kissing Breton on the mouth and covering both of his eyes with her hands, while he is driving a car), is rather more alarming than that of her madness (receiving letters from a statue).

At all events, even when interacting psychically with Breton and Nadja, Paris remains a comfortingly familiar village-city, with its cafés and squares, hotels and statues, theatres and coal-merchants. It is smaller than life-size, so that any two strangers are bound to meet at random every few days. It is resolutely old-fashioned – the very antithesis of Apollinaire's hum of trams and blaze of electric lighting. It secretes individuals, not the anonymous throngs of Cendrars' New York. If it is not assimilable stylistically to realistic description, it compensates by taking on a distinctly anthropomorphic topos through the mediation of the idealistic, desirous, transcendental psyche.

But the split between the dreams, desires and intuitions of the individual, and the fantastical reality of the world outside is not thereby healed. Paradoxically, Breton reserves his most lyrical prose for an impassioned *theoretical* argument against psychiatrists and asylums ('on y fait les fous', p. 161; 'tous les internements sont arbitraires. Je continue à ne pas voir pourquoi on priverait un être humain de liberté. Ils ont enfermé Sade; ils ont enfermé Nietzsche; ils ont enfermé Baudelaire', p. 166). For the asylum and the psychiatrist support a rigorous divide between real and ideal, objective and subjective. Breton writes a passionate defence of madness as a kind of freedom: 'la liberté, acquise ici-bas au prix de mille et des plus difficiles renoncements, demande à ce qu'on jouisse d'elle sans restrictions dans le temps où elle est donnée, sans considération pragmatique d'aucune sorte.' ('freedom, attained in this world at the expense of the most endless and arduous renunciation, demands to be enjoyed without restriction on the occasions she is available, without any considerations of practicality whatever') (p. 168).

The narrative refuses to transform the schismatic world into a smoothly homogenised textual unity. Breton's odd mixture of flat allusion, brute illustration and lyrical theory is a beautiful enactment of the problem, on a formal plane. Yet one cannot help feeling that he thereby denies himself the

stylistic and structural means to conjure up in the reader's imagination his own imaginings, rather than the cold record of their misadventure.

Aragon's *Le Paysan de Paris* is in some ways a more consummate rejection of autonomous, willed narration in favour of topographical or unconscious forces than is *Nadja*. The narrator structures his narrative around the non-fictional exploration of the arcades around the Paris 'Opéra' and their boutiques.[5] But the differences in Aragon are striking. The everyday appears more resolutely trivial, more obviously anecdotal: Aragon describes a bookshop, notes that it is easy to steal books there, then records the exact value of the books stolen at another bookshop in 1920 (twenty million francs) (p. 27). With an almost Balzacian attention to detail Aragon describes the angle from which the caretaker and his wife can observe the stairs leading past their apartment (p. 27). However, this direction of the narrative according to the realistic topography of a walk through the arcades, and an objective description of their denizens is never sustained — it is constantly subverted by the forces of fantasy on the one hand and of sheer matter on the other.

The sum of money noted on page 27 was only an hors d'oeuvre; a little later the narrator passes by a notice of sale of a shop, where the shopkeeper has written out a protest detailing the amount of compensation which he will receive for being expropriated. The narrative does not précis or allude to the poster. It reproduces its entire text and layout and typography, as well as the literal text of a newspaper article commenting on the series of expropriations in the arcades, which has been stuck up in another shop window (p. 37–8). Similarly, when the narrator walks into a café and sits down, the narrative yields to a literal transcription of the notices in the café, to the extent that a whole page of text can become a series of adverts for drinks, and their prices (p. 98). These realia, motivated on a realistic plane by their intrusion into the narrator's field of vision, then spill over and as it were contaminate the narrative. The list of drinks in the cafe is accompanied by a rambling sequence of observations about them (p. 96). The newspaper article and protest poster of pages 36 and 37 lead the text into a long enumeration of the financial arguments carried in other newspapers either displayed elsewhere in the neighbourhood or simply read by the narrator. These range from the brute textual fragment of newspaper literally copied on page 40, where only the middle column, discussing the affair, is readable, and the two outside columns are cut off down the middle either by the exigencies of the size of the page of the novel or perhaps by an imitation of the peremptory framing operated on a text by any act of reading, to the selective quotation and accompanying commentary of a more traditional kind (p. 41–2), or a kind of *discours indirect libre* which

seamlessly accumulates the matter of the journalistic arguments (p. 38).

These various intrusions of reality – *real* reality – into the framework of the narrative – *realistic* narrative, are disturbing. Are these passages of the text real, concrete reality? Our acceptance of them as such then clearly disturbs our ability to accept the rest of the narrative as an imitation of reality – it immediately appears more obviously fictional. And then we may react from this standpoint against the textual inclusions – is their reality perhaps fictional, are they perhaps referred to, adduced by, generated by the fictional text? Is text the only reality, a fictional reality which reduces all rival external reality to the status of text? The phenomenon is also disturbing for its distortion of the narrative dynamic, traditionally driven by psychological, social or metaphysical springs, by some kind of quest or series of actions, and, even in this novel, by the topological vector of the walk through the city (as in Joyce's *Ulysses*[6] or Apollinaire's 'Zone'[2]). And finally, the whole convention of a linguistic transposition of reality, according to the code of 'realism' seems threatened by the blurring of the process of transcription, by the foregrounding of the physical medium of the visual accidents of reality, seen as a college of rival texts, creating a new reality transgressing the framework both of traditional text and conventional reality, rather as Picasso's collages or Duchamp's readymades transgressed these boundaries.

The richness of Aragon's textual procedures is far from exhausted by this approach to his maniacal, self-conscious flooding of the text by a series of associations in the narrator's mind. As the narrator enters the arcades they set up reverberations in his mind which will enable him to move into the world of the 'merveilleux', advocated by Breton in his *Premier manifeste du Surréalisme*;[7] for outside reality is able to enlighten the workings of the mind, particularly if that outside reality is itself mysterious. In the strangely-lit, unusually enclosed 'passages', a transitional, mediatory world invites the narrator to loosen his grip on external reality and allow his internal fantasies to flower and proliferate:

> La porte du mystère, une défaillance humaine l'ouvre, et nous voilà dans les royaumes de l'ombre. Il y a dans le trouble des lieux de semblables serrures qui ferment mal sur l'infini. Là où se poursuit l'activité la plus équivoque des vivants, l'inanimé prend parfois un reflet de leurs plus secrets mobiles: nos cités sont ainsi peuplés de sphinx méconnus qui n'arrêtent pas le passant rêveur, qui ne lui posent pas de questions mortelles. Mais s'il sait les deviner, ce sage, alors, que lui les interroge, ce sont encore ses propres abîmes que grâce à ces monstres sans figure il va de nouveau sonder. La lumière moderne de l'insolite, règne bizarrement dans ces sortes de galeries couvertes qui sont nombreuses à Paris aux alentours des grands boulevards et que l'on nomme d'une façon troublante *des*

passages, comme si dans ces coulours dérobés au jour, il n'était permis à personne de s'arrêter plus d'un instant. (p. 20–1).

(The doorway to mystery, opened by a moment of human abandonment, leads us now into the realms of shadow. In the murkiness of this place there are such locks as fail to properly conceal infinity. Where the most ambiguous activities of the living are pursued, the inanimate may sometimes catch a reflection of their most secret motives: our cities are thus peopled with unrecognised sphinxes, which will not stop the musing passer-by and ask him mortal questions. But if in his wisdom he can guess them, then let him question them, and it will still be his own depths which, thanks to these faceless monsters, he will once again plumb. The modern lighting of the unusual reigns strangely over the kind of covered shopping arcades of which there are many in Paris in the neighbourhood of the 'grands boulevards', and which are called, disturbingly, *passages*, as if in these corridors hidden from the light of day, everyone was forbidden to stop for more than a moment.)

The associations, the fantasies which are developed are the illustration of the idea that man is motivated by desire and by chance, rather than by reason and by will – an idea that is obviously indebted to Breton's championing of Freud's discovery of a fundamentally libidinous unconscious, whose traces as discovered in jokes and dreams and slips of the tongue indicate that it operates according to an irrational process of association.[8] But there is also Breton's Surrealist belief in the existence of a transcendental plane where the conflict between desire and reality will be resolved: and the whole of Aragon's novel is the record of a quest for and an adventure within the magical realm of the transcendental, like one of Chrétien's Arthurian heroes who has wandered into an enchanted forest:

C'était un soir, vers cinq heures, un samedi: tout à coup, c'en est fait, chaque chose baigne dans une autre lumière . . . On vient d'ouvrir le couvercle de la boîte. Je ne suis plus mon maître tellement j'éprouve ma liberté. Il est inutile de rien entreprendre . . . Je suis le ludion de mes sens et du hasard. (p. 11–12).

(It was one evening towards five o'clock, a Saturday: suddenly, it had happened, everything was bathed in a different light. The lid has just been taken off the box. I am no longer in control of myself, so strong is my feeling of freedom. There is no point in planning to do anything . . . I am at the mercy of my sensations and of blind chance.)

The strange light and the feeling of alienation from choice are distinctly dreamlike. The random arrangement of the city arcades will now closely enmesh with the imagery liberated by desire. A shop window filled with carved walking-sticks will become a sea in which a mermaid swims (p. 31–2), a tatty 'maison de passe' will be described as if its corridors were the

wings of a theatre, its bedrooms the artists' dressing-rooms, its layout a
network of 'labyrinthes voluptueux', its protagonists either 'assassins
sentimentaux' or 'héros maudits' (p. 24–5). The scruffy 'Théâtre Moderne'
itself presents various arrangements of nude women rather perfunctorily
disguising their celebration of desire as one or other of the dramatic genres
of the legitimate stage. Aragon argues wickedly that this is the best kind of
avant-garde drama:

> le modèle du genre érotique, spontanément lyrique, que nous voudrions
> voir méditer à tous nos esthètes en mal d'avant-garde. Ce théâtre qui n'a
> pour but et pour moyen que l'amour même, est sans doute le seul qui nous
> présente une dramaturgie sans truquage, et vraiment moderne. (p. 132).

> (the ideal erotic play, spontaneously lyrical, which we would like to offer
> as an object of study to all our aesthetes with avant-garde yearnings. This
> theatre whose only means and end are love itself, is doubtless the only truly
> modern, unfaked drama.)

that it derives from the miracle play:

> le besoin de faire vivre quelques filles et leurs maquereaux, a fait naître un
> art aussi premier que celui des mystères chrétiens du Moyen Age. Un art
> qui a ses conventions, ses disciplines et ses oppositions

> (the need to subsidise a few whores and their pimps has given birth to an
> art as elemental as that of the medieval Christian mystery plays. An art
> with its conventions, constraints and antitheses.)

and fulfils the communal aims of Classical comedy and Tragedy:

> Les grands ressorts de la comédie antique, méprises, travestissements
> dépîts amoureux, et jusqu'aux menechmes, ne sont pas oubliés ici. L'esprit
> même du théâtre primitif y est sauvegardé par la communion naturelle de
> la salle et de la scène, due au désir, ou à la provocation des femmes, ou à des
> conversations particulières. (pp. 133–4)

> (The great springs of Classical comedy, misunderstandings, disguises,
> crossed loves, and even menechme, are here remembered. The very spirit
> of primitive theatre is preserved in the natural communion between audi-
> ence and actors, caused by desire or by provocation on the part of the
> women or by private conversations.)

The café, too, is a temple where there are sacred rituals (for the proper
serving of coffee (p. 99)); and here the modern writer, surrounded by
friends and by the traces of reality and desire, can call for pen and ink and
realise his dreams:

> C'est ici que le surréalisme reprend tous ces droits. Images, descendez
> comme des confetti. Images, images, partout des images. Au plafond. Dans
> la paille des fauteuils, Dans les pailles des boissons. Dans le tableau du

standard téléphonique. Dans l'air brillant. Dans les lanternes de fer qui éclairent la piece. Neigez, images, c'est Noël. (p. 101)

(Here Surrealism comes into its own. Images, fall like confetti. Images, images, everywhere images. On the ceiling. In the straw in the armchairs. In the straws in the drinks. On the telephone switchboard. In the gleaming air. In the iron lamps that illuminate the room. Snow, images, it's Christmas.)

And lest it be thought that the brothel, the theatre and the café are too easily tempting to poeticise, Aragon waves his magic wand over the petrol pumps of Texaco and transforms them into 'grands dieux rouges', 'une étrange statuaire', 'ces fantômes métalliques', 'Ces idoles':

Bariolés de mots anglais et de mots de création nouvelle, avec un seul bras long et souple, une tête lumineuse sans visage, le pied unique et le ventre à la roue chiffrée, les distributeurs d'essence ont parfois l'allure des divinites de l'Egypte ou de celles des peuplades anthropophages oui n'adorent que la guerre. O Texaco motor oil, Eco, Shell, grandes inscriptions du potentiel humain! bientôt nous nous signerons devant vos fontaines, et les plus jeunes d'entre nous périront d'avoir considéré leurs nymphes dans le naphte. (p. 144–5)

(Daubed with English words or newly minted words, having only one long and supple arm, a luminous, faceless head, a single leg, and a belly in the form of a numbered wheel, the petrol pumps take on sometimes the air of Egyptian divinities, or the gods of cannibal peoples whose idol is war. O Texaco motor oil, Eco, Shell, great inscriptions of human potential! Soon we will worship at your founts, and the youngest among us will perish for having contemplated their nymphs in your naphtha.)

The twin poles of libidinous fantasy and random observation are seen by the narrator as a constant tension, but also as a fundamental source of imaginative power:

à la limite des deux jours qui opposent la réalité extérieure au subjectivisme du passage, comme un homme qui se tient au bord de ses abîmes, sollicité également par les courants et par les tourbillons de soi-même, dans cette zone étrange où tout est lapsus, lapsus de l'attention et de l'inattention, arretons nous un peu pour éprouver ce vertige. . . . Un instant, la balance penche vers le golfe hétéroclite des apparences. Bizarre attrait des dispositions arbitraires: voilà quelqu'un qui traverse la rue, et l'espace autour de lui est solide, et il y a un piano sur le trottoir, et des voitures assises sous les cochers. (p. 60–1).

(on the border between the two kinds of light opposing external reality to the subjectivity of the passage, like a man about to fall into his own abyss, tugged by the waves and by his inner maelstrom, in this strange zone where all is lapsus, lapse in concentration and lapse in relaxation, let us wait

awhile to savour the vertigo . . . For a moment the balance tips towards the heteroclite gulf of appearances, with the odd attractiveness of arbitrary arrangements: now someone crosses the street, and the space surrounding him is solid, and there's a piano on the pavement, and vehicles seated beneath coachmen.)

Compared with his own creativity the novelist finds that that of God is somewhat limited: 'je m'étonne grandement de l'imagination de Dieu: imagination attachée à des variations infimes et discordantes. On dirait que pour Dieu le monde n'est que l'occasion de quelques essais de natures mortes' (p. 61) ('I am greatly surprised by God's imagination, which is limited to minute, discordant variations. It's as if for God the world is only an excuse for some tentative still-lifes').

God, it would appear, is a nineteenth-century realist. Whereas Aragon is perpetually blurring the frontier between sheer reality and wild fantasy, if he approaches too close to reality it becomes fantastic in its disproportion. Thus the author's 'passages' create imagery:

> Je quitte un peu mon microscope. On a beau dire, écrire l'oeil à l'objectif même avec l'aide d'une chambre blanche fatigue véritablement la vue. Mes deux yeux, déshabitués de regarder ensemble, font légèrement osciller leurs sensations pour s'apparier à nouveau. Un pas de vis derrière mon front se déroule à tâtons pour refaire le point: le moindre object que j'aperçois m'apparaît de proportions gigantesques, une carafe et un encrier me rappellent Notre-Dame et la Morgue. (p. 42)

> (I leave my microscope for a moment. Say what you will, writing with the eye glued to the lens in a light chamber is truly tiring to the eyesight. My two eyes, unaccustomed to observing in concert, let their senses gently oscillate in order to realign themselves. A screw inside my forehead unwinds gropingly to focus again: the slightest object that I perceive seems to take on gigantic proportions, a carafe and an inkwell remind me of Notre-Dame and the Morgue.)

But this creative oscillation is not allowed to create a novel merely varying between the documentary and the poetic, the realistic and the fantastic. The whole narrative enterprise which synthesises these two modes is in its turn torn apart from the inside by the capricious behaviour of thought and of language. In the great tradition of Sterne's *Tristram Shandy*[9] and Diderot's *Jacques le Fataliste*[10], Aragon plays cat and mouse with his novel and the reader. Gide was to do as much around the same period with *Les Caves du Vatican*[11] and *Les Faux-monnayeurs*.[12] Aragon may well sing the praises of Death, Lapsus and Libido, but he hastens to deflate: '*Libido* qui, ses jours-ci, a élu pour temple les livres de medicine et qui flâne maintenant suivie du petit chien Sigmund Freud' (p. 44) ('*Libido* who of late has made

his shrine of medical text-books and who now wanders around followed by his little dog Sigmund Freud').

Aragon talks of suspense and mystery but constantly abandons his already flimsy plot in order to describe, say the décor of a hairdressing salon (p. 51), he analyses, nay personifies feelings but they immediately dissolve into whirlpools of language, as when he juggles with the letters and the rhythms of the word *Pessimisme* (p. 62). He propounds philosophical or psychological views of a provocative nature, but his plan for an atlas of bodily pleasure (p. 57–8), his likening of the Parisian passer-by to Hegel's Idea (p. 45) or his declaration that female desire is better represented by a woman groping for a man's flies than by more mundane cinematic fictions, all dissolve into deliberate whimsy (p. 70). As the book progresses, its pretensions of representation and of fantasy become increasingly sabotaged by the workings of language. A lyrical appreciation of all persons and things blonde becomes entirely unhinged in what could be seen as a savage parody of the traditional 'Symphonie en Blanc majeur':

> Le blond ressemble au balbutiement de la volupté, aux pirateries des lèvres, aux frémissements des eaux limpides. Le blond échappe à ce qui définit, par une sorte de chemin capricieux où je rencontre les fleurs et les coquillages. C'est une espèce de reflet de la femme sur les pierres, une ombre paradoxale des caresses dans l'air, un souffle de défaite de la raison ... Qu'y a-t-il de plus blond que la mousse? J'ai souvent cru voir du champagne sur le sol des forêts. Et les girolles! Les oronges! Les lièvres qui fuient! Le cerne des ongles! La couleur rose! Le sang des plantes! Les yeux des biches! La mémoire est blonde vraiment. A ses confins, là où le souvenir se marie au mensonge, les jolies grappes de clarté! La chevelure morte eut tout à coup un reflet de porto: le coiffeur commençait les ondulations Marcel. (p. 52–3).

> (The blonde resembles the stammerings of voluptuousness, the piracy of lips, the tremors of limpid waters. The blonde escapes whatever defines it, by a kind of whimsical way where I encounter flowers and seashells. It's a sort of reflection of woman on stones, a paradoxical shadow of aerial caresses, a breath of the defeat of reason. What is blonder than moss? I have often imagined that I saw champagne on the ground in the forest. And chanterelles! And agaric mushrooms! Hares in flight! The quick of nails! The colour pink! The blood of plants! The eyes of does! Memory: memory is truly blonde. On its borders, where recall relates to mendacity, what juicy bunches of light! The dead hairstyle suddenly took on a port-wine reflection: the hairdresser had embarked upon his 'Marcel' permanent waves)

(And one can perhaps see traces of pastiche of Marcel Proust's white and pink hawthorns[13] and Rimbaud's hares leaping around in 'Après le déluge',[14] as well as of poor Gautier's 'Symphonie'.)[15]

We have seen the voice of narrative itself seriously shattered by the inclusion of alternative texts. The unity of the narrative voice is further upset by the intrusion of sing-song jingles (p. 70), language games borrowed from Desnos (p. 111), by an obsessive vibration of fricative alliteration: 'La femme est dans le feu, dans le fort, dans le faible, la femme est dans le fond des flots, dans la fuite des feuilles, dans la feinte solaire où comme un voyageur sans guide et sans cheval j'égare ma fatigue en une féerie sans fin? (p. 209) ('Female is in fire, in fortitude, in feeble; female floats fathoms deep, flutters in foliage, in the phoney sunlit phantasies where like a guideless, horseless traveller I exploit my exhaustion in infinite fairyland'), by a fragmentation of narrative coherence into a farcical dialogue, or should I say triologue, between Sensibility, Will and Intelligence personified as in some medieval allegory – a trick copied perhaps from Gide, with his angels and his devils in *Les Faux-monnayeurs*[12] (p. 76–9). In this hecatomb of novelistic convention sexual love itself comes in for demystification as the narrator shows us the advert for massage which leads him into a very casually physical experience in a dirty room with a girl with a gold tooth, and closes his clinical description of the brief encounter with an overt challenge to the romanticising or fictionalising reader: 'Que les gens heureux jettent la première pierre', declaring of the monogamous: 'Mes masturbations valent les siennes' (p. 126). And even the sacrosanct dream, when it interrupts the narrative, produces a parody of its own pretensions, as it delivers chiefly a little box with 'rien' written inside it and an inky schoolboyish drawing with 'J'en sors' scribbled across it (p. 159).

Walk and desire, random chance and the libido, that is, set out as the motors of this narrative, and their prolix dialectic provides an increasingly fantastical city landscape, which is ultimately much more a textual creation and a hysterical narrative than any pedestrian musing, or mimesis of passion. The prose style and the narrative structure buckle and flex under the impetus of their own elan, as the rhetoric ebbs and flows between object and fantasy, between denotation, connotation and ironic deflation of both. The narrative flows round and through a real city, of course, and we could weakly argue that Aragon is exploring the boundaries of the real city within the limits of the textual, but it would probably be more helpful to argue that he is exploring the boundaries of the text within the limits of the urban, as his gear-crashing discursive disjunctions judder through brute textual matter and through fantastical reorganisations of the whole city topos in relation to a language borne on by a frenzy of imagery and of paranoid flight from reference. These distortions are increasingly obsessive and hallucinatory towards the end of the later section of the book (*Le*

Sentiment de la Nature aux Buttes-Chaumont) as consciousness appears overrun by objects and subordinate clauses:

> Le taxi qui nous emportait avec la machinerie de nos rêves ayant franchi par la ligne droite de l'interminable rue Lafayette le neuvième et le dixième arrondissement en direction sud-ouest nord-est, atteignit enfin le dix-neuvième à ce point précis qui portait le nom de l'Allemagne avant celui de Jean Jaurès, où par un angle de cènt cinquante degrés environ, ouvert vers le sud-est, le canal Saint-Martin s'unit au canal de l'Ourcq, à l'issue du Bassin de la Villette, au pied des grands batiments de la Douane, au coude des boulevards extérieurs et du métro aérien. (p. 167)

> (The taxi which carried us off including the apparatus of our dreams having crossed via the straight line of the interminable rue Lafayatte the Ninth and the Tenth Arrondissements in a South-West/North-East direction, attained at last the nineteenth Arrondissement at the precise point where the name Allemagne gave way to the name Jean-Jaurès, where at an angle of approximately one hundred and fifty degrees towards the South-East the St. Martin Canal links up with the L'Ourcq Canal, in the confluence of the La Villette Basin, at the foot of the tall buildings of the Customs and Excise, at the juncture of the outer boulevards and the overground metro.)

whilst at the other extreme from this maniacal parody of Balzac or the later Robbe-Grillet, the narrator seizes his own discourse by the throat in an act of naked aggression on his own sentence-structure as well as on the hapless reader clinging on to syntactical logic:

> Ainsi . . .
> Ah je te tiens, voilà l'ainsi qu'attendait frénétiquement ton besoin de logique, mon ami, l'ainsi satisfaisant, l'ainsi pacificateur. Tout ce long paragraphe à la fin traînait avec soi sa grande inquiétude, et les ténèbres des Buttes-Chaumont flottaient quelque part dans ton coeur. L'ainsi chasse ces ombres opprimantes, . . . L'ainsi se promène de porte en porte, vérifiant les verrous mis, et la sécurité des habitations isolées. L'ainsi appartient à la société des veilleurs de l'Urbaine. Et je ne parlerai pas de la bicyclette de l'ainsi. (p. 184–5)

> (Thus . . .
> Ah, there I have you, there's the thus that your frenzied requirement for logic awaited, my friend, the comforting, soporific thus. This whole long paragraph was starting to gather its anxiety copiously about it, and the darkness of the Buttes-Chaumont Park was floating around somewhere in your heart. Thus puts these oppressive shades to flight. . . . Thus patrols from door to door, checking that the bolts are fastened, and that lonely dwellings are securely closed. Thus is a member of the Urban Vigilante Society. Not to mention thus's bicycle.)

The work has become a self-referential hall of mirrors openly

questioning its own sources of inspiration and expression, and sabotaging its own shaping as a reflective narrative, threatening to regenerate itself in perpetuity. In Aragon's struggle between thought and the city, between dream and the number, neither opponent can win – it is language itself, exemplified in the surrealist image, which emerges bloody but unrepentant:

> Le vice appelé *Surréalisme* est l'emploi déréglé et passionnel du stupéfiant *image* ... car chaque image à chaque coup vous force à réviser tout l'Univers. Hâtez-vous, approchez vos lèvres de cette coupe fraîche et brûlante. Bientôt, demain, l'obscur désir de sécurité qui unit entre eux les hommes leur dictera des lois sauvages, prohibitrices. Les propagateurs du surréalisme seront roués et pendus, les buveurs d'images seront enfermés dans les chambres de miroirs. Alors les surréalistes persécutés trafiqueront à l'abri des cafés chantants leurs contagions d'images ... le principe d'utilité deviendra étranger à tous ceux qui pratiqueront ce vice supérieur. L'esprit enfin pour eux cessera d'être appliqué. Ils verront reculer ses limites, il feront partager cet enivrement à tout ce que la terre compte d'ardent et d'insatisfait. Les Facultés seront désertes. On fermera les laboratoires. Il n'y aura plus d'armée possible, plus de famille, plus de métiers. (p. 82–3.)

> (The vice called *Surrealism* is the uncontrolled, emotive use of the narcotic *image* ... for each image every time obliges you to revise the whole Universe. Hurry to press this cool and burning cup to your lips, for soon, tomorrow, the dark desire for safety that makes men unite will inspire them to write ferocious, repressive laws. Propagators of Surrealism will be beaten and hanged, drinkers of images will be locked up in rooms lined with mirrors. Then the persecuted Surrealists will peddle under cover of cabarets their poxy images ... The utility principle will become alien to all who practice this superior vice. The mind will at last cease to surround them, they will see its limits retreat, they will share out their intoxication with everyone ardent and frustrated on earth. The universities will be deserted, laboratories will have to close. The army will disappear, and the family, and work.)

The unreal cities of Breton and Aragon are a hallucinatory projection of the unreal narrators trying strenuously to write out a space in which to exist through the linguistic formulation of their desire, in the face of a city which figures as an enticing mirror of their desire, but which finally eludes their control, by affecting the shape of the image of their desire, which reacts by distorting the reality of the city, and so on *ad infinitum*. In which they make poetic prose fiction take the decisive inward turn which characterises modernism.

Notes to chapter 13

1 B. Cendrars, 'Les Pâques à New York', 1912. Available in *Du Monde entier*, Gallimard 'Poésie' paperback.
2 G. Apollinaire, 'Zone', 1914. Available in *Alcools*, Gallimard 'Poésie' paperback; or *Alcools*, ed. G. Rees, Athlone Press, 1975.
3 L. Aragon, *Le Paysan de Paris*, 1926. Page references in this chapter are to the Gallimard 'Folio' edition, Paris, 1978.
4 A. Breton, *Nadja*, 1928. Page references in this chapter are to the Gallimard 'Folio' edition, Paris, 1982.
5 W. Benjamin, 'Paris: the capital of the nineteenth century', 1935, in *Charles Baudelaire*, Verso Editions, 1983, discusses these arcades.
6 J. Joyce, *Ulysses*, 1922. Available in 'Penguin'.
7 A. Breton, *Manifestes du Surréalisme*, 1924, 1930, 1942. Available in Gallimard 'Idées' paperback.
8 S. Freud, *Jokes and their relation to the unconscious*, 1905, *The Interpretation of dreams*, 1900, *The psychopathology of everyday life*, 1904. All available in Penguin.
9 L. Sterne, *Tristram Shandy*, 1760.
10 D. Diderot, *Jacques le fataliste* (written 1773, published 1796).
11 A. Gide, *Les Caves du Vatican*, 1914. Available in 'Folio' paperback.
12 A. Gide, *Les Faux-monnayeurs*, 1925. Available in 'Folio' paperback.
13 M. Proust, *Du Côté de chez Swann*, 1913. Available in 'Folio' paperback.
14 A. Rimbaud, *Illuminations*, 1872–5. Available in *Poésies; Une Saison en enfer; Illuminations*, Gallimard 'Poésie' paperback; or *Illuminations*, ed. N. Osmond, Athlone Press, 1976.
15 T. Gautier, 'Symphonie en blanc majeur', in *Emaux et Camées*, 1852, Garnier, 1954.

Suggestions for background reading

S. Alexandrian, *Surrealist Art*, London, 1970.
M. Haslam, *The Real World of the Surrealists*, New York, 1978.
N. Nadeau, *The History of Surrealism*, London, 1968.
R. Short, *Dada and Surrealism*, London, 1980.
P. Waldberg, *Surrealism*, London, 1965.

Lorca: Poet in New York

When Lorca went to New York in June 1929 it was his first journey outside Spain. Whereas most of the writers and artists discussed in this book might at some earlier stage in their careers have been able to give their address as 'exile', not so Lorca. There were other Spaniards and Catalans who had made the obligatory pilgrimage to Paris: Larrea, Dali, Diego, Picasso. Salinas had even made his way here to Cambridge, to teach and to absorb English life within the walls of the colleges. But for Lorca the primary journey of exploration had been from Granada, still one of the most beautiful cities of southern Spain, to Madrid. Here he became acquainted with the intellectual life of the capital through the Residencia de Estudiantes, not so much a hall of residence as a centre of cultural and artistic life. But Madrid itself was at this time not a large city by European standards: the central zone could still be crossed on foot in under half an hour.

His journey to New York was also remarkable in that it was made at a time of relative artistic maturity. He was thirty-one when he left for New York, and although the journey was probably conceived of by him as a way of getting over, or getting away from a period of personal crisis, there is no doubt that his reputation both as poet and dramatist had been firmly established before his departure. In particular he was celebrated for the *Romancero gitano* ('Gypsy ballads') of 1928.

His reasons for going to New York, rather than to a more accessible European city, remain obscure. But the extreme experience of New York was to have a profound effect on his imagination and produced an extraordinary poetic response.

The city had come into its own in Spanish poetry in the writings of the *ultraístas* and *creacionistas*. Initially it was seen as a place of fun and excitement. The gentle urban landscapes of Gerardo Diego and Vicente Huidobro display playfulness and no fear. Diego's 'Cosmopolitano' presents a vision of a city that is softened by natural associations:

 Mil agostos te he visto, frutecida
 Ciudad.
 Ciudad de hojas caducas como mujer en rústica

(A thousand Augusts have I seen you, fruited city. City of dead leaves like a woman in country garb.)[1]

And Huidobro's 'Torre Eiffel' is full of whimsy and affection, as this extract shows:

 Torre Eiffel
 Guitarra del cielo

 Tu telegrafía sin hilos
 Atrae las palabras
 Como un rosal a las abejas

 Durante la noche
 no corre el Sena

 Telescopio o clarín
 TORRE EIFFEL

 Eres una colmena de palabras
 O un tintero lleno de miel

 Al fondo del alba
 Una araña con patas de alambre
 Tejía su tela de nubes

 Oh, mi pequeño muchacho
 Para subir a la Torre Eiffel
 Se sube sobre una canción
 Do
 re
 mi
 fa
 sol
 la
 si
 do
 Y ya estamos arriba.

(Eiffel Tower, Guitar of the sky. Your wire-less telegraphy attracts words as a rose bush does bees. In the night the Seine does not flow. Telescope or trumpet EIFFEL TOWER. You are a hive of words or an inkpot full of honey. In the depths of the dawn a spider with wire legs was weaving its web of clouds. Oh my little boy, to go to the top of the Eiffel Tower you have to go up on a song. Doh re mi fah soh lah ti doh. And we're up.)[2]

In the writings of the better-known members of the Generation of '27, such as Pedro Salinas and Rafael Alberti, the city had been, initially at least,

a cause for celebration and delight. Alberti's collection *Cal y canto* ('Firm rock') (1926–7) approaches the city in a spirit of playfulness and romance. The city is not particularly real, but it is not threatening. His sensitivity to detail can be seen in the 'Madrigal al billete del tranvía' ('Madrigal to the tram ticket'):

> Adonde el viento, impávido, subleva
> torres de luz contra la sangre mía,
> tú, billete, flor nueva,
> cortada en los balcones del tranvía.

(There where the wind, dauntless, raises towers of light against my blood, are you, ticket, new flower, cut on the balconies of the tram.)[3]

This forms a striking contrast to the agonised attention to suggestive detail which creates such a menacing atmosphere in the *Poeta en Nueva York*. Just occasionally Alberti does anticipate Lorca's vision, as in the following lines:

> Nueva York
> Un triángulo escaleno
> asesina a un cobrador.
>
> El cobrador, de hojalata.
> Y el triángulo, de prisa,
> otra vez a su pizarra

(New York. A scalene triangle murders the conductor. The conductor, tinplate. And hurriedly the triangle goes back to its blackboard)[4]

Pedro Salinas in *Seguro Azar* ('Sure chance') (1924–8) had given fleeting glimpses of the city, and in the city scenes contained in *Víspera de gozo* ('Eve of pleasure'), his prose work of 1926, the keynotes are lightness, speed, excitement and sophistication.[5] This view of the city was to continue through *Fábula y signo* ('Fable and sign') (1931), where typewriters are endowed with delicate life and grace, where telephones are instruments to bring lovers close, and telegrams do not bring doom, but are seen as ways of responding to emotion. Thus in 'Los adioses' ('The goodbyes'):

> Poner telegramas:
> 'Imposible viaje. Surgió adiós imprevisto.'

(Send telegrams: 'Journey impossible. Unforeseen goodbye arisen.')[6]

It would be wrong to assume that Lorca, because he did not go to Paris, had nothing to do with those young 1920s enthusiasts who did make the pilgrimage there or who treated the city as a delightful environment. For the *ultraístas* the city was the more delightful for being the backdrop to feelings

that might have been associated with softer environments. The sensibility that had an eye for the cityscape blurred through the romanticising haze of rain was one that was also alive to the gentle ins and outs of human affections and moods. The *ultraístas* were not the only writers of the 1920s to declare enthusiasm for the city, however: there were also the Futurists, and the signatories to the *Catalan Anti-Artistic Manifesto*. This manifesto, though from its title apparently rather local, even parochial, in its terms of reference, was similar to other Futurist manifestos in the vehemence with which it condemned academic art and the insistence with which it proclaimed the virtues of youth, strength, speed, energy, and the modern. When it was published first in Catalan, we find Lorca himself among its signatories. And when, in April 1928, it appeared in Spanish, it was in the literary supplement to a Granada paper which had been launched with considerable effort on the part of Lorca.[7] This detail alone shows how Lorca, despite his strongly local attachments, was by no means untouched by the enthusiasms of the literary avant-garde. His poetic response to the city is intense and particularly remarkable when seen in contrast with the climate of enthusiasm elsewhere in Europe.

Excited anticipation about the potential of the city, whether Futurist or *ultraísta*, does not immediately square with what one senses of Lorca's direct reaction to the city from reading the New York poems, and it does not square with various critical interpretations which have been advanced. Critical interpretations of the *Poeta* tend to fall into certain well-defined categories. On one front we have the view that the book is one of protest against the miseries suffered by the blacks in New York. Alternatively there is the view based on the undeniably large number of religious images and allusions, that Lorca was, in the *Poeta*, writing a religious book, as an attempt to find his own brand of faith through a critical examination of established religion. Yet again, there is the view that this book is simply an expression of inner crisis.

One of the difficulties is that until recently critics have based their readings of the *Poeta* on the 1940 Séneca edition, believed to have been close to Lorca's final intentions about the work by the time of his death at the hands of the Nationalists in July 1936 in Granada, some six years after his return from New York. The tale of what constitutes the correct canon of the *Poeta* is a long and sad one. It would not be relevant to bring it forward here were it not for the fact that it undeniably affects the way that we regard the collection. To tell the tale briefly, there is a marked difference between the list of poems known to have been composed by Lorca during his New York stay, and the poems included in the *conferencia-recital* (combined lecture and poetry-reading) given by Lorca in 1931, and on

several subsequent occasions. There is an even more marked difference between these two lists and the extended version we now find in the Aguilar edition and which is based, in general, on the 1940 Séneca edition. Comparison with the dates of poems known to have been written during the New York stay show that the Séneca edition is no straight chronological record: a great deal of re-shuffling has taken place. This edition, which is, for the most part, the one from which the Ben Belitt translation was made, falls into sections which can be seen to form a coherent pattern, as indicated by Angel del Río in the introduction to that edition. He outlines how we are taken from (I) the poet's initial disorientation in America, to (II) focus on pain and passion in the mechanical jungle, with the negro as victim. This is followed by a dance of death. Then (III) is a bucolic interlude, 'a moment of stillness', as if the poet were 'finally awakening from a nightmare'. In (IV) the poet returns to the city to denounce its evils, and in (V), now ready to leave, utters two powerful odes, one of indictment ('Grito hacia Roma') and one of some hope, the ode to Walt Whitman.[8]

That the pattern of the sections may not be an authentic reflection of what the poet wished, is a relatively minor issue. Of more importance is the fact that the order implied by the pattern does not reflect his reactions to the city at the moment of experience. Because of this I propose to confine my discussion primarily to features of the *Poeta* which do not depend for their meaning on any overall structure.

Lorca's poetic reaction to New York contains a great deal of revulsion, confusion and horror at man's inhumanity to man, and a painful awareness of the sweat, smells and stains of urban life. Where Whitman had emphasised the excitement and dynamism of the city, Lorca sees it as unsuited for human habitation, and degrading for those who nonetheless are obliged to inhabit it. This was of course by no means unprecedented. The Expressionists have already shown us that same horror, confusion and disorientation. And we also have the dazed reaction of Cendrars in 1912, though in his case the horror is offset by the God in whom he, despairingly, continues to confide.[9] But in one respect Lorca's position was unique. He had not until this point made any excursion into foreign cities, unlike most of his contemporaries. And he had not written poetry or plays about the metropolis. Seville, Granada and Cordoba appear in the *Cante jondo* and the *Romancero gitano*, and there is a celebration of the 'ciudad de los gitanos' in the 'Romance de la Guardia Civil Española' but the vision is lyrical and the experience could with difficulty be claimed as urban. His poetic output up to the New York stay is rooted in Andalusia and his theatre, farces, puppet plays and the historical drama *Mariana Pineda*, all draw heavily on local rural traditions and artistic forms such as the ballad, the *cante jondo*

and the puppet-theatre. Thus when Lorca went to New York, there was a section of personal and artistic experience which had been, as it were, held in abeyance. His response was to be intensified by a sensitivity to rural tradition that was far from naïve.

The *Poeta en Nueva York* in addition shows him drawing on a mixture of traditions: there is a background of *vanguardista* enthusiasm which may have affected the way in which he envisaged the experience to come; within surrealism itself there is the shift from the concept of image as belonging to the domain of language to image as direct, disturbing visual impression (so powerfully exploited by Lorca's friend and contemporary, Salvador Dalí); and there are, finally, traditional patterns of Spanish life, patterns of festival, procession, celebration of religious feasts, which can not only be presented as grotesque and undermined, but also provide a strong emotional structuring for the chaotic world of the past. This emotional structuring operates on two levels: on the original one of the strength and reassurance that religious ritual, in whatever form, brings to human life, and on the level of the simple familiarity of traditional ritual which can remind us of a world that we once perceived as ordered.

The background to Lorca's visit to New York, particularly as it is revealed by his correspondence, gives indications of a man of tremendous excitement and activity. In the two years preceding his departure he was a man involved in a whirl of hyperactivity, bordering on frenzy, as he plunged himself into different literary campaigns, such as the launching of the *Gallo*, and his wholehearted participation in the 1927 gathering in Sitges to commemorate the work of Góngora, a seventeenth-century poet renowned as much for his obscurity as for his brilliance.

But at the same time, there is evidence of a more troubled side to Lorca in the late 1920s. As early as the end of 1926 or beginning of 1927, in a letter to Melchor Fernández Almagro, in which he expressed dissatisfaction with his poetry because it did not convey what he felt to be his true self, he suddenly remarks 'Necesito irme muy lejos' (I need to go a long way away). Travel is seen as a potential means of escape, but also as a means of finding a new or the true self, whether poetic or otherwise.[10] In about September of 1928 a letter to Jorge Zalamea again speaks of a time of crisis in both the poetry and the personal life.[11] And a letter of the same time, September 1928, to Sebastián Gasch, speaks similarly of Lorca passing through a great emotional crisis, from which (showing even here a courageous optimism) he hopes to emerge cured.[12]

The decision to go to America, nonetheless, came out of the blue. Lorca announced it to Morla Lynch in June 1929 (just before his departure), adding that if Lynch was surprised by the decision, so too was he, Lorca,

and indeed was hilariously amused by it. His attitude to New York and to the journey is extremely ambivalent: 'New York seems horrible to me, but that's precisely why I'm going there. I think I'll have a very good time!'[13] Contrast Lorca's ambivalence with Buñuel's lack of it on the matter of visiting America: 'I adored America before I knew it. I liked everything: the customs, the films, the skyscrapers and even the uniforms of the policemen.'[14]

Despite the evidence of personal crisis, Lorca's literary output in his seven months' stay is impressive. While in New York he not only wrote the great majority of the poems that would form the 1940 Séneca canon for the collection but finished the major poem 'Oda al santísimo sacramento del altar', revised the farces *La zapatera prodigiosa* and *Amor de don Perlimplín con Belisa en su jardín*, and began work on two very different and highly innovative plays, *El público* and *Así que pasen cinco años*.[15] This was all in a space of seven months.

If we are viewing the *Poeta* in its avant-garde context, two further points are relevant. First, Lorca appears to have been working on a prose piece, 'La ciudad' (The city), and spoke of his work in New York as a book of 'interpretations' of that city.[16]

Secondly, in the *conferencia-recital*, a public lecture with readings from the New York poems given by Lorca on a number of occasions between 1931 and 1935, there is a strong element of *vanguardista* excitement. And in addition we find Lorca insisting that he does not wish to tell his audience how New York is when seen 'externally' (underlined in the manuscript of the lecture), but to give them his 'poetic reaction to the city'. Indeed, as Harris puts it, the subject of the *Poeta* 'is the poet not the city'.[17] For Lorca, the salient features of New York are its 'geometry and anguish'. On the geometry he was eloquent:

> The sharp edges rise up to the sky desiring neither cloud nor glory. The Gothic spires are born from the heart of the old who are dead and buried; they ascend, cold, with a beauty that has neither roots nor urge towards an end, clumsily sure, not managing to conquer, and, as happens in spiritual architecture, to surpass the architect's intention which is always inferior. Nothing more poetic and terrible than the battle of the skyscrapers with the sky that covers them. Snow, rain and fog emphasise, wet, cover the great towers, but they, blind to all games, give expression to their cold intention, enemy of mystery, and cut the hair of the rain, or make their three thousand swords visible through the soft swan of the fog.[18]

This seems like a genuine modernist excitement at the city, which could trace its lineage directly back to its *ultraísta* forbears, not to mention lateral relations elsewhere in Europe among the Futurists and Expressionists. But

the *conferencia-recital* also shows the less positive side of Lorca's reaction. One of the last comments is most revealing since it indicates ambivalence about the New York experience, even in this retrospective account. In the manuscript Lorca made a reference to leaving New York with a feeling of 'profound admiration'. The phrase 'profound admiration' was crossed out and then reinstated.

I propose to take a reading of the *Poeta* which starts from this excitement and visual response and then to look at some of the poems as they were written, that is, as immediate and often painful reactions to the city.

The first impression one has on reading the New York poems is that they give us little or no sense of the city of New York. This is how 'unreal' and interior Lorca's city is. And this was how he intended it to be, to judge by his statement in the *conferencia-recital* about not showing its externals. Nonetheless, given those striking and *ultraísta* expressions in the *conferencia-recital* about the geometry of New York, the anguished force of its skyline, it is curious, and a little disappointing, that the architecture of the city is not more prominent in the poems. In 'Navidad en el Hudson' of December of 1929 we do come close to the 'aristas' or sharp edges referred to in the *conferencia-recital*:

> ¡Esa esponja gris!
> ¡Ese marinero recién degollado!
> ¡Ese río grande!
> ¡Esa brisa de límites oscuros!
> ¡Ese filo, amor! ¡Ese filo!
> Estaban los cuatro marineros luchando con el mundo,
> con el mundo de aristas que ven todos los ojos,
> con el mundo que no se puede correr sin caballos.

(That grey sponge! That sailor with throat just slit! That great river! That breeze of dark limits! That edge, o love! That edge! The four sailors were battling with the world, with the world of sharp edges that all eyes see, with the world one cannot travel over without a horse.)[19]

Here the edges of the architecture are not part of a powerful impressive world that touches the elements, but one that is simply hostile. The elements are there – the breeze of dark (unknown) limits, the grey sponge of sky or clouds. The edges do not play with them, but are part of an environment, which, though so alien to man, cannot be traversed without man's natural drives, as suggested by the reference to the horse. Hostile, only to be challenged or met by natural man, not the sailors, victims of the unnatural city. If we look at 'Aurora' ('Dawn'), both elements and skyline are presented in terms that negate the habitual elevation derived from dawn, from

doves, from the aspirations of architecture:

> La aurora de Nueva York tiene
> cuatro columnas de cieno
> y un huracán de negras palomas
> que chapotean las aguas podridas.
> La aurora de Nueva York gime
> por las inmensas escaleras
> buscando entre las aristas
> nardos de angustia dibujada.

(Dawn in New York has four columns of mire and a hurricane of black doves that the rotting waters splatter. Dawn in New York goes moaning along the great stairways searching on the edges for lilies of sketched-out grief.) ('Aurora', O.C., I, 485).

Fleetingly in the 'Cementerio Judío' ('Jewish cemetery') we glimpse an *ultraísta* merging of architecture and nature:

> Las arquitecturas de escarcha,
> las liras y gemidos que se escapan de las hojas diminutas
> en otoño, mojando las últimas vertientes,
> se apagaban en el negro de los sombreros de copa.

(The architectural forms of frost, lyres and moans that are let out by the tiny leaves in autumn, wetting the last slopes, were extinguished by the blackness of the top-hats.) ('Cementerio judío', O.C., I, 520)

If Lorca does give us a visual impression of New York, it is more with the eyes turned downwards, to the gutter, to the river bank, and not to the towering heights of the skyline. There is the same eye for the sordid and banal details of life found in *The Waste Land*, as in the negative suggestion:

> The river bears no empty bottles, sandwich papers,
> Silk handkerchiefs, cardboard boxes, cigarette ends
> or other testimony of summer nights

or where, in 'The Hollow Men', Eliot likens voices to 'wind in dry grass/or rats' feet over broken glass/in our dry cellar'.[20]

The external details of city life that are picked out are those whose inclusion in poetry Pablo Neruda was to recommend in his essay on 'poetry without purity':

Worn surfaces, the wear that hands have inflicted on things, the frequently tragic and often pathetic atmosphere of these objects, instills a type of attraction towards the reality of the world that is not to be scorned.[21]

However, this human debris, in Lorca's eyes, is not valued for itself, but will be washed away by a great flow of blood:

>por los tejados y azoteas, por todas partes,
>para quemar la clorofila de las mujeres rubias,
>para gemir al pie de las camas ante el insomnio de los lavabos
>y estrellarse en una aurora de tabaco y bajo amarillo.

(over rooftops and roof-gardens, everywhere, to burn the pallor of blonde
women, to moan at the foot of beds by the sleeplessness of washbasins and
to explode in a dawn of base yellow tobacco ('Los negros', O.C., I, 461)

In the absence of an architectural panorama, we find two strong alterna-
tive visions: of emptiness, and of crowded chaos. Both may in the first
instance be externally experienced, but ultimately indicate the nature of the
internal world of the poet. At the same time Lorca's vision is an intensifi-
cation of motifs which we encounter in other modernist poetry of the city.
His vision of emptiness conveys a desolation even greater than that of *The
Waste Land*. And his images of crowded chaos express an 'asphalt jungle'
even more anarchic than that of Brecht, since his city is transformed into a
terrain thronged with animals, as is suggested by one of the drawings by
Lorca included in the 1940 edition of the *Poeta* (Fig. 33).

The poems of emptiness, of which the most notable are 'Vuelta de
paseo' ('Return from the Walk') and 'Intermedio (1910)' ('Interlude
[1910]'), pick up threads of reaction and attitude from Lorca's contempo-
raries Luis Cernuda and Rafael Alberti. Cernuda had opened his short
surrealist collection *Un río un amor* (A river a love) with the poem
'Remordimiento en traje de noche' ('Remorse in evening dress'):

>Un hombre gris avanza por la calle de niebla;
>No lo sospecha nadie. Es un cuerpo vacío;
>Vacío como pampa, como mar, como viento,
>Desiertos tan amargos bajo un cielo palpable.

(A grey man moves down the street of fog; no-one suspects he's there.
He's an empty body; empty like the prairie, the sea, the wind, deserts so
bitter beneath a palpable sky.)[22]

Sobre los ángeles ('Of angels') by Alberti similarly opens with bleak, empty
images of isolation and alienation within a ghostly urban setting:

>Ciudades sin respuesta,
>ríos sin habla, cumbres
>sin ecos, mares mudos

(Cities without response, rivers without speech, hills without echoes,
mute seas)[23]

Although Alberti's collection ends on a note of survival, it is with bleak
post-holocaust images.

'Vuelta de paseo' ('Return from the walk') of September 1929 is, like

Alberti's vision, of a poet who has been killed. The images are of death, blankness, the tree that has been polled (the word used here, 'muñones', being the one for the stump of a human limb), the white face of a child, the destroyed toys. It is among these objects and others that the poet wanders, with an equivocal resolution: 'Dejaré crecer mis cabellos' (I shall let my hair grow long).[24] 'Intermedio (1910)' of August 1929, a poem poignantly containing echoes of childhood (the year 1910) is also bleak, with a sense of life and experience which have been witnessed, but with an insistent use of the preterite which emphasizes separation from that experience. The poet has retreated into numbness, after his gaze has fallen on the waste-matter and human chaos of the city:

> Aquellos ojos míos de mil novecientos diez
> vieron la blanca pared donde orinaban las niñas,
> el hocico del toro, la seta venenosa
> y una luna incomprensible que iluminaba por los rincones
> los pedazos de limón seco bajo el negro duro de las botellas.

(Those eyes of mine of nineteen-ten saw the white wall where the girls pee'd, the muzzle of the bull, the poisonous toadstool and a moon eluding understanding that shed light in the corners on strips of dried lemon beneath the hard black of bottles.) ('Intermedio (1910)', O.C., I, 448.)

The retreat into non-communication is more emphatic than in Cernuda and Alberti. Elsewhere we will find that detachment permits a reaction of invective and disgust:

> No preguntarme nada. He visto que las cosas
> cuando buscan su pulso encuentran su vacío.

(Ask me nothing. I have seen that when things seek their pulse they encounter their emptiness.) (O.C., I, 448.)

In counterbalance to these poems of intense inner desolation, which can only imply the city in fragmented images, there are the poems of crowds. The best known are the 'Paisaje de la multitud que vomita', 'Paisaje de la multitude que orina', 'Oda al rey de Harlem', and 'Norma y paraíso de los negros' ('Landscape of the vomiting crowd', 'Landscape of the urinating crowd', 'Ode to the King of Harlem', 'Pattern and paradise of the negroes'). These poems are packed with people, with energy, action, movement – uncoordinated, grotesque, and yet with their own logic and crazy pattern. The New York depicted by Cendrars in 1912 had been populated, but by isolated groups of the many and varied nationalities in the city. Lorca's crowds move inexorably, *en masse*. They resemble Spanish religious procession, with all the oddities that such processions can contain. It is an eye that is acquainted with processions of Easter penitents hooded like the

33. Lorca, *Urban Perspective with Self-Portrait*

Ku-Klux-Klan, or the huge figures that roam the streets in the *fallas* of Valencia that can perceive the order and disorder of the New York throngs. The 'Paisaje de la multitude que vomita' (Landscape of the vomiting crowd) picks out only the first of the train:

> La mujer gorda venía delante
> arrancando las raíces y mojando el pergamino de los tambores;
> la mujer gorda
> que vuelve del revés los pulpos agonizantes.

(The fat woman came first, pulling up the roots and wetting the parchment of the drums; the fat woman, who turns inside-out the octopuses in their death agonies.) (O.C., I, 473.)

The repeated imperfect tenses 'corría por las calles . . . dejaba por los rincones . . . levantaba las furias . . . llamaba al demonio de pan' (She went running through the streets . . . leaving in the corners . . . raising the Furies . . . calling on the devil of bread) which then follow, add to the sense of over-fullness of the poem and are given resolution in a devastating simple use of the verb 'to be', that converts the multitude to a dead and ever-present crowd:

> Son los cementerios, lo sé, son los cementerios
> y el dolor de las cocinas enterradas bajo la arena;
> son los muertos, los faisanes y las manzanas de otra hora
> los que nos empujan en la garganta.

(It is the graveyards, I know, it is the graveyards and the pain of kitchens buried beneath the sand; it is the dead, the pheasants and apples of yesteryear that press in our throats.) (O.C., I, 473.)

In the 'Paisaje de la multitud que orina' ('Landscape of the urinating crowd') there is less sense of movement; instead we have silent members of the multitude, in isolation, with no chance of finding a space that is free from painful experience. In the 'Oda al Rey de Harlem' ('Ode to the King of Harlem'), an undescribed being pens the poem (that is, leads the procession for the reader) with acts of nonsense and violence:

> Con una cuchara,
> arrancaba los ojos a los cocodrilos
> y golpeaba el trasero de los monos.
> Con una cuchara.

(With a spoon he gouged out the crocodiles' eyes and beat on the rumps of the monkeys. With a spoon.) (O.C., I, 459)

The image recurs in this poem as further movement ensues (the advancing tanks of rotten water, the children who chop up small squirrels), and the

sense of procession involves the reader through images of compulsive action.

> Es preciso cruzar los puentes . . .
>
> Es preciso matar al rubio vendedor de aguardiente
> a todos los amigos de la manzana y de la arena,
> y es necesario dar con los puños cerrados
> a las pequeñas judías que tiemblan llenas de burbujas,
> para que el rey de Harlem cante con su muchedumbre . . .

(We must cross the bridges . . . We must kill the blond seller of brandy, all the friends of apple and sand, and with our closed fists we must set about the little jewesses who tremble full of bubbles, so that the King of Harlem can sing with his crowd . . .) (O.C., I, 459–460)

The reader is gripped by the threatening level of energy and surge in these poems. It is, however, the poem 'Danza de la muerte' ('Dance of death') that provides the most memorable and oddly heartening visual images of the collection. The dance of death is part of an ancient and primitive tradition, and derives a great deal of its strength from that. But besides the powerful general background of tradition connected with the dance of death, there is also for Lorca a more local tradition: the essay written by Larra on the eve of Hallowe'en, when on the verge of suicide.[25] In the essay we see how the crowds in the city of Madrid were converted for him into a wild, horrifying carnival parade that overwhelmed him. 'Danza de la muerte' (December 1929) is full of frenzy and chaos, in which the advance of death is an inexorable and oddly reassuring comfort and certainty, since it will destroy the obscenities of New York. The coming is so firmly believed in that Lorca documents it with a series of anticipatory past tenses. After the invitation to behold the advancing mask of death, the poem shifts to the past, with 'Era el momento de las cosas secas' (It was the moment of dry things), and in assured apocalyptic vision prophesies animal participation in this new carnival parade:

> Era la gran reunión de los animales muertos,
> traspasados por las espadas de la luz;
> la alegría eterna del hipopótamo con las pezuñas de ceniza
> y de la gazela con una siempreviva en la garganta.

(It was the great meeting of the dead animals, shot through with swords of light; the eternal happiness of the hippopotamus with its hooves of cinder, and of the gazelle with an immortelle at its throat.) (O.C., I, 469)

As the mask of death weaves its way through the city it cannot but be welcome, since death will cleanse: a primitive power that can obliterate the modern nightmare.

The inclusion of the dance of death in the *Poeta* is not simply the addition of a decorative traditional extra. The coming of Death to New York has all the strength of a ritual enactment that is stirring and dramatic. The vigour of Lorca's portrayal could simply be attributed to the vitality of his poetic imagination, but as a Spaniard he was able to draw on direct experience of ritual such as the imposing Easter processions that are still celebrated in Spain throughout Holy Week, and to convey the excitement of this type of experience. By contrast, ritual for Eliot, while important, is a much more cerebral matter, conveyed by an erudite level of reference which might fail to make its mark with a less than well-lettered reader.

Lorca and Eliot have on occasion been compared, and their interest in myth and ritual is one of the justifications for so doing.[26] Whether Eliot, as the earlier published poet, had influence on Lorca, is another matter. Although Angel del Río refers to Lorca reading a translation of Eliot's work, the Flores translation of *The Waste Land* did not appear until 1930, which makes it very unlikely that Lorca was able to consult it in the period when most of the New York poems were being composed.[27] Thus *The Waste Land* would not have had a substantial influence on the content and expression of the *Poeta*. More likely is the possibility that Lorca did have access to it between his return from New York and his death in 1936, the period in which the poems were being set into a new order. And in that order, where, like Angel del Río, we might trace steps, and observe a positive and significant structure, we may also find that the *Poeta*, by virtue of this perceived structure, has acquired some measure of the detachment of *The Waste Land*. We are left with the question of whether this acquired detachment effectively constitutes a loss.

In 'New York, (Oficina y denuncia)' (New York. [Office and denunciation]') published in January 1931 and probably composed during the New York stay, Lorca, in a moment that is curiously Eliot-like, asks '¿Qué voy a hacer? ¿Ordenar los paisajes?' (What shall I do? Set my landscapes in order?). We might interpret this in a general way (should Lorca order the confused data of the poems?) or in a more particular way, remembering the poems called 'landscapes' (should the poems of the *Poeta* be set in order?). The setting of landscapes in order may have made the final Lorca more like Eliot, but it tempers the raw excitement and horror of the New York experience as it occurred. Where Lorca grips us is not in a final structure that may be perceived by the attentive, but within individual poems and the patterns contained in them, patterns that tap primitive forces, and work through images of ancient power and devastation to meet the cause of pain.

Notes to chapter fourteen

1 Gerardo Diego, 'Cosmopolitano', 1919.

2 Vicente Huidobro, *Obras completas*, 2 vols, Santiago, 1976, I, 269.

3 Rafael Alberti, *Poesía (1924–1967)*, Madrid, 1967, p. 283.

4 'Telegrama', Alberti, *Poesía (1924–1967)*, p. 292.

5 *Víspera de gozo*, republished in Pedro Salinas, *Narrativa completa*, Barcelona, 1976, pp. 9–63).

6 See the poems 'Underwood girls', 'El teléfono' and 'Los adioses' in Pedro Salinas, *Fábula y signo, Poesías completas*, prologue by Jorge Guillén, second edition, Barcelona, 1975, pp. 203, 199 and 205–7. For more detailed comparative treatment of the reaction to the city by Lorca and some of his contemporaries see C. G. Bellver, 'La cuidad en la poesía española surrealista', *Hispania*, 66, no. 4, December 1983, pp. 542–51.

7 The Catalan version can be found in Jaime Brihuega, *Manifiestos, proclamas, panfletos y textos doctrinales: Las vanguardias artísticas en España. 1910–1931*, Madrid, 1979, pp. 157–61. This manifesto was signed by, among others, Picasso, Gris, Chirico, Miró, Arp, Le Corbusier, Reverdy, Tristan Tzara, Eluard, Aragon, Desnos, Cocteau, Strawinsky, Breton and García Lorca. The Spanish version of the manifesto can be seen in Paul Ilie, *Documents of the Spanish Vanguard*, University of North Carolina Studies in the Romance Languages and Literatures, 78, Chapel Hill, 1969 pp. 153–62. Lorca's involvement with the *Gallo* can be traced through his correspondence. See his *Epistolario*, 2 vols, Madrid, 1983, II, 28–44 and p. 102.

8 Federico García Lorca, *Poet in New York*, trans. Ben Belitt, introduction by Angel del Río, London, 1940, pp. xviii–xxvi.

9 See pp. 215–16.

10 *Epistolario*, II, 24.

11 *Epistolario*, II, 108–9.

12 *Epistolario*, II, 109.

13 *Epistolario*, II, 127. Letter to Carlos Morla Lynch.

14 Luis Buñuel, *Mi último suspiro*, Barcelona, 1982, p. 125.

15 For details on this see A. Anderson, 'Lorca's "New York poems": a contribution to the debate', *Forum for Modern Language Studies*, 17, no. 3, July 1981, 256–70 (p. 256). For a reconstructed diary of the stay see Daniel Eisenberg, 'A chronology of Lorca's visit to New York and Cuba', *Kentucky Romance Quarterly*, 24, 1977, pp. 233–50.

16 *Epistolario*, II, p. 137. See P. Menarini, '*Poeta en Nueva York* y *Tierra y luna*: dos libros aún "inéditos" de García Lorca', *Lingua e stile*, 13, 1978, no. 2, 283–93, and A. Anderson, pp. 259–60.

17 Derek Harris, *García Lorca: Poeta en Nueva York* (Critical Guides to Spanish Texts), London, 1978, p. 69.

18 The text of the *conferencia-recital* in the complete edition by Eutimio Martín, *Langues Néo-Latines*, 70, 1976, no. 216, 52–67, (p. 58). Another version of this (without crossings-out and other alterations) is given in an appendix to E. Martín's edition of *Poeta en Nueva York. Tierra y luna*, Barcelona, 1981, pp. 303–17.

19 'Navidad en el Hudson', García Lorca, *Obras completas*, 2 vols, Madrid, 1980, I, 478. All subsequent references to Lorca's poems will be to this edition.

20 T. S. Eliot, *Collected Poems 1909–1962*, London, 1974, pp. 70 and 89.

21 Pablo Neruda, 'Sobre una poesía sin pureza' (October 1935), reprinted in *Pablo Neruda: a basic anthology*, selection and introduction by Robert Pring-Mill, Oxford, 1975, pp. 30–1.

22 Luis Cernuda, *Poesía completa*, Barcelona, 1974, p. 83. *Un río un amor* was first published in 1929.

J

23 'Paraíso perdido', *Sobre los ángeles* (1927–8), reprinted in *Poesía 1924–1967*, Madrid, 1972, p. 317.

24 The line is oddly reminiscent of 'The Love-Song of J. Alfred Prufrock', 'I grow old . . . I grow old . . . / I shall wear the bottoms of my trousers rolled', T. S. Eliot, *Collected poems 1909–1962*, p. 17.

25 Mariano José de Larra, 'Día de difuntos de 1836', *Artículos completos*, prologue by Melchor de Almagro San Martín, 3rd edition, Madrid, 1961, pp. 1321–7.

26 See, for example, Richard Saez, 'The ritual sacrifice in Lorca's *Poet in New York*', *Lorca: a collection of critical essays*, ed. Manuel Durán, New Jersey, 1962, pp. 108–29.

27 Angel del Río introduction to translation of the *Poeta*, p. xxxi.

Musil's Vienna and Kafka's Prague: the quest for a spiritual city

> Falling towers
> Jerusalem Athens Alexandria
> Vienna London
> Unreal

It may seem paradoxical to represent Vienna as unreal. The city, even today, seems so solid, monumental and unchanging. Having suffered less than other cities from the bombs of the Second World War, it is an enduring monument to the grandeur of Hapsburg civilisation: an inner city of baroque churches and palaces on the bank of the Danube, circled by the magnificent Ringstrasse, with its main thoroughfares radiating out through solidly constructed residential quarters into the leafy suburbs and the surrounding Viennese woods. When Eliot's celebrated lines about the 'unreal city' were published in 1922, the Austro-Hungarian Empire had just collapsed as a result of defeat in the First World War. In *The Waste Land* Vienna thus exemplifies the precariousness of imperial power, indeed of western civilisation as a whole, foreshadowing the decline of London. But in 1900 Vienna was still an 'imperial city', enjoying unprecedented power and affluence.[1] The great public buildings of the Ringstrasse outshone those of London and Paris as emblems of imperial splendour and cultural achievement. The paradox to be explored in this chapter is that even in that period of apparent stability a significant number of Viennese writers were already portraying the city as unreal.

The architectural opulence of Vienna was one of the primary sources of that sense of unreality. Vienna was (still is) so evidently a baroque city, a city of the seventeenth or early eighteenth century. Even the great public buildings of the nineteenth century were all constructed in earlier historical styles. Vienna, indeed the Austro-Hungarian Empire itself, seemed like a

grandiose attempt to stop the clock. Rapid demographic change was not
accompanied by a corresponding modernisation of social institutions. But
while Austria-Hungary slumbered, convulsed by occasional eruptions of
military conflict and civil strife, dynamic changes were occurring elsewhere.
And suddenly around 1900 people in Vienna woke up, rubbed their eyes
and looked around them in amazement. They were still living in that
traditional baroque city, although its old ramparts had been transformed
into spacious boulevards. But they recognised that in other great cities there
had been a qualitative change. As principal city of central Europe, Vienna
had been overtaken by the dynamic growth of Berlin. Technologically, the
small craft industries of Vienna could no longer compete with the sophisti-
cated products of Paris and London. And an awareness of the skylines of
Chicago and New York made the domes and spires of Vienna seem anach-
ronistic.

The Shock of the New is the title which Robert Hughes has given to the
transformation of attitudes towards art and architecture which occurred
around 1900.[2] In Austria that shock took an extreme form. Vienna in 1900
was a city riven by the conflict between tradition and modernisation. The
terms of this conflict were more extreme in Austria-Hungary than in other
parts of Europe. On the one hand there was an essentially medieval model
of society, based on the Christian moral order, the authority of the Catholic
Church and the infallibility of the Pope on questions of doctrine, the divine
right of kings, the principles of multinational empire and dynastic alle-
giance, the predominance of aristocratic and military castes, and the loyalty
of a quasi-feudal peasantry. On the other, there was the sudden and
disruptive impact of twentieth-century civilisation with its factories and
urban slums, its mass political movements and rapid means of communi-
cation, bringing into prominence a new capitalist bourgeoisie of manufac-
turers and bankers (many of them Jewish in origin) and secular creeds like
liberalism, scientism, racialism and especially anti-semitism. In Austria the
process of adaptation to modern industrial society was not spread over two
centuries, as it was in England, leaving time for a gradual assimilation of
disruptive social forces. In Austria, as in Germany, this process took place
within a single lifetime, and the medieval and modern orders collided
head-on. It was (as Karl Kraus put it) a 'techno-romantic' civilisation,
where modern industrial forces were still decked out in the trappings of
imperial tradition.

Consciousness of the discrepancy between the 'technical' present and
the 'romantic' past left the intellectuals of Vienna in a vacuum. By twen-
tieth-century standards their environment seemed so theatrical – a city of
masks. This is the theme proclaimed by the front cover of Kraus's magazine

Die Fackel ('The Torch'), which he launched in April 1899 at the start of a satirical crusade which was to last until his death in 1936. Bursting through the clouds of obscurantism, the torch of satirical disclosure starkly illuminates the silhouette of the city. But the rays of light project like the boards of a stage, with the grimacing masks of comedy and satire emphasising the theatricality of Austrian public life. Compared with Kirchner's Expressionist image of the city (Fig. 21), the *fin-de-siècle* flourishes of Kraus's anonymous illustrator seem harmless enough (Fig. 34). But in the final years before the First World War Kraus's image of Vienna was to become as stark and apocalyptic as that of any Expressionist. For although his satire was based on documented events, his theme (as he insisted) 'was not the real, but the possible': the explosive potential which was being generated by the ideological turmoil of his age. Austria-Hungary, he concluded (in an essay written one month before the outbreak of the War), was an 'experimental station for the end of the world'.[3]

This view of Vienna was shared by Kraus's friend, the architect and designer Adolf Loos. In their different spheres they conducted a campaign against a common enemy: the anachronistic cultural institutions of Hapsburg Austria. Their aim was the demolition of façades. This theme was announced in Loos's essay 'Potemkin's city' (1898), in which he derided the pretentious façades of the Ringstrasse. The Russian General Potemkin had constructed whole villages out of cardboard and canvas, in order to deceive Catherine the Great into believing that progress was being made in the Ukraine. The façades of the Ringstrasse (Loos argues) are equally spurious, since they are designed to make modern apartment blocks look like the palaces of aristocrats. To satisfy the vanity of the *nouveaux riches*, ornamental façades have been nailed on to imitate baroque stucco or Tuscan stone. But in fact they are made of cement. In other essays Loos extended this argument into a comprehensive critique of Austrian design. In every sphere, from leatherwork to plumbing, he insists on the need for practical efficiency rather than ornamental design. The beauty of a practical object (he concludes) can only exist in relation to its function.

Loos had visited London and spent a year in Chicago. He knew what a dynamically modern city looked like, and it was this that inspired his functionalist principles. Reacting against the anachronistic clutter of Vienna, he declared ornament to be a 'crime'. But the functional elegance of his buildings so affronted Austrian tastes that he received relatively few commissions. For he was too principled to compromise with the prejudices of his day. He confronted the imperial opulence of Vienna with an alternative vision of a functionalist society. He even dreamed of an era

when 'the streets of the cities will shine like walls of whiteness. Like Zion, the sacred city'.[4]

This tendency to construct alternative cities of the mind can be seen on an even grander scale in the designs of Otto Wagner (1841–1918). Wagner was the initiator of functional architecture in Vienna. But where Loos was a purist, Wagner was a pragmatist. He was willing to make the concessions necessary to secure commissions for important public works – the Metropolitan Railway (Stadtbahn) and the regulation of the Danube Canal. His functional designs are encrusted with classical or *Jugendstil* embellishments which reflect the changing fashions of his day. Yet even Wagner's vision had a utopian element. He too was caught between the traditions of old Vienna and the dream of a purely functional city, which finds expression in his influential writings, *Moderne Architektur* (1895) and *Die Großstadt* (1911). Wagner's plans for the expansion of Vienna have a geometrical severity which is out of keeping with the character of the city. He seems to be dreaming of that ideal city which was later to be invoked in Musil's novel *The Man Without Qualities:*

> a kind of super-American city where everyone rushes about, or stands still, with a stop-watch in his hand. Air and earth form an ant-hill, veined by channels of traffic, rising storey upon storey. Overhead-trains, overground-trains, underground-trains, pneumatic express-mails carrying consignments of human beings, chains of motor-vehicles all racing along horizontally (*MQ*, I, 30).[5]

This reads like a parody of Wagner's architectural ideals; and Musil's novel emphasises how remote this model of the metropolis was from the retarded tempo of life in Vienna.

Wagner's plans were not mere pipe-dreams. He accurately identified the dynamics of metropolitan development. Indeed, visions dreamed up in *fin-de-siècle* Vienna have shaped the life of the twentieth century in spectacular ways. This is particularly true of the work of political visionaries. Theodor Herzl, founder of modern Zionism, was literary editor of a Viennese newspaper. His blueprint for the foundation of a new Jewish state, *Der Judenstaat*, was greeted with incredulity and ridicule when it appeared in 1896. But only twenty years elapsed between the launching of the Zionist movement and the Balfour Declaration which gave it political reality.[6] 'Next year in Jerusalem!' ceased to be a pious wish and became a practical possibility.

The way in which this transformed the horizons of German Jews may be illustrated by the career of Else Lasker-Schüler. Lasker-Schüler was a poet who never had a settled home, although she was a key figure both in the

34. *Die Fackel:* Cover design

DIE FACKEL

HERAVSGEBER:

KARL KRAVS.

ERSCHEINT DREIMAL
IM MONAT.

PREIS 10 KR. WIEN.

Sturm circle in Berlin and for Kraus in Vienna. In her poetry the Jewish dream of a spiritual city finds its most poignant expression:

> Ich suche allerlanden eine Stadt,
> Die einen Engel vor der Pforte hat . . .
>
> (I seek a city in some distant land,
> Before whose gate there doth an angel stand . . .)[7]

In her drawings and poems she created a fantasy city of Thebes, peopled by the ennobled figures of her friends and lovers: Gottfried Benn as Giselheer the Barbarian, Franz Werfel as Prince of Prague, Karl Kraus as the Dalai Lama, the anarchist Senna Hoy of Sascha, Prince of Moscow. She herself was Yussuf, Prince of Thebes, visible at the window in her image of the dream city (Fig. 35), which harmoniously blends Islamic and Judaic motifs. But when the dream collapsed under the impact of German politics, it was in the real city of Jerusalem that she found her final resting-place. Herzl's vision offered hope to a beleaguered generation of Jews, although few were fortunate enough to reach the Promised Land.

For there was another political dreamer who dreamt the opposite dream. Adolf Hitler came to Vienna in 1908 as an aspiring student of architecture. His five formative years in the city left an indelible stamp on his personality. In *Mein Kampf* he describes the corruption of the metropolis in lurid terms: unemployment and destitution in the doss-house, the miseries of slums and building sites, the glaring contrast between rich and poor, the growing power of the masses, the corruptness of the press, the decadence of bohemian life and the lure of prostitution. Hitler may have stylised his account (he was not actually as destitute as *Mein Kampf* suggests). But the horrific impact of the metropolis on a young man without contacts or resources clearly shaped his political vision.[8]

Hitler attributed the evils of the city to a single factor: the Jews. It was the Jews who were responsible for the lies of the press and the decadence of modern art, the socialist creed that was corrupting the workers and the miscegenation which was polluting the lifeblood of the German *Volk*. For Hitler antisemitism had the power of a religious revelation. Suddenly the chaos of the metropolis made sense, as a battleground between good and evil, German and Jew. He was clearly seized by a kind of paranoia. But so widespread was the revulsion against modern civilisation which Hitler epitomises that he was able, twenty years later, to impose his paranoid vision upon millions of German followers.

Hitler's career illustrates the dangers of that reaction against the city which has been analysed in this book. The critics of urban alienation were in dangerous political company. Moreover the avant-garde critics of the

35. Else Lasker-Schüler, *Thebes with Yussuf*

city were strangely reluctant to define their alternatives to megalopolis. Their visions of the unreal city were overwhelmingly negative. They were reluctant to align themselves with the great political movements of socialism and communism, which made the industrial cities their base for programmes of radical change. And when they did construct alternative models of society, the results were decidedly idealistic: the utopian communities of Kropotkin or Landauer, the visionary cities of Sant'Elia, Le Corbusier and Bruno Taut. Hitler, by contrast, was a realist. He knew exactly what he wanted: a city purged of inferior races, an authoritarian state, and a Europe under German domination. He even had precise architectural plans for his regenerated Germanic cities: Linz, Nuremberg and Berlin.[9] Hitler combined paranoia with pragmatism.

Hitler's revulsion against the city had sexual undertones. He was haunted by images of lecherous Jews debauching innocent German maidens. One of the most emotionally charged passages in *Mein Kampf* describes his evening walks through the Jewish quarter of Vienna, where he was overwhelmed by the spectacle of prostitutes and pimps. The sexual displays of the city were indeed deeply disturbing, as is clear from Stefan Zweig's memoir of Vienna before the First World War, *The World of Yesterday* (London, 1943): 'The present generation has hardly any idea of the gigantic extent of prostitution in Europe before the First World War . . . The sidewalks were so sprinkled with women for sale that it was more difficult to avoid them than to find them'.[10] Prostitution formed a dimension of the unreal city which only came to life after dark, but in the daytime lurked beneath the threshold of consciousness.

This was the domain of Sigmund Freud. His archaeology of the emotions probed beneath the surface of urban social life to uncover a turbulent realm of sexual appetites. 'If I cannot move the higher powers, I shall stir up the underground river of Acheron' is the motto of his *Interpretation of Dreams* (1900). He unquestioningly accepted the 'higher powers', the superstructure of Austrian society, leading an amazingly conventional middle-class life as physician, professor and paterfamilias. But beneath the frock-coated respectability of the Viennese bourgeoisie he revealed an animal only partly tamed and vulnerable to eruptions of unsublimated instinct: sexual desire, aggression, the impulse towards death and destruction. In an essay of 1908 he identified 'civilised' sexual morality as the source of 'modern nervousness'. And in *Civilization and its Discontents* (1930) he even suggested that society as a whole may have become 'neurotic'.[11]

Freud's work radically undermined traditional conceptions of 'reality'. The stable self vanishes into a vortex of conflicting impulses which strain

against social cohesion. This questioning of stable identity was all the more subversive because it was supported by the findings of other psychologists: not only the members of Freud's own circle but also the philosopher Ernst Mach. Mach's contributions to physics influenced the early work of Einstein. In psychology his seminal work was *Die Analyse der Empfindungen* ('The analysis of sensations', 1885). Where Freud explores the workings of the unconscious, Mach analyses conscious sense-impressions, radicalising Kant's model of the subjectivity of perception. What our senses of sight and sound, time and space convey to us is not 'reality', but an unstable sequence of sensory stimuli. Consciousness is composed of a multiplicity of chance impressions and memories. The notion of a stable and unified self is therefore untenable: 'Das Ich ist unrettbar'.[12] When this provocative claim, coalescing with the ideas of Freud, filtered through into general intellectual debate in Vienna after 1900, its impact was incalculable.

This questioning of received 'reality' becomes one of the central preoccupations of Austrian writing.[13] The coffee-houses of Vienna (and to a less extent of Prague) were the meeting places for groups of exceptionally gifted writers and thinkers, artists and musicians. Each leading figure had his own circle which might regularly meet a particular coffee-house or on a specified evening: Freud's Wednesday evening gatherings of psychoanalysts, Schoenberg's group of avant-garde composers, Schnitzler's circle (which included high-minded authors like Hofmannsthal), Kraus's clique of iconoclasts (which included Adolf Loos), the painters around Klimt and the Social Democrats around Victor Adler. At certain points the circles intersected, which ensured a rapid circulation of ideas and a fertile interaction between different art forms.

Among such a diversity of talent it is hard to identify common factors. What is striking, however, is the paucity of realistic representations of social life and of the city itself. Led by Gustav Klimt, the painters of Vienna developed an exotic idiom for the exploration of inner states, coloured by sensuous eroticism (Klimt) or extreme nervous tension (Kokoschka and Schiele).[14] The poets and novelists were equally cavalier in their disregard for social realism. There is no Viennese equivalent of Dickens, Balzac or Fontane. The work of Arthur Schnitzler comes closest to reflecting the social life of the city. His novel *Der Weg ins Freie* (1908) and his play *Professor Bernhardi* (1912) portray the ideological conflicts of the day, particularly the emergence of anti-semitism and the clash between scientific scepticism and the clericalism of established institutions.

Schnitzler's fundamental attitude is revealed in a passage from his autobiography (written during the First World War) which looks back on his own carefree existence as a young doctor:

Did he not have a homeland from which to draw strength and life, a fatherland of which he was a citizen, with or without pride? Wasn't there history, world history, which never stood still and which blew around one's ears as one raced through time? Of course there was. But homeland was a place to cavort in, wings and backdrop for one's private fate; fatherland was a creation of chance, a totally indifferent administrative affair.[15]

Although this passage refers to younger days, it epitomises the disjunction between social environment and individual sensibility which characterises Viennese art and literature around 1900. Social life is perceived as the 'backdrop' ('Kulisse') against which to play out individual emotional dramas.

The theatrical metaphor reminds us again of the cover design of *Die Fackel* (Fig. 34). In Schnitzler's writings the artificiality of life in Vienna seems to be taken for granted. In Kraus's work it becomes the target of satirical attack. This reaches its climax in his satirical drama *Die letzten Tage der Menschheit* (*The Last Days of Mankind*), where the events of the First World War are pictured as a 'tragic carnival' played out by masks and marionettes.[16] But the most sophisticated exploration of the divorce between social environment and individual sensibility is to be found in Musil's novel *Der Mann ohne Eigenschaften* (*The Man Without Qualities*). Although not published until 1930–3, the first two volumes of this novel give definitive expression to the inauthenticity of life in Hapsburg Vienna.[17]

Robert Musil was trained as an engineer, but he was a man of literary and philosophical inclinations, and in 1902 he fell under the spell of Ernst Mach (on whom he wrote a doctoral dissertation). About the ideas of Freud he was more sceptical, although his early story *Törless* (1906) is a study of adolescent emotional ambivalence which echoes some of the findings of psychoanalysis. After living through the collapse of Austria-Hungary, Musil set about the task of writing a kind of alternative history of that historical crisis, in a fictional form which bears clear traces of Mach's influence.

Set in the final years before the First World War, the novel explores the ideological turmoil of Vienna and the impending collapse of Hapsburg institutions. But Musil does not dwell on political factors, such as the resurgence of Slav nationalism or the rivalry between Britain and Germany. His focus is on the instability of the human mind and the turmoil of thoughts and feelings which animate it. Life in Vienna exemplifies that 'intellectual revolution' which occurred with the onset of the twentieth century:

The contradictions . . . were unsurpassable. The Superman was adored

and the Subman was adored; health and the sun were worshipped, and the delicacy of consumptive girls was worshipped; people were enthusiastic hero-worshippers and enthusiastic adherents of the social creed of the Man in the Street; one had faith and was sceptical, one was naturalistic and precious, robust and morbid; one dreamed of ancient castles and shady avenues, autumnal gardens, glassy ponds, jewels, hashish, disease and demonism, but also of prairies, vast horizons, forges and rolling-mills, naked wrestlers, the uprisings of slaves of toil, man and woman in the primeval Garden, and the destruction of society.
(*MQ*, I, 59)

This ideological turmoil is explored through the personality of Ulrich, Musil's hero. But 'personality' is the wrong word. For Ulrich is a man 'without qualities', a Machian hero whose character dissolves into a multiplicity of divergent selves:

For the inhabitant of a country has at least nine characters: a professional one, a national one, a civic one, a class one, a geographical one, a sex one, a conscious and an unconscious and perhaps even too a private one; he combines them all in himself, but they dissolve him . . . Hence every dweller on earth also has a tenth character, which is nothing more or less than the passive illusion of spaces unfilled . . . an empty, invisible space with reality standing in the middle of it like a little toy brick town, abandoned by the imagination. (*MQ*, I, 34)

The disjunction between reality and self could hardly be more radically formulated. Ulrich lives his life 'hypothetically', guided not by his 'sense of reality' but by the 'sense of possibility' (*MQ*, I, 12).

The novel begins realistically enough. We are plunged into the streets of Vienna in the rush hour, with cars intersecting the bustle of pedestrians and a hundred different sounds converging and fragmenting around us. Braking sharply, a lorry swerves and knocks down a pedestrian. But Musil is not concerned to analyse the cause of such an accident (as Brecht does in a well-known essay).[18] Musil's focus is on the responses of the onlookers. A sentimental lady feels a paralysing sensation in the pit of her stomach. But her companion responds with the pragmatic observation: 'These heavy lorries they use here have too long a braking-distance.' This technical analysis is intended to be reassuring, especially as the gentleman adds: 'According to American statistics there are over a hundred and ninety thousand people killed on the roads annually over there'. (*MQ*, I, 5–6)

These contrasting responses express the problem which preoccupies the whole novel: how to reconcile scientific exactitude with spiritual truth, 'facts' with 'eternal verities' (*MQ*, I, 295). We are living in a civilisation created by scientific precision and statistical analysis, where (as Musil seems

to have anticipated) the computer will soon be king – the symbol he invokes in the slide-rule (*MQ*, I, 38). How can this urban, technocratic civilisation accommodate the claims of emotional and spiritual life? The problem is explored from a multitude of different narrative angles with immense intellectual verve and stylistic subtlety. The solution which Ulrich aspires to is a synthesis of science and spirituality. It is adumbrated in the novel through his relationship with his sister Agathe, a kind of mystical union which guides them towards the realm of 'the other condition' ('der andere Zustand'). The novel begins with the screeching of brakes on the streets of a recognisable city. It ends, or rather peters out (for Musil's sprawling manuscript remained incomplete) in a realm of disembodied intellectuality.

The real city, in short, is reduced to 'a little toy brick town abandoned by the imagination', while the narrative moves into that 'empty, invisible space' where all contradictions may be reconciled. But this dislocation is the fault of the city as much as the novelist. For the novelists of the early twentieth century, the city has become too amorphous for structured, sequential narrative. In Dickens each chapter corresponds to a clearly defined social milieu, and we are offered a coherent map of social interaction. But the dynamic rhythms of the modern metropolis are felt to be too elusive to be fixed in this way, its social relations too fractured and impersonal, its states of consciousness too fluid. The contours of the city streets dissolve in Musil's Vienna as they do in Rilke's Paris, Joyce's Dublin, Woolf's London and Döblin's Berlin. The richness of these novels lies in their exploration of states of consciousness, dissolving and reforming amid the uban turmoil. The subtlety of Musil's response is at times reminiscent of Joyce's *Ulysses* (as Michael Long has argued in Chapter 9). But the life of the metropolis ultimately defies representation.

This sense of a loss of reality is related to a loss of confidence in language. The inadequacies of language form one of the recurrent laments of Austrian writing, from Hofmannsthal to Peter Handke. The work of the philosopher Ludwig Wittgenstein is centred on precisely this problem. But few imaginative writers shared Wittgenstein's confidence that language can be reduced to an orderly system. One passage from the *Philosophical Investigations* even suggests that language can be mapped in a way one would map a city: 'our language can be seen as an ancient city: a maze of little streets and squares, of old and new houses, and of houses with additions from various periods; and this surrounded by a multitude of new boroughs with straight regular streets and uniform houses.'[19] Wittgenstein's analogy for lexical accretion is too static to accommodate the problems encountered by Austrian imaginative writers of his generation. New

words in a dictionary may be like new houses on a city plan. But the lived experience of the city eludes linguistic expression.

There are few Viennese writers of this period who seem securely at home, either in the city where they lived or in the language which they wrote. They felt themselves to be living among 'sleepwalkers' – people unaware of the vacuum on which the social consensus rested (*Die Schlaf-wandler* is indeed the title Hermann Broch gave to his ambitious novel on this theme, published in 1931). Their dilemma is summed up in Elias Canetti's novel *Die Blendung* (1935), an allegory of the intellectual who takes refuge among his books from a city with which he has lost rapport. The fire which finally engulfs him and his great library is reflected in the novel's English title *Auto-da-Fé*. But the folly of this enterprise of trying to construct a stable intellectual edifice amid the turmoil of the city is more appropriately reflected by the title under which this novel first appeared in America: *The Tower of Babel*.

Of course there were minor poets in Vienna, like Anton Wildgans, who wrote about the city in a more traditional and homely idiom. Most notable among them was Josef Weinheber, a poet who came from humbler social origins and wrote vernacular poetry which echoes the rhythms of Viennese dialect. The poems of his *Wien wörtlich* (1935) celebrate the tranquil suburbs and wine villages, where the thirsty soul may find refreshment even if they offer no solace to the exacting mind. But the more rigorous authors of the Austrian avant-garde were spiritual exiles in their own city, long before they were forced – like Musil, Broch and Canetti – into exile by political events.

In Prague the sense of estrangement was even greater. The historical context has been reconstructed in *The World of Franz Kafka*.[20] Prague is another city where time seems to have stood still. A beautiful but haunted cityscape of medieval alleys and baroque palaces converges on the banks of the Moldau under the dominating presence of castle and cathedral. Rapid industrialisation generated an extensive sprawl of new suburbs in the late nineteenth century. But the buildings of the old city remained relatively intact. They are still there, crumbling magnificently away, to this present day. In 1900 the air of unreality was even greater. For Prague was a German outpost in a Czech hinterland. The resurgence of Czech nationalism had left the German-speaking urban élite stranded in a turbulent sea of Slavs. It was a relationship of master and servant, in which the Austrian ruling class was still supposedly in command but the Czech populace were already flexing their muscles. For the Czechs this meant cultivating the art of survival under an oppressive regime and awaiting the moment when the political tables could be turned. This situation is reflected in the relationship between

Czech servant and Austrian master in the great picaresque novel, *The Good Soldier Svejk* by Jaroslav Hasek. Svejk's earthy realism enables him to survive the First World War, while the Austro-Hungarian system is falling apart around his ears. Whatever the crisis, Svejk can always be counted on to take refuge in a reassuring anecdote or a cosy pub around the corner.

In Kafka's writings, by contrast, the city dissolves into a penumbra of insecurity. It is often argued that as a German-speaking Jew living in the Czech capital Kafka suffered from a double alienation, and that this explains the existential anxiety of his writings. But it must be remembered that Kafka was only one of a whole group of Jewish writers who contributed to the brief but spectacular efflorescence of German literature in Prague. And it is against their work that his responses must be measured.

The central figure was the ebullient Franz Werfel. It is not adequate to argue that Kafka wrote as he did 'because he was a German Jewish writer living in Prague'. Werfel too was a German Jewish writer living in Prague, yet he wrote in a style that is the exact antithesis to Kafka's. The relation between urban environment and imaginative response must not be simplistically conceived. Werfel's early poems, published under the title *Der Weltfreund* in 1911, express a joyous world-embracing philanthropy. He celebrates the multifarious activities of modern urban society in a manner reminiscent of Walt Whitman. His vision of brotherhood forms the positive counterpart to the apocalyptic mood of German Expressionism and is given particular weight in the later, more optimistic sections of the anthology *Menschheitsdämmerung*. Werfel's all-embracing humanism is the converse of Kafka's vision of inescapable solitude. But each in his own way transcends realistic representation. Werfel's joyous band of brothers are as remote from actual social relations in the city as Kafka's desolately isolated outsiders.

German Jewish writers thus responded to the situation in Prague in very divergent ways. But there is no doubt that a specifically Jewish predicament contributed to the intensity of their writings. With the growth not only of Czech nationalism but also of a particularly virulent antisemitism among the Germans of Bohemia, the Jewish communities did feel exceptionally vulnerable. But this insecurity expressed itself in a diversity of ways: in Max Brod's Zionism and Martin Buber's revival of the Chassidistic tradition, as well as Werfel's compensatory optimism and Kafka's quiet despair.

Kafka certainly did not lack the gift of realistic observation. His stance in the early volume *Betrachtung* (1912) is that of a solitary man 'with a window looking on to the street'. As he stands idly at his window-sill, 'the horses below will draw him down into their train of waggons and tumult, and so at last into human harmony' (KS 384)[21]. The prose sketches of

Betrachtung are so sharply observed that the English title might well be 'Observation' rather than 'Meditation'. They are snapshots of urban experience with existential undertones:

On the Tram

I stand on the end platform of the tram and am completely unsure of my footing in this world, in this town, in my family. Not even casually could I indicate any claims that I might rightly advance in any direction. I have not even any defence to offer for standing on this platform, holding on to this strap, letting myself be carried along by this tram, nor for the people who give way to the tram or walk quietly along or stand gazing into shop windows. Nobody asks me to put up a defence, indeed, but that is irrelevant . . . (*KS* 388)

Under Kafka's gaze, the routine experience of the city commuter becomes an existential challenge. And the passenger's sense of insecurity is intensified by the contrast (in the second paragraph of the same sketch) with the young woman who seems so amazingly self-assured as she prepares to alight from the tram. Existence has to be justified – though by what authority?

Kafka does not create a dream city, as Alfred Kubin did in the fantastic novel *Die andere Seite* (*The Other Side*, 1907). Kafka's art makes the mundane mysterious. He starts with the most familiar of situations, like waking up for breakfast or rushing to catch a train:

Give it Up!

It was very early in the morning, the streets were clean and deserted, I was on my way to the station. As I compared the tower clock with my watch I realized that it was much later than I had thought and that I had to hurry; the shock of this discovery made me feel uncertain of the way, I wasn't very well acquainted with the town as yet; fortunately, there was a policeman at hand, I ran to him and breathlessly asked him the way. He smiled and said: "You asking me the way?" "Yes," I said, 'since I can't find it myself." "Give it up! Give it up!" said he, and turned with a sudden jerk, like someone who wants to be alone with his laughter. (*KS* 456)

From these small-scale vignettes of alienation in the city and among the crowd Kafka moves on to his classical exploration of urban insecurity in his masterpiece *Der Prozess* (*The Trial*, 1925). His language modulates so that 'asking the way' ceases to be a practical inquiry and becomes an existential quest.

The compelling power of his novel derives from these transitions between real and surreal. He starts (as he puts it in his own note 'On parables') with 'the cares we have to struggle with every day'. (*KS* 457) But we cannot

deny the impulse to 'go over' into some 'fabulous beyond'. Anxieties arise out of a recognisable social environment: an apartment block, a neighbour's bed-sitter, a lawyer's office, an artist's studio or a corridor at the bank. But we never know whether the door will open into an adjacent room or an existential void. The flow of images between social environment and subjective response is all the more bewildering because it is a two-way process. The novel acquires a hallucinatory quality when the urban milieu assumes shapes which reflect the hero's anxieties. It doesn't really matter which part of the city he visits in his quest for self-vindication. For his haunted mind will find a court sitting in judgment 'in almost every attic' (KN 125).

There is a further source of Kafka's exceptional power. His image of the city synthesises elements from the work of other critics reviewed in this chapter. It is usually Musil's novel that is praised as a monumental work of intellectual synthesis. But The Man Without Qualities explores the conflicting ideologies of the age at a level of intellectual abstraction. In Kafka's novel they are assimilated more subtly and imaginatively, so that they form a sub-text in which the reader becomes inextricably enmeshed. Kafka synthesises Mach's emphasis on the unreliability of perception with Freudian eruptions of unconscious impulse; Kraus's satire on bureaucratic obstruction and misinformation with the clutter of claustrophobic interiors which Loos sought to sweep away; Herzl's and Buber's articulation of specifically Jewish aspirations with Hitler's rabid underworld of assassins who arrive at night. Kafka's individual sensibility fuses the aspirations and anxieties of his age into a remarkable imaginative synthesis.

A journey through these cities of the imagination is likely to leave the reader with ambiguous feelings. These feelings become particularly acute when we actually visit Prague or Vienna after having read Musil of Kafka. The city seems so solid. It has vitality and charm. It offers congenial creature comforts. But from within the city we can hear two incompatible voices. Near at hand is a vernacular voice – the voice of Weinheber or Hasek. This voice reassuringly says: 'That reminds me, there's a pub just round the corner. Let's go in and have a drink!' But we can also hear the voices of Musil and Kafka. Their vision directs our gaze towards a more distant horizon, towards the hills that surround Vienna or the castle which floats so enigmatically over the rooftops of Prague. Their words are equally powerful. Authentic life (they say) is not to be found in the city. It can only be glimpsed if we 'go over' into that 'other condition' which is 'beyond'. But the castle (as in Kafka's second great novel) seems to recede, the more we strive to approach it. The quest is ultimately for a spiritual city which is by definition unreal.

Notes to chapter 15

1 Ilsa Barea, *Vienna: Legend and Reality* (London, 1966), chapter 5.
2 Robert Hughes, *The Shock of the New* (London, 1980).
3 Kark Kraus, *Die Fackel*, 400–3 (July 1914), p. 2.
4 Adolf Loos, *Sämtliche Schriften* (Vienna, 1962), pp. 153–6 & p. 278.
5 Quotations from Robert Musil, *The Man Without Qualities*, trans. Eithne Wilkins and Ernst Kaiser, 3 vols. (London, 1953) are identified by *MQ* followed by volume and page number.
6 Oskar K. Rabinowicz, *Herzl, Architect of the Balfour Declaration* (New York, 1958).
7 Else Lasker-Schüler, *Sämtliche Gedichte* (Munich, 1966), p. 269; *Theben: Gedichte und Lithographien* (Frankfurt, 1923).
8 Hitler, *Mein Kampf*, trans. Ralph Mannheim (London, 1969), chapter 2.
9 *Hitlers Städte: Eine Dokumentation*, ed. Jost Dülffer (Cologne, 1978).
10 Stefan Zweig, *The World of Yesterday* (London, 1943), p. 72.
11 Freud, *Standard Edition*, IX, 177–204 & XXI, 144.
12 Ernst Mach, *Die Analyse der Empfindungen*, second edition (Jena, 1900), p. 17.
13 For more comprehensive accounts of Viennese culture in this period see Carl E. Schorschke, *Fin-de-siècle Vienna* (Cambridge, 1981); Allan Janik and Stephen Toulmin, *Wittgenstein's Vienna* (London, 1973). The problematic aspect of this questioning of 'reality' is analysed by J. P. Stern, ' "Reality" in *Der Mann ohne Eigenschaften*', in *Musil in Focus*, ed. Lothar Huber and John J. White (London, 1982), pp. 74–84.
14 See Peter Vergo, *Art in Vienna 1898–1918*, second edition (Oxford, 1981).
15 Arthur Schnitzler, *My Youth in Vienna* (London, 1971), p. 234.
16 Karl Kraus, *Die letzten Tage der Menschheit* (Vienna, 1919); English translation abridged and ed. Frederick Ungar (New York, 1974).
17 A comprehensive account of this theme would of course include a wider range of authors; see William M. Johnstone, *The Austrian Mind 1848–1938* (Berkeley, 1972).
18 Bertolt Brecht, 'Die Strassenszene', *Gesammelte Werke in acht Bänden* (Frankfurt, 1967), VII, 546–58.
19 Ludwig Wittgenstein, *Philosophical Investigations*, trans. G. E. M. Anscombe (Oxford, 1953), p. 8.
20 F. W. Carter, 'Kafka's Prague', in *The World of Franz Kafka*, ed. J. P. Stern (London, 1980), pp. 30–43.
21 References are to *The Penguin Complete Short Stories of Franz Kafka* (Harmondsworth, 1983), abbreviated as *KS*; and *The Penguin Complete Novels of Franz Kafka* (London, 1983), abbreviated as *KN*.

Abercrombie, Lascelles, 124
Adler, Victor, 255
Alberti, Rafael, 231–2, 239–40
Alciati, Andrea, 92, 95
Altomare, Libero, 71, 73, 76
Andreas-Salomé, Lou, 99, 102–4
Andrewes, Lancelot, 148
Apollinaire, Guillaume, 4, 7–8, 35, 39–40,
 42–3, 74, 80, 87, 89–92, 95, 108, 134,
 215, 220
Aragon, Louis, 10, 108, 216, 219–24, 226,
 228
Auden, Wystan Hugh, 11

Baldwin, Stanley, 125
Balla, Giacomo, 73, 77
Balzac, Honoré de, 27, 219, 227, 255
Banham, Reyner, 57, 78
Barzun, Henri-Martin, 83
Baudelaire, Charles, 1, 7–8, 19, 25–6, 32,
 34, 36–7, 39, 42–3, 45, 80–3, 85–6,
 89–90, 97–101, 108–9, 113–16, 145,
 214, 218
Becher, Joahannes, 119
Beckmann, Max, 180
Beethoven, Ludwig van, 106
Belitt, Ben, 234
Bely, Andrey, 4, 9, 161–5, 167, 173–4, 176
Benjamin, Walter, 7, 19, 25–7, 34, 43, 184
Benn, Gottfried, 118, 253
Bergson, Henri, 3
Berkeley, George, 217
Bètuda, Mario, 72
Blake, William, 148
Blériot, Louis, 59
Blok, Alexander, 161
Blunden, Edmund, 113, 119
Boccioni, Umberto, 8, 54, 57–9, 65, 74, 77,
 118
Boileau, Nicolas, 36
Booth, Charles, 18
Borgers, Gerrit, 134
Braque, Georges, 86, 91, 217
Braun, Otto, 125
Brecht, Bertolt, 1, 10, 60, 117, 178, 180,
 182, 184–91, 239, 257

Breton, André, 10, 108, 216–18, 220–1,
 228
Breuer, Josef, 104
Broch, Hermann, 180, 259
Brod, Max, 260
Brooke, Rupert, 9, 112–16, 123
Bruckner, Ferdinand, 180
Buber, Martin, 260, 262
Bugaev, Boris, 161
Buñuel, Luis, 236
Burliuk, David, 165
Buzzi, Paolo, 70, 73, 75–6

Campendonk, Heinrich, 132
Canetti, Elias, 259
Cangiullo, Francesco, 71
Carrà, Carlo, 58
Catherine the Great, 158, 176
Cavacchioli, Enrico, 71, 76
Céline, Louis-Ferdinand, 27
Cendrars, Blaise, 215–16, 218, 234, 240
Cernuda, Luis, 239–40
Cézanne, Paul, 49, 51
Chaplin, Charlie, 203, 210
Chesneau, Ernest, 47
Chrétien de Troyes, 221
Claudel, Paul, 115
Conan Doyle, Sir Arthur, 17
Constable, John, 30
Constant, Benjamin, 32
Corradini, Bruno, 69
Corrazzini, Sergio, 69
Correnti, Dinamo, 70
Courbet, Gustave, 45

D'Alba, Auro, 74
Dalí, Salvador, 230, 235
D'Annunzio, Gabriele, 69
Dante, Alighieri, 145, 148, 215
Danton, Georges-Jacques, 91
Däubler, Theodor, 132
Daumier, Honoré, 45
Davies, William Henry, 113
de la Mare, Walter, 113
Degas, Hilaire Germain Edgar, 45
Delaunay, Robert, 4, 8, 59–60, 63

Derain, André, 86
Desnos, Robert, 226
Dickens, Charles, 7, 17–19, 255, 258
Diderot, Denis, 224
Diego, Gerardo, 230
Dix, Otto, 8, 60, 63, 180
Döbin, Alfred, 27, 180, 182, 203, 258
Doré, Paul Gustave, 45
Dos Passos, John, 18, 180
Dostoyevsky, Feodor, 160
Drinkwater, John, 113
Duchamp, Marcel, 214, 220

Einstein, Albert, 255
Eisenstein, Sergei, 10, 167, 193, 208,
 211–12
Elgar, Edward, 125
Eliot, Thomas Stearns, 1, 3–4, 7, 9–10, 16,
 19, 35, 37, 42–3, 95, 113, 125, 144–51,
 153–4, 156, 207, 238, 244, 247
Engels, Friedrich, 7, 17–18
Ensor, James, 49, 51
Esslin, Martin, 189

Falconet, Etienne, 159
Fernández Almagro, Melchor, 235
Fielding, Henry, 17
Fildes, Luke, 49
Fischer, Samuel, 182
Flaubert, Gustave, 7, 19, 25, 27, 150–1,
 155–6
Flores, Angel, 244
Folgore, Luciano, 73, 75–6, 78
Fontane, Theodor, 255
Fourier, Charles, 39
Freud, Sigmund, 4, 8, 11, 98, 103–4, 106–8,
 221, 224–5, 254–6, 262
Freund, Karl, 201, 206
Friedländer, Salomo, 132

García Lorca see Lorca
Gasch, Sebastián, 235
Gaskell, Elizabeth, 17
Gauguin, Paul, 49, 51
Gautier, Théophile, 19, 25, 81, 225
George, Stefan, 115
Gide, André, 99, 224, 226
Girouard, Mark, 194
Gissing, George, 16–17
Goebbels, Joseph, 125, 207
Goethe, Johann Wolfgang von, 208

Gogol, Nikolai, 160, 162, 174
Góngora, Luis de, 235
Govoni, Corrado, 70
Goya, Francisco, 120
Gozzano, Guido, 69–70
Graves, Robert, 113, 119
Gray, Thomas, 113
Gropius, Walter, 125
Grosz, George, 8, 60, 125, 131–2, 180, 182
Gurney, Ivor, 113
Guys, Constantin, 45

Hadermann, Paul, 133
Hamburger, Michael, 178
Handke, Peter, 258
Harbou, Thea von, 194–5, 197, 200
Hardy, Thomas, 113
Harris, Derek, 236
Hartlaub, Georg Friedrich, 178
Hasek, Jaroslav, 260, 262
Haussmann, Eugène, Baron, 19, 25–6, 45
Hegel, Georg Wilhelm Friedrich, 161, 225
Helm, Brigitte, 200
Herzl, Theodor, 11, 250, 253, 262
Heym, Georg, 7, 9, 111, 118, 120, 122–5,
 182
Hiller, Kurt, 111
Hitler, Adolf, 11, 253–4, 262
Hoddis, Jakob van, 111, 118–20, 123, 142
Hofmannsthal, Hugo von, 115, 130, 255,
 258
Holz, Arno, 117
Homer, 77
Horváth, Ödön von, 180
Hoy, Senna, 253
Hughes, Robert, 248
Hugo, Victor, 81, 89
Huidobro, Vicente, 230–1

Ibsen, Henrik, 106, 108
Ihering, Herbert, 182

Jacobsen, Jens Peter, 101
James, William, 4
Jammes, Francis, 115–16
Jarry, Alfred, 217
Jessner, Leopold, 195
Joyce, James, 4, 7, 9, 42–3, 144, 146–7,
 150–6, 180, 220, 258

Kafka, Franz, 10–11, 247, 259–62

Kaiser, Georg, 181–2
Kandinsky, Wasily, 132
Kant, Immanuel, 161, 255
Kästner, Erich, 180, 183–4
Khlebnikov, Velimir, 166
Kipling, Rudyard, 187
Kirchner, Ernst Ludwig, 7, 52, 54, 120, 122, 249
Kley, Heinrich, 120
Klimt, Gustav, 255
Klinger, Max, 49
Kokoschka, Oskar, 255
Kracauer, Siegfried, 201
Kraus, Karl, 248–9, 253, 255–6, 262
Kropotkin, Peter, 254
Kruchenykh, Nikolai, 166
Kubin, Alfred, 261

Laforgue, Jules, 1, 7, 19, 25, 39–40, 42–3, 86
Lamarck, Jean-Baptiste, 76
Landauer, Gustav, 254
Lang, Fritz, 10, 193–5, 200–1, 211–12
Larra, Mariano José de, 243
Larrea, Juan, 230
Lasker-Schüler, Else, 250
Lautréamont, Comte de, 25
Lawrence, David Herbert, 113
Le Corbusier, Charles-Édouard Jeanneret, 149, 254
Le Gallienne, Richard, 19
Leavis, Frank Raymond, 146
Léger, Fernand, 30
Lenin, Vladimir, 172
Lessing, Gotthold Ephraim, 120
Lewis, Wyndham, 59
Liebknecht, Karl, 131
Lissitzky, El, 168
Loerke, Oskar, 182–3
Loos, Adolf, 11, 249–50, 255, 262
Lorca, Federico García, 1, 3, 10, 215, 230, 232–40, 243–4
Luther, Martin, 184
Lutyens, Edwin, 125
Luxemburg, Rosa, 131

Mach, Ernst, 11, 255–6, 262
Malatesta, Sigismondo, 149
Mallarmé, Stéphane, 82–3, 90–1, 214
Mandelshtam, Osip, 9, 161, 173–6
Manet, Edouard, 28, 30–1, 45, 106

Marc, Franz, 132
Marinetti, Filippo Tommaso, 8–9, 57–8, 65–6, 68–72, 75–8, 82–3, 134, 165
Marsh, Edward, 114, 126
Marx, Karl, 39–40, 117
Masefield, John, 113
Mathilde, Princess, 19
Matisse, Henri, 32
Mayakovsky, Vladimir, 9, 161, 165–8, 170, 172–4, 176
Mayer, Carl, 201, 207
Meidner, Ludwig, 3–4, 7, 47–9, 51–2, 54, 118, 120
Menzel, Adolph, 52
Metzinger, Jean, 132
Mix, Tom, 203
Monet, Claude, 7, 27–8, 30, 45, 47–9, 51
Morla Lynch, Carlos, 235
Morrison, Arthur, 18
Munch, Edvard, 7, 49, 51
Murnau, Friedrich Wilhelm, 195
Musil, Robert, 10–11, 156, 180, 247, 250, 256–9, 262

Napoleon, Emperor, 128
Neruda, Pablo, 238
Nerval, Gerard de, 81
Nicholas I, 160
Nielsen, Asta, 140
Nietzsche, Friedrich, 82, 161, 218

Oppenheim, Meret, 214
Ostaijen, Paul van, 9, 128–42
Owen, Wilfred, 113
Oxilia, Nino, 69

Palazzeschi, Aldo, 70–1
Parnell, Charles Stewart, 153
Péguy, Charles, 115
Peter the Great, 158–9, 163, 166
Pfemfert, Franz, 111
Picasso, Pablo, 8, 28, 86, 91–2, 214, 220, 230
Pinthus, Kurt, 123
Pirandello, Luigi, 72
Pissarro, Camille, 30, 47
Poe, Edgar Allan, 34
Pound, Ezra, 3, 9, 35, 43, 113, 144, 146–50, 156, 180, 203
Proust, Marcel, 39, 99, 225
Pushkin, Alexander, 159–60, 162–3, 174

Radischev, Alexander, 158
Ray, Man, 214
Régnier, Henri de, 115
Renaud, Philippe, 90
Renoir, Pierre-Auguste, 28, 30, 45
Rilke, Rainer Maria, 3, 7–8, 37, 97–109,
 118, 124–5, 258
Rimbaud, Arthur, 7, 19, 25, 37–40, 42–3,
 225
Río, Angel del, 234, 244
Robbe-Grillet, Alain, 227
Rodin, Auguste, 101
Rothenstein, William, 126
Russolo, Luigi, 58
Ruttmann, Walther, 10, 207–8, 211–12

Sade, Marquis de, 218
Saint-Point, Valentine de, 72
Saint-Simon, Comte de, 32
Salinas, Pedro, 230–2
Sant'Elia, Antonio, 7–8, 66, 68, 71–3, 78,
 254
Sasson, Siegfried, 113
Schiele, Egon, 255
Schnitzler, Arthur, 114, 255–6
Schoenberg, Arnold, 125, 255
Schopenhauer, Arthur, 161
Settimelli, Emilio, 69
Seurat, Georges, 28, 30, 49
Shakespeare, William, 115
Soffici, Ardengo, 74
Soloviev, Vladimir, 161
Sorley, Charles, 113
Spencer, Stanley, 125
Stadler, Ernst, 114–18
Stalin, Joseph, 176
Steinlen, Théophile, 49
Sterne, Laurence, 224
Strindberg, August, 114

Stuckenberg, F., 132

Taut, Bruno, 254
Thomas, Edward, 113
Thomson, James, 7, 16
Titian, Tiziano Vecelli, 28
Tolstoy, Leo, 160
Toulouse-Lautrec, Henry de, 30–1
Tressell, Robert, 18
Trotsky, Leon, 2

Uccello, Paolo, 217

Van Eyck, Jan, 31
Van Gogh, Vincent, 49, 51, 120
Velazquez, Diego de Silva y, 31
Verhaeren, Emile, 115–16
Vermeylen, August, 129–30
Vigny, Alfred de, 7, 32

Wagner, Otto, 11, 250
Walden, Herwarth, 54, 111
Webster, John, 114
Wedekind, Frank, 114
Weill, Kurt, 185
Weinheber, Josef, 259, 262
Wells, Herbert George, 19, 166, 194–5
Werfel, Franz, 253, 260
Westhoff, Clara, 99
Whitman, Walt, 116, 234, 260
Wildgans, Anton, 259
Wilson, Woodrow, President, 141
Wittgenstein, Ludwig, 258
Woolf, Virginia, 99, 258
Wordsworth, William, 7, 15, 18, 113

Zalamea, Jorge, 235
Zola, Emile, 27, 40, 98–9
Zweig, Stefan, 254

ACKNOWLEDGEMENTS

The editors are grateful to Gonville and Caius College and Trinity College, Cambridge, for generous financial assistance.

Thanks are also due to the following institutions for kindly providing illustrations: Kunstmuseum, Basel (Emanuel Hoffman-Stiftung) Cover design and Fig 3; National Gallery, London (Fig. 4); Courtauld Institute, London (Fig. 5); Nelson Gallery, Atkins Museum, Kansas City (Fig. 6); Private Collection, Cologne (Fig. 7); Collection Rasmus Meyer, Bergen (Fig. 8); Museum of Modern Art, New York (Fig. 9); Niedersächische Gallerie, Hanover (Fig. 10); Musée National d'Art Moderne, Paris (Fig. 11); Collection Thyssen, Lugano (Fig. 12); Staatsgalerie, Stuttgart (Fig. 13); Collection Lady Hulton, London (Fig. 17); National Film Theatre, London (Figs. 26–32). Other illustrations are based on printed sources.